RESEARCH IN MIDDLE EAST ECONOMICS

Series Editor: Jennifer Olmsted

RESEARCH IN MIDDLE EAST ECONOMICS VOLUME 4

THE ECONOMICS OF WOMEN AND WORK IN THE MIDDLE EAST AND NORTH AFRICA

EDITED BY

E. MINE CINAR
Loyola University Chicago, USA

2001

JAI
An Imprint of Elsevier Science

Amsterdam – London – New York – Oxford – Paris – Shannon – Tokyo

ELSEVIER SCIENCE B.V.
Sara Burgerhartstraat 25
P.O. Box 211, 1000 AE Amsterdam, The Netherlands

© 2001 Elsevier Science B.V. All rights reserved.

This work is protected under copyright by Elsevier Science, and the following terms and conditions apply to its use:

Photocopying
Single photocopies of single chapters may be made for personal use as allowed by national copyright laws. Permission of the Publisher and payment of a fee is required for all other photocopying, including multiple or systematic copying, copying for advertising or promotional purposes, resale, and all forms of document delivery. Special rates are available for educational institutions that wish to make photocopies for non-profit educational classroom use.

Permissions may be sought directly from Elsevier Science Global Rights Department, PO Box 800, Oxford OX5 1DX, UK; phone: (+44) 1865 843830, fax: (+44) 1865 853333, e-mail: permissions@elsevier.co.uk. You may also contact Global Rights directly through Elsevier's home page (http://www.elsevier.nl), by selecting 'Obtaining Permissions'.

In the USA, users may clear permissions and make payments through the Copyright Clearance Center, Inc., 222 Rosewood Drive, Danvers, MA 01923, USA; phone: (+1) (978) 7508400, fax: (+1) (978) 7504744, and in the UK through the Copyright Licensing Agency Rapid Clearance Service (CLARCS), 90 Tottenham Court Road, London W1P 0LP, UK; phone: (+44) 207 631 5555; fax: (+44) 207 631 5500. Other countries may have a local reprographic rights agency for payments.

Derivative Works
Tables of contents may be reproduced for internal circulation, but permission of Elsevier Science is required for external resale or distribution of such material.
Permission of the Publisher is required for all other derivative works, including compilations and translations.

Electronic Storage or Usage
Permission of the Publisher is required to store or use electronically any material contained in this work, including any chapter or part of a chapter.

Except as outlined above, no part of this work may be reproduced, stored in a retrieval system or transmitted in any form or by any means, electronic, mechanical, photocopying, recording or otherwise, without prior written permission of the Publisher.
Address permissions requests to: Elsevier Science Global Rights Department, at the mail, fax and e-mail addresses noted above.

Notice
No responsibility is assumed by the Publisher for any injury and/or damage to persons or property as a matter of products liability, negligence or otherwise, or from any use or operation of any methods, products, instructions or ideas contained in the material herein. Because of rapid advances in the medical sciences, in particular, independent verification of diagnoses and drug dosages should be made.

First edition 2001

Library of Congress Cataloging in Publication Data
A catalog record from the Library of Congress has been applied for.

ISBN: 0-7623-0714-5

∞ The paper used in this publication meets the requirements of ANSI/NISO Z39.48-1992 (Permanence of Paper).
Printed in The Netherlands.

DEDICATION

I would like to dedicate this book to the great teachers who have shaped my life – to Melahat Kantar and to the memories of Ahmet Kantar, Samiye Kaygulu, Munevver Kaygulu, Demir Demirgil, Linda Blake and Naomi Foster. I would also like to thank my husband Ali Cinar for his endless encouragement of this project.

<div align="right">E. Mine Cinar</div>

CONTENTS

LIST OF CONTRIBUTORS	xi
REFEREES	xiii
INTRODUCTION E. Mine Cinar	1
CLOSING THE GENDER GAP IN THE MIDDLE EAST AND NORTH AFRICA Nemat Shafik	13
FEMALE ENDANGERMENT: THE CASE OF THE MIDDLE EAST AND NORTH AFRICA Djehane Hosni and Adriana Chanmala	33
FEMALE LABOR FORCE PARTICIPATION AND ECONOMIC ADJUSTMENT IN THE MENA REGION Massoud Karshenas and Valentine M. Moghadam	51
ANALYSIS OF SEX-BASED INEQUALITY: USE OF AXIOMATIC APPROACH IN MEASUREMENT AND STATISTICAL INFERENCE VIA BOOTSTRAPPING Sourushe Zandvakili	75
WOMEN, WORK, AND ECONOMIC RESTRUCTURING: A REGIONAL OVERVIEW Valentine M. Moghadam	93
IS ALL WORK THE SAME? A COMPARISON OF THE DETERMINANTS OF FEMALE PARTICIPATION AND HOURS OF WORK IN VARIOUS EMPLOYMENT STATES IN EGYPT Ragui Assaad and Fatma El-Hamidi	117

MEN'S WORK/WOMEN'S WORK: EMPLOYMENT,
WAGES AND OCCUPATIONAL SEGREGATION
IN BETHLEHEM
 Jennifer Olmsted *151*

GENDER SEGMENTION IN THE WEST BANK AND
GAZA STRIP: EXPLAINING THE ABSENCE OF
PALESTINIAN WOMEN FROM THE FORMAL LABOR
FORCE
 Rema Hammami *175*

WHY WOMEN EARN LESS? GENDER-BASED FACTORS
AFFECTING THE EARNINGS OF SELF-EMPLOYED
WOMEN IN TURKEY
 Simel Esim *205*

FACTORS AFFECTING FEMALE MANAGERS'
CAREERS IN TURKEY
 Isik Urla-Zeytinoglu, Omur Timurcanday Ozmen,
 Alev Ergenç Katrinli, Hayat Kabasakal and Yasemin Arbak *225*

GENDER-BASED OCCUPATIONAL SEGREGATION
IN THE TURKISH BANKING SECTOR
 Gülay Günlük-Senesen and Semsa Özar *247*

POST-FORDIST WORK, POLITICAL ISLAM AND
WOMEN IN URBAN TURKEY
 Aysenur Okten *269*

WORKING WOMEN AND POWER WITHIN
TWO-INCOME TURKISH HOUSEHOLDS
 E. Mine Cinar and Nejat Anbarci *289*

FERTILITY, EDUCATION, AND HOUSEHOLD
RESOURCES IN IRAN, 1987–1992
 Djavad Salehi-Isfahani *311*

IRAN'S NEW ISLAMIC HOME ECONOMICS:
AN EXPLORATORY ATTEMPT TO CONCEPTUALIZE
WOMEN'S WORK IN THE ISLAMIC REPUBLIC
 Fatemeh E. Moghadam *339*

LIST OF CONTRIBUTORS

Nejat Anbarci	Florida International University
Yasemin Arbak	Dokuz Eylul University, Izmir, Turkey
Ragui Assaad	University of Minnesota
Adriana Chanmala	University of Central Florida
E. Mine Cinar	Loyola University Chicago
Fatma El-Hamid	University of Pittsburgh
Alev Ergenç Katrinli	Dokuz Eylul University, Izmir, Turkey
Simel Esim	International Center for Research on Women
Gülay Günlük-Senesen	Istanbul University, Istanbul, Turkey
Rema Hammami	Bir-Zeit University
Djehane Hosni	University of Central Florida
Hayat Kabasakal	Bogazici University, Istanbul, Turkey
Massoud Karshenas	University of London
Fatemeh Moghadam	Hofstra University
Valentine M. Moghadam	Illinois State University
Jennifer Olmsted	Occidental College

Aysenur Okten	Yildiz University, Istanbul, Turkey
Semsa Özar	Bogazici University, Istanbul, Turkey
Omur Timurcanday Ozmen	Dokuz Eylul University, Izmir, Turkey
Djavad Salehi-Isfahani	Virginia Polytechnic Institute and State University
Nemat Shafik	The World Bank
Isik Urla-Zeytinoglu	McMaster University
Sourushe Zandvakili	University of Cincinnati

REFEREES FOR THE ECONOMICS OF WOMEN AND WORK IN MIDDLE EAST AND NORTH AFRICA

The refereeing process for the volume was double blind and numerous papers were rejected as a result. I thank the referees listed below who commented on papers alongside with me. Their contributions are invisible but invaluable to the volume. E. Mine Cinar.

Engin Akarli	Brown University
Nejat Anbarci	Florida International University
Sohrab Behdad	Denison University
Kathleen Cloud	University of Illinois at Urbana-Champaign
Salpie Djoundourian	Lebanese American University, Byblos, Lebanon
Simel Esim	International Center for Research on Women
Marianne Ferber	University of Illinois at Urbana-Champaign
Elizabeth Fernea	University of Texas
Deniz Kandiyoti	University of London
Shah Mehrabi	Montgomery College
Fatemeh Moghadam	Hofstra University

Valentine Moghadam	Illinois State University
Jeffrey Nugent	University of Southern California
Jennifer Olmsted	Occidental College
Semsa Ozar	Bogazici University, Istanbul, Turkey
Ferhunde Ozbay	Bogazici University, Istanbul, Turkey
Suleyman Ozmucur	Bogazici University, Istanbul, Turkey and University of Pennsylvania
Karen Pfeifer	Smith College
Moyara Ruehsen	Monterey Institute of International Policy Studies
Djavad Salehi-Isfahani	Virginia Polytechnic Institute and State University
Insan Tunali	Koc University, Istanbul, Turkey
Ali Esref Turan	Yonelim, Inc., Istanbul, Turkey
Cimen Turan	Yonelim, Inc. Istanbul, Turkey
Isik Urla-Zeytinoglu	McMaster University
Bulent Uyar	University of Northern Iowa
Sourushe Zandvakili	University of Cincinnati
Hamid Zangeneh	Widener University

INTRODUCTION

E. Mine Cinar

It is time to examine the economics of women and work for the Middle East and North Africa (MENA) region. At the macro level, persistently high rates of unemployment are major features of the labor markets. Private investment, growth and job creation have remained stagnant and public sectors are running large deficits. Rural to urban and international labor migration are major issues. All macro statistics show large gender gaps in literacy, wages, and job opportunities. The increasing overall unemployment puts more pressure on women in the region (Cinar, 1995). Informal markets are large and unaccounted for. Immigrant labor and preferential labor markets continue to be important issues for some countries in the region while child labor and polygamy affect women's labor in some other countries.

MENA region countries need to rise to meet the global challenges and changes in the years to come. A critical source of inefficiency in the region is the status of women, as evidenced by large gender gaps in literacy, education, formal sector participation, legal rights and job opportunities. Poverty reduction in all areas is an essential feature of development studies and gender-specific poverty alleviation generates large positive externalities (Bardhan & Udry, 1999, p. 136).

Given the inequalities in all macro-gender statistics (or gender gaps) for MENA, it is evident that more studies are needed on the economics of female labor dynamics at both micro and macro levels. At the micro level, endogenous labor decisions and welfare and at the macro level, market supply-demand restrictions, labor segmentation, legal environments, and wage gaps need to be studied closely. MENA economists need to examine human capital formation, intermittent work (such as taking off time to raise children, therefore depreciating

human capital in the interim), self selectivity for jobs, sexual harassment, job turnover rates and the partitioning of the gender gaps. This book includes many studies which cover topics in some of these areas.

Micro data is scarce, unreliable or non-existent for most of the MENA countries. A number of scholars publishing in this book (Esim, Cinar and Anbarci, Urla-Zeytinoglu et al., Olmsted) have collected data for their analysis. Others have relied on national and international statistics to explain their hypothesis.

There is not a single unified approach to studying women and work in the Middle East. There are two reasons for this: one is due to different approaches adapted by economists in studying race and gender problems and the other is because of diversity of the countries in the region. The different approaches by economists are discussed below. The diversity of MENA follows in the next section.

STUDYING WOMEN'S WORK IN ECONOMICS

A large body of literature on labor economics has developed in the last thirty years. Approaches to race and gender problems in economics are varied. Solow (1994) states that one studies race and gender problems in economics as long as there is labor discrimination which affects either the demand or the supply of labor in a way that is independent of the persons in question. Altonji and Blank (1999) study discrimination by examining race and gender wage gaps for the U.S. and decompose the gaps into two main components of human capital differences and of 'discrimination'. The discrimination component can further be decomposed into pure discrimination or prejudice, and statistical discrimination. Statistical discrimination results from inadequate information because employers have limited information about workers and they rely on physical characteristics such as gender to evaluate potential performance. Altonji and Blank state that in the long run, even statistical discrimination will be a self-fulfilled prophecy, where the discriminated group will have no incentive to invest in skills required for higher-level jobs.

Feiner (1994) does a good summary of schools of thought in economics when she examines race and gender relations in the United States. She distinguishes between three schools of economic thought (conservative/free market school, the liberal/imperfect market school and the radical/exploitation school) in her study. The conservative/free market school of thought relies on the assumption that the individual's economic status is the result of her/his own personal endowments and personal choices. In this case, public policy does not help the individual's welfare since the responsibility, work effort and intellectual/physical endowment depends on the individual. The liberal/imperfectionist school

looks at individual's choices in association with social structures and patterns of culture to explain the inequality in the market and proposes government regulation to correct imperfections. The radical/exploitation school studies the system rather than the individual and explains discrimination/exploitation by the hypothesis that the economy thrives upon and nurtures social and sexual discrimination for its very survival.[1] Folbre (1994) has divided the schools of thought even further and has proposed a synthesis to studying gender. In her work on feminist theory and political economy, she discusses the differences between the traditional Neoclassical model and the Neoclassical Institutionalist model. In the first category, rules, norms and preferences are exogenous and in the second, partially endogenous. In both categories, the individual is the primary agent. Her synthesis for studying gender calls for combining the structural factors of all schools by adding assets to structural factors in the Neoclassical schools and preferences/utility to the constructs in radical schools. She envisions an examination of all; that is, of firms, states, markets and families as sites in which coercion, production, exchange and coordination take place (Folbre, 1994, p. 49).

In recent years, the literature in economics of gender places more emphasis on the institutionalist and feminist approaches. The term institutionalism is used in at least two different interpretations. In one well-known approach, efficient market outcomes are possible with well defined individual property rights unless there are high transactions costs and an absence of legal infrastructure which then make markets very costly to maintain (Coase, 1960). This version does not call for government intervention in the labor markets.[2] Another variant states that legal institutions make and lead markets and one can therefore change market rules by changing regulations.

Feminism also contains two main versions of its own. One, called the maximalist perspective, or essentialism, postulates that there are either biological or social conditioning differences between the sexes, that these are deeply rooted and result in different approaches between genders which benefit the society. The other, the minimalist perspective (also called constructionism), finds the two sexes fundamentally similar, and states that gender differences are socially constructed and kept in place by the way each sex is located in the social fabric of the society (Epstein, 1988). Most feminist studies see no difference in preferences or endowments between genders and hence consider all roles negotiable within and outside the household.

There is also a wide divergence in the study of gender issues in developing countries as to what constitutes women's work and how to measure women's welfare. According to Papanek (1985, p. 82), women's work should be broadly defined to include activities paid for in cash or kind, unpaid family labor and

other family production. For a long time, gender literature in social sciences has also focused on the issue of marginalization to measure women's welfare. Scott (1986) discusses four different dimensions of marginalization.[3] First, marginalization is seen as women being excluded from productive employment, where productive employment is interpreted as either the labor force participation rate or as the waged and salaried labor. Second, marginalization is interpreted as concentration of working women into marginal occupations such as those in small scale employment or the domestic service. The third interpretation is closely related to the second and has to do with the segregation of industries where the low-wage industries or occupations are 'feminized' with high concentration of women. Fourth is the degree and the causes of pay inequality within industries where women receive lower pay and fringe benefits compared to men.

Women and work issues have complex dimensions, time-varying interactions and they are multi-variable problems. Nonetheless, some earlier studies have examined one dimension of work which is the female labor force participation rate in the formal markets. The most noted and quoted statistics for MENA is the low formal labor force participation rates of women. This rate is the lowest among all world regions. There is now substantial literature on informal markets which argue that this workforce cannot be ignored in the national accounts. Since bureaucracy, red tape and union rules discourage part-time employment in many countries, including those in MENA, informal home work is also an important feasible outlet for part-time work for women in the Middle East (Cinar, 1994).[4] Some articles in this book address the social and institutional reasons on why low formal and high informal work is prevalent in MENA.

WOMEN AND WORK IN DIVERSE COUNTRIES IN MENA

Almost all of the MENA countries have sizable income distribution problems. The political systems are generally repressive. The checks and balances which are necessary to maintain more pluralistic democracies such as a free press, free speech, a non-partisan legislative system and an elected executive head are generally undeveloped. Repressions have allowed corrupt bureaucracies, non-market incentives and thin and selective capital markets to exist and widen the income distribution gaps. Rebuilding of market incentives, checks and balances and democratic institutions in these societies since the 1990s have been slow and remain one of the biggest challenges in the region.

MENA itself is not a monolithic body. Nonetheless, most studies focus on Islam when it comes to studying gender issues in the Middle East. Esim (1994)

Introduction 5

notes that religious explanations are used as the first resort when researchers examine the area. She notes that religion-centered approaches dominate other economic and social variables. In her words, "While Islam interacts with many of the social processes and is embedded in the culture, in analyzing such issues as of women's employment in the informal sector, we are mainly talking of economic need and necessity factors . . . Gender issues in MENA as any other part of the world can be therefore explained on class and income basis" . . . (p. 1).

It is also worth noting that there is a non-Islamic state (Israel) as well as substantial Jewish and Christian populations and other religious minorities in many other states. Moreover, Islam itself is not a monolithic body, but has two major sects of Shi'a and Sunni and also several Sunni sects. There are also legal and institutional differences between the states. While some use the Koranic law, Sharia, as the legal basis (Saudi Arabia), others separate the "church and the state" and have secular legal and institutional systems (Turkey). However, the recent tide of fundamentalism or political Islam that is sweeping across MENA and parts of Asia cannot be ignored.[5] Versions of political Islam are in political power for decades (Iran, Saudi Arabia) and political Islam has popular backing among lower socio-economic classes and small-scale business networks in Egypt, Algeria and Turkey.[6] The proponents of religious fundamentalists envision a different social order and society than the present system, where they call for a mercantilist 'just system'. They redefine the scope of women's work and place in society, see a restrictive role of women in the labor markets and promote gender apartheid. Nevertheless, it is true that political Islam has offered the lower socio-economic class women a grass-roots movement with its own particular brand of feminism (in separate spheres) by creating women's networks and work opportunities (Hooglund, 1995). Yet the choice of work and agenda are all set outside of the women's domain. Political Islam and women's work are discussed in Okten's and F. Moghadam's contributions in this book.

Even without the different institutional backgrounds, the countries in the Middle East show patterns which are intriguing from an initial economic development point of view. Some economies are dominated by state economic enterprises (such as Algeria and Egypt) while others have viable private sectors (Israel, Turkey). Several have population growth rates exceeding 3% per year (such as Algeria, Jordan, Syria and Yemen) and sizable local unemployment (WB, 1995, p. 77). The differences in the GDP per capita and total population size are large between the countries. Some countries in the region have large surplus oil and gas reserves and export minerals (Saudi Arabia, Kuwait, U.A.E., Libya, Iran) and most of these import labor.[7] A majority of others are energy and/or water deficient, have serious balance of payments deficits and have relied

on workers' remittances from abroad as well as international debt to alleviate part of the balance of payments deficit (Egypt, Turkey, Syria). Some are in more complex situations, where they both export and import labor, and the citizens compete with lower immigrant wages (Lebanon, Jordan). There are also some built-in contradictions. The higher GDP per capita figures in oil exporting states stem from exports which accrue to the state or to the ruling family. These countries exhibit low human development indexes with high income per capita figures (UNDP, 1997).

Table 1 below shows countries for which data are available in MENA. The table ranks countries by their population and also gives GNP per capita and the illiteracy rates of women. The variations in population sizes, GNP per capitas and the illiteracy rates all point to the diversity of the countries in the region.

Table 1. The Diversity of the MENA Countries, Ranked by Population.

COUNTRY	POPULATION (MILLIONS)	GNP/CAPITA 1998 DOLLARS	FEMALE 1998 ADULT ILLITERACY (%)
Kuwait	1.9	19,420*	23
Oman	2.3	5,140*	N.A.
UAE	2.6	18,220	N.A.
Lebanon	4.2	3,560	22
Jordan	4.6	1,520	18
Libya	5.3	N.A.	N.A.
Israel	6.0	15,940	7
Tunisia	9.4	2,050	44
Syria	15.0	1,020	43
Yemen	16.5	300	79
S. Arabia	20.7	7,050*	38
Iraq	22.3	N.A.	42
Morocco	27.8	1,250	67
Sudan	28.3	90	47
Algeria	30.0	1,550	52
Egypt	61.4	1,290	60
Iran	61.9	1,770	34
Turkey	63.5	3,160	26

Source: World Bank, World Development Report 1999/2000, pp. 230–235, 272–273 unless noted otherwise. * denotes figures taken from UNDP, Human Development Report, 1997, p. 164.
Note: Female illiteracy rates are missing for Oman, UAE and Libya, but the illiteracy rates for all adults (which tend to be lower than female illiteracy rates) are 33% for Oman, 25% for UAE. and 24% for Libya.

High female illiteracy seems to be dominant in the MENA countries, regardless of their population or energy export status and despite the recent push for literacy in the last decade. The only single digit illiteracy rate belongs to the state of Israel. Palestine also has a low female illiteracy rate but has been excluded from the tables due to lack of data. In general, the table does not show a correlation between female illiteracy, population or GNP per capita.

When compared with other regions, MENA region countries show comparable high public expenditures in education as a percentage of GDP. These numbers do not reflect the realities of the large illiteracy rates in the region (WB, 1999–2000, pp. 240–241). Among the prominent reasons for the high illiteracy rates in these countries are the lack of special education facilities for children with special needs (as indicated by the large number of dropouts from first and second grades after repeating the grades) and the lack of enrollment of girls in the grade school in the first place (as shown by the unequal numbers of first graders between sexes). Female literacy rate is not necessarily elastic with respect to education spending per capita by state, i.e. spending more money by the state would not necessarily increase female literacy (Cinar, 1995).

Why are the female illiteracy numbers in MENA important? In the first section, I discussed the variety of ways race and gender problems can be studied in economics. Even though economists diverge in their approaches to studying gender, one thing that all economists of *all* schools agree on is the *importance* of human capital. From the point of view of the first two schools of thought, human capital gives women more choices in determining work and other life decisions, raises productivity and narrows gender gaps. All radical/exploitation schools see women's education as part of the solution to the problem of re-distribution of assets and power in the society. One of the largest inefficiencies that exists in the MENA region today is in the case of women, with respect to education, work and legal rights. In a way, women can be considered the largest untapped resource in the region.

CONTENTS OF THIS VOLUME

The collection of studies presented here are both invited and contributed articles which went through a double-blind refereeing process before acceptance. I am most grateful to the authors who contributed their studies and their refereeing time to this volume. To reach wider audiences, I have asked most of the authors to keep mathematical notation to a minimum. I hope this collection of articles is also readable by the general audience and researchers from all branches of social sciences. I have also invited the views of non-economists who work

on gender in Middle East and North Africa and the book contains studies of scholars in urban sociology, industrial relations and women's studies (see articles by V. Moghadam, R. Hammami, Urla-Zeytinoglu et al., and Okten).

The diversity of languages, religions, economic development status, cultures, norms and institutions in each country dictate a more specialized approach to MENA. The collection of contributions in this book provide a multifaceted analysis. The book starts out with several articles which overview the region. In terms of general policies, Nemat Shafik's article examines the large gender gaps in MENA region and explores the relative importance of demand versus supply based policies for reducing gender inequities. The paper by Djehane Hosni-Adriana Chanmala studies the widely used and quoted gender development indexes published by the UNDP in the last decade. They introduce a new concept of female endangerment and develop a composite index for the region to identify socio-economic determinants of female endangerment to assess its impact on development. Massoud Karshenas-Valentine Moghadam formulate a hypothesis to explain MENA's low female labor force participation rates with no-longer sustainable family structures and female socio-economic roles. They find that the economic adjustment and development in the MENA region is conditional on the improvement of the socio-economic role of women. Sourushe Zandvakili has a theoretical paper on measuring exact gender income gaps where he suggests the use of Generalized Entropy family of measures for the analysis of short-run and long-run earnings inequality based on gender in the MENA countries. He advocates using long-run measures of earnings inequality, and suggests decompositions based on individual characteristics to detect between-group earnings inequality to understand overall earnings inequality. Valentine Moghadam examines macro trends in the region to find an increase in the supply of job-seeking women, along with high female unemployment rates. Moghadam also finds the "feminization" of government employment in MENA, as public wages erode and she inspects social policies for the working women.

Country studies start with the work by Ragui Assaad and Fatma El-Hamidi who study data from Egypt. Their investigation of the determinants of female labor force participation and hours of work relate the form of work to the impact of a woman's life-cycle, education, residency, and her role and status within the family. Jennifer Olmsted uses micro-level household data to examine gender differences in labor force participation, occupations and wages for Palestinians in the Bethlehem area. She finds evidence of occupational segregation and of a gender wage gap, especially among less educated women. Rema Hammami's work examines the dichotomy of high educational endowments and low formal sector participation of Palestinian women. Her paper states that the extremely

constrained labor opportunities for the population as a whole and limited growth in the labor markets with high female demand make the informal sector the default option for women in the West Bank and Gaza Strip. Simel Esim inspects the determinants of earnings differences between men and women among the urban self-employed in Turkey. She examines the impact of social and institutional factors as well as human capital factors on the earnings of self-employed men and women. Isik Urla-Zeytinoglu, et. al. use a database of female and male managers, and study legal and institutional factors affecting female managers careers in Turkey. Focusing on the behavioral, human capital and demographic factors, they examine different leadership styles and personalities between female and male managers. The paper by Gulay Gunluk-Senesen-Semsa Ozar analyzes patterns of employment in the banking sector in Turkey during the post-1980 era from the occupational sex segregation perspective. Based on a bank survey data, the authors study employment composition of private banks by gender and education. They report indices for occupational segregation for each bank as well as for the sector and examine the qualifications of female employees in the banking sector. Aysenur Okten investigates post-modern production and the growth of the informal sector in Turkey. She finds that the replacement of formal work organizations with informal ones introduce a social concept of women which is compatible with the political Islamist movement in Turkey. She examines long-term trends in a patriarchal society and finds that under the influence of role perception of orthodox Islam, women should be expected to be increasingly inclined to supply their labor in a limited area of the formal labor market or in the informal market. Mine Cinar and Nejat Anbarci use a field survey conducted in Izmir, Turkey, to measure the welfare of working women in three different socio-economic strata in the Turkish households. They study proxies based on income, absolute and proportional spending and personal leisure time to find significant differences (of relative household power) between socio-economic classes. Djavad Salehi-Isfahani examines the effect of education on fertility to find that the family planning program in Iran demonstrates the dilemma Iranian society faces between tradition and modernity. He finds that education and fertility are closely related, over time and across households, in rural and urban areas in Iran. Fatemeh Moghadam studies the legal and ideological treatment of women's work in the Islamic Republic of Iran. She examines the impact of the government's recognition of three categories of female labor and the unique provisions for compensation of *household* labor on the role and the status of the working women in Iran.

The economics of women and work in MENA is an all important issue for the welfare of women, children and families. I hope this book helps shed light on the issues and leads the way to more research.

NOTES

1. The Neoclassical school is firmly based on the utilitarian principles and the radical/exploitation tradition is based on rule theory within the schools of ethics. While there are variations of radical/exploitation theories of labor and gender, these paradigms rest on how some exploitation of one group is necessary to the well being and survival of the other. There are many variations of this theme. For example, dependency theory studies apply this paradigm to the framework of capitalistic development. Some of the studies on informal markets state that this exploitation is a condition for the development of formal markets or for the export growth of the country. Erkut (1982) uses this in a micro context and talks about how the 'army of maids and servants' in urban Turkey (all unskilled immigrant women) are necessary to the professional women to carry on with both their professional and their household duties at the same time.

2. For the description of the "old" institutionalism which studied how habits related to institutions, based on Darwinian biology, and the "new" institutionalism which explains the relations between rational expectations, rational behavior of agents and of institutions, see Hodgson (1998).

3. The main ideas of female marginalization stem from the organization of production and the use of labor. The basic premise is that there is a separation of production and reproduction as industrialization takes place. The rise of surplus labor and the industrial reserve army results in women's increasing confinement to home or to inferior jobs or to jobs commonly referred to as the informal sector.

4. For disguised employment in the urban informal sector in Istanbul, Turkey, see Cinar (1994). For the composition of the labor force within formal sector firms versus within families during the economic development process and the distortions in the labor markets by monopsonistic power, governmental regulations and rents, see Schultz (1990).

5. There have been major increases in all political religious fundamentalist movements (Jewish, Christian and Islam) in the U.S., Central and SouthWest Asia and in MENA in the last three decades of the 20th century. Since Islam is the dominant religion in the MENA region, only political Islam is discussed here.

6. For small and large business networking among firms which join the religious organization MUSIAD in Turkey, see Financial Times, 12/3/1998, and for social policies of the Shas party in Israel, see Chicago Tribune, 12/20/1999.

7. Those who exported oil have suffered from stagnant growth in the last decade due to lower oil prices, lack of public sector hiring (which was heavily relied on) and marginal growth in the private sector. Oil-exporting countries who subsidized domestic labor despite a lack of productivity have to change their policies in order to survive in the coming decades.

REFERENCES

Altonji, J. G., & Blank, R. (1999). Race and Gender in the Labor Market, working paper, Institute for Policy Research, Northwestern University, Evanston, Illinois.

Bardhan, P., & Udry, C. (1999). *Development Microeconomics*. New York: Oxford University Press.

Chicago Tribune (1999). Shas Party's Clout Hardly Orthodox, June 20, Section 1, p. 3.
Cinar, M. (1995). The Role of the Middle Eastern State: Education Spending and Increasing Female Illiteracy, Paper presented at MEEA/ASSA Meetings, January 1995.
Cinar, M. (1994). Unskilled Urban Migrant Women and Disguised Employment: Home-working Women in Istanbul, Turkey. *World Development*, 22(3), 369–380.
Coase, R. (1960). The Problem of Social Cost. *Journal of Law and Economics*, 3, October, 1–44.
Epstein, C. F. (1988). *Deceptive Distinctions: Sex, Gender and the Social Order*. Connecticut: Yale University Press, New Haven.
Erkut, S. (1982). Dualism in Values Toward Education of Turkish Women. In: C. Kagitcibasi (Ed.), *Sex Roles, Family, Community in Turkey* (pp. 121–132). Indiana University Turkish Studies, Bloomington, Indiana.
Esim, S. (1994). Women Living at the Margins: A Comparative Analysis of Informal Sector Women in the Middle East, World Bank Document, March 22.
Fenier, S. F. (1994). Three Economic Paradigms. In: S. E. Feiner (Ed.), *Race and Gender in the American Economy* (pp. 22–27). New Jersey: Englewood Cliffs.
Financial Times (1998). Islamic Business: Emerging Picture in Different Shades of Green, December 3, p. IV.
Folbre, N. (1994). Feminist Theory and Political Economy. In: *Who Pays for the Kids?* (pp. 16–50). New York: Routledge Press.
Hodgson, J. (1998). The Approach to Insitutional Economics. *Journal of Economic Literature, Vol. XXXVI*, March, 166–192.
Hooglund, E. (1995). Islamic Feminism. *Middle East Insight*, XI(5), 70–72.
Papanek, H. (1985). Low-Income Countries. In: J. Farley (Ed.), *Women Workers in Fifteen Countries* (pp. 81–89). ILR Press, Cornell University.
Schultz, T. P. (1990). Women's Changing Participation in the Labor Force: A World Perspective. *Economic Development and Cultural Change*, 457–488.
Scott, A. M. (1986). Women and Industrialization: Examining the 'Female Marginilization' Thesis. *The Journal of Development Studies*, 22(4), July, 649–680.
Solow, R. (1994) How Race and Gender Issues Arise in Economics In: S. E. Feiner (Ed.), *Race and Gender in the American Economy* (pp. 5–8). New Jersey: Prentice Hall, Englewood Cliffs.
World Bank, World Development Report 1990, published for the World Bank by Oxford University Press, New York.
World Bank, World Development Report 1994, published for the World Bank by Oxford University Press, New York.
World Bank (1995). Claiming the Future: Choosing Prosperity in the Middle East and North Africa, October, IBRD report.
World Bank, World Development Report 1999–2000, published for the World Bank by Oxford University Press, New York.
UNDP, Human Development Report 1994, published for the United Nations Development Program by Oxford University Press, New York.
UNDP, Human Development Report 1997, published for the United Nations Development Program by Oxford University Press, New York.

CLOSING THE GENDER GAP IN THE MIDDLE EAST AND NORTH AFRICA

Nemat Shafik

ABSTRACT

The gender gap in the Middle East and North Africa (MENA) region is one of the largest in the world, despite considerable evidence that gender equality is associated with higher economic growth and improved human development. The size and implications of the gender gap in the region are reviewed to explore alternatives for reducing gender inequities. Unlike the focus on supply-side interventions, such as providing access to schools or to contraceptives, highlighted in some of the gender literature, this paper argues that progress in enhancing women's economic roles must rely more on changing the demand for women's education and employment.

INTRODUCTION

There is a growing body of evidence that there is a positive relationship between economic growth and narrowing the gender gap in education (King & Hill, 1993). Cross-country econometric studies have shown that countries with small gender gaps tend to grow faster, to a large extent because they more effectively take advantage of their human capital. The spectacular success of the East Asian economies has, in part, been attributed to the speed with which they eliminated gender gaps in education at both the primary and secondary levels (World Bank, 1993). Work by Jalan and Subbarao (1994) indicates that gender gaps tend to

follow an inverted "U" shape in many countries, with an initial bias in favor of men, followed by greater gender equality in social investments over time. However, authors argue that although economic growth tends to result in improvements in human development, general progress in economic growth and social indicators does not by itself redress gender disparity. Strong public action is necessary to close the gender gap in human resources. Gender gaps may exist because many of the gains to educating girls are public (like lower fertility or better educated and healthier children) whereas many of the costs of schooling are borne privately by parents (such as direct costs of school attendance as well as opportunity costs).

In this paper aggregate socio-economic indicators are used to examine the status of women in the Middle East and North Africa (MENA). Demographic and socio-economic indicators, including life expectancy, fertility, education and labor force participation indicate that there remains a large gender gap in MENA, despite large gains in income. The pattern for most social indicators though has been significant improvement over time, but with persistence in the gap between men and women and particularly poor performance when compared with other regions, especially for the Gulf countries. Recent evidence that assesses the relationship between gender gaps and growth found that the OPEC countries were below average among a sample of ninety-nine developing countries (Sadeghi, 1995). Gender disparities in MENA were largest in the case of labor force participation and literacy, followed by primary and secondary enrollment. Figure 1 depicts the differences between men and women in MENA for five different indicators (each depicted on a different axis) – life expectancy, primary and secondary enrollment, labor force participation and literacy. The gender gaps implied by this graph are discussed in more detail below.

DEMOGRAPHIC INDICATORS

As can be seen in Table 1, although women in MENA do outlive men, their lives are shorter relative to international norms. In most middle-income countries, women have an average life expectancy of 71 years and outlive men by an average of 6–7 years. For a region comprised mainly of middle-income countries, MENA's female life expectancy, as well as the number of years by which women outlive men, is low. Whereas men in MENA on average live 68 years, the same as in other middle income countries, women only live 68 years, 3 years less than in other middle income countries. If women's life expectancy in the region were closer to the average, there would be one million more women alive in the Middle East today. These million "missing women" are evidence of the deprivation experienced by females throughout their lives.[1]

Fig. 1. Gender Disparities in MENA.

Table 1. Life Expectancy at Birth, 1995 (in years).

Region	Female	Male	Female Advantage
MENA	68	65	3
EAP	70	67	3
LAC	72	66	6
SA	62	61	1
ECA	73	64	9
SSA	54	51	3
Middle Income Countries	71	65	6

Source: World Bank, WDI database. MENA: Middle East and North Africa; EAP: East Asia and Pacific; LAC: Latin American Countries; SA: South Asia; ECA: Europe and Central Asia; SSA: Sub-Saharan Africa.

The region has the highest total fertility rate after Sub-Saharan Africa, with exceptionally high birthrates in Yemen, Oman, Iraq, Saudi Arabia, Afghanistan, Sudan, and Libya (Table 2). Despite fairly high income levels, countries such as Saudi Arabia (6.3), Oman (7.1) and Libya (6.4) are as high as those in some of the poorest countries in Africa.

A number of factors may be contributing to high fertility, including low age at first marriage, low education and low contraceptive prevalence. Each of these factors in turn is interrelated. Educated women are likely to marry later and use contraception. In Egypt for instance, women with some secondary education marry six years later than those without. In Yemen contraceptive prevalence rates among women with a primary education are three times those with no education. (Population Reference Bureau, 1994).

Maternal and infant mortality rates in MENA are also high relative to East Asia and Latin America, although they are low relative to Sub-Sahara Africa, South and Southeast Asia. There is substantial scope for improved prenatal care and care at birth (Table 3). On average, only 49% of pregnant women in MENA receive prenatal care, compared to at least half of all women in every other region of the developing world. Within the region, prenatal care ranges from 99% of pregnant women in Kuwait and Bahrain to around 40% in Egypt and Syria to just 17% in Yemen. Moreover, only 53% of births in MENA were attended by health personnel. Only Sub-Saharan Africa has a lower percentage of medically supervised births.

Table 2. Total Fertility Rates and Contraceptive Prevalence.

	Total Fertility Rate		% Married Women Using Contraceptives
	1965	1994	1990s
High Income Countries	2.8	1.7	
Kuwait	7.4	3.0	35
Qatar	7.0	3.0	26
Bahrain	7.0	3.0	54
Saudi Arabia	7.3	6.3	–
U.A.E.	6.8	4.1	–
Israel	3.8	2.4	–
Upper-Middle Income Countries	5.1	2.8	
Oman	7.2	7.1	9
Libya	7.4	6.4	–
Lower-Middle Income Countries	5.6	2.7	
Jordan	8.0	4.8	40
Iran	7.0	4.7	–
Syria	7.7	6.1	–
Tunisia	7.0	3.0	50
Turkey	5.7	3.2	63
Lebanon	6.0	2.9	–
Iraq	7.1	7.0	18
Algeria	7.4	3.7	36
Egypt	6.8	3.5	47
Morocco	7.1	3.5	42
Yemen, Rep.	7.0	7.4	10
Low Income Countries	6.3	3.3	
Afghanistan	7.0	6.9	–
Sudan	6.7	6.1	9
MENA	7.1	4.5	
Sub-Saharan Africa	6.6	5.9	
South Asia	6.3	3.6	
East Asia/Pacific	6.2	2.2	
LAC	5.8	2.9	

Sources: Total Fertility Rate from World Development Report, 1992 and 1996, numbers in italics from Population Data Sheet, Contraceptive prevalence rates from Population Reference Bureau, World Population Data Sheet.

Table 3. Prenatal Care and Maternal Mortality Rates.

Region	Pre-natal care %[1]	Trained Attendant at Delivery 1993[2]	Maternal Mortality Rates[3]
MENA	49	53	330
LAC	72	76	180
SSA	89	40	980
South Asia	35	31	460
East Asia	87	95	90
Southeast Asia	70	58	460

Sources: Human Development Report, 1994.
"Coverage of Maternity Care A Tabulation of Available Information" World Health Organization. Division of Family Health Geneva. Third Edition 1993.
Notes:
[1] Estimates, using 1990 UN projections for numbers of live births, were calculated for 1993 based on studies for the period of 1993.
[2] Based on 1990 UN projections of live births.
[3] The estimates for the most developing countries are taken from Revised 1990 Estimates of Maternal Mortality. Data for developed countries are the most recently reported three or four year averages from the UN Demographic Yearbook, 1994.

LITERACY AND EDUCATION

Female literacy for the MENA region is a mere 40%. This is similar to Sub-Saharan Africa, where incomes are far lower, and well below literacy rates in Latin America (91%) and East Asia and the Pacific (66%). However, there is considerable divergence across the region. In Afghanistan and Sudan over 85% of women are illiterate while in countries such as Kuwait, Qatar, Jordan, Turkey and Lebanon, illiteracy is around 30%. Nevertheless, the region as a whole performs relatively badly on female literacy even controlling for per capita income. No country in the region is a "star performer", exceeding the average for all developing countries. The major outliers are Saudi Arabia, Iran and Algeria where female literacy is well below the norm for developing countries.As can be seen in Table 4, female enrollments in the Middle East and North Africa have almost doubled from their 1965 levels of 43%. This suggests that rapid progress has occurred in some countries, but female enrollments still remain lower than they should be. Countries such as Tunisia, Iran and Algeria have made notable progress since 1965 and have succeeded in achieving universal primary education for girls. Egypt, Turkey, and Iraq have also

Table 4. Primary School Enrollment Rates for Women.

Country	1965 Total	1965 Female	1994 Total	1994 Female
Low-Income Countries	73	–	101	93
Afghanistan	16	5	–	–
Egypt	75	60	98	91
Sudan	29	21	50	43
Lower-Middle Income Countries	88	80	–	–
Syria	78	108	103	97
Jordan	95	–	94	95
Tunisia	91	65	118	113
Turkey	101	83	97	94
Algeria	68	53	105	98
Morocco	57	35	80	68
Yemen, Rep.	13	3	83	47
Upper-Middle Income Countries	99	96	105	105
Saudi Arabia	24	11	75	75
Iraq	74	45	91	83
Iran	63	40	101	97
Oman	–	–	83	80
High Income Countries	104	106	104	103
Israel	95	95	95	95
U.A.E.	–	–	110	108
Kuwait	116	103	69	69
MENA	61	43	86	77
Sub-Saharan Africa	41	31	74	67
South Asia	68	52	98	85
LAC	99	97	110	108
East Asia/Pacific	88	–	111	109

Source: UNESCO Statistical Yearbook 1996; World Bank, WDR various years.
Note: Data for Israel, Saudi Arabia and Yemen is for the year 1993 and for Iraq it is 1992.

achieved significant improvements in female primary enrollment. But some countries have actually seen a deterioration. In Kuwait, primary enrollment among girls fell from universal levels in 1965 to 91% in 1989, while in Morocco female primary enrollment rates fell from a low rate of 62% to an even lower 55% over the same period. Generally, primary enrollment remains well below the 97% rates prevailing in Latin America and the 52% rate in the much poorer region of South Asia.

The gender gap in primary education is relatively high with only 79 girls enrolled for every 100 boys for the region as a whole. This rate is not significantly better than Sub-Saharan Africa or South Asia, and markedly worse than in Latin America and East Asia (Table 5). Nevertheless, there has been a significant narrowing of this regional gender gap between 1970 (54 girls for every 100 boys) and 1991 (79 girls for every 100 boys). Countries such as Oman, Syria, Tunisia, Turkey and Iran have contributed much to the improvement in the region.

Once girls get into the educational system, they tend to stay. Women in the region seem to fare much better at the secondary level than they do at the primary level. Female secondary enrollment rates between 1965 and 1991 have increased dramatically – rising almost six-fold in twenty-five years. By 1991,

Table 5. The Enrollment Gender Gap.

Country	Primary 1970	Primary 1991	Secondary 1970	Secondary 1991
Low-Income Countries	–	78	–	–
Egypt	61	80	48	76
Sudan	61	75	40	80
Lower-Middle Income Countries	–	–	–	–.
Syria	57	87	36	71
Jordan	78	94	53	105
Tunisia	64	85	38	77
Turkey	73	89	37	63
Algeria	60	81	40	79
Morocco	51	66	40	69
Yemen, Rep.	10	31	3	18
Upper-Middle Income Countries	94	95	100	112
Saudi Arabia	46	84	16	79
Iran	55	86	49	74
Oman	16	89	0	82
High Income Countries	96	95	95	98
Israel	92	98	131	116
U.A.E.	61	93	23	103
MENA	54	79	41	72
Sub-Saharan Africa	63	77	44	67
South Asia	55	69	38	54
LAC	96	97	101	114
East Asia/Pacific	–	88	–	76

Source: WDR, various years.

secondary enrollment rates for women were 51%, second only to those in Latin America. The gender gap for secondary enrollment is 72 girls for every 100 boys, which is fairly high in comparative terms, although there has been a substantial narrowing over time. The evidence for secondary school enrollments points to the fact that there are persistence effects – once girls overcome the barriers and enter the educational system, they tend to continue. For example, in rural Morocco in 1990–1991, girls who entered secondary school were three times more likely than boys to finish.[2]

EMPLOYMENT

Women's paid labor force participation is low. No Arab country has a female labor force rate that exceeds 20% and the MENA region's overall rate is the lowest in the world. For over half of the MENA countries, female labor force participation is less that 10%. By contrast, female labor force participation is about 27% in Latin America, 42% in East Asia, 22% in South Asia and 37% in Sub-Saharan Africa in 1993.

Among those who are economically active, a large percentage of Arab women fall into the category of non-salaried labor. Data from the International Labor Organization indicate that the percentage of women who are economically active but do not receive a wage ranges from a low of 4% in Kuwait and Qatar, to 42% in Egypt, 44% in Iran, 48% in Syria, 49% in Tunisia, 50% in Iraq and 68% in Turkey (UNDP, 1999, Table 26).

Some of the shortfall in female labor force participation can be attributed to strong social pressures. Middle Eastern men tend to feel that women should not work outside the household. In general, most Middle Eastern societies display strong preferences for women bearing responsibility for household work and childbearing at the expense of wage labor outside the home.

Nevertheless, there is a trend toward greater labor force participation. Increasingly, women are entering the labor force by choice and by economic necessity. In countries such as Tunisia and Bahrain, female labor force participation increased threefold between 1965 and 1989. In other countries, such as Algeria, Jordan, Kuwait, and Syria, overall labor force participation fell, but the female share actually increased. In Morocco and Tunisia, growing female employment in export-oriented garment industries has been an important source of household income for poor families. Women's occupational distribution varies by country. Women in Algeria are predominantly in professional occupations, while those in Egypt, Morocco, Syria and Turkey are employed in agriculture. In Kuwait, the vast majority of females are in services, while in Tunisia production work (largely textiles) is the major employer of women.

With stagnant demand for labor in most Arab countries, increasing female employment has not been a priority. Unemployment rates in MENA countries are the highest in the world (averaging about 10%) and real wages remain stagnant at 1970 levels. Given these labor market conditions, increasing female employment has not been a policy priority, even though employing greater human capital would be good for growth. Without the macroeconomic conditions that will generate more buoyant growth and demand for labor (such as those that spawned the gains in female employment in the industrial countries), it is unlikely that there will be major gains in women's labor force participation.

POLITICAL PARTICIPATION

The gender gaps observed in health, education, employment and political participation in the MENA partly reflect the political, social, cultural and religious context. As can be seen in Table 6, women in MENA continue to have very

Table 6. Women's Political Participation.

Country	Year of Right to Vote	Parliamentary Seats Occupied by Women, 1987(%)	Women Decision makers in All Government Ministries, 1987 (number)
Algeria	1962	2.4	1
Bahrain	–	–	4
Egypt	1956	3.9	0
Iran	1963	1.5	0
Iraq	1980	13.2	0
Israel	1948	8.3	16
Jordan	1973	0.0	0
Kuwait	–	–	5
Lebanon	1957	0.0	0
Libya	–	–	–
Morocco	1963	0.0	0
Oman	–	–	1
Qatar	–	–	0
Saudi Arabia	–	–	1
Sudan	1953	0.7	0
Tunisia	1956	5.6	3
Turkey	1934	3.0	0
U.A.E	–	–	0

Source: Moghadam, Valentine, 1993, Modernizing Women: Gender and Social Change in the Middle East.

low participation rates in the political arena. With the exception of Tunisia and Israel, the percent of parliamentary seats occupied by women in 1987 was below 5%.

CLOSING GAPS: WHAT ARE THE ECONOMIC IMPLICATIONS?

What are the economic implications of the patterns observed? What would happen if MENA countries closed some of these gender gaps? What would be the costs and benefits and resulting implications for population growth, infant mortality, human capital accumulation, and growth? And what policies would be most effective in achieving such changes?

There is a growing consensus on the positive linkages between health and education services and a variety of indicators of human development. Investments in education are associated with improvements in:

- health (since nutritional knowledge improves and the use of health services increases),
- fertility (as age of first marriage rises, desired family size falls and the ability to regulate fertility is enhanced),
- productivity (as human capital is accumulated this results in higher wages and externalities for other workers),
- civic participation (as children become educated, they are better socialized for their roles in society).

Similarly, health investments are associated with improvements in:

- fertility (as fertility falls, child survival increases),
- productivity (as health improves, work days lost due to illness are reduced).

Although these "virtuous circle" effects are important, basic education is the point of entry for any human resource strategy since it is the source of the most important externalities for health, fertility decline, higher productivity, and greater social returns to other investments such as family planning (Cassen, 1992). Although the quality of education clearly matters (especially for productivity), many of the externalities and benefits associated with education occur at even very low levels of quality. Moreover, female labor force participation has a direct impact on the demand for education. Therefore the rest of this paper will focus on these two areas – education and employment.

Female education has high economic payoffs – international estimates of wage returns to education for women are 12.4% while they are only 11.1% for men.[3] In addition, educating girls has enormous externalities for other measures of human development, which justify some public policy intervention. The most important correlate for both infant mortality and life expectancy in developing countries is what proportion of the previous generation's girls went to primary school.[4] One additional year of education reduces female fertility by 5–10%. Women with primary education marry 2–3 years later than those with no education, resulting in a tendency for smaller and healthier families. Women with primary education are 1.5–2 times more likely to practice family planning. An additional year of schooling for 1000 women will prevent two maternal deaths (Summers, 1994).

The externalities also cross generations – educational attainment of mothers clearly affects their children's aspirations, especially of daughters. A study of female education in Egypt found that girls whose mothers were illiterate were more likely to aspire only to secondary education whereas children of educated mothers intended instead to seek a university degree (Moghadam, 1993).

The payoff to female education is high, even when one only looks at the effects on fertility and infant and child mortality. For example, an extra year of primary schooling for 1000 women in India would cost $32,000, but would yield a social benefit of $52,000 (after discounting for the time lag between the time when girls are educated and when they grow up to be mothers). The results are similar in Kenya and Pakistan where the returns to investing in female education more than cover the costs, even before the benefits to family health and labor force participation are included.

Unfortunately, although the returns to girls' education are clear, countries in the MENA region continue to spend more on the military than on public education. In fact, as Table 7 shows, the ratio of military expenditures to education and health in MENA is 166, much higher than sub-saharan Africa and Latin America, but about the same as South Asia. Similarly, there are far more people in the military than in the teaching profession in the region.

The public benefits of education then do not seem to have induced MENA countries to act, even though the cost of doing so is relatively small. As table 8 suggests, among countries for which data are available, the additional expenditure required to eliminate the gender gap at the primary level ranges from approximately 0% of national GNP in Syria to just 0.4% in Morocco. The corresponding numbers at the secondary level range from 0% of national GNP in Tunisia to 0.4% in Turkey. While closing the gender gap in education may be financially feasible and socially beneficial, further attention must also be paid to demand factors driving educational outcomes.

Table 7. Public Expenditures.

	Public Education Expenditure, 1986		Public Health Expenditure, 1986		Military Expenditure		Ratio of Military Exp to Combined Education and Health	Armed Forces as a Percentage of Teachers
	1960	1986	1960	1986	1960	1986	1986	1986
High Income Countries	–	–	–	–	5.4	–	–	82
Bahrain	–	5.4	–	–	–	–	–	44
Kuwait	–	5.1	–	2.7	–	5.8	74	–
Qatar	–	5.6	–	–	–	–	–	–
Saudi Arabia	3.2	10.6	0.6	4.0	5.7	22.7	155	46
U.A.E.	–	2.2	–	1.0	–	8.8	275	358
Middle Income Countries	2.4	3.8	–	–	7.5	8.4	221	110
Iran	2.4	4.6	0.8	1.4	4.5	20.0	333	112
Iraq	5.8	3.7	1.0	0.8	8.7	32.0	711	428
Jordan	3.0	6.5	0.6	2.7	16.7	13.8	150	245
Lebanon	–	–	–	–	–	–	–	43
Libya	2.8	10.1	1.3	3.0	1.2	12.0	92	104
Oman	–	5.3	–	2.3	–	27.6	363	275
Syria	2.0	2.90	0.4	0.4	7.9	14.7	445	320
Tunisia	3.3	5.4	1.6	2.2	2.2	6.2	82	55
Turkey	2.6	2.8	0.8	0.5	5.2	4.9	148	271
Yemen	–	5.6	–	1.2	–	9.1	132	188
Morocco	3.1	5.0	1.0	0.9	2.0	5.1	8.6	102
Egypt	4.1	5.5	0.6	1.1	5.5	8.9	135	168
Algeria	5.6	6.1	1.2	2.2	2.1	1.9	23	71
Low Income Countries	2.0	2.8	0.9	1.1	6.5	4.5	116	60
Afghanistan	–	1.8	–	–	–	–	–	209
Sudan	1.9	4.0	1.0	0.2	1.5	5.9	140	88
MENA	3.5	5.8	0.9	1.8	4.9	12.6	166	183
Sub-Saharan Africa	2.4	3.8	0.7	0.9	0.7	3.3	70	90
South Asia	2.1	3.4	0.5	1.0	2.8	7.2	164	47
Asia & Oceania	–	3.0	–	–	8.2	5.2	–	–
LAC	2.1	3.3	1.4	2.0	1.8	1.5	29	42

Table 8. The Cost of Eliminating Gender Discrimination in Education, by Country.

Country	Per Student Expenditure (US$) Primary	Per Student Expenditure (US$) Secondary	Per Student Expenditure (US$) Basic[1]	Additional Girls Needing Education (million) Primary	Additional Girls Needing Education (million) Secondary	Additional Girls Needing Education (million) Basic	Additional Expenditure as Percentage of GNP Primary	Additional Expenditure as Percentage of GNP Secondary	Additional Expenditure as Percentage of GNP Basic
Egypt	202	1,165	123	0.6	0.2	0.8			0.3
Morocco	189	1,107	387	0.5	0	0.5	0.4		0.7
Tunisia	155	894	312	0.1	0	0.1	0.2	0.2	0.2
Iran			278	0.7	0.3	1.0	0.1	0	0.2
Israel	1,561	3,123	2,082			0			
Jordan			263		0.1	0.1			0.7
Oman	881	1,958	1,151	0.01	0	0.01	0.1		0.1
Syria	50	181	70	0.1	0.1				
Turkey	403	1,020	505	0	0.4	0.4		0.4	0.4

[1] Weighted average of primary and secondary per student expenditure. Additional expenditure at the primary and secondary level do not sum to the potential additional expenditure at the basic level, possible because of the weighting use in calculating per student expenditure at the basic level.

SUPPLY VERSUS DEMAND INTERVENTIONS

The decision to send girls to school depends on both supply and demand factors. The supply curve for both boys and girls is upward sloping and similar, but demand curves vary by sex – parents demand more school places for boys at any given price than they do for girls. This difference in demand for schooling is the source of the gap in education by sex (and resulting implications for employment). Most policies to increase female enrollment focus on shifting the supply curve for girls downward (through various subsidies and incentives), thereby lowering the price for parents and reducing this gap.

We know a great deal about how to supply education that increases the likelihood that girls come to school. International experience has shown that policy interventions that reduce the costs, enhance access, or create demand for education for girls can substantially increase female enrollments. Because girls do chores at home and poor families cannot do without their labor contribution, lowering the direct costs (through free textbooks or scholarships for girls) or the indirect costs (through childcare centers or more flexible school hours) can increase female enrollments. The neglect of girls' health and nutrition, which adversely affects learning ability, can be offset by school feeding programs that compensate for nutritional deficiencies at home. Facilities that accommodate girls – such as single sex schools, separate bathrooms and schools that are not very distant – are also important. Similarly, providing more female teachers, especially in rural areas and reducing gender bias in the school curriculum by providing positive role models, can increase enrollments. In addition, creating better job opportunities for girls, for example through education in non-traditional occupations which result in high paying jobs, can affect the demand for girls' education.

Many of these interventions have been implemented in the MENA region on a pilot basis, often with donor support (Chowdury, 1995). Egypt and Yemen have emphasized new school construction. Yemen has established vocational centers for women, as well as training institutes for female teachers, especially for rural areas. Morocco has developed materials and an extension service and promotional campaigns promoting girls' education. Both Morocco and Yemen have provided sanitary facilities that cater to girls and Morocco has provided childcare facilities for siblings to enable older girls to stay in school. Although many of these efforts have been successful, they have had only a small impact on overall female enrollments because they have rarely been expanded to the national level and have rarely generated widespread demand for more school places for girls.

The supply-oriented literature tends to follow a version of "Say's Law" – that supplying educational services for girls will create its own demand. But there has been an extensive debate between those advocating increased supply of social services, such as school places for girls or family planning and health clinics, versus those who emphasize the need to create demand for female education, for contraception, and for better health care. A parallel argument has been made in discussions of fertility outcomes. Econometric work by Pritchett (1994) indicates that 90% of the differences in fertility levels across countries can be explained by differences in desired fertility (i.e. demand factors) rather than the supply of contraceptives (Pritchett, 1994). Although contraceptive prevalence is an important proximate determinant of fertility rates, once variations in desired fertility are taken into account, contraceptive prevalence can explain about 1–2% of cross-country fertility variation. Therefore, the emphasis should shift to the factors that affect desired fertility, such as women's education, economic opportunities, health, and their role and status in society. Similarly, if education outcomes can be explained based primarily on demand outcomes, the focus should also be there.

While there may be public returns to girls' education, the decision to educate is based on private returns and the observed gap between boys and girls reflects individuals' or families' assessment of the relative payoffs of investing in their daughters. As Behrman (1991) has argued, families may be investing rationally, based on the fact that labor market opportunities for women are often limited. He goes on to point out that without changes in the employment opportunities for women, which in turn increase the demand for female education, greater supply of school places will not increase enrollments.

Given the very low rates of job creation in most MENA economies, greater economic growth that is labor-intensive will be a precondition to greater demand for female labor. Reducing wage discrimination and differential access to resources (capital, land, credit, etc.) that operate against women workers are also issues that can raise the payoffs to female schooling.

Unfortunately, a significant part of the demand problem reflects social preferences or "culture" – which represent uncharted waters for economists. Many opponents of greater female education and employment are expressing social preferences which place a high value on mothers being at home to raise children (even if it means lower household income) – thereby emphasizing the preeminence of women's reproductive roles over their productive ones. In East Asia, some of this was addressed by educating women, but focusing on the positive spillovers for children and the household (rather than on employment and autonomy). Thus in East Asia, one observes very high female enrollment rates alongside low levels of female labor force participation. In MENA such

an outcome is conceivable and perhaps more consistent with prevailing social values, but would require deliberate attempts to educate the public on the positive spillovers, at the household level, of educating girls.

CONCLUDING REMARKS

The solution to the gender gap in MENA is not necessarily more money, but greater public commitment. The MENA countries devote more public resources to education and health than any other developing country region. The region spent 5.5% of GNP on education in 1994 and 1.8% of GDP on health in 1986. Part of this reflects the very young populations in the regions, but even adjusting for demographic effects, the levels of spending are sizable. Since 1960, almost all Arab countries increased the share of national income devoted to the social sectors, particularly in the oil economies which had considerable catching up to do on human resource development. Saudi Arabia, for example, increased public expenditure on education three-fold and on health almost sevenfold. Other countries that have expanded resources in these areas are Libya, Jordan, Tunisia, Egypt and Algeria. The problem is clearly not one of insufficient resources, but one of how resources are used.

The inadequacies in the social sector stem from both pure inefficiencies and from important urban, gender and class biases in the service delivery systems.[5] The average public recurrent cost for basic education (primary and secondary school) in MENA is relative high at about $331 per student per year, compared to an average of $102 in lower middle income countries, $297 for upper middle income countries, and $1551 for high income countries. In the case of female education, the total cost of eliminating the gender gap in basic education is a little over one-half of 1% of MENA's GDP. The problem is one of persuading governments to reallocate resources away from male-oriented services, urban areas, higher education, and curative medicine and toward programs that educate parents about the benefits of sending girls to school and that create new economic opportunities for women. More generally, MENA countries need policies that restore growth and create jobs – without which both men and women in the region will face adverse prospects.

ACKNOWLEDGMENTS

This paper was originally prepared as background for a presentation on women in the economy as part of the Council of Foreign Relation's study group on "Pluralism in the Muslim World." Some of the empirical evidence presented in this paper was prepared by Thomas Bonaker, Varuni Dayaratna and Ebru

Engin, all of whom provided excellent research assistance. Comments from Willem van Eeghen are also gratefully acknowledged. The views expressed here are solely those of the author and should not be attributed to the World Bank.

NOTES

1. For a global discussion of female deprivation and the impact on life expectancy, particularly in South Asia, see Amartya Sen (1990).
2. A study by Khandker et al. (1993) cited in Chowdury (1995) found that 56% of the girls who entered first grade in rural Morocco completed primary school and 6% completed all 13 years of school. The completion rate for boys was 62% for primary school and about 2% for secondary school.
3. The estimates of wage returns by level of education and by gender are as follows: for primary school: men (20.1%) and women (12.8%); for secondary school: men (13.9%) and women (18.4%); for higher education: men (13.4%) and women (12.7%). See G. Psacharopolous (1993), *Returns to Investment in Education: A Global Update*, Working Paper 1067, World Bank, Washington, D.C.
4. Caldwell found that the most important correlate for both infant mortality and life expectancy in 99 developing countries is the 1960 female primary enrollment rate. See J. Caldwell (1986), "Routes to Low Mortality in Poor Countries", *Population and Development Review*, volume 12, number 2, June.
5. Measuring the efficiency of education is fraught with methodological problems. For a discussion, see M. Lockheed and E. Hanushek (1994), "Concepts of Educational Efficiency and Effectiveness", Human Resources Development and Operations Policy Working Papers, number 24, March.

REFERENCES

Behrman, J. L. (1991). *Investing in Female Education for Development: Women in Development Strategy for the 1990s in Asia and the Near East*, Research Memorandum, 129, Center for Development Economics, Williams College, Massachusetts, May.
Caldwell, J. (1986). Routes to Low Mortality in Poor Countries. *Population and Development Review*, *12*(2), June.
Cassen, R. (1992). *Human Resources in Economic Development: Past and Future*. Institute of Development Studies Silver Jubilee Paper 5, University of Sussex, England.
Chowdury, K. (1995). *Women's Education: Barriers and Solutions*. mimeograph, The World Bank, Washington, D.C.
Jalan, J., & Subbarao, K. (1994). Gender Disparity in Human Resource Development: Cross Country Patterns, Education and Social Policy Department Discussion Paper Series Number 25, April.
King, E. M., & Hill, M. A. (1993). *Women's Education in Developing Countries – Barriers, Benefits and Policies*. Baltimore: The Johns Hopkins University Press.
Lockheed, M., & Hanushek, E. (1994). Concepts of Educational Efficiency and Effectiveness, Human Resources Development and Operations Policy Working Papers, number 24, March.
Moghadam, V. (1993). *Modernizing Women: Gender and Social Change in the Middle East*. London: Boulder.

Pritchett, L. (1994). Desired Fertility and the Impact on Population Policies. *Population and Development Review*, 20(1), March.
Psacharopolous, G. (1993). Returns to Investment in Education: A Global Update. Working Paper 1067, World Bank, Washington, D.C.
Population Reference Bureau (1994).
Sadeghi, J. M. (1995). The Relationship of Gender Difference in Education to Economic Growth: A Cross-Country Analysis. Working Paper 9521, Economic Research Forum for the Arab Countries, Iran and Turkey.
Sen, A. (1990). *More than 100 million women are missing*. NY Review of Books, 12/20/1990, (pp. 61–65).
Summers, L. (1994). Investing in All the People: Educating Women in Developing Countries. EDI seminar Paper number 45. The World Bank, Washington, D.C.
UNDP (1999). *1999 Human Development Report*. Oxford University Press, 1999.
World Bank (1993). *The East Asian Miracle*. World Bank and Oxford University Press.

FEMALE ENDANGERMENT: THE CASE OF THE MIDDLE EAST AND NORTH AFRICA

Djehane Hosni and Adriana Chanmala

ABSTRACT

In this paper we examine cross-country evidence on the status of women in the Middle East and North Africa, where high female illiteracy, fertility and maternal mortality rates are observed. We introduce a new concept, "female endangerment," and construct a composite index using these three components, to look at female endangerment in the region. We argue that gender empowerment cannot be properly assessed independently of women's deprivation. We take a first step of identifying the socio-economic determinants of female endangerment and their relationship to other development correlates.

I. INTRODUCTION

One of the most threatening issues facing the world today is the extent of women's deprivation. Women make up over 50% of the developing world's population and yet they represent a disproportionate share of the world's poor (70%) and the world's one billion illiterate adults (75%) (UNDP, 1997, p. 24). In the developing countries, 40% of women are illiterate (UNDP, 1998, p. 133). As much as half of the global labor supply is therefore undermined. Moreover,

these statistics understate the magnitude of the problem since negative externalities, or the deprivation effects on the next generation of children, are not factored in. Since women play a central role in molding the future workforce of any nation, and since there is evidence that education improves women's ability to care for their children (Hadden & London, 1996), governments should place a very high priority on the eradication of female illiteracy. According to the World Bank, this is the most crucial investment for developing countries and has high payoffs (Summers, 1992). Stated differently, the benefits of female literacy exceed the education expenditures needed to eliminate illiteracy.

In this paper we discuss the issue of women who have been bypassed by development. We introduce a new concept (female endangerment) to examine the condition of women in the Middle East and North Africa (MENA).[1] The United Nations Development Programme (UNDP) has developed a number of measures of 'human development' including the human development index (HDI), a composite index of three basic dimensions of longevity, educational attainment and income (UNDP, 1992, p. 3), the Gender Development Index (GDI), which adjusts a country's HDI score for gender differences, and the Gender Empowerment Measure (GEM) to examine women's access to political and economic power. Our contribution is to develop a measure which captures the extent of female deprivation or endangerment and apply that measure to look at conditions in the MENA region.

MENA, known for its oil resources, has achieved tangible progress in human development over the past decades. Between 1960–1995 the region achieved the highest HDI improvement (179%) as compared to other parts of the world (East Asia 165% and Latin America and the Caribbean 79%). Moreover, the UNDP identified five MENA countries among the top eleven achievers with the largest HDI increases during 1970–90 (UNDP, 1992, p. 24).[2] Yet, for some countries (e.g. Kuwait and Iraq), lower ranks in HDI relative to GDP per capita (PPP$) reflect incomplete success in converting economic prosperity into human capabilities (UNDP, 1998, p. 20). Overall, the region still suffers from a major human shortfall in the area of female illiteracy (50%) (World Bank, 1998, p. 18). This problem is more acute than with other nations with comparable levels of human development. As such, in this paper we plan to examine the issue of female illiteracy, in conjunction with fertility and maternal mortality, using Female Endangerment Measure (FEM) which we have developed. In the following section, we briefly review the different issues discussed in the literature about women and development in the third world. A statistical profile of the MENA region in comparison to East Asia and Latin America is provided in Section III. Demographic, educational and health-related characteristics for individual MENA countries are compared in Section IV. In Section V we present

our measure of female deprivation and compare it to UNDP gender measures. A discussion of the link between the female deprivation measure and other development correlates follows. The implications for national policy and development prospects of the region are considered in the conclusion.

II. WOMEN'S ISSUES IN DEVELOPMENT

The role of women in development has been assessed extensively over the last three decades. It is generally believed that as economies develop, women's living conditions improve. Cultural influences are often cited to account for the disadvantaged position of women in developing countries. The low status of MENA women is often ascribed to Islamic ideology (Moskoff, 1982). This argument is not, however, substantiated by other researchers (Moghadam, 1993; El-Sanabary, 1989). For some cultures, as in the case of India, the "daughter-neglect" notion was advanced as an explanation for why girls receive less food and medical attention (Bournet & Walker, 1991). Fortunately, it was resolved that the status of women in a culture is not immutable and can be modified by specific interventions (Basu, 1992).

Education and labor force participation have been used as measures of women's position and their effect on a wide range of demographic, social and economic outcomes has also been studied (Hadden & London, 1996; Benavot, 1989; Bellew et al., 1992; Al-Qudsi, 1995). In developing countries girls face many constraints that prevent them from pursuing education, including poverty, the use of the daughters' labor in the households, and early marriage. According to the World Bank, a 'female education paradox' is in effect, wherein parents' limited expectations regarding the future options of their daughters reduce the incentives to invest in their human capital (World Bank, 1991).

Female illiteracy is often associated with high fertility, as childbearing is seen to be the only means to acquire self-esteem and financial security in old age. But declines in fertility are not solely attributed to female educational attainment. For some, the provision of birth control methods has been identified as having the greatest direct influence on fertility rates (Robey et al., 1993). However, Sirageldin (1995) maintains that the responsiveness of fertility change to increased female education is not as strong in the Arab states. He emphasizes instead the "unmet need" for contraceptives.

The relationship between development, fertility, education and labor force participation is complex. According to neoclassical economic theory, higher educational attainment raises female participation in the labor market. However, population growth often reduces the viability of investment in female education, thus lowering the economic participation of women and contributing to

persistent poverty (Wood, 1988). Empirical studies of development and labor force participation have yielded mixed results. Statistical evidence suggests that there is a U-shaped relationship between female labor force participation and the stage of development, as proxied by per capita income (Tumham, 1993). Low levels of income are associated with high levels of female participation. The economic activity rate drops for middle income countries and increases again at higher income levels. On the other hand, Meng (1996) found an inverse U-shaped relationship for women in Asia, where women's economic activity rate increased as the country grew economically. But, beyond a point, the income effect dominated and participation dropped. Female education should allow women easier access to urban labor markets and improved agricultural techniques (Boserup, 1970). According to Papps (1992), improving the well-being of women necessitates an increase in their share of income as well as a higher demand for labor. Early agricultural-led growth is critical to the structural transformation of developing economies. It opens up employment opportunities for women in non-agricultural work (Lele, 1986). Successful industrialization has relied on the expansion of female labor, particularly in the export processing zones (Standing, 1989).

The dynamics of female deprivation are also examined in the context of the "basic needs" approach. The inadequate provision of basic needs (food, water, sanitation and housing) seriously affects women's health and contributes, particularly in the case of multiple births, to maternal deaths (Harrison, 1997). Because economic growth does not automatically result in improved living standards for most people, a trickle-up strategy of basic needs provision was proposed to challenge the theory of trickle-down. In addition, it was argued that income alone did not indicate quality of life. Quality of life indicators were developed to complement the income yardstick. The Physical Quality of Life Index (PQLI) was one of the first measures of basic needs. The PQLI is made up of three indicators: literacy, life expectancy, and infant mortality. In the nineties, when the UNDP embraced human development as the critical component of improving national prosperity, HDI replaced PQLI as the leading quality of life index. In addition, in order to focus more precisely on women's conditions and needs, the UNDP developed two measures to look at women's progress. First, the Gender Development Index (GDI) adjusts the average human development achievement in each country to the disparity between women and men in relation to the same three HDI variables of life expectancy, educational attainment and income. It therefore adjusts HDI downward for gender inequality (UNDP, 1998, p. 108). A lower GDI relative to HDI indicates that women have benefited less from economic growth. Second, the Gender Empowerment Measure (GEM) was introduced in 1995 to emphasize

the importance of engendering human development. The GEM focuses on women's status in both the labor market and the political system. It is a composite index that reflects women's participation relative to men in both economic (professional opportunities and earned income) and political (membership in parliament) arenas (UNDP, 1995, p. 72). The higher the GEM, the greater the empowerment of women. GEM values are only available for 13 MENA countries (UNDP, 1998, p. 138). As expected, both GEM and GDI trail HDI ranks, with GEM ranks significantly worse than the other two.

According to some international organizations, economic policies should focus on quality of life indicators. Over the years, this view has been expressed at various international conferences. These included but were not limited to the 1987 World Health Organization on Safe Motherhood Conference in Kenya, the 1990 World Conference on Education for All in Thailand, the 1994 United Nations Conference on Population and Development in Cairo, the 1995 United Nations Fourth World Conference on Women in China, and the 1995 United Nations Social Summit Conference on Human Development in Copenhagen. In 1996, the OECD charted a new development strategy for the next century (Strategy 21). More specifically, six global target goals were identified for achieving economic well-being, social development and environmental sustainability (World Bank, 1998, p. 5):

(1) reduction of extreme poverty by half,
(2) achievement of universal primary education in all countries by 2015,
(3) elimination of gender disparity in primary and secondary education by 2005,
(4) reduction of infant and child mortality by two-thirds,
(5) access to reproductive health services for all people of appropriate age by 2015,
(6) implementation of national strategies (2005) for the reversal of environmental resource loss by 2015.

Several observations emerge from this brief review. First, various approaches, including demographic, economic and others, have been taken to examine women's status. Many studies have focused on a single variable such as literacy or fertility and its relationship to other socio-economic aspects of development to look at the condition of women. The consolidation of such cross-disciplinary findings to formulate a composite measure of women's plight could prove valuable for the identification of appropriate policy interventions. Second, most studies have examined position of women relative to men. Yet, a comparison among women can also be enlightening. As an example, a recent study documents health differences between two female groups, one disadvantaged (characterized by risk factors such as early marriage, poor contraceptive usage

and high fertility) and other advantaged (characterized by more education) (Harrison, 1997). Third, studies from different disciplines have acknowledged that the consequences of female deprivation not only impact women themselves, but also their children and the economy. They reached the same conclusion: by helping women, countries move to the next stage of development. It is useful to document this relationship statistically. Fourth, because research findings have often implied a two-way causation between the variables (Dasgupta, 1995), it is important for a country to pursue a bi-directional development strategy, where women's well-being is both a cause and effect of economic and social progress (Al-Qudsi, 1995, p. 27). Finally, committed public policy is perceived as critical for the alleviation of female deprivation. In this regard, the experience of the "Newly Industrializing Countries" (NICs) of Asia should prove valuable. At the very early stages of their development, government policies targeted female illiteracy, health and primary education, while also offering parallel family planning programs to reduce family size. Such basic needs and demographic provisioning enhanced women's ability to improve nutrition and sanitation at home and productivity outside the home, thus reinforcing the 'virtuous cycle' of development. Such policies had a positive impact on the economic transformation of the NICs. The experiences of these countries offer valuable lessons on the role of gender during structural change, in the MENA region and elsewhere.

III. MENA STATISTICAL PROFILE

How do the MENA region and its individual countries compare to other parts of the world in terms of women's absolute position? The MENA region represents less than 5% of the world's population. The countries of the region, with the exception of Israel, are all classified as developing countries although the average per capita income in the region (in US dollars for 1996) is almost twice that of low- and middle-income countries.[3] The average GNP per capita in the region is PPP $4,530,[4] the second highest among all developing areas, after Latin America and the Caribbean (LAC) (World Bank, 1998, p. 14).

Some general and female-specific regional indicators are presented in Table 1. Although MENA is rapidly reducing illiteracy, adult illiteracy in MENA (39%) significantly exceeds that of both East Asia and the Pacific (EAP) and LAC (17% and 13%, respectively). Its female illiteracy (50%) is much higher than in the other two regions (24% and 15%, respectively) despite relatively higher spending by MENA governments on education as a percentage of GNP (5.6%).[5] Fertility rates are higher (4.0) and contraceptive prevalence rates (37%) lower, as well. Research indicates that demographic differences between MENA and the High Performing Asian Economies (HPAEs) explain one third of their growth gap (ERF, 1998, p. 7).

Table 1. Socio-economic Characteristics of MENA and Other Regions.

	Middle East & North Africa	East Asia & Pacific	Latin America & Caribbean
	MENA	EAP	LAC
Female Illiteracy (%) 1995	50	24	15
Public Expenditures on Education (% GNP) 1995	5.6	2.6	3.9
Total Fertility Rate 1996	4.0	2.2	2.8
Contraceptive Prevalence Rate 1990-95	37a	82 b	64
Maternal Mortality Rate (per 100,000 live births) 1990	396a	95b	191
Infant Mortality Rate **(per 1,000 live births) 1996**	**50**	**39**	**33**
Underweight Children under age 5 (%) 1990–97	17a	16b	10
Women in the Labor Force (%) 1996	26	44	33
Children 10–14 in labor force % age group 1996	5	11	9
Trade Share of GDP (%) 1996	54	58	33
Foreign Direct Investment (Millions $):			
1996:	614	58,681	38,015
1990:	2,757	10,347	8,188
Net Official Development Assistance & Official Aid (Million $):			
1996:	5,342.5	8,359.5	8,025.1
1991:	10,311.9	7,541.2	5,850.2

Source: World Bank, World Development Indicators, 1998.
a. Arab States – UNDP, Human Development Report, 1998.
b. East Asia – UNDP, Human Development Report, 1998.

The higher levels of female illiteracy and fertility contribute significantly to the maternal mortality problem in the MENA region. Infant mortality rates and the number of underweight children under five years of age also surpass their counterparts in other regions despite higher public spending on health relative to GDP (2.4% compared to 1.7% in EAP). MENA's share of women in the

labor force is trailing other regions. Women's lower involvement in the labor market could, among other things, account for their higher deprivation.

According to the World Bank, the MENA region is positioned to take advantage of a 'window of opportunity' (World Bank, 1995). Reforms have been accelerated to respond to the necessities of global integration. MENA countries are relatively open to trade. The region's average trade share of GDP (53%) compares favorably with that of EAP (58%) (World Bank, 1998/99, p. 229). Differences in comparative advantage among developing countries are greatly affected by, among other things, skill differentials. The Asian model suggests that it is necessary to upgrade the manpower skill configuration in order to change a country's trading pattern from primary to skill-intensive export-manufacture. There is strong evidence that workers with no schooling are of little use in modern manufacturing (ERF, 1998, p. 62). Hence, MENA's high rate of female illiteracy may, in fact, retard its competitiveness and limit its ability to reap the full benefits of globalization.

As Table 1 also shows, the recent surge in capital, in the form of foreign direct investment (FDI), has bypassed the MENA region, suggesting that MENA is losing out in the shift to globalization. Whereas inflows have typically increased fivefold or more in EAP and LAC, they shrank by that much in the MENA region between 1990 and 1996. In relative terms, MENA's share of FDI has dropped from 13 to 0.6% of PPP$ GDP (World Bank, 1998, p. 336).

Official aid is also fleeing the area in both absolute and relative terms. The region experienced a noticeable cut in dollars, with aid being reduced to less than 50% of previous levels, as compared to a gain of more than 10% for the two other regions. MENA's relative share of official aid also dropped from 43.5 to 24.6% (World Bank, 1998, p. 344). As such, MENA governments face the challenge of expanding their foreign sector employment opportunities to meet the needs of a growing population while facing decreasing capital inflows. At this juncture, we need to remember that export-led development and FDI have always relied on an increased flow of women into the labor force. Recognition of this eventuality has already prompted the leadership of some countries (e.g. Egypt) to make the eradication of female illiteracy as a top national priority. How are various MENA countries faring in this regard? The next section addresses this critical issue.

IV. DIMENSIONS OF THE PROBLEM

We have established that MENA women trail behind those in EAP and LAC, but how do they fare within the countries of the region? Table 2 presents statistics from various countries in the region. A number of interesting observations

Table 2. MENA Cross-country Comparison.[a]

Country	GNP Per Capita $ 1996	HDI 1995	Female Illiteracy 1994	Fertility Rate 1994	Maternal Mort. Rate 1994	Military Exp. (% of Ed & Health Exp.) 1990–91
Algeria	1,520	0.746	56.5	4.1	160	11
Bahrain	7,840	0.872	10.9	3.2	-	41
Comoros	450	0.411	49.6	5.8	-	-
Djibouti	-	0.324	-	5.6	-	-
Egypt	1,080	0.612	63.3	3.6	170	52
Iran	-	0.758	40.7	5.0	120	-
Iraq	-	0.538	57.8	5.6	310	271
Jordan	1,650	0.729	20.6	5.4	150	138
Kuwait	17,390	0.848	27.4	2.8	29	88
Lebanon	2,970	0.796	10.5	3.0	300	-
Libya	-	0.806	42.2	6.2	220	71
Mauritania	470	0.361	74.4	5.3	930	40
Morocco	1,290	0.557	72.3	3.5	610	72
Oman	4,820	0.771	54.0	7.2	190	293
Qatar	11,600	0.840	-	3.9	-	192
Saudi Arabia	7,040	0.778	52.4	6.2	130	151
Sudan	-	0.343	68.7	4.9	660	52
Syria	1,160	0.749	47.0	4.1	180	373
Tunisia	1,930	0.744	49.6	3.0	170	31
Turkey	2,830	0.782	28.9	2.4	180	87
UAE	17,400	0.855	22.1	3.6	26	44
Yemen	260	0.356	61.0	7.1	1,400	197
Dev. Countries	823	0.576	39.7	3.1	471	63

a. Some countries are omitted due to lack of data.
Source: UNDP, Human Development Report, 1998.

emerge. More than two-thirds of the MENA countries are classified as having high (23%) or medium (45%) human development[6] (UNDP, 1998, p. 224), yet, more than 70% of the countries under study exhibit higher female illiteracy than the developing countries' average (39.7%). For the majority of the countries (82%), fertility is much higher than the mean rate of the developing world (3.2) (UNDP, 1998, p. 177). Maternal mortality, although at less than half the developing countries' average except for four cases, is still significantly above that of EAP and LAC.

Within the MENA region there are big differences in their performance. At one end, Mauritania tops the MENA female illiteracy list (74.4%), exceeding

Angola (71%) (UNDP, 1998, pp. 131-133). At the other end, Lebanon, with a female illiteracy rate of 10.5%, closely matches Thailand (9.3%). The same holds true for total fertility rates, where Yemen (7.6) is comparable to Niger (7.3) and Turkey (2.4) not much different from New Zealand (2.1) (UNDP, 1998, pp. 176–177). That same differential also applies to maternal mortality rates which range from 1,400 in Yemen to 26 per 100,000 live births in the United Arab Emirates (UNDP, 1998, pp. 156–157).

Finally, it is important to note that military spending as a percentage of the combined education and health expenditures is higher than the mean average (63) of all developing countries for eleven out of the eighteen countries reported (UNDP, 1998, p. 171). Thus MENA countries could afford to alleviate women's conditions by shifting resources out of military spending.

V. MEASURING WOMEN'S PROGRESS

Since education, reproduction and health are key interacting factors affecting women's lives, we propose that, for many developing countries, these variables should be the point of departure in the race toward gender equality. Following Amartya Sen's "human capabilities" approach (Nussbaum & Sen, 1993), we define female endangerment as "a condition limiting the capabilities of women to live a tolerable life, to function, and to protect future generations." Since the three conditions (high illiteracy, fertility and maternal mortality) have been identified in the literature as having a negative impact on the fate of women in the developing world, we argue that all three should make up a measure to capture the level of female endangerment in a country. Female endangerment is a serious threat to women's basic rights and, therefore, gender empowerment cannot be assessed independently of it. It also poses serious obstacles to society more generally by delaying development and full integration in the global economy. As such, the study and eradication of female endangerment is essential to further development.

We propose the female endangerment measure (FEM) to measure the level of female deprivation. This index includes measures of female illiteracy, fertility, and maternal mortality.[7] The data to construct this measure were obtained from the UNDP's Human Development Reports for 1997 and 1998. Equal weights are assigned to the three factors. FEM values range from 0 to 1 (best to worst). A country with a score of zero would have a maternal mortality rate of zero, female illiteracy rate of zero and replacement fertility.

How does our measure of female depreviation compare with the UN measure GEM? Table 3 classifies MENA countries by FEM and GEM. It should be noted that a number of countries with high GEM rankings have low FEM

Table 3. Status of Women in MENA Countries.

	1994 FEM Value	Rank*	1994 GEM Value	Rank*
Algeria	0.378	8	0.282	5
Egypt	0.378	8	0.278	6
Iran	0.299	6	0.251	8
Iraq	0.488	–	–	–
Jordan	0.265	4	0.211	12
Kuwait	0.182	1	0.333	2
Lebanon	0.182		–	–
Libya	0.449	10	0.423	1
Mauritania	0.647	13	0.177	13
Morocco	0.486	11	0.303	4
Saudi Arabia	0.467	–	–	–
Sudan	0.556	12	0.225	11
Syria	0.348	7	0.319	3
Tunisia	0.298	5	0.260	7
Turkey	0.194	2	0.250	9
UAE	0.204	3	0.237	10
Yemen	0.806	–	–	

Source: UNDP, Human Development Reports, 1997 & 1998.
*Only countries with comparable data are ranked.
Note: A high FEM value suggests a high level of female deprivation, whereas a high GEM denotes a high level of female empowerment.

rankings and visa versa. In addition, the correlation coefficient between the two measures indicates only a moderate positive correlation (0.371). This suggests that GEM, by itself, cannot accurately reflect the status of women in a given country. It focuses primarily on the shares of women in professional, managerial and political positions, ignoring those women left to suffer at the other end of the spectrum.

GEM values, for twelve out of the thirteen MENA countries reporting such data, are less than the mean for all developing countries (0.367). At the same time about 40% of the MENA countries for which comparable data were available have FEM values higher than the mean of the developing countries (0.396). These are the countries then where women are at higher risk of suffering deprivation. The GEM score of Sudan (0.225) slightly exceeds Jordan's (0.211). Based on GEM alone, women appear more empowered in Sudan than in Jordan. Yet, the female endangerment value (0.556) is more than twice as high! Obviously, this new information requires us to reexamine the situation more closely. FEM adds a new dimension to the evaluation of women's status.

Table 4. Bivariate Estimates.

Dependent	Coefficient*
Life expectancy at birth	−33.2
Gross primary enrollment (fem%male)	−66.1
Gross secondary enrollment (fem%male)	−95.7
Poverty @ less than $1 per day	66.4
Prevalence of contraceptive use	−87.8
% of children not reaching grade 5	51.4
GDP per capita	−23207.5
% LF in agriculture	75.9

* all coefficients are significant at the 95% confidence level or higher.

VI. FEM AND OTHER SOCIO-ECONOMIC INDICATORS

Table 4 displays the results of separate bivariate regression runs using FEM as the explanatory variable. Given the number of dependent variables examined (8), we will only discuss the regression coefficients estimated.

FEM is correlated negatively with life expectancy and with the ratio of female to male enrollment at both the primary and secondary level. A FEM index of 0 would imply an average life expectancy rate of 78 years. For every decline in the FEM index by ten points (0.100), life expectancy is about 3.3 years higher. Other indicators with which FEM is correlated include poverty, family planning, per capita GDP, primary school drop out rates and labor market structure. Poverty, as measured by the proportion of the population that lives on less than $1 per day, drops by 6.6 percentage points for each decline of 10 index points in FEM. More than half of female endangerment variation among MENA countries may be attributable to differing poverty levels as measured by this variable.

Women's endangerment is negatively linked to access to family planning, as measured by the prevalence of contraceptive use, undoubtedly one of the most potent development oriented policies. Rising FEM is also linked to increases in the number of children who drop out of school before grade five.

FEM is only weakly correlated with the proportion of the labor force engaged in agricultural activity but is nonetheless statistically significant. The estimate suggests that rural economies have higher levels of female deprivation. The shift to industry and services generally occurs simultaneously with a rise in

literacy, declines in the number of pregnancies and a decline in maternal medical complications among the females entering or already in the workforce. As such these factors are occurring simultaneously and interacting. These results suggest the important link between reducing female deprivation and the productivity of women who must enter the workforce before sustainable economic development can take root.

Multivariate analysis shows that FEM is statistically related to female labor force participation (ages 15–64) in 1995, infant mortality rate per 1,000 live births for 1996 and the percentage of the population without access to safe water over the period 1990–1996. Infant mortality can be viewed as a proxy for the level of healthcare in a given society since it is highly correlated with indicators such as access to medical care and life expectancy at birth. Likewise, the proportion of the population that does not have access to safe water is used as a proxy for poverty by capturing the level of deprivation in basic human development (UNDP, 1997, p. 14). The subsequent analysis is premised on the rationale that satisfaction of women's basic needs and their participation in the labor market should lower female endangerment levels. Thus, corresponding policy responses of public provisioning of basic needs and employment opportunity creation can be implemented.

The estimated regression equation for the female endangerment measure in MENA countries is given by:

$$FEM = \alpha - \beta_1 FLFP + \beta_2 IMR + \beta_3 PASW + \varepsilon$$

FLFP represents the female labor force participation rate. IMR stands for infant mortality rate, and PASW is the percentage of the population that does not have access to safe water. We expect FEM to have a negative relationship with FLFP, and a positive relationship with IMR and PASW.

Table 5 shows the results of an ordinary least squares regression.[8] FLFP is very highly significant at the 0.1% level. It has a negative coefficient, as expected, indicating that a higher female labor force participation rate is correlated with lower female endangerment as measured by FEM. For MENA countries, a ten-percentage point increase in the female labor force participation rate is linked to a decline of FEM by 0.113 index points. IMR is also very highly significant at the 0.1% level, and has the expected positive coefficient. The coefficient indicates that for MENA countries, a decrease in the number of infant deaths by 10 (per 1,000 live births) is linked to an improvement of FEM by 0.037 index points. Finally, the PASW coefficient suggests that FEM and inaccessibility of the population to safe water are linked. An additional 10% increase in the population with access to safe water leads to a drop in female endangerment by approximately 0.052 index points.

Table 5. Estimation Results.

Destination Variable	Coefficient	t-score
Constant	0.335	7.508***
FLFP	−0.01130	−5.147***
PASW	0.005196	3.311**
IMR	0.003705	5.300***
$R^2 = 0.817$		

** significant at 1% level (p-score < 0.01).
*** significant at 0.1% level (p-score < 0.001).

VII. CONCLUSION

In this paper we introduce a measure of female endangerment (FEM) which includes three components: female illiteracy, fertility, and maternal mortality. Comparing this measure with GEM we are able to identify where female deprivation is most acute in the MENA region. We also look at the statistical relationship between FEM and labor market, health and poverty determinants. The findings indicate a link between various development measures and female endangerment. The outcome of the study should guide MENA governments to reallocate their investments towards improving women's lives and devise policy alternatives with female endangerment alleviation potential. Public investment in basic needs (education, basic health delivery systems, safe drinking water and sanitation services) and public delivery of contraceptive information and services to couples of childbearing age will increase women's capabilities and enhance their productivity. MENA governments need to take a firm stand regarding family planning and commit substantial resources to such programs. Furthermore, employment creation to attract women to the workplace is highly recommended.

Although the paper focuses on the link between FEM and various other socioeconomic indicators, evidence from other research suggests increasing liberalization and openness will particularly benefit women as employment is created. For instance, the example of the Asian tigers, suggests that eradication of female deprivation, women's productivity, and access to the labor market and sustainable development are linked. Export-oriented industrialization should provide opportunities to make full use of semi-skilled and unskilled workers. This policy, operating through the labor market, should also enhance women's purchasing power. Foreign investment can also make a difference. It has created

significant employment opportunities for poor women in Malaysia – as many as 85,000 jobs in the electronic sector alone in the late 1980s (World Bank, 1993, p. 303). Governments should adopt a liberal and open attitude with only minor restrictions and regulations imposed on foreign investors. In this regard, the experience of Thailand may be quite relevant. Because of its aggressive promotion of export-oriented foreign investment, both foreign investment and manufactured exports boomed in Thailand (World Bank, 1993, p.142).

Given the wide disparities in the levels of economic development in the MENA countries, no single strategy of female endangerment eradication can be prescribed across the region. In view of the rapid pace of globalization and intense international competition, the MENA region, including the Arab states, Iran and Turkey, need to address their specific female endangerment problems promptly. Women should be drawn into the playing field of the global economy; otherwise, they will continue to be marginalized, to the detriment of national competitiveness. The rewards for such intervention are high, with a direct bearing on increasing life expectancy and GDP per capita, closing the gender gap at both primary and secondary levels of education and facilitating structural transformation. The benefits should extend to future generations as well. Further research in the area of female deprivation and its impact on development is clearly needed. One extension of this study would be the estimation of the costs and benefits of each recommended policy alternative in dollar terms, thereby providing decision-makers with an operational action framework.

ACKNOWLEDGMENT

The authors thank all referees for their insightful comments and constructive criticism.

NOTES

1. This study has adopted the MENA country classification used by the Economic Research Forum for Arab States, Iran and Turkey. It covers the following twenty-four countries: Algeria, Bahrain, Comoros, Djibouti, Egypt, Iran, Iraq, Jordan, Kuwait, Lebanon, Libya, Mauritania, Morocco, Oman, Qatar, Saudi Arabia, Somalia, Sudan, Syria, Tunisia, Turkey, United Arab Emirates, West Bank & Gaza and Yemen. Not all countries are reported due to lack of data. Israel, while geographically considered part of the Middle East region, is excluded because of its status as an industrial country.

2. These five countries include Saudi Arabia, Tunisia, Syria, Turkey and Algeria.

3. This average is highly distorted by the rich oil exporters of the region. However, in this study, no distinction is made between the two subgroups (oil exporters and the remaining MENA countries) because there is no statistical difference at the 90% confidence level between the mean FEM.

4. Purchasing power parity (PPP) of a country's currency represents the number of units of that currency needed to acquire the same basket of goods and services that a US dollar would buy in the United States.

5. This figure may reflect an upward bias as part of the education expenditures is spent toward study abroad (Cinar, 1997, p. 58).

6. UNDP classifies high development an an HDI of 0.800 and above; medium as an HDI of 0.500–0.799; and low as an HDI below 0.500.

7. Female illiteracy rate (adult) represents the percentage of females age 15 and older who cannot both read and write simple statements on their everyday life. Fertility rate (total) represents the average number of children born to a woman during her lifetime in accordance with prevailing age-specific fertility rates. Maternal mortality rate accounts for the annual number of female deaths from pregnancy-related causes per 100,000 live births (UNDP, 1998, pp. 217–219).

8. Diagnostic plots show the errors as homoskedastic and normally distributed; thus, there is no evidence that the functional form of the model is misspecified. While some of the explanatory variables have low to moderate correlation with each other, multi-collinearity does not appear to be a problem, as none of the standard errors are overestimated and all coefficients are significant.

REFERENCES

Al-Qudsi, S. (1995, July–August). Labor force Participation of Arab Women. *Economic Research Forum Newsletter*, *2*(2), 26–27.

Basu, A. M. (1992). The Status of Women and the Quality of Life Among the Poor. *Cambridge Journal of Economics*, *16*(3), 249–267.

Bellew, R., Raney, L., & Subbarao, K. (1992, March). Educating Girls. *Finance and Development*, *29*(1), 54–56.

Benavot, A. (1989). Education, Gender, and Economic Development: A Cross-sectional Study. *Sociology of Education*, *62*, 14–32.

Boserup, E. (1970). *Women's Role in Economic Development*. New York: St. Martin's Press.

Bournet, K., & Walker, G. (1991). The Differential Effect of Mother's Education on Mortality of Boys and Girls in India. *Population Studies*, *45*, 203–221.

Cinar, E. M. (1997, Fall). Privatization of Education, Educational Spending and the Case of the "Missing Girls" in Grade Schools. *Critique*, 53–64.

Dasgupta, P. S. (1995, February). Population, Poverty, and the Local Environment. *Scientific American*, 40–45.

Economic Research Forum for the Arab Countries, Iran and Turkey (1998). *Economic Trends in the MENA Region*. Cairo, Egypt: ERF.

El-Sanabary, N. (1989). Determinants of Women's Education in the Middle East and North Africa: Illustrations from Seven Countries. A paper prepared for the World Bank.

Hadden, K., & London, B. (1996). Educating Girls in the Third World: The Demographic, Basic Needs, and Economic Benefits. *International Journal of Comparative Sociology*, *XXXVII*(1–2), 31–46.

Harrison K. (1997, March 1). The Importance of the Educated Healthy Woman in Africa. *The Lancet*, *349*, 644–647.

Lele. U. (1986, January). Women and Structural Transformation. *Economic Development and Cultural Change*, *34*(2), 195–221.

Meng, X. (1996, May). The Economic Position of Women in Asia. *Asia-Pacific Economic Literature, 10*(1), 23–41.
Moghadam, V. (1993). *Modernizing Women: Gender and Social Change in the Middle East.* Boulder, CO: Lynne Reiner Publishers, Inc.
Moskoff, W. (1982, Winter). Women and Work in Israel and the Islamic Middle East. *Quarterly Review of Economics and Business, 22*(4), 89–104.
Nussbaum, M., & Sen, A. (Eds) (1993). Human Capabilities, Female Human Beings in Women. *Culture and Development.* Oxford: Clarendon Press.
Papps, I. (1992, July). Women, Work and Well-Being in the Middle East: An Outline of the Relevant Literature. *The Journal of Development Studies, 28*(4), 595–615.
Robey, B., Rutstein, S., & Morris, L. (1997, December). The Fertility Decline in Developing Countries. *Scientific American,* 60–67.
Sirageldin, I. (1995, July-August). Female Education, Desired fertility and Unmet needs: Critical Issues in Population and Development in the Arab Region. *Economic Research Forum for the Arab Countries, Iran, and Turkey, 2*(2), 24–25.
Standing, G. (1989). Global Feminisation through Flexible Labor. *World Development, 17*(7), 1077–1095.
Summers, L. (1992, August). The Most Influential Investment. *Scientific America, 132.*
Tumham, D. (1993). *Employment and Development: A New Review of Evidence.* Paris: OECD Development Center Studies.
United Nations Development Programme (UNDP) (1992). *Human Development Report,* 1992. New York: Oxford University Press.
United Nations Development Programme (UNDP) (1995). *Human Development Report,* 1995. New York: Oxford University Press.
United Nations Development Programme (UNDP) (1997). *Human Development Report,* 1997. New York: Oxford University Press.
United Nations Development Programme (UNDP) (1998). *Human Development Report,* 1998. New York: Oxford University Press.
Wood, Jr. R. (1988, March). Literacy and Basic Needs Satisfaction in Mexico. *World Development,* 405–418.
World Bank (1991a, November 14). Poverty Reduction Linked to Education for Girls. *World Bank News,* 2–3.
World Bank (1991b). *World Development Report,* 1991. New York: Oxford University Press.
World Bank (1993). *The East Asian Miracle: Economic growth and Public Policy.* New York: Oxford University Press, Inc.
World Bank (1995). *Will Arab Workers Prosper or Be Left out in the Twenty-First Century?* Washington, D. C.: The World Bank.
World Bank (1998, March). World Development Indicators, 1998. Washington, D.C.: *The World Bank,* 1998.
World Bank (1998/99). *World Development Report,* 1998/99. New York: Oxford University Press.

FEMALE LABOR FORCE PARTICIPATION AND ECONOMIC ADJUSTMENT IN THE MENA REGION

Massoud Karshenas and Valentine M. Moghadam

ABSTRACT

This paper investigates the relationship between female labor force participation rates and structural adjustment in the Middle East and North Africa (MENA). We put forward a new hypothesis to explain MENA's low female labor force participation rates, and argue that during the oil boom era MENA countries locked themselves into family structures and female socio-economic roles which are not compatible with current economic realities in an era of globalization. We conclude that the socio-economic role of women can be an important missing link in explaining the puzzle of economic adjustment in the MENA region.

1. INTRODUCTION

In this paper we investigate the role of female labor force participation in wage competitiveness and economic adjustment in the MENA region. We argue that far from being a peripheral issue, attention to gender is indispensable to an understanding of the evolution of labor markets in the MENA region, and that

increasing women's labor-force participation may be a key to the success of structural adjustment and to the international competitiveness of MENA countries. We argue that the prevailing patriarchal, one-breadwinner, family structures in the MENA region entail relatively high social cost of reproduction of labor as compared to the competitor countries, e.g. those in Southeast and East Asia.

The paper includes five parts. Following this introduction, we review the existing approaches to the role of female employment in the adjustment process. Section 3 provides an overview of the nature of economic adjustments required in the MENA region, with a particular focus on the issue of wage competitiveness. In Section 4 we examine the different explanations for the persistence of patriarchal family structures and low rates of female labor force participation in the MENA region, and put forward a new explanation in terms of wage rates and the cost of maintaining patriarchal families at the early stages of modern economic growth. In Section 5 we examine the implications of this conclusion for economic adjustment in the post oil era. We argue that the persistence of patriarchal family structures in the region makes it difficult to adjust product wages in accordance with the requirements of international competitiveness, while maintaining consumption wages at a level required for the upkeep of the one-breadwinner families in the region. Women's roles in the labor market thus become central issues of adjustment policy in the era of globalization.

2. APPROACHES TO WOMEN AND STRUCTURAL ADJUSTMENT

The main analytical framework in the existing literature on women and economic adjustment consists of a mapping between the structural changes which structural adjustment is meant to bring about in the economy and the nature of sex segregation in the labor market of the economy in question. This framework is shared by feminist economists (e.g. Elson, 1991; Palmer, 1991; Stewart, 1992) and by conventional economists (e.g. Collier, 1993; Haddad et al., 1995). In the conventional approach, adjustment policies, by changing relative prices and removing quantitative restrictions, are supposed to lead to a restructuring of the economy towards the expansion of the traded-goods sectors and a simultaneous squeeze on the non-traded goods sectors, thus reinstating internal and external equilibrium and providing the conditions for the sustainable growth of the economy. Women workers can be adversely affected by the adjustment program if they are initially concentrated in the non-traded sectors, and/or if, due to labor-market segmentation along sex lines, there are barriers

to their mobility across sectors. Depending on their initial distribution across sectors, women workers also can be adversely affected during the transition period irrespective of the constraints on their mobility. For example, if women are initially concentrated in the non-traded goods sectors such as social and community services, they would be adversely affected in the transition period when the non-traded goods sectors are being squeezed and resources being shifted to traded goods sectors. In addition, if there are barriers to their moving into new export-oriented traded goods sectors, the deterioration of real wages and conditions of work for women can be prolonged and can even persist in the final equilibrium when the economy has fully adjusted to the relative price changes resulting from the liberalization program.

Of course, the lack of mobility of female labor resulting from discriminatory practices can also have a debilitating effect on adjustment programs. However, since labor shortages do not seem to be a major constraint on the growth of traded-goods sectors in the developing countries, this latter effect is less emphasized in the literature. It is more the adverse effects of the adjustment programs on female labor under the conditions of limited mobility that have formed the main object of empirical research in this field. The conventional approach is described by Paul Collier (1993) in a study of the impact of adjustment on women with the following words: "It should be stressed that gender is not a topic in itself but rather a possible disaggregation to be borne in mind when studying a topic."

The feminist approach has included elements of the above but has tended to concentrate on the functions of women within the family, the implications of intrahousehold inequalities, and the likely effects of the adjustment program on women in their reproductive role rather than their role as direct laborers (*World Development*, 1995).Women within the household are often responsible for partial provision of services such as nutrition and food, healthcare, socialization and education, and other daily provisions which may or may not have substitutes in terms of purchasable goods and services. Hence, it is argued, if the adjustment program leads to cuts in government social expenditures on health, education and other social services, or to increases in the price of food, this could intensify women's work within the household. Similarly, if the adjustment program, at least in the early stages, leads to a squeeze on real household income, this may have important implications for women's work within and outside the home. That is, women may have to compensate for the withdrawal of subsidies or for cutbacks in social expenditures, and increase their workload within the home and seek an income outside the home to supplement the household budget (Elson, 1991).

Feminist economists also point out that structural adjustment can have important long-term implications for female employment prospects by affecting the

access of girls to education. The introduction of "user fees" for purposes of "cost recovery" in education can discourage the continuation of schooling for girls from poor households. This effect can be further strengthened if the adjustment policy also leads to an increased need for adult women to work outside home, e.g. in commercial agriculture, hence increasing the need for younger girls to attend to domestic work (Sparr, 1994). Lack of education is shown to have deleterious effects on the future prospects of women both in the labor market and within the household (Haddad et al., 1995; King & Hill, 1993).

The feminist and conventional approaches have formed the main analytical bases for most of the empirical investigations of the impact of adjustment on women. Whereas the feminist approach begins by positing gender as an analytical variable and gender bias as a theoretical presupposition, in the conventional approach the impact of adjustment on female employment becomes mainly an empirical question largely determined by exogenous barriers to women's job mobility or wage discrimination. In both approaches, however, the emphasis has been on the effects of structural adjustment on women's productive (or reproductive) activities. The participation of women and their position in the labor market can itself have crucial implications for the success of the structural adjustment program in the first place. Such implications in the literature have been discussed in terms of possible inefficiencies that the lack of mobility of women can create in the adjustment process or in the post-adjustment final equilibrium situation. In the context of economies in the MENA region however, as we argue below, gender issues may play a more central role in the adjustment process because of the way the prevailing patriarchal family structures and gender roles impinge upon the process of wage determination in the economy.

This point becomes clearer if we recall the processes whereby the adjustment program according to orthodox economic theory is believed to restore the growth of the economy on a sustainable basis. As noted above, relative price changes resulting from the liberalization program are the central mechanisms of structural change and the restoration of sustainable growth in the economy. One of the critical relative prices in the economy whose behavior is central to the adjustment program is the real exchange rate. Here we argue that, given the level of skills and production efficiency in the MENA region compared to other competitor economies, combined with the role of women within the patriarchal social and family structures in the region, there may not exist a real wage which could bring about a competitive exchange rate while at the same time maintaining the traditional role of women in the economy. To argue this, we first need to broadly examine the nature of structural adjustments in the MENA region economies.

3. THE NATURE OF ADJUSTMENT PROBLEMS IN THE MENA REGION

The nature of the required adjustments and the constraints on economic growth in the MENA region since the 1980s can best be analyzed in the context of the experience of growth during the oil boom years. The MENA countries achieved high rates of growth of GDP and rapid structural change during the 1960s and the 1970s. During these decades the region exhibited some of the fastest rates of growth in the world economy. This applied to output growth rates in all the main sectors of the economy in almost all the individual countries in the region as well as the average growth rates for the region as a whole (Karshenas, 1994; Page, 1998).

Oil and other primary commodity exports provided the engine to growth of the MENA economy during these years. The availability of ample foreign exchange revenues allowed governments to implement import-substitution policies, which led to fast rates of growth in industrial investments and output in the region. The problems associated with this phase of rapid industrialization were not due to low investment in the tradable goods sectors. Major investments were undertaken in industry and agriculture in all the economies in the region in this period, and the overall growth of investment and the growth of tradable goods such as industry and agriculture in this period were amongst the highest in the world economy (Karshenas, 1994). The major problems which came to haunt the economies of the region in the post oil boom era were associated with the production inefficiencies which resulted from the inward orientation of the industrialization strategy. With the end of the oil era in the early 1980s, the productive assets which were created during the earlier period became a liability, in the sense of being a considerable net foreign-exchange drain with high recurrent import requirements and without being competitive enough to export.

Another important structural feature of the MENA economies, inherited from the experience of rapid growth and structural change during the oil boom era, was that although the level of income and wages was high, the quality of the labor force in terms of skills, training, and education remained fairly low. While in terms of per capita income levels and the structure of output and employment most of the MENA region countries fell within the category of the World Bank's middle income country grouping by the early 1980s, in terms of the educational attainment of the adult population the region lagged behind the other middle income countries. As can be seen from Table 1, educational attainment in the MENA region is below the developing country average, and considerably below the East and Southeast Asian economies.[1] Adult illiteracy amongst the female

Table 1. Adult Illiteracy and Mean Years of Schooling in the MENA Region and East & Southeast Asia.

	% Adult illiteracy, 1984 (15+ age group)			Mean years of Schooling 1990 (Adults aged 25+)		
	Total	Male	Female	Total	Male	Female
MENA						
Algeria	51	37	65	2.6	4.4	0.8
Egypt	55	40	71	2.8	3.9	1.6
Iran	52	41	64	3.9	4.6	3.1
Iraq	48	36	59	4.8	5.7	3.9
Jordan	26	14	38	5.0	6.0	4.0
Lebanon	23	14	31	4.4	5.3	3.5
Libya	44	30	60	3.4	5.5	1.3
Morocco	58	46	71	2.8	4.1	1.5
Syria	41	26	57	4.2	5.2	3.1
Tunisia	42	32	53	2.1	3.0	1.2
Turkey	24	12	36	3.5	4.7	2.3
MENA (median)	44	32	59	3.5	4.7	2.3
MENA (mean)	42	30	55	3.6	4.8	2.4
Developing Countries (mean)	35	25	45	3.7	4.6	2.7
East & Southeast Asia						
China	32	20	45	4.8	6.0	3.6
Hong Kong	–	–	–	7.0	8.6	5.4
Indonesia	28	20	37	3.9	5.0	2.9
Korea, Rep.	5	2	9	8.8	11.0	6.7
Malaysia	26	17	35	5.3	5.6	5.0
Philippines	12	12	13	7.4	7.8	7.0
Singapore	–	–	–	3.9	4.7	3.1
Sri Lanka	13	8	19	6.9	7.7	6.1
Thailand	9	5	13	3.8	4.3	3.3
Viet Nam	12	8	17	4.6	5.8	3.4
Asia (median)	13	12	19	5.3	6.0	5.0
Asia (mean)	18	12	24	5.8	6.7	4.8
t-Test for difference Between the Means (Asia & MENA)	4.6*	4.2*	4.7*	−3.4*	−2.7*	−3.9*

Source: Human Development Report, United Nations, 1993, and UNESCO, 1994.
Notes: * Significant at 5% level.

population is particularly high in the MENA region, by any standards, with the gender gap in literacy in the region being one of the highest in the world.[2] Formal education plays an important enabling role in the process of learning and skill formation in the economy, but some of the necessary skills in the economy are also generated within the production process through learning-by-doing or through on-the-job training by the firms. Given that most of the labor force in the MENA region is engaged in low productivity agriculture, consists of first-generation urban migrants, or is young, the existing stock of industrial skills is likely to be relatively even lower than that suggested by the data on the rates of illiteracy amongst the adult population discussed above.

The level of skills and industrial know-how in the MENA economies should be considered relative to the level of incomes that such skills are required to sustain, and in comparison to relative skill/income levels in other developing countries. This is particularly important in the post oil boom era, when the MENA economies have had to develop alternative sources of foreign exchange earnings by developing non-oil exports in competition with other newly industrializing countries. A comparison with Asian countries in this respect would be instructive. As can be seen from Table 2, up to the late 1970s the MENA economies managed to sustain relatively high per capita income levels, well above the average for the newly industrializing countries in Asia. The rapid rate of growth of GDP in the MENA region in this period meant that despite their high rates of population growth they managed to somewhat reduce their per capita income gap in relation to the industrial countries and widen their distance from Asia in general and even the fast growing countries in East Asia. With the end of the oil era, however, these rapid rates of growth were no longer sustainable. In the ensuing period, the MENA economies developed substantial external and internal imbalances, and per capita incomes began to decline. By the early 1990s, the East Asia block had surpassed the MENA region in per capita income terms and Asia as a whole had considerably narrowed its income gap. Of course the different MENA economies have varied in terms of the timing and the intensity of economic retrogression in the post oil era. The majority of the larger economies in the region – namely, Iran, Iraq, Syria, Jordan, Egypt and Algeria – have witnessed declining per capita incomes since the early 1980s. Tunisia, Turkey and Morocco have shown moderate growth rates, but even in these countries the trend growth rates are well below those achieved in the earlier periods. This process of economic retrogression has been combined with a remarkable collapse of the investment process in these economies as compared to the earlier periods.

Since the 1980s, almost all MENA region countries have taken measures to restructure their economies, render them more competitive and create the condi-

Table 2. Per Capita GDP by Region, 1960–90.

	1960	1979	1990
MENA[1]	100	194	176
Syria	94	247	232
Turkey	96	176	222
Iran	177	271	202
Iraq[2]	204	510	190
Jordan	69	191	173
Tunisia	65	141	173
Algeria	102	167	165
Morroco	49	112	128
Yemen[2]	45	74	118
Egypt	48	91	114
East Asia[3]	50	115	199
Hong Kong	134	472	979
Korea	53	197	396
Malaysia	84	206	304
Singapore	97	395	695
Taiwan	75	252	79
Thailand	56	128	212
ASIA[4]	41	63	97
India	46	50	75
China	34	52	79
Bangladesh	56	65	83
Indonesia	38	71	117
Industrial Block[5]	387	708	885

Notes: [1] MENA, 1960=100, at 1985 international prices in US $. MENA refers countries in the Middle East and North Africa, excluding the small Persian Gulf states.
[2] Dates for Yemen refer to 1969, 79, 90, and for Iraq refer to 1960, 79, and 87.
[3] East Asia refers to Asia Pacific region excluding China.
[4] Asia refers to all the Asian countries listsed in the table, including East Asia.
[5] Industrial Block refers to OECD countries excluding Turkey & Mexico.
Source: Penn World Tables, Mark 5.

tions for the resumption of investment and growth in an outward-oriented environment. A review of these policies falls beyond the confines of the present paper. What is important to note in this respect, however, is that international competitiveness and the growth of non-oil exports is central to any successful structural adjustment in the economies of the region in a post oil era. As we have already noted, the relatively low levels of skills and industrial efficiency in the region may imply that a prerequisite for this is some degree of real wage reduction in the region. The declining per capita income trends in the region since the early 1980s suggest that this process of real wage reduction has been already taking place. It is also known that even in countries such as Turkey, Tunisia, and Morocco, where per capita incomes have been rising moderately, substantial real wage reduction has taken place (see, e.g. Karshenas, 1994; Van der Hoeven et al., 1997). Beyond a certain limit real wage reductions can be counterproductive, in the sense of exacerbating production inefficiencies and discouraging private investment by creating social tension and uncertainty. Therefore, the success of the adjustment program depends crucially on the ability to improve competitiveness without undue pressures on the standard of living of the workers. Such an adjustment process is therefore much more complex than a mere shift of labor between the non-traded and the traded goods sectors which a real devaluation of the exchange rate or sufficient reduction in real wages could bring about.

In order to be successful, MENA's adjustment policies need to address at least two basic issues. The first one relates to the build-up of skills through education and training and the improvement of productive efficiency. Improved competitiveness resulting from efficiency gains within the traded goods sectors, especially in non-traditional manufacturing, is necessary for the resumption of growth without exacerbating the external imbalances which have emerged in the post oil boom economies in the region. The second essential requirement is the resumption of investment growth in the region at a rate that would be adequate to address the problems of growing unemployment and underemployment of labor and the inadequacies of human capital formation. The resources made available through efficiency gains, as well as lower real wage and consumption levels, may help to finance the required rates of investment growth. However, depending on the level of industrial development and the existing capital stock in the economy, external finance may be needed to a greater or lesser degree to supplement domestic resources in order to achieve an adequate rate of investment in the different economies. Though labor-market flexibility can play an important role in the process of structural adjustment, to rely "excessively" on real wage reductions and casualization of labor can hinder this process by reducing work effort and learning, alleviating the pressure on the firms to improve efficiency, and reducing investment incentives.

In our view, the role of women's employment in the adjustment process should be considered in relation to these complex processes rather than the possible barriers to the mobility of women between the traded and the non-traded goods sectors. In particular, women's role in the economy and society is closely related to real wage determination and can play an important part in the determination of what is deemed as "excessive" real wage reduction in the adjustment process. We elaborate this point in the sections below.

4. EXPLANATIONS FOR LOW FEMALE LABOR FORCE PARTICIPATION RATES

With the exception of Tunisia and Morocco, the extremely low rate of female labor-force participation in non-agricultural activities and salaried employment is a significant feature of the labor markets in the MENA countries. Available data reveal a number of important features of women's participation in non-agricultural activities in the MENA region. These are particularly highlighted in contrast to the prevailing patterns in East and Southeast Asia as shown in Table 3. Firstly, the share of female workers in the total workforce in all the non-agricultural activities, and particularly in paid employment, is much below those in East and Southeast Asia. Secondly, the trends in female participation in non-agriculture in the MENA region are either stagnant or declining, in contrast with the rapidly increasing trends in the East Asia.

Only Morocco and Tunisia are distinct in exhibiting increasing trends in female participation in non-agriculture. These contrasting patterns are particularly magnified in the case of manufacturing employment. What is significant to note is that whereas the share of female labor in the non-agricultural sector in East and Southeast Asia is close to 40%, with manufacturing in the 40–50% range, in the case of the MENA countries the ratio is in the 10–15% range, except for Morocco and Tunisia. These data suggest that while in the case of East and Southeast Asian countries the majority of non-agricultural workers belong to families with two breadwinners, in the case of the MENA region countries – again with the exception of Tunisia and Morocco – the majority belong to one wage earner families.[3]

Researchers have long recognized and debated the low labor-force participation of women in the MENA region. Some have tried to explain it in terms of religious and cultural factors (Youssef, 1978; Abu Nasr et al., 1985; Clark et al., 1991) and others in terms of economic factors such as the capital intensity of production techniques and resulting low demand for female labor (Moghadam, 1993, 1995). Another explanation is that the persistence of patriarchy, and in particular the patriarchal family unit, has constituted a significant customary constraint on

Table 3. Female Share of Employment in Non-Agricultural Activities.

	All Workers		Paid Employment			All Workers		Paid Employment	
MENA	Manufacturing	Non-Agriculture	Manufacturing	Non-Agriculture	Far East	Manufacturing	Non-Agriculture	Manufacturing	Non-Agriculture
Egypt					China				
1960	4	11	3	12	1980	39	35	39	35
1966	5	10	4	13	1991	45	39	45	39
1976	7	14	7	12					
1989	—	—	9	18					
Iran					Hong Kong				
1956	34	23	30	24	1961	33	30	35	32
1966	40	21	33	22	1976	46	37	48	39
1976	38	22	20	17	1986	46	40	47	42
1986	15	11	7	11					
Jordan					Korea				
1961	16	11	3	10	1960	27	27	26	26
1979	6	10	5	12	1975	38	34	38	33
					1980	36	34	38	34
Morocco									
1960	30	16	22	22					
1982	36	26	—	—	Indonesia				
					1961	38	30	—	—
Syria					1971	43	35	35	25
1960	7	10	7	12	1980	45	35	36	24
1981	11	12	9	13					
Tunisia					Malaysia				
1956	22	17	8	12	1957	17	14	14	14
1975	52	29	29	21	1980	41	31	42	32
1984	56	30	34	24					
Turkey					Thailand				
1965	8	8	—	—	1960	38	39	27	23
1970	23	13	14	12	1980	47	44	43	37
1980	15	13	14	15					
1985	15	13	15	16					
UAE									
1975	1	5	0.4	6					
1980	1	7	1	8					

Source: ILO, 1990, 1995.

women's mobility and employment. A number of scholars have addressed the issue of the patriarchal family in the Middle East (Kandiyoti, 1988; Moghadam, 1993; Shami et al., 1990) and have defined the patriarchal family as a kinship based unit in which members have clearly defined gender roles derived from age and sex, and within which women are economically dependent upon the males, who are the ones engaged in market activities. In urban areas the patriarchal family tends to be nuclearized and less defined by extended-kin ties, but it is still predicated upon the male-breadwinner, female-homemaker gender division of labor. This patriarchal structure is also "protected" by various legal codes, social policies, and family laws, creating constraints to women's employment.

Drawing on this literature, Moghadam (1993, 1995) has explained women's economic roles and prospects in the MENA from a sociological perspective in terms of types of political economy and the specific configurations of gender relations and gender ideologies. Since the transformation of patriarchal family structures and the emergence of double wage-earning families are only very recent phenomena (a post-World War II development in Western Europe and the United States, somewhat earlier in Soviet Russia) it is almost tautologically true that traditional cultures tend to preserve the patriarchal family structures. What needs to be explained is why in some societies the patriarchal family structures persist longer than others, both within the MENA region and outside the region. The choice of technique explanation also begs the question, in that within the market-based economies the supply of labor is supposed to determine the choice of technique and not the other way round, and in the case of centrally-controlled economies the choice of technique by the government needs to be explained. Furthermore, for any given demand for labor the allocation of jobs to male or female laborers still needs to be explained.

The economic explanation of female labor force participation put forward by conventional family economics revolves around women's earning power in market activities. With the growth of women's earning power in the market, the opportunity cost of time spent on household activities increases, leading to increased female labor force participation rates.[4] This statement, as far as it posits a strong correlation between female labor force participation and earning power of women, is indeed correct and has been empirically substantiated by various researchers with respect to industrial economies. To check this in relation to the developing countries we have estimated the following cross-section regression equation for female labor force participation for 51 developing countries (including 15 MENA countries:[5]

LF =	−2.38	−1.03 Y	+2.46 W	Adj. R^2 = 0.55
t-ratio	(−11.55)	(−3.55)	(8.82)	No. obs. = 51

where the dependent variable, LF, is a logistic transformation of female participation rates, Y is per capita income used as a proxy for average family income, and W is a measure of female education as a proxy for average lifetime earning power of women. A fuller description of the data and variable definitions as well as a more extensive econometric analysis are detailed in a working paper by the authors, available on request. What is important to note for the present argument is that even such a simple and crude model seems to lend support to the above hypothesis. As predicted by the conventional family economics model, income exerts a negative effect on female labor force participation and women's earning power has a highly significant and positive effect. The problem with this explanation, however, is that it is based on a circular argument. Variables such as female education and earning power are themselves influenced by female labor force participation, and it is likely that factors that determine female labor force participation, simultaneously determine female education and earning power as well. In other words, women's education and earning power may be good predictors of female labor force participation, but they cannot be regarded as exogenous explanations for the variations in female participation rates across countries. An adequate explanation of the low female labor force participation in the MENA region in contrast to other regions, need not contradict the predictions of the family economics model, but it has to go beyond the latter by taking into account the historical specificities of the development paths in the different regions.

Such historical analysis of female labor force participation is exemplified by the pioneering work of Ester Boserup. Boserup (1970) tries to explain the variations in female labor force participation in non-agricultural activities across different developing countries in terms of the pre-existing agrarian structures, as well as customs and cultural attributes and the nature of foreign influence in various countries. Her analysis provides valuable insights into the varied patterns of female labor force participation across developing countries in the early stages of development. It is, however, plausible to expect that with the passage of time and after a long experience of modern economic development, the patterns of female labor force participation will be increasingly influenced by the variations in the path of development. More specifically in the context of the MENA region, the hypothesis put forward in this paper is that the preservation of the patriarchal family structures is significantly related to the fact that these were relatively high-wage economies. This has made the absence of women from market activities and paid employment affordable to the household in the non-agricultural sector, at the early stages of modern economic development.

A comparison of wage trends in major MENA economies and Indonesia, an Asian country with a predominantly Muslim population, would help to illustrate

this point. Table 4 shows the movement in dollar wages for the MENA countries and Indonesia over the 1963–92 period. The wage rates in the first three columns of the table are measured in US dollars at current market exchange rates.[6] As can be seen, manufacturing wages in the MENA region in the early 1960s were between four to over ten times higher than prevailing wages in Indonesia in 1970.[7] Despite the rapid growth of dollar wages in Indonesia during the 1970s, the substantial gap between the wage rates in that country and the MENA countries was maintained and in some cases was even widened. Dollar wages, converted at current market exchange rates, are important from the point of view of cost competitiveness and matter more to the employers. What matters from the point of view of workers is the real consumption wage, that is, money wages relative to the prevailing retail prices of the wage basket consumed by workers. In order to measure consumption wages in a manner which is comparable across the countries we have estimated these at consumption purchasing power parity exchange rates.[8] These measures which we have referred to as 'relative consumption wages', are shown in last three columns of Table 4. As expected, the deflation of wages by the relative consumption price indexes across the countries narrows the consumption wage gap between the rich and the poor countries.[9] Nevertheless, the considerable gap between wages in Indonesia and in various MENA countries remains intact, with the consumption wages in MENA in the early 1960s being between two to eight times higher than those in Indonesia in 1970. It appears that at a crucial stage of their development, when large scale urbanization and diversification away from traditional agriculture was taking place, the MENA region, in comparison to Indonesia, was in a much more favorable position to sustain one-breadwinner patriarchal families in the non-agricultural sectors. This is clearly a much more important factor, which needs to be taken into account in explaining the differences between female labor force participation rates in Indonesia and the MENA countries, than the usual explanations in terms of Islamic culture.

Indonesia is of course one of the low wage economies in East and Southeast Asia. However, as per capita income levels shown in Fig. 1 and Table 2 indicate, it appears that the wage rates in other East Asian economies with relatively high female labor force participation rates have been historically much lower than the average wage rates in the MENA region.[10] There is of course wide variation in the wage rates in various MENA region economies, and in a number of these countries, particularly in the 1980s, wages had fallen below wages in some of the fast growing countries in East Asia. Similarly, within the MENA region there is not always a correspondence between non-agricultural wage rates or per capita incomes and female labor force participation. Our contention in this paper in not that in each and every year, or even over longer periods such

Table 4. Manufacturing Wage Rates in the MENA region, Indonesia Korea & Malaysia, 1963–91.

	1963–65	1978–80	1989–91	1963–65	1978–80	1989–91
	Current $ at Market Exchange Rates[1,2]			Current $ at World Consumption Prices[1,2]		
Algeria	2173	5770	5521	2959	6701	7580
Egypt	611	1400	1906	874	3321	5273
Iran	671	7734	4064	1529	10589	6781
Iraq	896	3025	8969	2928	8978	7021
Jordan	762	3611	3262	1089	4715	5711
Morroco	1420	4010	3074	2811	6630	8152
Syria	570	1688	4219	663	4133	18078
Turkey	1457	4913	5702	1784	7018	14983
Tunisia	1052	3164	3003	1454	5178	7728
Libya	2190	7506	—	na	na	na
Indonasia	139[3]	668	758	399[3]	1355	3031
Korea	260	2646	9529	611	3715	14277
Malaysia	678	1828	3000	1395	3252	7509

Notes: 1. Wage rates refer to total compensation of labour divided by number of labourers.
2. At current US $.
3. Refers to 1971.

Source: Wage and Employment Data is based on UNIDO, INDSTAT, 1996, Consumption PPP exchange rates are based on Penn World Tables Mark 5.

as a decade, one should observe a one to one correspondence between non-agricultural wages and female labor force participation. The hypothesis is rather that during crucial stages of their development, as traditional agrarian societies are being opened up to the operations of market forces, and when a growing differentiation is taking place away from traditional agriculture and towards non-agricultural market based activities, the patterns of female labor force participation in the non-agricultural sector will be systematically formed by the level of prevailing wages or per capita incomes during the transition period. In societies such as those in East Asia, where population pressure on land has been extreme, and where per capita incomes and wages in the non-agricultural sector during the transition period were low, one would expect relatively high female labor force participation rates in non-agriculture, as patriarchal family structures in the modern sector are not affordable.[11] On the other hand, in countries

Notes: * Excluding China
Source: Penn World Tables, Mark 5.

Fig. 1. Per Capita GDP Trends in MENA and Other Regions.

such as those in the MENA region where in the period of transition there existed much more favorable land-labor ratios and where due to oil and other mineral exports much higher wage rates in the non-agricultural sectors, the one-breadwinner patriarchal family structures persisted.

The prevailing female labor market participation rates in developing countries are thus the outcome of specific life histories of these economies in terms of non-agricultural wages during the process of modernization, and particularly during the early stages when new social habits in terms of gender roles are being forged. This has been one of the fundamental factors which has shaped the prevailing patterns of non-agricultural female labor force participation across the developing countries. Apart from these fundamental forces there are of course various other elements, such as the pre-existing socio-cultural and religious factors as well as other socio-political and cultural experiences during the transition process, which we believe in the long run play a less systematic role in female labor force participation. This is not to dismiss the importance of socio-cultural factors with regard to female labor force participation at any point in time, but rather to indicate that these factors are themselves fundamentally shaped by the long experience of modern economic development. In other words, the forces of modern economic development are likely to randomize the impact of the pre-existing traditional cultures in assigning females roles across the different societies. In societies with relatively high per capita incomes in the non-agricultural sector during the transition period, those elements of traditional culture which restrict the role of women become prominent, while in others where due to relatively low incomes one-breadwinner families are not affordable, new cultural norms are forged which allow greater female labor force participation. The implications of this phenomenon for economic adjustment in present day MENA economies may be significant. It is to the analysis of such implications that we shall now turn.

5. IMPLICATIONS OF LOW FEMALE PARTICIPATION FOR COMPETITIVENESS AND ECONOMIC ADJUSTMENT

The MENA economies seem to have inherited from their past experience of development a set of economic structures and social institutions which are at odds with the new realities of the global economy and the requirements of adjustment in the post oil era. As we have already observed, in terms of human capital, industrial skills, manufacturing productivity and export experience, the MENA countries seem to be well behind the economies in East Asia with similar or even lower levels of per capita income and wage levels in the early

1980s. Economic adjustment in the post oil era has therefore inevitably entailed a certain degree of real wage reduction, as suggested by the conventional theory of comparative advantages. Economic adjustment according to conventional theory, however, assumes a downward flexibility in real wages which, beyond a certain limit, may not be attainable in the MENA region, given the consumption requirements of the prevailing one breadwinner patriarchal family structures in that region. A comparison between the MENA countries and three countries in Southeast and East Asia, namely, Indonesia, Korea and Malaysia, would help to bring this problem into clear relief.

As can be seen in the second column of Table 4, dollar wages at current exchange rates in the MENA countries at the beginning of the 1980s were in general higher than the three countries in East and Southeast Asia. Egypt and Syria were the only exceptions. Given the lower levels of education and skills of manufacturing workers in the MENA region, from the point of view of the manufacturing firms, the MENA region wages at the time were certainly not competitive in comparison to the countries in East and Southeast Asia. Viewed from the workers' standpoint, that is, in terms of relative consumption wages, a similar picture is revealed. As can be seen from the second to last column of Table 4, relative consumption wages in all the MENA countries were more than those in Indonesia, Korea, or Malaysia in the early 1980s – and in some countries many times more. Caution is needed in making conclusions based on consumption wages about standards of living across countries because of uncertainty about labor force participation rates within households. During the early 1980s in East and Southeast Asia between 40 to 45% of the workers in the non-agricultural sector were women, whereas in the MENA region, with the exception of Tunisia and Morocco, this rate was closer to 10 or 15% (see Table 3). The implication is that while in East and Southeast Asia the majority of non-agricultural workers belonged to two breadwinner families, with the exception of Tunisia and Morocco, this ratio is marginal in the MENA. If we further consider that due to their extremely low levels of education and skill the majority of the female workers in the MENA region are engaged in low-pay and low-productivity jobs, the overall family wages from market activities in the MENA region, relative to the countries in East and Southeast Asia, would be well below the relative scales indicated by consumption wages in Table 4.

This picture becomes even bleaker if we take into account the other extra costs of maintaining the patriarchal one breadwinner families in the MENA region. Patriarchal societies with large gender gaps in education clearly experience significantly higher fertility and child mortality rates (Schultz, 1994). Higher fertility in turn means larger families which are more costly to maintain for sole wage earners. Greater child mortality means greater medical expenses,

not to mention its other psychological and physical costs for women. Furthermore, healthcare and other services and provisions which constitute part of the nonmarket activities of women within the household in patriarchal societies, are likely to be performed in an inefficient and costly manner due to lack of education and training of women. This may involve even higher unit input costs in terms of purchased provisions compared to families in less patriarchal societies where mothers are more educated.[12] In addition, the MENA region does not take advantage of economies of scale which can be gained by the market provision of many goods and services, and relies instead on millions of housewives for the provision of these goods. Thus it would not be unreasonable to assume that the monetary cost of maintaining one breadwinner families in the MENA region is quite high.

It appears, therefore, that though product wages (at international prices) in the MENA region in the early 1980s were very high by international standards, this did not apply to the same extent to family consumption wages, given the prevailing social institutions in the region. In other words, in order to maintain similar per capita consumption levels as the economies of East and Southeast Asia, MENA with its preponderance of one wage earner families (in the non-agricultural sector) has needed to maintain much higher wage levels than the former group of countries. In the post oil boom era this situation is clearly no longer sustainable. This is reflected in the considerable wage reduction which has occurred in the MENA region during its liberalization phase since the early 1980s (Van der Hoeven et al., 1997; Karshenas, 1994). The attainment of international competitiveness through real wage reduction, however, is limited by the subsistence needs of the one wage earner families in the region. The existing evidence suggests that such limits in a number of economies in the MENA region may have already been reached.

Turkey is an example of one such economy that managed to bring about substantial wage reduction in industry during the 1980s liberalization phase. The subsequent wage explosion and the resulting instabilities could be indicative of the limits to such wage reduction in patriarchal societies. An additional cost was that during the 1980s there was a 50% deterioration of terms of trade against agriculture in Turkey, which could be interpreted as a consumption subsidy to the non-agricultural sector. In Iran, during the post-revolutionary period, female labor-force participation in non-agriculture was drastically curtailed through the intensification of patriarchal policies emphasizing women's family roles, made possible only by the provision of huge consumer and producer subsidies. More recently, however, the drastic fall in per-capita consumption levels has forced more women to seek jobs – only to find structural and customary obstacles, hence the high and growing unemployment rates

among the women in the region.[13] In Egypt, Algeria, Jordan and other countries in the region, mounting social tensions and the lack of response of private investment to the liberalization policies may be symptoms of the same phenomenon. Examples of household heads having two or three jobs in order to maintain their one breadwinner families, with the consequent inefficiencies, abound in all the countries in the region. It may not be just a coincidence that the only two countries in the region which seem to have had a smoother ride in opening up to the global economy are Tunisia and Morocco, both with high female labor force participation in the non-agricultural sector.

6. CONCLUSIONS AND POLICY RECOMMENDATIONS

In the conventional economics literature, many studies of the impact of adjustment on women have treated gender issues as a derivative or secondary subject in the analysis of adjustment. The impact of adjustment on the economy and society is first analyzed in general, and the impact on women is derived by reference to the role of women in the economy or society under question. As such policy prescriptions regarding women have also remained secondary. In this paper we have taken a different approach. If structural adjustment programs are supposed to constitute entirely new development strategies and bring about such momentous socio-economic changes, then the role of gender issues and in particular family structures cannot be treated as a side issue. We have also treated the question of adjustment as one that applies to empirically given economies rather than as an abstract model to be imposed on all economies. In this approach history matters. The MENA region economies during the oil era seem to have locked themselves into family structures that do not conform to the stage of their development, their production capabilities and the new realities of the international economy. The adjustment to the post oil era, that is, the integration of the region into the global economy on a new basis, thus poses important questions regarding the role of women and patriarchal family structures, not as derivative issues but as issues central to the adjustment process itself. The policy conclusions matter here not only in relation to the position of women but also in relation to the success of the adjustment program in the first place.

The economic slowdown in the MENA region since the 1980s, combined with fast population growth rates, has led to mounting problems of unemployment and underemployment of labor. Under these circumstances it is likely that women's employment would be sacrificed for men's employment – a process that seems to be already taking place in the region, as the unemployment figures for women, which are much higher than men and growing faster, well indicate

(Moghadam, this volume). The high rate of unemployment amongst educated women (Shaban et al., 1993) may also convey the impression that educated women are in excess supply, prompting calls for the curtailment of women's education. As we have argued in this paper, however, a key element in the attainment of wage competitiveness in the region is greater integration of women in the workforce, greater education and training of women, and the transformation of patriarchal family structures. Without due consideration to gender issues, economic liberalization policies per se can lead to a economically retrogressive chain of events. This chain of events can include excessive pressure on wages (excessive in relation to subsistence wages for one breadwinner families), social tension and uncertainty, low private investment, declining labor productivity, growing unemployment, further isolation of women from the labor market, further strengthening of patriarchal family structures, and so on. At the heart of this chain of events lies the fact that under the prevailing production conditions there exists no real wage which can reconcile international competitiveness with the prevailing patriarchal family structures.

In light of this argument, governments in the region need to introduce policies to remove the continuing barriers to female employment by helping to close the gender gaps in education, reducing wage and employment discrimination against women, designing vocational training for women, and investing in physical and social infrastructure which is more woman-friendly. Removing these constraints should be done in tandem with the introduction of policies to proactively encourage female employment. These policies may take various forms, including: tax incentives for enterprises that hire large numbers of women; the passage of legislation prohibiting employment discrimination against women; the removal of restrictions on women's engagement in night work; the modernization of family laws to eliminate the requirement that women obtain permission from fathers and husbands to seek employment, obtain loans and credits, and engage in travel; and the provision of childcare and maternity leave through various forms of financing to facilitate women's labor-force attachment and at the same time reduce discrimination against women. Such policies are obviously necessary not only for the success of adjustment and liberalization program, but also to improve the position of women within the household and in the society at large.

ACKNOWLEDGMENTS

We would like to thank Mine Cinar and two anonymous referees for valuable comments on an earlier draft of the paper. The authors are of course solely responsible for the analysis and any errors.

NOTES

1. We compare MENA to East and Southeast Asia because it includes countries that are Muslim as well as countries that in terms of development, income and resource availabilities provide useful reference points for the countries in the MENA region.
2. For a more detailed discussion of educational attainment and gender gaps in the MENA region see chapter two of Moghadam (1998).
3. These are of course rough estimates which at best indicate general tendencies. The correspondence between female labor force participation and the number of breadwinners in households depends on the age structure of the population, marriage age, and the age structure of the female active population. Our inspection of the data on the age structure of the female labor force published by the ILO indicates that there does not seem to be a significant difference between Asia and MENA, but this needs further research as the ILO data refers to total employment rather than the non-agricultural employment considered here.
4. This is summarized by Gary Becker (1991: 55) who explained the growing female labor force participation in industrialized economies as follows: "The major cause of increased participation of married women during the twentieth century appears to be their increased earning power as Western economies developed, including the rapid expansion of the service sector. The growth in the earning power of married women raised the foregone value of their time spent at child care and other household activities, which in turn reduced the demand for children and encouraged a substitution away from parental, especially mothers', time. Both of these changes raised the labor force participation of married women."
5. The list of the countries is provided in the note to Table 5.
6. Wage rates here refer to total labor compensation divided by the number of employees, as given by UNIDO database, INDSTAT, 1996.
7. Data on manufacturing wages prior to the 1970s are not available for Indonesia on the same bases as the data for other countries in Table 4.
8. That is, the dollar value of per capita consumption in each country is deflated by its international consumption expenditure price index, with the United States as the numeraire. The consumption expenditure price indices are based on Penn World Tables, Mark 5.
9. On the relation between the purchasing power parity exchange rates and per capita income levels see, e.g. Balassa (1964), Kravis and Lipsey (1983), and Summers and Heston (1991).
10. The MENA average is a weighted average and includes Algeria, Egypt, Iran, Iraq, Morocco, Syria, Tunisia and Turkey. The inclusion of small high wage economies in the MENA region, such as the oil surplus states in the Persian Gulf and Libya, would of course push up the MENA average to much higher levels. Data on wage rates for poor East Asian countries such as China, Vietnam and Cambodia are not available. But wage rates in these countries are unlikely to be higher than in Indonesia.
11. On the relationship between land/labor ratios and non-agricultural wages in the MENA region and Asia see Karshenas (1999).
12. A good example is the cost of preventive healthcare administered by more educated mothers in contrast to curative medical expenses.
13. While male unemployment in the early 1990s stood at around 10% for the region as a whole, female unemployment rate was close to 25%. See Shaban et al., (1993) and Moghadam (1998, and this volume) for more detailed figures on female unemployment.

REFERENCES

Abu Nasr, J., Azzam, H., & Khoury, N. (Eds) (1985). *Women and Development in the Arab World*. Leiden: Mouton.
Balassa, B. (1964), The Purchasing-Power Parity Doctrine: A Reappraisal. *Journal of Political Economy*, 72, 584–596.
Becker, G. S. (1990), *A Treatise on the Family*. Cambridge, Massachusetts: Harvard University Press.
Boserup, E. (1970). *Women's Role in Economic Development*. London: George Allen and Unwin Ltd.
Boserup, E. (1990). Economic and Demographic Relationships in Development, T. Paul Schultz (Ed.), Baltimore: The Johns Hopkins University Press.
Clark, R., et al. (1991). Culture, Gender, and Labor Force Participation: A Cross-National Study. *Gender & Society*, 5(1), 47–66.
Collier, P. (1993). The impact of adjustment on women. In: L. Demery, M. Ferroni, C. Grootaert with J. Worg-Valle (Eds), *Understanding the Social Effect of Policy Reform*. Washington DC: World Bank.
Elson, D. (1991). Male Bias in the Development Process: The Case of Structural Adjustment. In: D. Elson (Ed.), *Male Bias in the Development Process*. London: Macmillan.
Haddad, L., et al. (1995). The Gender Dimensions of Economic Adjustment Policies: Potential Interactions and Evidence to Date. *World Development*, 23(6), 881–896.
International Labor Office (ILO) (1990). *Yearbook of Labor Statistics*, Retrospective Edition on Population Censuses, 1945–89, Geneva.
International Labor Office (ILO) (1995). *Yearbook of Labor Statistics*, Geneva.
Kandiyoti, D. (1988). Bargaining with Patriarchy. *Gender & Society*, 2(3), September, 274–290.
Karshenas, M. (1994). *Macroeconomic Policies, Structural Change and Employment in the Middle East and North Africa*. Geneva: ILO.
King, E. & Hill, M. A. (Eds) (1993). *Women's Education in Developing Countries: Barriers, Benefits, and Policies*. Baltimore: The Johns Hopkins University Press.
Kravis, I. B., & Lipsey, R. (1983). Toward an Explanation of National Price Levels. *Princeton Studies in International Finance*, 52, Princeton, NJ.
Moghadam, V. M. (1993). *Modernizing Women: Gender and Social Change in the Middle East*. Boulder, CO: Lynne Rienner Publishers.
Moghadam, V. M. (1995). The Political Economy of Women's Employment in the Arab Region. In: N. Khoury & V. M. Moghadam (Eds), *Gender and Development in the Arab World*. London: Zed Books.
Moghadam, V. M. (1998). *Women, Work, and Economic Reform in the Middle East and North Africa*. Boulder, Co: Lynne Rienner Publishers.
Page, J. (1998). From Boom to Bust – and Back? The Crisis of Growth in the Middle East and North Africa. In: N. Shafik (Ed.), *Prospects for Middle Eastern and North African Economies: From Boom to Bust and Back?* (pp. 133–159). London: Macmillan.
Palmer, I. (1991). Gender and Population in the Adjustment of African Economies: Planning for Change. *Women, Work and Development Series*, 19. Geneva: ILO.
Penn World Tables, Mark 5 (1994). Philadelphia: University of Pennsylvania.
Schultz, T. P. (1994). Human Capital, Family Planning, and their Effects on Population Growth. *The American Economic Review*, 84(2), May 1994, 255–260.
Shaban, R. A., Assaad, R., & Al-Qudsi, S. (1993). *Employment in the Middle East and North Africa: Trends and Policy Issues*. Prepared for the ILO (October).

Shami, S., Morsi, S., & Tamimian, L. (1990). *Women in Arab Society: Work Patterns and Gender Relations in Egypt, Jordan and Syria*. Paris: Unesco.

Sparr, P. (Ed.) (1994). *Mortgaging Women's Lives: Feminist Critiques of Structural Adjustment*. London: Zed Books.

Stewart, F. (1992). Can Adjustment Policies Incorporate Women's Interests? In: H. Afshar & C. Dennis (Eds), *Women and Adjustment Policies in the Third World*. London: Macmillan.

Summers, R., & Heston, A. (1991). The Penn World Table (Mark 5): An Expanded Set of International Comparisons, 1950-1988. *Quarterly Journal of Economics*, 327–368.

UNDP (1993). Human Development Report 1993. New York: Oxford University Press.

UNESCO (1994). Education for All: Status and Trends 1994, Paris: UNESCO.

UNIDO, INDSTAT (1996). Industrial Statistics Database, Vienna.

Van der Hoeven, R., Karshenas, M., & Szirascki, G. (1997). Privatization and labor issues in the context of economic reform. In: T. H. Hanaan (Ed.), *The Social Effects of Economic Reform on Arab Countries*. Washington D.C.: International Monetary Fund.

World Bank (1995). *Socio-economic Time Series Access and Retrieval System* (STARS). Washington, D.C.

World Bank (1991). *Growth, Poverty Alleviation and Improved Income Distribution in Malaysia: Changing Focus of Government Policy Intervention*. Washington, DC: The World Bank (January).

World Development (1995). Special Issue on Gender. *Adjustment and Macroeconomics*, 23(11), November.

Youssef, N. (1978). The Status and Fertility Patterns of Muslim Women. In: L. Beck & N. R. Keddie (Eds), *Women in the Muslim World* (pp. 69–99). Cambridge, MA: Harvard University Press.

ANALYSIS OF SEX-BASED INEQUALITY: USE OF AXIOMATIC APPROACH IN MEASUREMENT AND STATISTICAL INFERENCE VIA BOOTSTRAPPING

Sourushe Zandvakili

ABSTRACT

I advocate the use of the family of Generalized Entropy measures for the analysis of short and long run earnings inequality between men and women and among women in MENA. In order to lend credibility to the analysis of earnings inequality by sex, long-run measures of earnings inequality free of transitory components and decomposable by specific characteristics, must be used. Utilizing such techniques in MENA is particularly important since the region is undergoing rapid changes in women's labor force participation rates. A priority of policy makers should be the collection of good longitudinal data that can address these questions.

1. INTRODUCTION

Recently the "feminization of poverty" has received a great deal of attention in the literature (Sen (1990)). Sex-based earnings inequality in different countries in the Middle East have been discussed by Blumberg (1988), Moghadam (1991), Aghjanian (1995), Olmsted (1996), and Anbarci-Cinar (1999). I would like to propose a new methodological approach for the purpose of analyzing inequality and investigating factors that may have influenced gender-based earnings inequality in static and dynamic frameworks. This approach uses the generalized entropy measures of earnings inequality in the short as well as the long run, allowing one to analyze income fluctuations and distinguish between transitory and permanent changes in income over time. The effect of factors such as sex, in conjunction with ethnicity, age, education and marital status, can easily be investigated. In addition, this approach allows for the generation of mobility profiles to examine the existence of permanent inequality.

Global labor markets have undergone a number of noticeable changes, including an increase in labor-force participation of women. This trend includes countries in the Middle East and North Africa (MENA). Existing studies have examined the consequences of these changes in wage, income or earnings inequality based on sex in a static framework. Some have used aggregated data to investigate this issue. I suggest that such an investigation must be conducted in a dynamic framework, using micro data and reporting statistical inferences to make the findings credible. The study of earnings inequality based on sex requires not only a comparison of earnings of men and women, but also an examination of the factors that may have influenced the earnings inequality among women. One must demonstrate not only the observed short-term inequality but also long-run earnings inequality, which is free of transitory components. Factors such as education (human capital), ethnicity, age, marital status, and family size must be considered as possible contributors to the overall earnings inequality. Regional differences as well as urban versus rural areas also play an important role in some countries. I anticipate that education and ethnicity may be the most influential factors explaining the observed earnings inequality in some of these countries. Most of the less developed countries have flat earnings stability profiles, which reveal permanent and chronic earnings inequality.

The labor markets in most of MENA have experienced drastic changes since World War II. These have influenced employee-employer relations as well as standard practices regarding hiring, promotion, and termination of workers. In addition, cultural and political changes have occurred in a number of these

countries, such as Jordan, Iran, Iraq, Turkey and Lebanon. In most cases the groups most strongly affected are women and minorities. The experience of women during these changing times in some of these countries has been devastating since services such as birth control have been disrupted.

One of the goals of public policy in these countries should be the enhancement of employment opportunities to reduce the earnings gap experienced by women and minorities. Yet the effectiveness and the consequences of such policcs arc not fully understood. Some observers argue that rapid growth in the rates of return to education, acceleration of industrial restructuring, and globalization of markets are the major contributors to the observed earnings inequality. Others use regional differences to advance our understanding of this situation.

Permanent, specific, individual differences such as sex play a major role in explaining the observed earnings inequality in most Middle Eastern countries. Women's labor-force participation generally has increased with education, regardless of the country. Their economic well being, however, has not increased correspondingly. Differences based on education are influenced as well by factors such as ethnicity, age and household head's marital status. In addition, age is associated with life-cycle factors, so earnings patterns over time need to be examined as well. The traditional life-cycle effect on earnings may not hold true for all women. Their earnings at the early stage of their careers tend to be limited by marriage and children. At the same time, the traditional notion of family has changed in some of the countries in the region, and some studies attribute the diversity of women's economic positions to their marital status. The observed rise in earnings inequality among women is understood only partially at best and needs further investigation.

An analysis over a longer period would permit a closer look at the effects of factors such as education, ethnicity, age, marital status and number of children. It would be subject to less distortion of the type contained in annual observations, with their transitory variations. Traditional methods, however, cannot be used to answer some of the most important questions regarding sex-based earnings inequality.

This paper is organized as follows. Section 2 provides a discussion of why it is important, particularly in the context of MENA, to decompose income data and adjust for dynamics. The methodology for the measurement of earnings inequality and earnings mobility,as well as a discussion of data needs, are provided in Section 3. Section 4 provides a framework and makes an argument for using bootstrapping to conduct statistical inference to test the validity of findings. The paper ends with concluding remarks.

2. DATA DYNAMICS AND SEX-BASED INEQUALITY

Earnings disparities between men and women in developed and less developed countries have been the subject of many debates. A number of hypotheses have been proposed, such as discrimination in labor-market opportunities and in job advancement, lower rates of return to education, career interruptions due to childbearing and other family responsibilities and women's lack of mobility relative to their male counterparts.

In recent years, in MENA, as well as other parts of the world, labor-market barriers have been lowered for women, and opportunities regarding the accumulation of human capital have improved. This has occurred for a number of reasons, including changes in public policy. Although an overall increase in women's participation has occurred, changes in women's participation have not been uniform, across class, ethnicity or country. As such, the variation in women's earnings has increased, and different groups of women have emerged, those who are engaged in the labor market, partially engaged and not engaged at all.

These findings should be viewed cautiously, however, because most analysts use aggregate (often annual) data in a static framework to examine earnings inequality in less developed countries. Yet annual data contains transitory components that may distort our view of true earnings inequality. To understand this distortion more clearly, let us consider the distribution of earnings between two individuals in three consecutive time periods as [1,2], [2,1], and [3,2]. Income vector [1,2] provides income of the first individual as 1 and the second individual as 2, in the first period. Income vector [2,1] provides income of the first individual as 2 and the second individual as 1, in the second period. Income vector [3,2] reports income of the first individual as 3, and the second individual as 2, in the third period. The observed short-run inequality has not changed from the first to the second period, and it declines from the second to the third period using any inequality measure. In reality there should be no observable inequality in the first two periods combined, if we assume linear aggregation and real earnings. Also, the long-run inequality for the three periods rises, rather than fall, for the short-run observation. Thus it is important to take a long-run, dynamic view of earnings inequality among households. Unfortunately, while it is easy to construct such examples where an understanding of dynamics is important, to demonstrate the inadequacy of the reported results empirically is far more difficult and involves some complex measurement issues.

In addition to the dynamics, other factors such as education and age in conjunction with sex are also important in the analysis of earnings inequality.

Decompositions based on such factors or combinations of factors can detect how "between-group" earnings inequality contributes to overall earnings inequality. Such analysis may also address a second question of whether earnings inequality among women is greater than among men. Decomposing the data allows the analyst to verify differences in earnings inequality based on sex and offer an explanation regarding its nature. If analysts are interested in evaluating the effectiveness of past polices and recommending new polices to increase economic well-being of women in MENA, they have to reconsider how they conduct analysis of earnings inequality.

Changes in the rates and patterns of women's labor-force participation, whether due to changes in policy or other factors, may also affect the observed inequality. Policy changes, however, have a complex influence on women's labor-force participation and on the analysis of public polices regarding sex-based earnings inequality. Could it be that there is greater incentive for full-time participation (or less incentive to be a nonparticipant or a partial participant), even for those with lower levels of economic well-being?

The pattern of labor-force participation for women has changed in relation to their age, marital status, and occupational choice. Fixed costs associated with labor-market activity also enter this decision-making process. Also, differences in human capital accumulation may be a major source of the observed inequality among and between men and women. Choice regarding education and career are influenced by a number of factors. Normally, one's desire or preferences for forming a family could create a disincentive to invest in human capital, and this may be particularly true among women. In recent years, however, the number of years in school for women has increased. This trend will increase the variance in their accumulated human capital as well as earnings inequality. Also, one's view of labor-market activity may be influenced by one's level of education.

Labor-market barriers and career interruptions for women have a distinctive effect on their earnings. Career interruptions tend to shorten the duration of return on investment, and depreciation of accumulated human capital affects the rate of return on education and training. As a result, women avoid certain types of jobs that require continuous labor-market participation. This pattern is changing rather slowly; the result is greater variation in women's earnings.

Another aspect of gender-based earnings inequality in the MENA region is ethnic inequality. Most countries appear to contain several classes of minorities and ethnic groups, such as the ones in Turkey and Iran. Some of these groups have benefited from past policies, and others have been left behind altogether. As a result, although the mean of earnings among women may be converging with men's, inequality among women may have increased over time.

Another contributor to the earnings gap is age. Accumulated human capital combined with experience accounts for this earnings differential. Thus one would expect between-group inequality to account for a significant portion of the overall inequality. I believe, however, that the traditional view of the life-cycle effect will fail to be fully supported in most, if not all, MENA countries. Factors other than the stage of one's life cycle may be far more important in explaining the observed earnings inequality based on sex. For example, because of the timing of labor-market participation and childbearing, and the resulting career interruptions, younger cohorts experience more variance in labor-force participation. Therefore we should find greater variations in earnings and an increase in inequality.

It has been asserted that marital status is one of the most important factors influencing women's earnings. I believe that this is particularly true in MENA countries. Thus marital status must be identified as an important factor in labor-force participation and differences in earnings. Single women without children spend a far larger proportion of time throughout their life cycle in labor-market activity; this fact would increase earnings' inequality among women. At the same time, the discontinuous pattern of women's labor-market activity tends to reduce incentives and labor-market opportunities. Also, in some MENA countries there are major institutional barriers for labor market activity once women are married. In some cases they have to have permission from their husband for labor market activity. The net effects varying among households are a matter for empirical investigation.

Here I raise a number of questions about the probable causes of earning differences, using short-run inequality, long-run inequality, and income stability measures that are decomposed by household head's ethnicity, age, education, and marital status (or combinations of factors). These decompositions will reveal more clearly the nature and direction of the observed changes. The decompositions contain between-group inequality and the weighted average of within-group inequality; these will be the most important elements in the observed differences among and within groups. I measure inequality for each group in order to learn about within-group trends.

3. METHODOLOGY

The measurement of inequality requires special attention to factors such as income source, income unit, equivalence scale, time duration, and weights. Each of these factors affects our view of the observed inequality, and influences how we evaluate economic well-being. Although I focus primarily on the measurement of inequality, a discussion of these factors will be useful.

In the inequality literature, income is the most commonly used variable in analyses of inequality. Different variations on income can be used for measurement, however, such as both pre- and post tax and transfer income. We can also measure inequality on the basis of earnings, expenditures, and wealth. The choice of income source must be justified according to the general purpose of the research question.

The proper choice of an income unit is critical in measuring inequality. The individual generally is a poor choice of an economic unit; household and family are more suitable. Although nonworking spouses and children do not have their own income, they are direct beneficiaries of household income. Thus the measurement of inequality at the individual level creates a misleading picture. At the same time, however, measures based on per capita household or family income are not appropriate because not all individuals in a household enjoy the same economic well-being. Therefore the problem must be addressed through an equivalence scale (Fisher, 1987). To use an equivalence scale, one must deflate household or family income for each extra member of the family unit. Equivalent income for a family or a household is equal to the observed income divided by the equivalence scale value for households or families similar to the one in question. The derivation of such scales is a problem: the choice is normative and must be justified on the basis of some consensus regarding the minimum level of consumption for households or families of similar type in each of these countries.

The time horizon for measuring inequality is another complicating factor, and of paramount importance. If permanent and chronic inequality is an issue, one must analyze inequality in the long run. This requires the use of aggregation techniques for measurement. The current literature, however, is dominated by short-run annual measures of inequality; these measures contain transitory components and must be used cautiously.

The emergence of micro data at the unit level has generated another variable that requires attention. The proper weighting schemes must be used to assure that the observed data are representative of the population under consideration, particularly when long-run measures of income are considered. The use of panel data to generate long-run measures of income is problematic because most panels are affected by attrition and by changes in the demographic composition of the population.

The impact of the choice of inequality measure must be kept in mind when estimating short-run and long-run inequality, as well as the income stability profile. Because of their characteristics, inequality measures vary in their degree of sensitivity to different parts of the distribution. This feature affects the weights attached to individuals' income fluctuations in computations of inequality.

There is no single rule for selecting an appropriate inequality measure. The ranking of inequality measures is not feasible, although the selection process interests us because each of these measures possesses some desirable properties. The axiomatic approach to inequality measurement proposed by Sen (1973), Shorrocks (1980), Cowell-Kuga (1981), Foster (1983) and Maasoumi (1986) is a step in this direction. It is desirable for inequality measures to be a real valued function for a population, and to satisfy the properties of mean independence or income homogeneity, whereby the inequality measure will be sensitive to proportional changes in all incomes; anonymity or symmetry, which requires the inequality index to be independent of labels that are assigned to income shares of the population; the Pigou-Dalton principle of transfer, which requires that a transfer from a rich person to a poor person will reduce inequality, provided that the transfer is not so large as to reverse their positions; the principle of population, which ensures that the inequality measures depend on relative densities rather than on the absolute density; and decomposability, whereby the total inequality in the distribution of a population's income can be broken down into a weighted average of (on one hand) the inequality existing within subgroups of the population, and (on the other) the inequality between the groups.

Decomposability is a useful property, but not all decomposable measures are accurate measures of inequality (Bourguignon, 1979; & Shorrocks, 1984). Those inequality measures which satisfy decomposability as well as the other desirable properties discussed above are of particular interest, while in special cases one could use some inequality measures that violate any one of these requirements (such as the Gini coefficient, which is not additively decomposable). The weights given to the inequalities within the various subgroups distinguish the additively decomposable measures. Population and income shares are generally used for the weights. Below I evaluate some of the measures of inequality with regard to these desirable properties.

A number of measures have been proposed in the literature. These fall into two categories: conventional measures with no explicit reference to the concept of social welfare, and measures that are based on some formulation of social welfare function. I will evaluate some of these measures with specific reference to the desirable properties indicated. The conventional measures most commonly used in research include the variance measure, the coefficient of variation, and the Gini coefficient.

Concerning the issue of "income homogeneity," the above-mentioned measures, with the exception of variance, are unaffected by equal proportional changes in all incomes. Variance is not defined in relation to the mean; thus it violates the mean independence property. A utility function is assumed

to be quadratic if the distributions are ranked according to the mean and variance. This implies increasing relative and absolute inequality aversion. Thus, according to Atkinson (1970), equal absolute increases in all incomes give rise to equally distributed equivalent income by less than the same amount.

The coefficient of variation and the Gini coefficient are sensitive with regard to the Pigou-Dalton condition of transfer. That is, a transfer from a richer person to a poorer person always reduces their measured value. The standard deviation of the logarithm occasionally violates the principle of transfer; this can happen when a transfer is made to a poor individual from a rich individual at very high levels of income. In reference to relative sensitivity, the coefficient of variation is equally sensitive at all levels of income. The standard deviation of logarithms is more sensitive to transfers in the lower income brackets and rather insensitive to transfers among the rich. In the case of the Gini coefficient, a higher weight is attached to transfers at the center of the distribution than at the two tails. Also, with reference to the decomposition property, the Gini coefficient is not additively decomposable.

The conventional summary measures violate some of the desirable properties described above. With each of these statistical measures, it would be preferable to examine directly the social welfare functions that we wish to employ, rather than using implicit value judgments. The inequality measures, which are homogeneous, symmetric, and decomposable, and which satisfy the Pigou-Dalton condition of transfer, belong to the class of generalized entropy measures.

Several factors are involved in measuring long-run earnings inequality. First, one must select the appropriate method of aggregating earnings needs. Several approaches are possible. I used a number of aggregation methods to gauge the sensitivity of long-run inequality to the method of aggregation in order to minimize the influence of normative preferences. Second, an appropriate index of inequality is necessary. It must possess a set of desirable properties designed to minimize the normative judgments involved in selection.

Consider a population of N households ($i = 1, \ldots, N$) with earnings received for T consecutive accounting intervals, ($t = 1, \ldots, T$). The earnings of individual i at time t are Y_{it}, and $Y_i = \sum_t Y_{it}$ is total earnings for individual i over the entire accounting period. Maasoumi (1986) developed a class of aggregator functions that place distinct weights on different attributes. If earnings at different points in time are viewed as distinct, different weights need to be used at different moments over the accounting interval. The aggregator functions should have distributions approximating T earnings distributions over the

accounting interval. Theil (1967) and Maasoumi (1986) have formalized this notion of "closeness" in information theory. Consider:

$$S_i(Y_{i1}, \ldots, Y_{it}) = \left[\sum_t \eta_t Y_{it}^{-\beta}\right]^{-1/\beta} \qquad \beta \neq 0, -1 \qquad (1a)$$

$$= \prod_t Y_{it}^{\eta_t} \qquad \beta = 0 \qquad (1b)$$

$$= \sum_t \eta_t Y_{it} \qquad \beta = -1 \qquad (1c)$$

where S_i is the aggregate composite measure of earnings over the accounting interval. η_t are the weights given to earnings in each period and $\sum_t \eta_t = 1$. As the period of accounting is extended, a new aggregate share measure for the ith individual is calculated. Note that $S^* = (S_1^*, \ldots, S_N^*)$ where $S_i^* = S_i / \sum_j S_j$ is the ith share of aggregate earnings. β is related to the elasticity of substitution σ, and by the following relation $-\beta = 1 - 1/\sigma$. S^* can be regarded as a measure of intertemporal utility or an evaluation of households' economic well being, given β and η. The relative inequality in S^* is computed by the Generalized Entropy family of measures as:

$$I_\gamma(S) = \sum_i \left[(NS_i^*)^{1+\gamma} - 1\right] / N\gamma(1+\gamma) \qquad \gamma \neq 0, -1 \qquad (2a)$$

$$= \sum_i S_i^* \log(NS_i^*) \qquad \gamma = 0 \qquad (2b)$$

$$= \sum_i N^{-1} \log(1/NS_i^*) \qquad \gamma = -1 \qquad (2c)$$

where $\gamma = -(1+\beta)$, and its choice determines the sensitivity to the two tails of income distribution. I_0 and I_{-1} are Theil's first and second measures of inequality respectively. Theil's measures are special cases for linear and Cobb-Douglas type aggregation. This family includes the monotonic transformation of the family of measures introduced by Atkinson (1970). The type of welfare function is defined by choosing γ, which is a measure of the degree of inequality aversion, i.e. and relative sensitivity to transfers at different income levels. As γ falls, we attach more weight to transfers at the lower end of the distribution and less weight to transfers at the top.

The decomposition of $I_\gamma(S)$ to "between-group" and a weighted average of "within-group" inequality for any partitioning of the population are desirable

as well. The usefulness of the additive decomposition property of Generalized Entropy measures in this context is discussed in Maasoumi-Zandvakili (1990). For example, Theil's second measure of inequality can be decomposed to:

$$I_{-1} = I_{-1}(S.) + \sum_r P_r I_{-1}(S^r) \tag{3}$$

where P_r is the population share of the rth group, $r = (1, \ldots, G)$. Note that S^r is the rth group's share vector and S is the vector of group means. The first term on the right hand side is the "between-group" component of the measured inequality. The second term is a weighted average of "within-group" inequalities.

To measure stability over a subset of the accounting period M, $M \leq T$ period, the corresponding long-run inequality $I_\gamma(S)$, and a weighted average of short-run inequalities in each period, $\sum_t \mu_t I_\gamma(Y_t)$, is calculated. A measure of stability over the M periods is derived from the following relationship:

$$R_M = I_\gamma(S) \Big/ \sum_t \mu_t I_\gamma(Y_t) \tag{4}$$

Where μ_t is the weight given to earnings at different time periods. If $\sum_t \mu_t = 1$, then μ_t can be replaced by η_t. As M approaches T, the profile generated by R_M reflects changes in the distribution of earnings (stability). The choice of $I_\gamma(S)$ affects the computation of R_M because inequality measures vary in their sensitivity to transfers in the distribution of earnings. Therefore, several inequality measures and aggregation methods were used. For some S_i, the restriction $0 \leq R_M \leq 1$ holds for all convex measures if $\sum_t \mu_t = 1$, where $\eta_t = \mu_t \big/ \sum_t \mu_t$. This restriction holds for other functions, following the propositions 1 and 2 in Maasoumi (1986) such that $-\gamma = (1 + \beta)$. Accordingly, R_M decomposes into the "between-group" and average "within-group" component such that:

$$R_B = I_\gamma(S.) \Big/ \sum_t \mu_t I_\gamma(Y_t) \tag{5}$$

and

$$R_W = \sum_t P_r^{-\gamma} S_{r.}^{1+\gamma} I_\gamma(S^r) \Big/ \sum_t \mu_{tr} I_\gamma(Y_t^W) \tag{6}$$

where $R_M = R_B + R_W$. Group-specific stability profiles are derived from the following expression:

$$R^W = \frac{I_\gamma(S^W)}{\sum_t \mu_{tr} I_\gamma(Y_t^W)} \tag{7}$$

where the earnings share of the ith household in the rth group at time t is Y_{tri} with the relative weights given as μ_{tr}. The value of R^W ranges between 0 and 1.

The "earnings-share matrix" y has a typical element $y_{it} = Y_{it}/\sum_j Y_{jt}$. The composite measure of earnings S^* based on Maasoumi (1986) is "closest" to the $y_t = (y_{1t}, \ldots, y_{nt})$ when:

$$D_\beta(S^*, y; \mu) = \frac{\sum_t \mu_t \sum_i S_i^* \left[(S_i^*/y_{it})^{-\beta} - 1 \right]}{\beta(\beta+1)} \tag{8}$$

It can be demonstrated that $0 \leq R_M \leq 1$ for all S_i when $-\gamma = (1 + \beta)$. For example:

$$I_0(S) = \sum_t \mu_t I_0(Y_t) - D_{-1}(S^*, y; \mu) \leq \sum_t \mu_t I_0(Y_t) \tag{9}$$

The second term in (9) is positive by definition. Long-run inequality, therefore, is less than a weighted average of short-run inequalities, and the measure of stability is between the bounds established for linear type aggregation functions. In the same fashion, it can be shown that:

$$I_{-1}(S) = \sum_t \mu_t I_{-1}(Y_t) - D_0(S^*, y; \mu) \leq \sum_t \mu_t I_{-1}(Y_t) \tag{10}$$

for Cobb-Douglas type aggregation functions. Equations (9) and (10) establish that R_M must be between the bounds established as benchmarks for our measure of stability. This enables the analyst to detect the changes in the size distribu-

tion of earnings over time. This is particularly important in understanding the nature of the observed movements (permanent or transitory).

To find the necessary data to take advantage of the above approach is of major concern in most MENA countries. The approach noted above requires micro data at the individual level for the family or the household. Thus one has to have earnings at the individual, household or family for a sample which is representative of the population under consideration. If the sample is not representative of the population, appropriate weights are needed to make proper adjustments. Furthermore, to use the dynamic framework, one has to have data for the same households over time. This will allow the analyst to measure long-run earnings inequality and income stability to detect chronic permanent earnings inequality, free of transitory components.

To take advantage of the decomposition property of this family of measures, analysts must have information regarding sex, education, age, number of children and ethnicity or any other factor that might be of interest. Once this information is provided, individuals will be coded into different categories based on sex, education, number of children, etc. The coding may have to be based on the analyst's judgment. For example, education may be coded 1 for all without reading and writing ability, 2 for all those with up to a high school degree, and 3 for those with some college education. Using individual characteristics, one may have many permutations of categorical variables.

A limited number of MENA countries such as Iran, Turkey and Lebanon, and Morocco, have micro data sets at this time. Efforts must be made to ensure that all MENA countries collect panel data over time and improve their data gathering techniques for the purpose of economics analysis.

4. STATISTICAL INFERENCE FOR ANALYSIS OF SEX

Researchers generally use measures of inequality to study income and welfare issues. These measures are employed most frequently for dynamic comparisons (comparing inequality measures across time) and for policy analysis (e.g. comparing the redistributive effects of current policy). In most studies, the major shortcoming is the failure to use statistical inference to determine the statistical significance of observed differences in the computed values of a particular measure. It should be obvious that statistical inference is needed with small samples. For example, with decomposition of overall inequality based on sex, one is working with a sample size of two. Even with large samples, however, it is essential to report statistical measures of precision.

The problem in conducting statistical inference for measures of inequality is that all of these measures are nonlinear functions of a random variable (usually wages, income, or earnings). Consequently the interval estimates available from asymptotic theory may not be accurate, and the small-sample properties of these intervals will not be known. Furthermore, decomposable measures of inequality are bounded: For example, the Gini coefficient lies in the [0,1] interval. Thus the application of standard asymptotic results may lead to estimated intervals that extend beyond the theoretical bounds of a particular measure (e.g. a negative lower bound for Gini).

Bootstrapping, an alternative method for computing probability intervals, provides interval estimates drawn from the small-sample distribution. These intervals are superior to asymptotic intervals both theoretically and in a variety of applications. For a detailed discussion see Burr (1994) and Hall (1992). Bootstrap intervals are computationally inexpensive and easy to calculate; the same method is applicable to all the inequality measures used in the literature; and the bootstrap method automatically takes into account any bounds that apply to a particular measure. Also, bootstrap intervals computed by the percentile method have a clear Bayesian interpretation. They provide a straightforward solution to the Behrens-Fisher problem of comparing means from two distributions. Given the advantages from bootstrapping, I find it worthwhile to consider its use in statistical inference for measures of inequality.

Bootstrapping is basically a method for recovering the distribution of a statistic by employing simulation methods to approximate the small-sample distribution. For detailed explanations of the bootstrap, see Efron (1979), Efron and Tibshirani (1993); and Freedman and Peters (1984). The bootstrap provides a numerical approximation to the distribution of interest, F, which is similar to a high-order Edgeworth expansion (an approximation to a distribution function that involves a series expansion around the normal distribution). Edgeworth expansions can represent considerable improvements over normal approximations, and the bootstrap is often superior to a practically calculable Edgeworth expansion. Bhattacharya and Qumsiyeh (1989) show that the bootstrap estimates outperform the short Edgeworth approximation.

Tail probability values for hypothesis tests can be calculated directly from the bootstrap distribution in the same manner as probability intervals. Often, however, we are more interested in comparing different values of an inequality measure, such as inequality for men and for women or for different points in time. The following test is analogous to the comparison of two means from two different samples.

Consider the statistic $D = H_1 - H_2$, where H_1 and H_2 are the two values of the inequality measure (for men and for women) that we wish to compare. The

distribution of D can be bootstrapped in the same manner as is used to obtain distributions for H_1 and H_2. Tail probability values for the hypothesis regarding D can be calculated directly from the bootstrap distribution $f(D)$. A confidence interval thus can be constructed by using the values of D associated with appropriate tail probabilities. Then, by exploiting the relationship between confidence intervals and hypothesis tests, we can conduct a hypothesis test for $D = 0$. Efron and Tibshirani (1993) provide a clear explanation of this approach.

The hypothesis test conducted by using the statistic D involves the comparison of means of two distributions, which has become known as the Behrens-Fisher problem. This is a difficult problem within the classical hypothesis-testing framework, and there is no generally accepted classical procedure for reaching a solution. The Bayesian procedure, however, is straightforward, as shown by DeGroot (1986). The bootstrap performs well for measures of inequality, and it represents an important advantage over the use of asymptotic interval estimates.

An important warning is needed in regard to application of the bootstrap. Because it involves resampling from the original sample with replacements, observations in the sample must be independent if this method is to be valid. This requirement does not necessarily preclude use of the bootstrap method in dynamic settings. If an independent cross-sectional sample for each time period is used to form the bootstrap distribution for that period, the dependence between periods will automatically be taken into account. That is, the bootstrap distribution obtained in a given period is conditional on the data observed in previous periods if the current realizations are statistically dependent on previous realization. For example, one can use the bootstrap for conducting hypothesis tests to compare before-tax and after-tax income inequality measures by first obtaining a bootstrap sample for the before-tax inequality measure, then obtaining a bootstrap sample for the after-tax inequality measure, and only then comparing the two bootstrap distributions. Because each distribution was obtained by using a cross-section sample of individuals, the independence assumption necessary to bootstrapping is not violated. We can use this approach to compare income inequality measures across time as well (Mills & Zandvakili, 1997).

CONCLUSION

In this paper I provide a general framework for the measurement of earnings inequality. I assert that studies regarding earnings inequality based on sex in the MENA region must be supported by sound economic theory, appropriate methodology for measurement and statistical testing. This is particularly important given the dramatic changes we are seeing in the region, particularly in

terms of women's labor force participation. For policy makers to be able to address inequality, they need an accurate understanding of the determinants of income in a dynamic framework. Unfortunately, some of these elements are lacking in the current literature which discusses earnings inequality and poverty. This shortcoming is due to both weaknesses in the empirical analysis and the data available for analysis.

As such, I recommend the use of information theory and the generalized entropy family of measures, combined with bootstrapping, to bring credibility to the claim of gender based earnings inequality in the MENA region. Only then, such findings may be received more favorably and will potentially bring about permanent changes in economic well-being of women in the region.

I also propose collecting panel data for the purpose of earnings inequality measurement and analysis. The use of panel data in conjunction with the latest techniques in earnings inequality measurement and statistical inference can provide an accurate picture of the status of women.

Decomposition is identified as a powerful tool. Measured earnings inequality based on gender and among women needs to be decomposed by individual characteristics. This will allow the analyst to learn about within group and between group differences in economic well being among individuals, as well as their contribution to the overall earnings inequality.

REFERENCES

Aghjanian, A. (1995). A New Direction in Population Policy and Family Planning in the Islamic Republic of Iran. *Asia-Pacific Population Journal, 10*.

Anbarci, N., & Cinar, E. M. (1999). Intra Marital Sharing Rules with Evidence from Turkey. In: *Topics in Middle East and North African Economies, 1*, 1999, electronic journal, www.luc.edu/depts/economics/meea/

Atkinson, A. B. (1970). On the Measurement of Inequality. *Journal of Economic Theory, 2*, 244–263.

Bhattacharya, R. N., & Qumsiyeh, M. (1989). Second Order Lp-Comparisons Between the Bootstrap and Empirical Edgeworth Expansion Methodologies. *Annals of Statistics, 17*, 160–169.

Blumberg, R. L. (1988). Income under Female versus Male Control: Hypothesis from a Theory of Gender Stratification and Data from the Third World. *Journal of Family Issues, 9*, 51–84.

Bourguignon, F. (1979). Decomposable Income Inequality Measures. *Econometrica, 47*, 901–920.

Burr, D. (1994). A Comparison of Certain Bootstrap Confidence Intervals in the Cox Model. *Journal of the American Statistical Association, 89*, 1290–1302.

Cowell F. A., & Kuga, K. (1981). Inequality Measurement: an Axiomatic Approach. *European Economic Review, 15*, 287–305.

DeGroot, M. H. (1986). *Probability and Statistics* (2nd ed.). Addison-Wesley, Reading, MA.

Efron, B. (1979). Bootstrap Methods: Another Look at the Jackknife. *Annals of Statistics, 7*, 1–26.

Efron, B., & Tibshirani, R. J. (1993). *An Introduction to the Bootstrap*. New York: Chapman & Hall.

Fisher, F. M. (1987). Household Equivalence Scales and Interpersonal Comparisons. *Review of Economics Studies, 54,* 519–524.
Foster, J. E. (1983). An axiomatic characterization of the Theil Measure of income inequality. *Journal of Economic Theory, 31,* 105–121.
Freedman, D. A., & Peters, S. C. (1984). Bootstrapping an Econometric Model: Some Empirical Results. *Journal of Business and Economic Statistics, 2,* 150–158.
Hall, P. (1992). *The Bootstrap and Edgeworth Expansion.* New York: Spring-Verlag.
Maasoumi, E. (1986). The Measurement and Decomposition of Multi-Dimensional Inequality. *Econometrica, 54,* 991–997.
Maasoumi, E., & Zandvakili, S. (1990). Generalized Entropy Measures of Mobility for Different Sexes and Income Levels. *Journal of Econometrics, 43,* 121–133.
Mills, J., & Zandvakili, S. (1997). Statistical Inference via Bootstrapping for Measures of Economic Inequality. *Journal of Applied Econometrics, 12,* 133–150.
Moghadam, V. (1991). The Reproduction of Gender Inequality in Muslim Societies. *World Development, 19,* 1335–1349.
Olmsted, J. (1996). Women Manufacture Economic Spaces in Bethlehem. *World Development, 24,* 1829–1840.
Sen, A. (1973). *On Economic Inequality.* Oxford: Clarendon Press.
Sen, A. (1990). *Gender and Cooperative Conflicts in Persistent Inequalities: Women and World Development,* I. Tinker (Ed.). (pp. 123–149). Oxford: Oxford University Press.
Shorrocks, A. F. (1980). The Class of Additively Decomposable Income Inequality Measures, *Econometrica, 48,* 613–625.
Shorrocks, A. F. (1984). Inequality Decomposition by Population Subgroups. *Econometrica, 52,* 1369–1386.
Theil, H. (1967). *Economics and Information Theory.* Amsterdam: North-Holland.

WOMEN, WORK, AND ECONOMIC RESTRUCTURING: A REGIONAL OVERVIEW

Valentine M. Moghadam

ABSTRACT

I examine patterns, problems, and prospects of women's employment in MENA, where the regional political economy is changing in the context of the pressures of globalization. The research indicates that a trend in all countries is an increase in the supply of job-seeking women, and a "feminization" of government employment. It is likely that the opening up of economies may subvert some patriarchal aspects of gender relations by increasing women's economic participation in the long run, but the social terms on which this is done are highly problematic in the short run.

INTRODUCTION

Since the late 1980s, a vast and growing literature situated in the field of women-in-development and gender-and-development (WID/GAD) has addressed itself to the neoliberal economic policy turn and the impact on women of economic restructuring and structural adjustment policies (Standing, 1989; Ward, 1990; Elson, 1991; Afshar & Dennis, 1992; Beneria & Feldman, 1992; Bakker, 1994; Sparr, 1994; Tanski, 1994). This literature is largely critical of the social and gender impacts of restructuring on women, children, the poor, and workers.

Certainly the adverse effects on such groups has been well documented for Latin America and Africa (e.g. Cornia, Jolly & Stewart, 1987). More recently, research on the economic, political, and cultural dimensions of globalization has examined its gender dynamics, with some authors stressing the opportunities as well as the risks involved (Moghadam, 1999a, 1999b; Marchand & Runyan, 1999).

The region of the Middle East and North Africa (MENA) has not figured prominently in the larger debates on women's employment, structural adjustment, and globalization. However, a separate literature dealing with the MENA region has addressed these issues (e.g. Handoussa & Potter, 1991; Karshenas, 1995, 1997; World Bank, 1995a, b; Moghadam, 1998; Khoury & Demetriades, 1998).

The WID/GAD literature and current developments in the MENA region raise a number of questions. How will economic restructuring and globalization in MENA affect women's labor-force participation and patterns of employment? Will economic liberalization in the MENA region increase demand for women workers and job opportunities for women across different sectors? Will the education and training of women receive more attention, and what kinds of jobs are likely to be available to women? How are women's organizations responding to the new economic policies and to the economic status of women?

These questions are the focus of the present paper. I will address them first by discussing the global context; second by describing the characteristics of the female labor force in the region; third by examining recent developments in women's employment; and fourth by analyzing women's responses to the present challenges.[1]

THE GLOBAL CONTEXT

In the current global environment of open economies, new trade regimes, competitive export industries, and expanding services, economic globalization relies heavily on female labor, both waged and unwaged, in formal sectors and in the home, in manufacturing and in public and private services. Around the world there has been a tremendous increase in female professionals, proletarians, and entrepreneurs. Much has been written about the growth of a female working class engaged in export manufacturing (e.g. Joekes, 1987; Ward, 1990), but an additional development has been the growth of the female share of public-service employment (Standing, 1989). The increase in women's employment worldwide is the result of: (1) women's educational attainment, (2) economic need on the part of women, and (3) the demand for (relatively cheap) female labor in export industries and in public-service jobs.

The increasing economic participation of women is good news. After all, access to paid work has been identified in the feminist literature as a basic right and a reflection of women's citizenship (Lister, 1997). In the WID/GAD literature it is seen as helping to raise women's status in the family, and as paving the way for women's social and gender consciousness and self-organization (Kahne & Giele, 1992; Kim, 1997; Moghadam, 1996; Safa, 1996; Tiano, 1994). However, the "feminization of labor" refers not only to increases in the female share of certain occupations and professions; it also refers to the deterioration of employment conditions (labor standards, income, employment status). As Standing explains, the feminization of employment has been occurring in the context of globalization and the pursuit of flexible forms of labor. Feminization, therefore, is often accompanied by, and sometimes preceded by, stagnating salaries or de-unionization. Moreover, the increase in women's employment has not been accompanied by a redistribution of domestic, household, and childcare responsibilities. Indeed, during the 1990s protective legislation for working women came under attack or was streamlined in many countries. Women remain disadvantaged in the new labor markets, in terms of wages, training, and occupational segregation (Anker, 1998). They are also disproportionately involved in the non-regular forms of employment that have increased: temporary, part-time, casual, or home-based work. Such forms of unstable and precarious employment are characterized by low wages and the absence of social security.

In developing countries, women workers include urban dwellers, recent rural migrants, immigrants, and foreign contract workers. They may be young, single women, married women, or women maintaining households alone. Nevertheless, social policies, labor legislation, and the urban infrastructure have not kept up with the large-scale entry of women into urban labor markets, with the differentiation of the female labor force, or with the vicissitudes of women's labor-force entry and exit. Education and training programs for women are not extensive, leaving women workers vulnerable to recession, increasing labor-market competition, and redundancies. Existing legislation providing social protection for women workers tends to be limited in scope and coverage, with benefits reaching a relatively small proportion of the total urban female labor force.[2] At the same time, such legislation, including maternity leave provisions, childcare facilities, and affirmative-action-type programs to encourage the employment of women, have come under scrutiny in the context of the expansion of neoliberal economic policies. As a result, some countries have streamlined or eliminated the entitlements and programs geared to women in the work force. Apart from the harm done to children and families, cutbacks limit women's ability to participate fully in market activities and to compete

fairly with men in the labor market. Meanwhile, unemployment or deteriorating real incomes have forced women in some countries to enter into prostitution.

Along with the growth in female employment, there has been a growth in female unemployment. Economic recession, economic restructuring, and low growth are said to be behind unemployment. Unemployment rates are very high by international standards in Algeria, Jamaica, Jordan, Egypt, Morocco, Nicaragua, Poland, the Slovak Republic, and Turkey (World Bank, 1995a, 1995c: 29; ILO, 1996: 145, 147). Yet although unemployment is high for men, it is often higher for women (see Moghadam, 1996, Figs 7.1–7.4; UN, 1995, Chart 5.13, p. 122). In many developing countries unemployed women are new entrants to the urban labor force (as in Egypt, Iran, Turkey, and Chile, where female unemployment rates have been as high as 30%, compared with 10% for men). In certain countries where restructuring has occurred in enterprises employing large numbers of women, or in export sectors that have lost markets, the female unemployment rates may also reflect job losses by previously-employed women (as in Malaysia in the mid-1980s, Viet Nam in the late 1980s, and Morocco, Tunisia and Turkey more recently).[3] The 1998 financial crisis in southeast Asia is said to have hit women workers especially hard (Ghosh, 1998).

Generally speaking, the situation is better or worse for women depending on the type of state and the strength of the economy. In terms of their economic status, women workers in the welfare states of northern Europe fare best, followed by women in other strong Western economies. In Eastern Europe and the former Soviet Union, the economic status of working women changed dramatically and for the worse following the collapse of communism (Einhorn 1993; Moghadam, 1993a). In much of the developing world, a class of women professionals and workers has certainly emerged, but vast sections of the female economically active population in the developing world lack formal training, work in the informal sector, have no access to social insurance, and are impoverished (UN, 1995). Increasing poverty among women in the developing world is said to be associated with structural adjustments (Meer, 1994).

The effects of economic globalization and its concomitants have not been lost on women's organizations around the world. Local women's groups and transnational feminist networks have turned their attention to economic policy issues, criticizing downsizing, restructuring, poverty, growing income gaps, and increasing pressures on women.[4] At the same time, women in many countries are seeking better representation in trade unions, or are building their own unions (Martens & Mitter, 1994). In a number of advanced industrialized countries, especially the United States, Australia, and the Nordic countries, women have been the largest growing union constituency (Eaton, 1992; Hastings & Coleman, 1992). In Taiwan the Grassroots Women Workers Centre, established

in 1988, engages in various activities, including defense of the rights of immigrant women workers, and publishes a newsletter called *Female Workers in Taiwan*. According to its Spring 1994 newsletter: "The Centre intends to provide opportunities for factory women and family subcontractors to reform the male-dominated workers' union, and to develop women workers' unions and workers' movements through the promotion of feminism".[5] In Guatemala, women workers at an export shirt-making factory won a union contract, the first in a Guatemala *maquiladora*.[6] In India, the Working Women's Forum and the Self-Employed Women's Association (SEWA) operate as trade unions and as consciousness-raising feminist organizations.

THE SITUATION IN THE MIDDLE EAST AND NORTH AFRICA

The MENA region has encountered economic crises, economic restructuring, and the challenges of a global economy with its own distinct features. One feature, of course, is the centrality of oil to such countries as Algeria, Iran, Iraq, Libya, Saudi Arabia, and the Gulf sheikhdoms. Another distinct feature pertains to the structure of the female labor force.

One of the longstanding labor-force characteristics in countries of the Middle East and North Africa has been the low rates of female labor-force participation, compared with other regions in the world economy, and compared with male participation rates.[7] A second, related characteristic, again relative to other regions and to men, has been the limited access of women to wage employment. Women generally constitute a small percentage of the total salaried work force in these countries.[8] A third feature is that female non-agricultural employment has been concentrated in the public sector, mostly in professional jobs. In addition, women have been conspicuously absent from certain occupations, especially in private sales and services, at least according to official statistics for wage employment (Doctor & Khoury, 1991; Moghadam, 1993; Anker, 1998).[9]

These characteristics are a result of both political economy and culture. That is, the nature of the regional economy and its place in the world-system, along with development strategies and state policies of particular countries, help to explain patterns of women's employment (and non-employment) in the region. Apart from the generally small size of the employee class in the countries of the region, capital-intensive technologies and relatively high wages for men during the oil era precluded a deeper involvement of women in the labor force (Moghadam, 1993b, ch. 2; Karshenas, 1997). Within the region, a comparison of women's employment across oil and non-oil economies, labor-poor and labor-

surplus countries, and rich and poor countries indicates that generally, the more open the economy and the less dependence on oil revenues, the greater women's involvement in the labor force. Thus the differences between Tunisia and Morocco, on the one hand, where in 1990 women comprised 22–30% of the work force, and Algeria and Iran, on the other, where women comprised about 10% of the work force. State policies – including attitudes of state managers and the legal framework – have also been important in explaining differences in women's access to paid work.

Culture also matters. The region has been characterized by what I call a "patriarchal gender contract", a set of relationships between men and women predicated upon the male breadwinner/female homemaker roles, in which the male has direct access to wage employment or control over the means of production, and the female is largely economically dependent upon male members of her family. The patriarchal gender contract also determines the occupations and professions that are considered suitable for women. During the oil boom, the patriarchal gender contract was made possible and indeed financed by the regional oil economy, the wealth of the oil-producing states, and high wages. (Although Turkey was not strictly speaking a part of the regional oil economy, other features described here, such as the limited access of women to paid employment, apply to that case as well.) The patriarchal gender contract is also codified into law, especially in the region's family laws. Currently, family laws in many countries require women to obtain the permission of fathers or husbands for employment, seeking a loan, starting up a business, or undertaking business travel. Women also inherit a smaller portion than men.

Both political economy and culture have resulted in women's limited participation in paid employment, and in the rather large gender gaps in literacy and educational attainment that exist across the region. In a cross-regional study of gender and jobs, Anker notes the following about his six sample countries from MENA: "the female share of non-agricultural employment is small", although it has been increasing, and "the number of years of schooling is low for both men and women in this region" (Anker, 1998: 145). Table 1 gives some indication of the cross-regional differences in women's occupational activity and the under-representation of MENA women in nearly all occupation groups. Table 2 illustrates the problems in the area of educational attainment, compared with other countries that are at similar stages of economic development or at similar income levels.[10]

As in other regions, MENA has turned from the previous economic development strategy of import-substitution industrialization to export-led growth, as a way to balance budgets and increase competitiveness. In the post-oil boom era, wages have eroded, especially in the public sector, and men have been

Table 1. Women's Share in Major Occupational Groups, 1990, by Region.

	Prof./Tech. & related	Admin./ manag.	Clerical & service	Sales workers	Production workers
Developed countries					
Western Europe	50	18	63	48	16
Other	44	32	69	41	22
Eastern Europe	56	33	73	66	27
Developing countries					
Sub-Saharan Africa	36	15	37	52	20
Oceania	41	18	52	53	17
Latin America	49	23	59	47	17
Caribbean	52	29	62	59	21
Eastern Asia	43	11	48	42	30
Southeast Asia	48	17	48	53	21
Southern Asia	32	6	20	8	16
Western Asia*	37	7	29	12	7
North Africa	29	9	22	10	10

* Western Asia refers to the Middle East.
Source: UN, The World's Women, 1995: Trends and Statistics, Chart 5.16.

taking on second and third jobs in the private sector and in the informal economy (World Bank, 1995b). Low productivity and inefficiencies pervade the labor markets (Karshenas, 1995). Unemployment has been growing in the MENA region (Shaban, Assaad & Al-Qudsi, 1995; ERF, 1996), the result of rapid growth of the labor force caused by high fertility rates, combined with poor economic growth. Countries have adopted structural adjustment policies, often with World Bank and IMF assistance, in order to rejuvenate growth. The World Bank's evaluation and recommendations for the Arab region (World Bank, 1995b: 15–18) emphasize the need for new policies:

> ... [T]he system inherited from the past – a dominant public sector, protected industry, bias against agriculture, distorted education system, unenforced labor standards – has become increasingly costly and unsustainable, benefiting a shrinking minority at the expense of the majority of workers.... What is needed now to benefit broader segments of the population, to fully utilize and expand human potential, and to stabilize social tensions is a set of policies that reduces dualism, equalizes opportunities, and relies on markets for the things they do best – encouraging investment and productivity growth. There is also an important role for governments in regulating markets, protecting the vulnerable, and improving working

Table 2. Mean Years of Schooling, 25+, early 1990s, by Sex and Country.

MENA country	males	females	Other developing countries	males	females
Algeria	4.0	0.8	Argentina	8.5	8.9
Egypt	3.9	1.9	Chile	7.8	7.2
Iran	4.6	3.1	China	6.0	3.6
Iraq	5.7	3.9	Colombia	6.9	7.3
Jordan	6.0	4.0	Malaysia	5.6	5.0
Kuwait	6.0	4.7	Mongolia	7.2	6.8
Lebanon	5.3	3.5	Philippines	7.8	7.0
Libya	5.5	1.3	Sri Lanka	7.7	6.1
Morocco	4.1	1.5	Thailand	4.3	3.3
Saudi Arabia	5.9	1.5	Viet Nam	5.8	3.4
Tunisia	3.0	1.2	Uruguay	7.4	8.2

Source: UNESCO, Education for all: Status and Trends, 1994. Paris, UNESCO, 1994.

conditions when markets fail. [p. 15] ... Education is the main way workers increase their productivity and incomes. ... The quality of education must also be upgraded to the demands of the twenty-first century. The emphasis needs to shift to cognitive skills and computer literacy [p. 18].

The global context, the changing regional political economy, the WID/GAD critique, and the World Bank's recommendations raise a number of questions. Will economic liberalization increase the demand for women workers and expand job opportunities for women across different sectors? Or will women face marginalization? What kinds of jobs are likely to be available to women – stable waged work or jobs in the informal sector such as homeworking? Will the education and training of women receive more attention? In the long term, how will economic liberalization affect women's position in the labor market, their social and legal status, and the system of gender relations?

Let us imagine a positive scenario in which economic liberalization and restructuring lead to more employment opportunities for women. Structural reforms result in fiscal changes and the mobilization of domestic resources, through such measures as expanding the tax base and making taxation more efficient. Governments may reason that in order to increase the income-tax-paying population, policies would be needed to increase the size of the female labor force. Countries focus on making their labor forces more qualified, partly by raising education and skill levels. There is thus increased attention on education,

vocational training, and skills-upgrading for women. There is a rising demand for women in the labor-intensive textiles and garments branches that are geared for export. Women's numbers increase in such expanding occupations as banking, insurance, accounting, computing, and so on (which are indeed becoming feminized internationally). The expansion of tourism breaks down cultural proscriptions against women's employment in sales and services occupations. As governments relinquish control over economic enterprises to focus on expanding and upgrading health, education, and social services, this enhances the participation of women in the social sectors. The emphasis on private-sector development leads to support for women-owned or managed businesses.

A more negative scenario, however, is equally plausible. Here, stagnation continues, investments do not increase, inequalities widen and poverty grows, women face marginalization from paid work, and informal-sector work grows. In addition, women continue to face the current constraints in access to paid employment. High population growth continues, causing further pressure on labor markets and limiting women's ability to seek wage employment.[11] High illiteracy, especially among rural women and older age groups continues, also limiting women's access to wage work. Large educational gaps between men and women persist, with women and girls experiencing inferior education and training and thus failing to be prepared for modern-sector jobs. High male unemployment (especially of young men), acts as a disincentive to hire women. A widespread perception of women as less reliable workers, coupled with a tendency to regard men as the real breadwinners and women as secondary earners only further weakens women's employment choices.[12] Provisions in labor legislation are unchanged. Women continue to be prohibited from night work (interpreted in some places as inability of women to apply for second-shift jobs in the industrial sector) and the cost of maternity leaves continues to be borne entirely by employers.[13] Infrastructural deficiencies (such as poor roads and public transportation) result in lengthy travel time. Social policies to help women balance wage work and family responsibilities remain inadequate. A lack of gender sensitivity and gender awareness on the part of government officials and planners, and absence of integration of a gender dimension in economic policy-making persists.[14] There continues to be an absence of influential women's organizations, including those that may focus on the problems of women in the labor force.

SOME RECENT TRENDS, PROBLEMS, PROSPECTS

Let us now examine some of the ways that economic restructuring in countries of the MENA region has been affecting women's employment during the 1990s. As we shall see, aspects of both the positive and negative scenarios have occurred.

Women and Poverty

Poverty and inequality in the region remain serious problems and have been increasing in some areas. According to a 1994 official report on the Arab region (ESCWA, 1995a):

> Despite the lack of accurate gender-disaggregated data on poverty in the Arab States consistent with the indicators adopted by the United Nations Commission on the Status of Women, it is obvious that the effect of global economic recession combined with structural adjustment policies and programs in some Arab States, the transition to a market economy and the associated shrinking in the role of the public sector in creating job opportunities and providing social services, as well as the exacerbation of the problem of foreign debt and its servicing and the dwindling of revenues and financial resources for development, have undermined the capacity of Governments to provide for the basic needs of their populations, and as such have undermined anti-poverty initiatives, especially those benefiting women and children (p. 15).

In Egypt, Iran, Jordan, and Syria, poverty increased during the 1990s, in part due to the sharp decline in wages when these countries underwent large adjustments. In Morocco and Tunisia, the growth in inequality and urban poverty was due largely to an increasing number of low-wage jobs in the booming export sectors (World Bank, 1995b). In Egypt, wages fell drastically, especially in sectors where women predominate, such as textiles and garments and the government sector (World Bank, 1991). What this suggests is that the category of "working poor" has increased in Egypt since the onset of the structural adjustment program. There has been a decline in school enrollments among girls and an increase in drop-outs in Egypt and Morocco, and this is attributed to the introduction of user fees and growing pressures on low-income families. In Jordan, poverty has increased since economic reforms began in the early 1990s (World Bank, 1994a; Khuri-Tubbeh, 1996), and a trend noted by researchers is the growing visibility of poor women (El-Solh, 1994).

Despite Morocco's high and labor-intensive pattern of growth, "not enough of this income has been channeled into categories of public spending – basic healthcare, schooling and essential infrastructure services – that improve the well-being of the poor" (World Bank, 1994b, Vol. II, Table 74).This low level of funding is partly linked to the macroeconomic adjustment and stabilization policies of the 1980s. During 1984–89 employment in the export sector expanded by 25% a year while real wages declined by 2.6%. It was during this period that female employment in the industrial sector saw a dramatic increase. The most competitive sectors – clothing, food, leather, shoes – had low and declining capital intensity and offered very low wages. These were also the sectors where women were concentrated. Women represent one-third of wage-

earners among the poor compared to 25% for the whole urban population. Poor females get as little as half the wage rate per hour earned by poor males (World Bank, 1994b).

Tunisia has spent more on poverty-reduction programs, but as in Morocco, there has been a growth in temporary, low-wage and low-skill employment (World Bank, 1995d). One-half of all new jobs in textiles and in tourism created in 1985–90 were of this nature. Moreover, in these two sectors, wages for temporary workers fell more than did wages for permanent workers. Thus the labor market in tourism and textiles – the latter being predominantly feminized – has become characterized by increasing flexibility.

Women and the Informal Sector

Little systematic work has been done on women's roles in the informal sector in the MENA region, and on the relation between the formal and informal sectors, but good ethnographic studies offer important insights. Lobban (1998) notes that women are involved in: small-scale retailing of food and clothing; weekly markets and street sales; household and domestic sales and services; informal or illegal sexual services; loan pools and cooperatives; and "the survival economy". Early (1998) found that women in Cairo were engaged as vendors, merchants, midwives, seamstresses, tattooers, bread bakers, henna appliers, and bath attendants. In Tunisia, surveys conducted in 1989 and 1991 found that the informal sector employed nearly 35% of total urban wage earners. About half of the informal sector workers (mainly apprentices and *aides familiaux*) had a salary significantly lower than the minimum wage (World Bank, 1995d). The types of informal-sector work encountered by Berry-Chikhaoui (1998) seemed to represent three forms of responses: to poverty, to traditions and food needs, and to modern aspirations. In each category women were a minority, but they were most represented in the second category, which consisted of: small-scale food production; seamstresses; public baths; hairdressers; small-scale metal work, textiles, and leather; artisanal crafts; potters, scribes; street food sales. Lobban (1998) states that "Tunisian women in the invisible economy are deeply involved in crafts and small industries, which rely heavily on young women and low wages to sustain them (p. 31)."

These and other ethnographic studies on women in the informal sector, along with small-scale surveys such as that conducted by Khuri-Tubbeh in Amman in 1993 (see Khuri-Tubbeh, 1996), suggest that increasing inequalities, growing unemployment among men, rising prices, and household survival strategies may be propelling more women into informal-sector work and self-employment.

Women in Manufacturing

Among countries prioritizing exports of manufacturing, and especially textiles and clothing, official statistics indicate a relatively large proportion of the female labor force in the manufacturing sector. In this respect, Tunisia and Morocco stand out. Indeed, in a region where women are greatly underrepresented in production occupations, they are disproportionately represented in the manufacturing sector in Tunisia (Anker, 1998). According to the census most of the female labor force in Tunisia was located in manufacturing in 1989, with women making up 43% of the manufacturing work force (ESCWA, 1995b; Moghadam, 1998). In Morocco in 1991, fully 37.4% of the manufacturing work force was female (ILO, 1994). Given these numbers, it could be argued that the recruitment of cheap female labor in the export sector has contributed to the competitiveness of Moroccan and Tunisian garments industry. The figures also suggest an important role for women workers in the manufacturing sector in Turkey (25% female in 1992) and Egypt (17.6% in 1989). Jordan's manufacturing sector absorbed about 35% of female recruitment between 1988 and 1990 (Khuri-Tubbeh, 1996).

But the data show disconcerting trends as well, such as declines in women's involvement in manufacturing, a high incidence of non-regular and non-salaried activity among women in this sector, and a wide gender gap in earnings. For example, in Tunisia there was a registered decline in women's share of manufacturing between 1984 and 1989, from 48% to 43% (Moghadam, 1998). Nearly half the women in Tunisia's manufacturing sector in 1989 were non-salaried (that is, unpaid family workers or own-account workers in the informal sector). In Syria, between 1981 and 1991 the share of female labor in manufacturing, electronics, construction, trade, finance, and community services decreased, while their share of agriculture increased. According to Alachkar (1996): "If we remember that the process of economic liberalization has led to increasing the role of the private sector in manufacturing, we will deduce that this liberalization has negative effects on women's participation in the labor force [in Syria] (p. 107)." In Turkey, the decline in real wages in manufacturing helped raise the competitiveness of Turkey's exports in the 1980s (Hansen, 1991; Karshenas, 1995), but it also widened the gender gap in earnings. According to Kasnakoglu and Dayioglu (1996), women on average earn 60% of male earnings. In Egypt, women's access to paid employment has actually decreased over the years. Whereas their share of paid employment in manufacturing was 8.8% in 1989 and 12.2% in 1990, it was 7.7% in 1994 (ILO, 1996, Table 2F).

Women in Sales and Services

As mentioned above, a characteristic of MENA labor markets has been the low participation of women in sales and services occupations. This is certainly due to political economy and culture, but it may also be a methodological matter. There has been a longstanding problem with measuring sales and services activities, indicating the need for improved enumeration methods and labor-force surveys. Much economic activity in this sector (and in agriculture) is unrecorded (Anker, 1995). For example, according to official statistics, in Tunisia women are strikingly underrepresented in the service sector, despite the importance of tourism. Different methods of enumeration, however, yield different results. In Egypt, the female share of employment in trade, restaurants, and hotels was only 7.3 according to the 1986 census but 17.7 according to the 1989 Labor Force Sample Survey (ILO, 1994; Moghadam, 1998).

In the long run, economic liberalization and current policies that prioritize expansion of the tourism sector could lead to increases in the demand for and supply of female labor in trade, restaurants, and hotels. Tourism is a mixed blessing for countries, cultures, and women. But it is a sector that could promote women's employment. Already hotel management schools are training young women in a number of MENA countries, women employees are seen in the large hotels of Turkey, Tunisia, and Egypt, and a trend in Turkey is the hiring of young women in the trendy cafes of Istanbul and Ankara. In Jordan, young women are now working in the upscale Safeway supermarket in Amman.[15] Can it be long before the Filipinas imported to work as waitresses in Jordan (because this occupation is considered inappropriate for Jordanian women) are eventually replaced by nationals?

In other services, some countries indicate a growing proportion of women. For example, in Morocco in 1991 some 32% of those employed in finance, insurance, real estate, and business services were women, while in Tunisia in 1989 the figure was 30% (ILO, 1994; Moghadam, 1998: 66). In Turkey, the female share increased from 25.8% in 1980 to 29.3% in 1990 (UN, *WISTAT*).

Women and Public Services

In most countries of the region, women's share of salaried employment steadily increased between 1970 and 1990 (See Table 3). This share is expected to grow further, mainly due to women's growing share of public-sector employment. Women continue to seek employment in the government sector, despite low incomes, because of job security and the availability of social insurance. Mona Said (1998) points out that in Egypt this is the preferred sector for women in

Table 3. Female Share of Total Employees, Selected Countries, 1970–90.

Country	1970	1980	1990
Algeria	5	8	10
Egypt	9	9	16
Iran	15	12	10
Iraq	N/A	8	11
Jordan	N/A	9	10
Kuwait	8	14	21
Morocco		18	25
Syria	10	9	15
Tunisia	6	15	17
Turkey	14	15	18

Sources: UN, WISTAT CD-ROM, 1994.
Notes: Egypt's female share was 17.7% in 1990, according to the ILO (see ILO, 1996, Table 2E).
On Lebanon, see Al-Raida, special issue on Women in the Labor Force (vol. XV, no. 82, summer 1998), which reports that women's share of employment is 20% (p. 16).
According to Iran's Statistical Yearbook 1375/1996, women are now 12% of the salaried population. See Table 3.4, p. 74, and Table 3.9, p. 81.
Khuri-Tubbeh (1996: 81) reports that Jordanian women's share of the employed population was 11.2% in 1993. The Jordanian Coordinating Office (1995: 19) reports that it was 15%.

part because gender-based earnings discrimination is low at all wage quintiles.

The public sector – especially government employment – has seen both a stabilization of recruitment and a feminization of employment. For example, in Syria, the female share of government employment increased from 18.7% in 1980 to 26.9% in 1992 (Alachkar, 1996). In 1994 in Turkey, women represented 35% of all public-sector employees (UNDP-Ankara, 1996: 54–55). The proportion of women in the government sector in Iran reached 31% in 1991 (Islamic Republic of Iran, 1995). In 1995 38.6% of permanent contract employees in the government sector (that is, those subject to labor law and social security) were women (Islamic Republic of Iran, 1997). In Jordan, while most men (60%) are in the private sector, among women 55% are in the government sector compared with 41% in the private sector (Khuri-Tubbeh, 1996).

It appears that as men gravitate toward the expanding and more lucrative private sector, more jobs in the public sector are available to women. Thus, although the concentration of the non-agricultural female labor force in public-sector professional jobs is in keeping with a pre-existing trend, one may conclude that economic liberalization, restructuring, and privatization have led to the feminization of public-sector employment.

Women-owned Businesses

In Jordan, women-owned businesses still represent a tiny proportion of the total, but there has been a relative increase in the numbers of women business owners – from 211 in 1979 to 250 in 1985 and to 1,043 in 1991 (Jordan Coordinating Office, 1995). In Egypt, women-owned businesses are growing, but many potential owners are blocked by the reluctance of banks to lend to women. Throughout the region, there is a great need for services and establishments that are owned and operated by women and that cater to women. However, women's entrepreneurship faces financial and legal obstacles.

If self-employment among women is to be encouraged, the modernization of Family Law, particularly with respect to inheritance and the right to travel without permission of a male family member, could assist women's ability to start up and manage a business. Training programs and credits for women should be enhanced, and should not be limited to traditional types of self-employment (e.g. garment-making or carpet-weaving). Some types of women-run businesses that could be especially socially useful as well as culturally appropriate are childcare centers, nursery schools, and kindergartens for the children. Also very useful would be women-owned and managed cafés, restaurants, health clubs, bookstores, and transport services.

Women and Unemployment

Table 4 includes estimates of unemployment rates for men and women in various MENA countries. High rates of unemployment among women in the MENA region, indicate that the supply of job-seeking women is growing, but women are encountering barriers to their participation. Unemployed women appear to be mainly new entrants (with secondary school education, as well as poorer women with only primary school education), but also some previously employed women who have lost jobs with enterprise restructuring or privatization, especially in Jordan, Morocco, and Tunisia (World Bank, 1995b). In Turkey, the vast majority (63%) of registered unemployed women are in the age group 15–24 (ILO, 1996, Table 3B). It appears that the most vulnerable persons in the labor market are women with incomplete education, although in Jordan educated women, and especially graduates of community colleges, also experience high levels of unemployment. Although in absolute numbers more men are unemployed, the rate of female unemployment is much higher, and disproportionately high, given women's smaller share of the labor force. Clearly there has been a feminization of unemployment in the region.

Table 4. Unemployment Rates by Sex, Various MENA Countries.

Country	Year	Male	Female	Total
Algeria	1992	24.2	20.3	23.8
Bahrain	1991	5.5	13.4	6.8
Egypt	1995	7.0	22.1	10.4
Iran	1991	9.5	24.4	15
Iraq	1987	4.3	7.4	5.1
Jordan	1991	14	35	18.8
Morocco	1992	13	25.3	16
Oman	1993	4.7	8.7	5.1
Syria	1991	5.2	14.0	6.8
Tunisia	1993	14.7	21.9	16.1
Turkey*	1993	8.2	7.2	7.9
Yemen	1991	14.0	6.0	12.3

* Urban unemployment in Turkey in 1994 was 19.8% female and 9.1% male (SIS, 1996).
Sources: World Bank (1995b), p. 5; ERF (1996), p. 103; ILO (1996), Table 3A; Moghadam (1998), pp. 57, 118, 138, 147, 168, 183.

RETHINKING SOCIAL POLICIES FOR WORKING WOMEN

As in other regions, there has been an ongoing debate in MENA countries concerning the need for social policies for working women. As mentioned previously, the vast majority of economically active women do not benefit from employment-related social insurance programs or labor legislation. However, the small numbers of women who are employed in the formal sector and are entitled to maternity leaves and childcare benefits have to confront widespread perceptions that they are less reliable than men, uncommitted to their work, and "expensive labor". According to the World Bank (1995b):

> Regulations intended to protect women have backfired in many countries, and now constrain many young, educated women seeking jobs in the formal private sector. In the past mandates such as low retirement age and generous maternity benefits encouraged women to stay in school and to work in the public sector, where these advantages are well enforced. . . . But these advantages are costly, and reduce the demand for women's labor in the private sector (p. 17).

This is especially the case in Egypt, where female public-sector employees have taken full advantage of the generous and lengthy maternity benefits available to them (three months' paid maternity leave and up to two years unpaid maternity leave, available up to three times, with no loss of seniority). Interviews conducted during fieldwork in Egypt in January 1995 confirmed that employers are very much opposed to lengthy maternity leaves. Moreover, a government study states: "...there seems to be implicit discrimination against female employment, especially in the private sector, mainly because of women's work discontinuity due to childbearing and rearing" (cited in Moghadam, 1998: 111). Private-sector employers circumvent the labor law that requires crèches and nursing breaks in enterprises with 100 or more women workers by deliberately hiring fewer than 100 women. Although Egypt has an anti-discrimination law, it is apparently not enforced, and compliance is not monitored. The labor law has been revised and unified to bring the public-sector benefits in line with private-sector benefits. For women this will mean the reduction of unpaid maternity leave from two years to one year, which can be taken twice instead of three times, and will be available to woman employees only after 10 months of service.

In Iran, women represent a very small part of the salaried work force, with most employed in the government sector. Labor legislation on maternity leave follows the ILO minimal recommendation of 12 weeks leave at two-thirds pay (Moghadam, 1998: 170). Currently, only employed women in urban areas and government employees are covered, which means that the majority of working women have no coverage. Another problem is that a maternity leave of three months is insufficient, and is in the interest of neither the baby's health nor the mother's labor-force attachment.

A better solution for both Egypt and Iran would be to extend maternity leave to six months and entitle women to take it at full pay twice in their career. This may encourage more women to enter and remain in the labor force. Maternity leave could also be financed through contributions from employer, employee, and general revenues.

Certainly the need for appropriate social policies for working women has not been lost on women's organizations in the region. For example, the Jordanian National Committee for Women (1993) forwarded the following economic demands: "Increasing the participation of women in the labor force, and guaranteeing that they are not discriminated against in employment in all spheres and sectors of work. Extending the necessary assistance to encourage women's entry and continued participation in the labor market by encouraging and developing support services." In the same document, they specify the need for:

> Making available the necessary support services to working women, and in particular encouraging the establishment of nurseries and kindergartens that are to be provided with improved

levels of supervision. These facilities would encourage women to opt for and continue in the job market, making use of the various legislative provisions contained in the Labor Law.

RESPONSES BY WOMEN'S ORGANIZATIONS

Women's organizations and feminist groups around the world are criticizing the negative aspects of economic restructuring and globalization, pushing for greater social spending, and urging more participation and democratization. Since the Fourth World Conference on Women (Beijing, September 1995), women's organizations have called for the implementation of the Platform for Action, a comprehensive document addressing women's poverty, work, health, participation in decision-making, and other issues. As part of this global trend, women's organizations have proliferated in the MENA region (Moghadam, 1999c). Although these groups place a greater focus on the modernization of family laws, they are also attentive to economic and employment issues, such as the adverse effects of structural adjustment and women's rights to employment and income. They are calling on governments that have not done so to sign, ratify, and implement the earlier Convention on the Elimination of All Forms of Discrimination Against Women, and to implement the Beijing Platform for Action. In various countries, women have formed organizations to defend the rights of working women. For example, in Israel, Arab women workers ignored by the Histadrut formed the Arab Women Workers Project, while in Palestine, the Working Women's Society was formed to support and promote women's economic and social rights.

Moroccan and Tunisian women's organizations are especially active in the field of women's socio-economic status and rights, no doubt due to the relatively large proportion of working women in the two countries. In 1995, a Roundtable on the Rights of Workers was organized by the Moroccan Democratic League of Women's Rights, and a committee structure was subsequently formed, consisting of 12 participating organizations. The objective was to revise the labor code to take into account women's conditions, to include domestic workers in the definition of wage-workers and to delineate their rights and benefits, to set the minimum work age at 15, and to provide workers on maternity leave with full salary and a job-back guarantee. In a highly publicized incident, Moroccan feminist groups came to the assistance of factory women who went on strike over sexual harassment.[16] More recently, the new socialist government and women's organizations worked to formulate a National Action Plan for Women and Development (although in Spring 2000 it met with the opposition of Islamic groups).

In Tunisia, the National Commission on Working Women was created in July 1991 within the Tunisian General Federation of Workers. More recently,

Tunisian women's organizations have been centrally involved in a national action plan to implement the recommendations of the Beijing Platform for Action. Tunisia's national action plan involves partnership among the Ministry of Women and Family, several other ministries, and 11 women's organizations. Among the latter are CREDIF, the Tunisian Association of Democratic Women, the National Chamber for Women Heads of Enterprises, the National Commission of the Working Woman, the National Federation of Tunisian Women Farmers, the Tunisian Association for Mothers, and the Tunisian League for Human Rights (WEDO, 1998).

Women's rights organizations (e.g. the Jordanian Women's Union), women's research centers (e.g. the Center for Research, Study, and Documentation of Information on Women, or CREDIF in Tunisia), and women's studies institutes (e.g. Institute for Women's Studies in the Arab World, Lebanon) conduct research and produce position papers on women's issues, including economic and employment issues. The activities of these and other types of women's organizations could expand as economic restructuring and political liberalization proceed in the region. In addition, worker-based and grassroots women's organizations, which are not very prevalent in the region to date, may grow as economic liberalization and further capitalist development draw more women into the workforce.[17]

CONCLUSION

This paper has reviewed issues pertaining to women and employment in an era of economic restructuring. By situating the changes in the region in a comparative and a global context, we have seen similarities and differences across countries in the region, and between the MENA region and other regions. We have also seen that aspects of both the positive and negative scenarios outlined above are being realized in the region. Women are seeking jobs, and they are making gains in access to paid work, but their unemployment rates are very high, their wages are low, and social policies for working mothers are limited and under attack. Poverty, incomplete education, and illiteracy among women make the informal sector the sole recourse for many women seeking to supplement household incomes. It is likely that the opening up of economies may subvert some patriarchal aspects of gender relations by increasing women's economic participation in the long run, but during the 1990s, the social terms on which this was done have been highly problematic.

At present, the women's organizations in the countries of the region are not very influential. The focus of their work is revision of family laws, which is important, but more attention needs to be directed to the problems and prospects

of women and work. Given the challenges of the changing political economy, however, the women's organizations may come to realize the need to forge alliances with other social groups and articulate the interests and needs of working women. In doing so, women's organizations and working women will be challenging the patriarchal gender contract in fundamental ways.

NOTES

1. This paper draws on research described in Moghadam (1998). In addition to examining the relevant secondary sources, I undertook research travel to Algeria, Morocco, Tunisia, Egypt, Iran, Jordan, and Turkey in 1990, 1994, 1995, and 1996, where I obtained official statistics on women's employment and interviewed statisticians, government officials, enterprise managers, working women, and women activists.

2. For a description of existing maternity leave benefits, see UN (1995), Table 10, p. 137.

3. According to ILO researcher Lin Lean Lim, more than half the total number retrenched between 1983–85 were from the two most feminized industries, electronics and textiles, while in administrative services the largest employment cuts were among clerks, another feminized occupation. See Moghadam (1995) for details. In 1991 and 1992 in Vietnam, "more than 8,000 people had to leave their jobs in state enterprises and organs, and 60% of them were women (p. 50)" (Li Thi, 1995).

4. Transnational feminist networks focusing on women's economic status include: DAWN (Development Alternatives with Women for a New Era), in which prominent women such as Gita Sen and Peggy Antrobus have written strong critiques of structural adjustment; WIDE (Women in Development Europe), which is based in Brussels, and consists of 12 national women's organizations that monitor the European Union's development assistance and trade relations with developing countries; and WEDO (Women's Economic and Development Organization), based in New York and with branches in Africa, Asia, and Latin America.

5. Information on women workers' group activities comes from various newsletters that are received by the author.

6. The Guatemala workers' union contract was won at the Camisas Modernas Phillips-Van Heusen plant in 1996. Early in 1999 Phillips-Van Heusen closed the factory. Both the union contract and the closing of the plant have been highly publicized.

7. The female share of the total labor force in various regions in 1995 was as follows: 17% in the Arab region, 37% in Sub-Saharan Africa, 24% in South Asia, 25% in South Asia, 43% in East Asia, 37% in Southeast Asia, and 27% in Latin America and the Caribbean. The average for all developing countries was 35%. See UNDP (1995), Table 39, p. 216.

8. However, because women's informal-sector, home-based work, and agricultural work is generally undercounted, a higher proportion of the measured female labor force are employed in the wage sector.

9. Indeed, according to Anker (1998) "women's share of employment in [the professional and technical group] is two and a half times their share in the non-agricultural labor force. Turkey, an OECD member, follows the typical pattern of Middle Eastern countries where a large proportion of working women are in a professional or technical

occupation. . . . Social and cultural factors do ensure that most adult women in the Middle East and North Africa region do not work in the non-agricultural labor force, but for the relatively few who do, an unusually high percentage (by world standards) have a professional or technical job (often teacher or nurse) (p. 164)."

10. The World Bank's (1995b) figures for mean years of schooling for Arab countries are higher, but they include all age groups in their estimates, not just the population aged 25 and above, as UNESCO does. In 1995, mean years of schooling as reported by the World Bank were 6.37 in Algeria, 6.23 in Bahrain, 5.90 in Iraq, 7.05 in Kuwait, 6.66 in Syria, and 4.22 in Tunisia. The authors also note that the majority of women are still illiterate in Algeria, Egypt, Morocco, and Saudi Arabia.

11. Among Arab countries, the population growth rate for 1992–2000 is, at 2.9% per annum, the same as in Sub-Saharan Africa, and higher than that of South Asia (2.5). The total fertility rate is 4.8 for the Arab countries, 3.4 in Turkey and 5.0 in Iran. These rates are of course considerably higher than those of Latin America and Southeast Asia (UNDP, 1995).

12. I have discussed this at length in Moghadam (1998). See especially the chapters on Egypt and Jordan.

13. See Moghadam (1998), especially chapters on Egypt and Jordan.

14. This is discussed at length in Moghadam (1998); see especially chapters on Egypt, Jordan, Algeria, Iran.

15. Personal observations. For details, see relevant chapters in Moghadam (1998).

16. This is described in detail in Moghadam (1998).

17. Seven types of women's organizations may be identified in the MENA region. These include: service organizations; professional associations; development research centers and women's studies institutes; women's rights organizations; development and women-in-development NGOs; women's organizations affiliated to political parties; and worker-based and grassroots women's organizations. For more discussion of these different types of women's organizations see Moghadam (1998).

REFERENCES

Afshar, H., & Dennis, C. (Eds) (1992). *Women and Adjustment Policies in the Third World*. London: Macmillan.

Alachkar, A. (1996). Economic Reform and Women in Syria. In: Khoury & Demetriades (Eds), *Structural Adjustment, Economic Liberalization, Privatization, and Women's Employment in Selected Countries of the Middle East and North Africa* (pp. 99–114).

Al-Raida. (1998). *Special issue on Women in the Labor Force* (Lebanon). Vol. XV, no. 82 (summer). Beirut: Institute for Women's Studies in the Arab World, Lebanese American University.

Anker, R. (1998). *Gender and Jobs: Sex Segregation of Occupations in the World*. Geneva: ILO.

Anker, R. (1995). Measuring Female Labour Force with Emphasis on Egypt. In: N. F. Khoury & V. M. Moghadam (Eds), *Gender and Development in the Arab World: Women's Economic Participation, Patterns, and Policies* (pp. 148–176). London: Zed Books.

Bakker, I. (Ed.) (1994a). *The Strategic Silence: Gender and Economic Policy*. London: Zed Books.

Beneria, L., & Feldman, S. (Eds) (1992). *Unequal Burden: Economic Crises, Persistent Poverty, and Women's Work*. Boulder, CO: Westview Press.

Berry-Chikhaoui, I. (1998). The Invisible Economy at the Edges of the Medina of Tunis. In: R. A. Lobban (Ed.), *Middle Eastern Women and the Invisible Economy*. (pp. 215–231).

Cornia, G. A., Jolly, R., & Stewart, F. (Eds) (1987). *Adjustment with a Human Face*. Oxford: Clarendon Press.

Doctor, K., & Khoury, N. (1991). Arab Women's Education and Employment Profiles and Prospects: An Overview. In: N. F. Khoury & K. C. Doctor (Eds), *Education and Employment Issues of Women in Development in the Middle East* (pp. 13–45). Nicosia: Imprinta Publishers.

Early, E. (1998). Nest Eggs of Gold and Beans: Baladi Egyptian Women's Invisible Capital. In: R. A. Lobban, (Ed.), *Middle Eastern Women and the Invisible Economy*. (pp. 132–147).

Eaton, S. C. (1992). *Women Workers, Unions and Industrial Sectors in North America*. Geneva: International Labour Office, IDP Women Working Paper 1 (October).

Einhorn, B. (1993). *Cinderella Goes to Market: Citizenship, Gender and Women's Movements in East Central Europe*. London: Verso.

El-Solh, C. (1994). Women and Poverty in the ESCWA Region: Issues and Concerns. Paper prepared under commission for ESCWA for the Arab Regional Preparatory Meeting for the FWCW, Amman, Jordan (6-10 November).

Elson, D. (1991). Male Bias in the Development Process: The Case of Structural Adjustment. In: D. Elson (Ed.), *Male Bias in the Development Process*. London: Macmillan.

ERF [Economic Research Forum]. (1996). *Economic Trends in the MENA Region*. Cairo: ERF.

ESCWA [Economic and Social Commission for West Asia]. (1995a). Arab Regional Preparatory Meeting for the Fourth World Conference on Women, Amman, 6–10 November 1994, Final Report High-Level Segment (9-10 November 1994). New York: UN.

ESCWA. (1995b). Arab Women in the Manufacturing Industries. *Studies on Women in Development, 19*. New York: UN.

Ghosh, J. (1998). Women and Economic Liberalization in the Asian and Pacific Region. *WINAP Newsletter, 22*(July). Bangkok: UN Economic and Social Commission for Asia and the Pacific [ESCAP].

Handoussa, H., & Potter, G. (Eds) (1991). *Employment and Structural Adjustment: Egypt in the 1990s*. Cairo: The American University of Cairo Press.

Hansen, B. (1991). *The Political Economy of Poverty, Equity, and Growth: Egypt and Turkey*. Oxford and NY: Oxford University Press.

Hastings, S., & Coleman, M. (1992). Women Workers and Unions in Europe: An Analysis by Industrial Sector. Geneva: International Labour Office, IDP Working Paper 4 (December).

International Labour Office. (1996). *World Employment 1996/97: National Policies in a Global Context*. Geneva: ILO.

International Labour Office. (1994, 1996). *Yearbook of Labour Statistics*. Geneva: ILO.

Islamic Republic of Iran. (1995). *National Report on Women in the Islamic Republic: Prepared for the Fourth World Conference on Women*. Tehran: Bureau of Women's Affairs.

Islamic Republic of Iran. (1376 [1997]). *Statistical Yearbook 1375* [1996]. Tehran: Statistical Center of Iran.

Joekes, S./INSTRAW. (1987). *Women in the Global Economy: An INSTRAW Study*. New York: Oxford University Press.

Jordan Coordinating Office for the Beijing Conference. (1995). *The Jordanian Women: Past and Present*. Amman: Coordinating Office for the Beijing Conference.

Jordanian National Committee for Women. (1993). *The National Strategy for Women in Jordan*. Amman: JNCW (September).

Kahne, H., & Giele, J. Z. (Eds) (1992). *Women's Work and Women's Lives: The Continuing Struggle Worldwide*. Boulder, CO: Westview Press.

Karshenas, M. (1997). *Female Employment, Economic Liberalization, and Competitiveness in the Middle East*. Cairo: Economic Research Forum Working Paper.

Karshenas, M. (1995). *Structural Adjustment and Employment in the Middle East and North Africa.* School of Oriental and African Studies, Department of Economics, Working Paper Series No. 50.

Kasnakoglu, Z., & Dayioglu, M. (1996). *Education and Earnings by Gender in Turkey.* Economics Research Center Working Paper no. 96/10 (July). Ankara: Middle East Technical University.

Khoury, N., & Demetriades, E. (Eds) (1998). Structural Adjustment, Economic Liberalization, Privatization, and Women's Employment in Selected Countries of the Middle East and North Africa. Proceedings of a Seminar Held in Nicosia, Cyprus, Nov. 1995. Nicosia: Department of Statistics and Research, Ministry of Finance.

Khuri-Tubbeh, T. (1996). Liberalization, Privatization and Women's Employment in Jordan. In: Khoury & Demetriades (Eds), *Structural Adjustment, Economic Liberalization, Privatization, and Women's Employment in Selected Countries of the Middle East and North Africa* (pp. 71–98).

Kim, S-K. (1997). *Class Struggle or Family Struggle? The Lives of Women Factory Workers in South Korea.* Cambridge, UK: Cambridge University Press.

Lister, R. (1997). *Citizenship: Feminist Perspectives.* London: Macmillan.

Li T. (1995). Doi Moi and Female Workers: A Case Study of Hanoi. In: V. M. Moghadam (Ed.), *Economic Reforms, Women's Employment, and Social Policies.* Helsinki: UNU/WIDER, World Development Studies 4 (August).

Lobban, R. A. (Ed.) (1998). *Middle Eastern Women and the Invisible Economy.* Gainesville: University Press of Florida.

Marchand, M., & Runyan, A. S. (Eds) (1999). *Gender and Global Restructuring: Sightings, Sites, and Resistances.* New York and London: Routledge.

Martens, M. H., & Mitter, S. (1994). *Women in Trade Unions: Organizing the Unorganized.* Geneva: ILO.

Meer, F. (Ed.) (1994). *Poverty in the 1990s: The Responses of Urban Women.* Paris: UNESCO.

Moghadam, V. M. (Ed.) (1993a). *Democratic Reform and the Position of Women in Transitional Economies.* London: Oxford University Press.

Moghadam, V. M. (1993b). *Modernizing Women: Gender and Social Change in the Middle East.* Boulder, CO: Lynne Rienner Publishers.

Moghadam, V. M. (Ed.) (1996). *Patriarchy and Development: Women's Positions at the End of the Twentieth Century.* Oxford: Oxford University Press.

Moghadam, V. M. (1998). *Women, Work, and Economic Reform in the Middle East and North Africa.* Boulder, CO: Lynne Rienner Publishers.

Moghadam, V. M. (1999a). Gender and the Global Economy. In: M. M. Ferree, J. Lorber & B. Hess (Eds), *Revisioning Gender.* Thousand Oaks, CA: Sage.

Moghadam, V. M. (1999b). Gender and Globalization. *Journal of World-Systems Research,* 5(2) (spring), 301–314.

Moghadam, V. M. (1999c). Women and Citizenship: Reflections on the Middle East and North Africa. *Civil Society,* 8(88), (April).

Safa, H. (1996). Gender Inequality and Women's Wage Labor: A Theoretical and Empirical Analysis. In: V. M. Moghadam (Ed.), *Patriarchy and Development.* Oxford: Clarendon Press.

Said, M. (1998). *The Distribution of Gender Differentials and Public Sector Wage Premia in Egypt.* Prepared for the ERF Fifth Annual Conference, Gammarth, Tunisia (31 Aug.–2 Sept.).

Shaban, R., Assaad, R., & Al-Qudsi, S. (1995). The Challenge of Unemployment in the Arab Region. *International Labor Review,* 135(1), 65–81.

SIS [State Institute of Statistics]. (1996). *1994 Household Labor Force Summary Results.* Ankara: SIS.

Sparr, P. (Ed.) (1994). *Mortgaging Women's Lives: Feminist Critiques of Structural Adjustment*. London: Zed.
Standing, G. (1989). Global Feminization Through Flexible Labour. *World Development, 17*(7), 1077–1095.
Tanski, J. (1994). The Impact of Crisis, Stabilization and Structural Adjustment on Women in Lima, Peru. *World Development, 22*(11), 1627–1642.
Tiano, S. (1994). *Patriarchy on the Line: Labor, Gender, and Ideology in the Mexican Maquila Industry*. Philadelphia: Temple University Press.
United Nations [UN] (2000). *The World's Women 2000: Trends and Statistics*. New York: UN and p. 112, Note 2: see also UN (2000), Table 5c, p. 140.
United Nations [UN] (1995). *The World's Women 1995: Trends and Statistics*. New York: UN.
United Nations [UN] (1994). *Women's Indicators and Statistics*, WISTAT - CD. New York: UN.
UNDP [United Nations Development Programme] (1995). *Human Development Report 1995*. New York: Oxford University Press.
UNDP-Ankara. (1996). *Human Development Report 1996 Turkey*. Ankara: UNDP.
Ward, K. (Ed.) (1990). *Women Workers and Global Restructuring*. Ithaca, NY: ILR Press.
World Bank (1995a). *Claiming the Future: Choosing Prosperity in the Middle East*. Washington, DC: The World Bank.
World Bank (1995b). *Will Arab Workers Prosper or be Left out in the Twenty-first Century?* Washington, DC: The World Bank.
World Bank (1995c). *World Development Report 1995: Workers in an Integrating World*. New York: Oxford University Press.
World Bank (1995d). *Republic of Tunisia: Poverty Alleviation: Preserving Progress While Preparing for the Future*. Washington., DC: World Bank.
World Bank (1991). *Egypt: Alleviating Poverty during Structural Adjustment*. Washington.: The World Bank.
World Bank (1994a). *Hashemite Kingdom of Jordan Poverty Assessment*. Wash.ington, DC: World Bank.
World Bank (1994b). *Kingdom of Morroco: Poverty, Adjustment, and Growth*. Vols 1 and II. Washington, D.C. World Bank.

IS ALL WORK THE SAME? A COMPARISON OF THE DETERMINANTS OF FEMALE PARTICIPATION AND HOURS OF WORK IN VARIOUS EMPLOYMENT STATES IN EGYPT

Ragui Assaad and Fatma El-Hamidi

ABSTRACT

We provide evidence that pooling different forms of employment into a single category is not warranted in the case of female workers in Egypt. We show that the determinants of participation and hours of work in regular versus, casual paid work, agricultural versus, non-agricultural self-employment are markedly different. Our results show that the type and hours of work are largely determined by the point of a woman's life-cycle, level of education, role in the household, and the employment status of male members of her household. We find different determinants of regular wage work and self-employment and unpaid family labor.

I. INTRODUCTION

In recent years, economists in the U.S. and other developed countries have devoted a great deal of effort to the study of the female labor supply. Many of the models developed in this context have been extended to analyze labor supply behavior in developing countries. Because they emerged from contexts in which wage and salary work is predominant, most of these models characterize the labor supply decision as a dichotomous one: to work or not to work. The limitations of such a specification become readily apparent for developing-country applications, where the majority of women who are economically active, according to currently agreed-upon international definitions, do not engage in paid work. In fact, a large proportion of working women engage in forms of economic activity that are closer to home work (non-economic activity) than to paid market work.[1]

Because women's social roles often place them at the interface of the household and the market economy, their participation in economic activity can be more usefully seen as lying on a continuum from home work to market work, rather than a choice between the two. In an attempt to take account of this fact, the Thirteenth International Conference of Labor Statisticians decided to extend the definition of "economic activity" to include "persons engaged in the production of economic goods and services for own and household consumption if such production comprises an important contribution to the total consumption of the household."[2] According to the System of National Accounts, the goods and services that qualify as "economic goods and services" without being produced for the purpose of market exchange include the extraction and processing of primary products and housing construction.

The current definition of "employment" comprises states of activity that are quite different from the notion of wage employment underlying the standard labor supply models. Some forms of economic activity subsumed by the definition, such as the raising of livestock and poultry for own use, are clearly at the home production end of the spectrum, while others like wage work, are at the market work end of the spectrum (Fig. 1). Others, such as unpaid work in family enterprises or self-employment producing for exchange occupy an intermediate position.

The distinction that the international statisticians make between the production and processing of primary and non-primary products for household consumption as the dividing line between participation and non-participation in economic activity is fairly arbitrary. Because the factors that affect participation at one end of the spectrum clearly differ from those affecting participation at the other end, a modeling strategy that specifies the labor supply decision as

Is All Work The Same?

```
                                                    Market
                                                    Work

                                 Production for     Sale of
                                 exchange           own labor
                                 (Self-             (wage
                                 employment         work)
                                 or unpaid
                                 family labor)

            ↕

                 Production
                 for own use
                 with some
                 exchange

Home
Work

      Production for own use

            primary                                 Economic Activity
            goods
            and
            services

      non-
      primary
      goods and
      services

      Non-
      economic
      Activity
```

Fig. 1. Disaggregation of Employment Types.

polychotomous is likely to perform better than one that treats the decision as dichotomous.

The objective of this paper is to examine the factors that affect individual choices among various employment states in Egypt and, once the choice has been made, the factors that determine the number of hours supplied in each state. The paper extends our previous work on female labor supply in Egypt that focused only on participation and hours of work in wage labor (Assaad & El-Hamidi, forthcoming). Because it is not possible from the data available to us to identify exactly all of the theoretical employment states identified in Fig. 1, we generate a classification that approximates these states. In our classification, non-participation – the reference state – is the left-most side of the continuum, which may include the production of non-primary goods and services for own consumption. Non-wage agricultural work approximates production for own use of primary goods and services. While it is theoretically possible that women can engage in farming and livestock production for the purpose of exchange as well as own use, data from other sources indicate that they do not.[3] The next category, females engaged in non-wage non-agricultural work represent the intermediate group, those who are producing for exchange as self-employed or unpaid family workers in non-primary activities. According to international definition, non-agricultural workers must be directing at least some of their production toward exchange to be counted as economically active. This category includes all employers, self-employed workers, and unpaid family workers working in such activities as trade, small-scale manufacturing, and services. We decided to pool the three employment states into one non-wage category because the employer category among women is very small and, in practice, it is difficult to distinguish between self-employment and unpaid family labor in may activities. The final two groups, casual and regular wageworkers, represent those who sell their own labor for pay. Regular wage work includes permanent and temporary workers with stable employment. Casual wageworkers are workers with intermittent or seasonal wage employment, who are often hired by the day and who may experience frequent periods of inactivity or unemployment between jobs. They include maids and temporary office workers in urban areas and agricultural laborers in rural areas. We opted to separate this group out because of their more tenuous attachment to the paid labor market compared to regular wageworkers.

II. MEASUREMENT OF FEMALE PARTICIPATION IN EGYPT

Reliable long-term trends of labor force participation by sex are hard to obtain in Egypt because of frequent methodological changes in the Labor Force Sample

Survey (LFSS), the main source of data on the subject. The changes relate primarily to the measurement of female participation in agriculture and informal home-based activities. Prior to 1983, the female participation rates obtained in official statistics were very low at close to 6%. In 1983, the Central Agency for Public Mobilization and Statistics decided to improve the training of enumerators and increase the number of female enumerators in an effort to get a better measurement of the phenomenon. As a result the rate nearly doubled to 12.5%, with most of the increase being attributable to better counting of females involved in agricultural production (Anker, 1990). In a special study designed to determine the sensitivity of the measurement of female participation to the definitions used, Anker (1990) reports participation rates for rural Egyptian women that vary from 13%, according to the paid labor force definition, to 40% for a market labor force definition, to 83% according to the extended labor force definition.

In the special round of the LFSS carried out in October 1988, which is the main source of data for this paper, an effort was made to strictly apply the extended definition of economic activity adopted in 1982 by the Thirteenth International Conference of Labor Statisticians. This resulted in an overall female activity rate of 42.3% for those aged 15 to 64.[4] Although the same definition has ostensibly been applied in the LFSS since then, the female labor force participation rate has varied from 29% in 1990 to 21.4% in 1995, with the decline almost certainly due to a waning effort in detecting female participation in subsistence agriculture. By analyzing results from all the labor force surveys from 1975 to 1995, Assaad (1997a) shows that most of the variation in measured participation rates in the LFSS is associated with the measurement of female participation in agriculture. He shows that if participation rates in agriculture had been held constant at the 1990 level, a rising trend in female participation in both urban and rural areas would have been observed. Under these assumptions he estimates that participation rates for females 12–64 increased from 11% in 1977 to 18% in 1995 in urban areas and from 20 to 27% in rural areas.

The Egypt Labor Market Survey of 1998 (ELMS 98) applied both the market and extended labor definitions, allowing for accurate measures of the size of the subsistence labor force in agriculture for the first time. ELMS 98 places the market labor force participation of females 15 to 64 at 21% and the extended participation rate at 46%. These results are consistent with those of the Egypt Integrated Household Survey of 1997 (EIHS 1997), which measured the market labor force participation at 21%. These results indicate that more than half the women who participate according to the extended definition are in fact engaged in subsistence agriculture, which mostly consists of animal and poultry raising

for household consumption. As mentioned above, ELMS 98 results show that when the extended definition of participation is used without a clear way to distinguish between market and non-market, the category of women in non-wage agricultural work is an adequate proxy for those who engage exclusively in subsistence work.

III. METHODOLOGY

We begin by estimating a binomial logit model for the probability of participation in any kind of work. We then estimate a multinomial logit model that disaggregates employment into the four states mentioned above, while maintaining non-participation as the base category. We then conduct a series of formal tests to determine whether any of the four employment states can be pooled into a smaller number of states without loss of information. We used the Cramer-Ridder (1991) test for pooling states in a multinomial logit model for this purpose. The test consists of estimating a restricted version of the model where two or more of the states are pooled into a single state, and an unrestricted version where each state is entered separately. A test of the implied restrictions is a test of the null hypothesis that the estimated parameters are equal across the pooled states.[5]

The next stage is to estimate reduced-form labor supply equations to examine the determinants of hours of work in each form of work. The hours equations are corrected for selectivity using the multinomial logit selection model suggested by (Lee, 1983). The method consists of using the parameter estimates from the first-stage multinomial logit selection equation to compute a variable (called the selection term), which is then included, in a second step, as an additional regressor in the hours equations.

The functional form of the model is as follows:
Let:

$y_i = 0$ for non-participation in economic activity
$y_i = 1$ for non-wage agriculture workers
$y_i = 2$ for non-wage non-agricultural workers
$y_i = 3$ for regular wage workers
$y_i = 4$ for casual wage workers (4)

The probability that the *ith* individual selects the *jth* working status is:

$$P_{ji} = \exp(\beta'_j X_i) / [1 + \sum_{j=0}^{4} \exp(\beta'_j X_i)] \quad (5)$$

where the subscript $j=0, 1,2,3,4$ is for working status, X_i is a vector of independent variables and β_j is the parameter vector for working status j. As usual, we adopt the normalization that $\beta_0 = 0$ to remove the indeterminacy in the model (Greene, 1993: 666).

The hours of work equations are given by:

$$H_{ji} = a'_j X^h_{ji} + e^h_{ji} \qquad \text{if } j = 1, \ldots, 4 \qquad (6)$$
$$= 0 \qquad \text{otherwise}$$

As shown in Lee (1983), correction for selectivity is achieved by including the term λ_{ji} as an additional regressor in the estimation equation:

$$H_{ji} = a'_j X^h_{ji} + \theta^h_j \lambda_{ji} + e^h_{ji} \qquad (7)$$

where $\hat{\lambda}_{ji} = \phi(H_{ji})/P_{ji}$, $H_{ji} = \Phi^{-1}(P_{ji})$, ϕ is the normal density function, P_{ji} is the estimated probability of individual i being selected into state j from the first stage, and Φ^{-1} is the inverse normal cumulative distribution function.[6]

IV. DATA AND EMPIRICAL FINDINGS

The data are drawn from the LFSS in October 1988. This round of the survey used a more detailed questionnaire to inquire about earnings and collected more detailed information about individual and household characteristics than those usually obtained in the LFSS. The sample was restricted to women 15 to 64 years of age, resulting in a sub-sample of 15,760 females, of whom 11,745 are non-workers, and 4,015 are workers.

The October 1988 LFSS collected data on hours and earnings for a long reference period of one year. For regular workers, (defined as continuously employed workers) annual hours of work were estimated by multiplying the average number of hours per day and the average number of days per week by the actual number of weeks worked per year. Wages for these workers were then estimated by dividing annual earnings by this estimate of annual hours. For casual workers, that is workers with more intermittent or seasonal employment, the workers were asked about the number of months worked in each of four quarters, the average number of days worked per month in each quarter, the average number of hours worked per day, and the average wage per day in each quarter. An estimate of the number of hours worked per year was then obtained by adding the estimated quarterly hours. The hourly wage was obtained by dividing the average daily wage by the average length of the working day

in the last quarter. In contrast to the number of days worked per month, the wage and hours per day variables do not vary much across quarters, resulting in fairly reliable estimates of hourly wages for casual workers. There is, however, considerable room for measurement error in the estimation of work hours for casual workers using this method because of recall problems and possibly some desire on the part of such workers to underreport the number of hours they supply. However, the small proportion of casual workers among female wageworkers makes such measurement problems less important.

In what follows we describe the general characteristics of the sample. Tables 1 and 2 show descriptive statistics of females between the ages of 15 and 64 for urban and rural areas, respectively. The overall participation rates for females 15–64 years is 25.5% , of whom nearly 60% work in rural areas. Wageworkers comprise over 75% of the working female population in urban areas, while non-wage workers represent over 80% of workers in rural areas. As indicated above, the vast majority of these rural female non-wage workers are engaged in subsistence agriculture and animal husbandry, rather than in market work.

Wageworkers tend to be younger than non-wage workers. Most rural female workers reside in rural Lower Egypt whereas about 60% of urban female workers are in the major metropolitan regions of Greater Cairo, Alexandria, and the Suez Canal region.

The descriptive statistics indicate that achieving secondary education is the main factor determining the form of employment females engage in in Egypt. Regular wage work, whether in urban or rural areas, is made up predominantly of secondary school graduates and above (81–84%). The vast majority of these educated female workers are working in the government as teachers, clerical workers, and health professionals. On the other hand non-wage work is done predominantly by women with no formal schooling (84% in urban areas and 93% in rural areas). Non-wage work outside agriculture consists primarily of petty trade activities and participation in family enterprises. Casual wageworkers are more educated than non-wage workers in urban areas, but less educated in rural areas. Although secondary education has been found to be a gateway to regular paid work for women elsewhere in the region (Olmsted, 1996, Moghadam 1998), its effect is compounded in Egypt by the long-standing, but now suspended, policy of guaranteeing employment to graduates of secondary and post-secondary institutions (See Assaad, 1997b).

Turning now to the household characteristics, we note that female heads of households are over-represented among non-wage, non-agricultural workers and casual wageworkers in both urban and rural areas. These women do not typically have the educational characteristics to obtain regular wage work, but their need for cash income forces them into the two other categories of market work.

Table 1. Means and Standard Deviations of Variables Used in the Analysis, Urban – Females 15–64.

Variables	Non-Workers	All Workers	Non-Wage Workers	Wage Work.	Non-Wage Agric. Work.	Non-Wage, Non-Agric. Work.	Regular Wage Work.	Casual Wage Work.
Age(in years)	33.549	33.172	36.388	32.162	33.981	37.883	32.339	26.368
	(14.098)	(10.355)	(12.743)	(9.260)	(13.032)	(12.352)	(9.095)	(12.406)
Region of Residence:								
Greater Cairo*	0.408	0.419	0.269	0.466	0.065	0.395	0.469	0.368
	(0.491)	(0.494)	(0.444)	(0.499)	(0.247)	(0.490)	(0.499)	(0.489)
Alexandria and								
Suez Canal Cities*	0.167	0.176	0.137	0.188	0.234	0.077	0.186	0.263
	(0.373)	(0.381)	(0.344)	(0.391)	(0.425)	(0.267)	(0.389)	(0.446)
Urban lower Egypt								
(Reference)	0.243	0.267	0.455	0.208	0.584	0.375	0.209	0.184
	(0.429)	(0.442)	(0.499)	(0.406)	(0.494)	(0.485)	(0.406)	(0.393)
Urban upper Egypt*	0.182	0.138	0.139	0.138	0.117	0.153	0.136	0.184
	(0.386)	(0.345)	(0.347)	(0.345)	(0.322)	(0.361)	(0.343)	(0.393)
Educational Attainment:								
Illiterate (Reference)	0.491	0.250	0.764	0.088	0.929	0.661	0.076	0.500
	(0.500)	(0.433)	(0.425)	(0.284)	(0.258)	(0.474)	(0.265)	(0.507)
Ability to read								
and write*	0.120	0.038	0.080	0.025	0.019	0.117	0.023	0.079
	(0.325)	(0.191)	(0.271)	(0.156)	(0.139)	(0.322)	(0.151)	(0.273)
Primary*	0.076	0.032	0.057	0.024	0.039	0.069	0.024	0.026
	(0.265)	(0.176)	(0.233)	(0.154)	(0.194)	(0.253)	(0.154)	(0.162)
Preparatory*	0.122	0.042	0.037	0.043	0.013	0.052	0.037	0.237
	(0.327)	(0.200)	(0.190)	(0.203)	(0.114)	(0.223)	(0.189)	(0.431)
Secondary								
and Above*	0.191	0.639	0.062	0.820	0.000	0.101	0.840	0.158
	(0.393)	(0.481)	(0.242)	(0.385)	(0.000)	(0.302)	(0.367)	(0.370)
Household Characteristics								
Head of Household*	0.100	0.114	0.177	0.095	0.104	0.222	0.093	0.158
	(0.300)	(0.318)	(0.382)	(0.293)	(0.306)	(0.416)	(0.290)	(0.370)
Unmarried*	0.403	0.403	0.308	0.433	0.253	0.343	0.421	0.816
	(0.491)	(0.491)	(0.462)	(0.496)	(0.436)	(0.476)	(0.494)	(0.393)
No. of children 0–2	0.377	0.335	0.562	0.264	0.883	0.363	0.267	0.158
	(0.668)	(0.632)	(0.804)	(0.548)	(0.921)	(0.647)	(0.551)	(0.437)
No. of children 3–6	0.565	0.556	0.960	0.430	1.422	0.673	0.432	0.368
	(0.843)	(0.894)	(1.225)	(0.716)	(1.529)	(0.878)	(0.721)	(0.541)

Table 1. continued.

Presence of other females 12–64*	0.691	0.628	0.706	0.604	0.870	0.605	0.597	0.842
	(0.462)	(0.483)	(0.456)	(0.489)	(0.337)	(0.490)	(0.491)	(0.370)
Male wage worker in household*	0.622	0.634	0.498	0.677	0.532	0.476	0.680	0.579
	(0.485)	(0.482)	(0.501)	(0.468)	(0.501)	(0.500)	(0.467)	(0.500)
Male agric. non-wageworker in household*	0.185	0.216	0.617	0.091	0.805	0.500	0.091	0.079
	(0.388)	(0.412)	(0.487)	(0.287)	(0.397)	(0.501)	(0.288)	(0.273)
Male non-agric. non-wage worker in household*	0.296	0.264	0.652	0.142	0.805	0.556	0.142	0.158
	(0.457)	(0.441)	(0.477)	(0.349)	(0.397)	(0.498)	(0.349)	(0.370)
Total male wage earnings (in 000s LE)	1.237	1.419	0.678	1.651	0.619	0.715	1.669	1.061
	(1.693)	(1.969)	(1.022)	(2.131)	(0.877)	(1.103)	(2.132)	(2.027)
Number of Observations	7095	1682	402	1280	154	248	1242	38

Standard Deviations are in parentheses.
* Indicates a dummy variable.

On average female workers and non-workers are equally likely to be married, but unmarried women are over-represented in types of work that require extended presence outside the home, namely casual wage work and to a lesser extent regular wage work. Wageworkers are also less likely to have children under the age of six,[7] while those who have young children are the most likely to be engaged in home-based, non-wage agricultural activities.

Female wageworkers in both regions are more likely to live in households containing a male wageworker than are non-wage workers. There is therefore an apparent association between the work status of husbands and wives. We also note higher earnings for male wageworkers than for non-wage workers and for urban dwellers, as compared to those rural areas.

The preceding discussion suggests that the form that female labor force participation takes in Egypt is strongly determined by age and education, and urban/rural location. These patterns are shown graphically in Figs 2 through 5. The figures show the average proportion of women participating in various employment states as well as the predicted probability of participation in these

Table 2. Means and Standard Deviations of Variables Used in the Analysis, Rural – Females 15–64.

Variables	Non-Workers	All Workers	Non-Wage Workers	Wage Work.	Non-Wage Agric. Work.	Non-Wage, Non-Agric. Work.	Regular Wage Work.	Casual Wage Work.
Age(in years)	32.268	32.112	32.798	29.058	32.668	33.531	28.156	30.243
	(13.918)	(12.487)	(12.859)	(10.139)	(12.975)	(12.176)	(7.812)	(12.483)
Region of Residence:								
Rural lower Egypt (Reference)	0.523	0.763	0.757	0.790	0.791	0.566	0.778	0.805
	(0.500)	(0.425)	(0.429)	(0.408)	(0.407)	(0.496)	(0.417)	(0.397)
Rural upper Egypt*	0.477	0.237	0.243	0.210	0.209	0.434	0.222	0.195
	(0.500)	(0.425)	(0.429)	(0.408)	(0.407)	(0.496)	(0.417)	(0.397)
Educational Attainment:								
Illiterate (Reference)	0.796	0.817	0.894	0.477	0.902	0.846	0.128	0.935
	(0.403)	(0.386)	(0.308)	(0.500)	(0.297)	(0.361)	(0.334)	(0.247)
Ability to read and write*	0.043	0.036	0.040	0.019	0.035	0.070	0.016	0.022
	(0.203)	(0.186)	(0.196)	(0.136)	(0.183)	(0.255)	(0.128)	(0.146)
Primary*	0.043	0.025	0.024	0.030	0.023	0.028	0.033	0.027
	(0.202)	(0.157)	(0.154)	(0.172)	(0.151)	(0.165)	(0.179)	(0.163)
Preparatory*	0.063	0.024	0.026	0.012	0.027	0.024	0.012	0.011
	(0.243)	(0.152)	(0.160)	(0.108)	(0.161)	(0.155)	(0.111)	(0.104)
Secondary and Above*	0.055	0.098	0.016	0.463	0.013	0.031	0.811	0.005
	(0.229)	(0.297)	(0.125)	(0.499)	(0.113)	(0.175)	(0.393)	(0.074)
Household Characteristics								
Head of Household*	0.077	0.128	0.121	0.157	0.113	0.168	0.074	0.265
	(0.266)	(0.334)	(0.327)	(0.364)	(0.317)	(0.374)	(0.262)	(0.442)
Unmarried*	0.314	0.336	0.325	0.386	0.317	0.371	0.288	0.514
	(0.464)	(0.472)	(0.468)	(0.487)	(0.465)	(0.484)	(0.454)	(0.501)
No. of children 0–2	0.768	0.771	0.814	0.582	0.855	0.580	0.605	0.551
	(0.892)	(0.893)	(0.924)	(0.711)	(0.947)	(0.739)	(0.750)	(0.658)
No. of children 3–6	1.049	1.105	1.169	0.820	1.214	0.909	0.745	0.919
	(1.164)	(1.155)	(1.181)	(0.979)	(1.198)	(1.049)	(0.927)	(1.037)
Presence of other females 12–64*	0.744	0.762	0.795	0.612	0.818	0.664	0.539	0.708
	(0.436)	(0.426)	(0.404)	(0.488)	(0.386)	(0.473)	(0.499)	(0.456)

Table 2. continued.

Male wage worker in household*	0.548	0.453	0.412	0.638	0.401	0.472	0.700	0.557
	(0.498)	(0.498)	(0.492)	(0.481)	(0.490)	(0.500)	(0.459)	(0.498)
Male agric. non-wage worker in household*	0.437	0.699	0.800	0.248	0.837	0.591	0.243	0.254
	(0.496)	(0.459)	(0.400)	(0.432)	(0.370)	(0.493)	(0.430)	(0.437)
Male non-agric. non-wage worker in household*	0.466	0.703	0.802	0.266	0.838	0.594	0.272	0.259
	(0.499)	(0.457)	(0.399)	(0.443)	(0.368)	(0.492)	(0.446)	(0.440)
Total male wage earnings (in 000s LE)	0.763	0.599	0.526	0.924	0.519	0.560	1.105	0.686
	(1.074)	(0.938)	(0.863)	(1.163)	(0.853)	(0.920)	(1.080)	(1.227)
Number of Observations	4650	2333	1905	428	1619	286	243	185

Standard Deviations are in parentheses.
* Indicates a dummy variable.

states based on the multivariate models discussed below. In Figs 2 and 3, the dashed line (actual) is a cubic spline through the average proportion participating in each state by age, the dots symbolize the predicted probability of participation for each individual, and the solid line is a cubic spline through the median values of these predictions at each age. Figs 4 and 5 are similar, with the only difference being that the dashed and solid lines are no longer cubic splines but simple connecting lines between the mean observed participation rates and the median predicted probabilities at each educational level.

According to Figs 2 and 3, women between 20 and 40 years of age are more likely to participate in economic activity than those at the two ends of the age distribution. Compared to their urban counterparts, however, rural females (Fig. 3) exhibit a less peaked age pattern of labor force participation. The pattern of the dots shows that the predicted probabilities of non-participation are divided into two distinct regimes, which is an indication of the strong dualism in the pattern of participation along the education dimension.

Is All Work The Same? 129

Fig. 2. Urban Females.

Fig. 3. Rural Females.

Non-wage work in and out of agriculture exhibits a weak age pattern. Casual wage employment is more prevalent among young women and declines with age. In urban areas, regular wage employment increases with age at first, peaks at age 30, and declines considerably after age 40. There is a similar pattern among some young rural females, those with secondary education, but because their proportion among all rural females is smaller, the pattern appears weaker than in urban areas. Non-wage, non-agricultural employment also exhibits a concave age pattern, but at much lower levels of participation than regular wage employment. The figures also reveal that rural females have a higher probability of working in non-wage agriculture than in any other form of work.

Figures 4 and 5 show participation rates at each educational level for urban and rural areas respectively. Fig. 3 shows that participation below the secondary level of education is very low and decreasing weakly with education. The decrease in participation at low levels of education is due to the pattern of participation in non-wage agricultural work, which explains why it is more marked in rural areas. That form of participation is inversely related to education.

There is a sharp increase in participation from the preparatory to the secondary level and the increase continues up to the university level.[8] This pattern is due to the effect of education on participation in regular wage employment. There is no discernable pattern by education for non-wage non-agricultural employment or casual wage employment in urban areas, but non-wage employment outside agriculture, like in agriculture, seems to decline with increasing education in rural areas. This sharp divide in the form that female employment takes around the secondary education threshold is compounded by the powerful effect of government policies on the structure of the labor market.

A. The Determinants of Labor Force Participation and Employment Status

In the previous section we examined how participation and employment status vary with age and education. Now we turn to the issue of whether the decision to participate in the labor force can be characterized as a single choice or as a multiplicity of choices each of which is determined by a different set of factors. To answer this question we use the Cramer-Ridder test of pooling states in a multinomial logit model described above. We find that we can easily reject the null hypothesis that the model parameters across pooled states are equal for any combination of the four work states. For example, the pooling of regular and casual wage work and of non-wage agriculture and non-wage non-agriculture work was rejected at p-values of 0.000. These tests suggest,

Fig. 4. Urban Females.

Is All Work The Same?

Fig. 5. Rural Females.

therefore, that analyses that pool these states into a single "employed" state result in a loss of information about how various characteristics influence women's employment decisions.

To illustrate the additional insights that can be gained from disaggregating employment states, we compare the results of a conventional analysis that assumes a single participation decision, by pooling employment states into a single employment category, with one that keeps them disaggregated. We begin by discussing the results from a binomial logit model of the single participation decision and then move to the results of the multinomial logit model that disaggregates employment into four states. The analysis is carried out separately for rural and urban females because previous studies have shown that there are important differences in the determinants of women's employment status in rural and urban Egypt (Assaad et al., 2000).[9]

Table 3 shows the marginal effects of the explanatory variables on the probability of participating in economic activity derived from a binomial logit model. Since, unlike OLS estimates, these marginal effects are not constant for all values of the explanatory variables, we report the effects at the sample means for the continuous variables and for the reference state for dummy variables. In the case of continuous variables, the reported marginal effect is the partial derivative of the probability with respect to that variable, and in the case of a dummy variable, it represents the effect of a change from 0 to 1. In urban areas, the reference individual for whom these marginal effects are computed is a 33 year-old illiterate female living in Lower Egypt, who is married but not a household head, who has no other adult female members in her household, and no male wage or non-wage workers in the household. The reference rural female is 32 years old and has all the same characteristics as the reference urban female.

According to Table 3, the reference urban female, a married illiterate woman in her early to mid thirties, has a 3.7% probability of participation as compared to a nearly 20% probability for the reference rural female. This large difference essentially has to do with the much lower threshold required to meet the definition of participation in rural areas since agricultural work does not have to be for the purpose of market exchange to qualify as participation. As expected, the set of variables with the biggest effect on participation is education. In urban areas, there is a small but statistically significant increase in participation at the primary and preparatory levels and a huge jump at the secondary and above levels, where participation reaches 26%.[10] In rural areas, participation declines with education up to the preparatory level, but then increases by 12 percentage points at the secondary and above level.

The disaggregated analysis shown in Tables 4 and 5 reveals that the non-monotonic result on education and the difference between urban and rural areas

Table 3. Marginal Effects – Binomial Logit Estimates of the Probability of Participation in Economic Activity Females Ages 15 to 64.

Variables	Urban	Rural
Probability for Reference individual	0.037	0.195
Explanatory Variables:		
Age	0.013 ***	0.019 ***
	(11.552)	(9.209)
Age Squared/100	-0.017 ***	-0.027 ***
	(-11.498)	(-9.843)
Greater Cairo*	-0.009 **	
	(-2.328)	
Alexandria and Suez Canal Cities	-0.007	
	(-1.235)	
Urban upper Egypt	-0.012 **	
	(-2.180)	
Rural upper Egypt		-0.126 ***
		(-6.527)
Ability to read and write	-0.014 **	-0.029
	(-2.504)	(-1.208)
Primary	0.010 **	-0.076 **
	(1.961)	(-2.550)
Preparatory	0.020 ***	-0.119 ***
	(2.626)	(-3.813)
Secondary and Above	0.225 ***	0.121 ***
	(15.041)	(4.822)
Head of Household	0.011	0.189 ***
	(0.947)	(6.362)
Unmarried	0.035 ***	0.050 ***
	(7.196)	(3.543)
No. of children 0–2	0.000	-0.009
	(-0.346)	(-0.773)
No. of children 3–6	0.006 *	0.002
	(1.852)	(-0.334)
Presence of other females 12–64	-0.002	-0.023 **
	(-0.771)	(-2.050)
Male wage worker in household	0.011 **	0.035 **
	(2.360)	(1.990)
Male agric. non-wage worker in household	0.052 ***	0.255 ***
	(4.650)	(8.526)
Male non-agric. non-wage worker in household	-0.012 ***	0.039
	(-3.450)	(1.058)
Total male wage earnings (in 000s LE)	-0.001	-0.010
	(-0.922)	(-0.729)
Total No. of Observations	8777	6983

t-stats are in parentheses. Significance of the coefficients at the 1% (***), 5% (**) and 10% (*) level is marked.

Table 4. Marginal Effects – Multinomial Logit Estimates of the Probability of Participation in Various Employment States, Females Ages 15–64, Urban Areas.

Variables	Non-Wage Agric. Work.	Non-Wage, Non-Agric. Work.	Regular Wage Work.	Casual Wage Work.
Probability for Reference individual	0.003	0.021	0.005	0.003
Explanatory Variables				
Age	0.000	0.005***	0.014***	0.000
	(0.910)	(4.726)	(20.78)	(0.868)
Age Squared/100	0.000	−0.007***	−0.018***	0.000
	(−1.230)	(−4.668)	(−19.94)	(−1.458)
Greater Cairo*	−0.003***	−0.005	0.000	0.000
	(−5.290)	(−1.153)	(−0.113)	(0.164)
Alexandria and Suez Canal Cities	−0.001	−0.013***	0.000	0.002
	(−0.770)	(−3.573)	(−0.310)	(1.014)
Urban Upper Egypt	−0.002***	−0.011**	0.000	0.001
	(−4.005)	(−2.368)	(0.015)	(0.198)
Ability to read and write	−0.003***	−0.005	0.001	−0.001
	(−3.519)	(−1.337)	(0.399)	(−1.176)
Primary	−0.002	−0.001	0.011***	−0.002*
	(−1.551)	(0.250)	(5.547)	(−1.796)
Preparatory	−0.003***	−0.008	0.020***	−0.001
	(−3.038)	(−1.050)	(6.684)	(−1.270)
Secondary and Above	##	−0.011**	0.170***	−0.002**
		(−2.262)	(21.42)	(−2.288)
Head of Household	0.009***	0.030***	−0.000	0.002
	(2.592)	(2.848)	(−0.534)	(1.063)
Unmarried	−0.001**	0.007	0.008***	0.009***
	(−2.314)	(1.614)	(8.427)	(2.696)
No. of children 0–2	0.001	−0.002	−0.001**	−0.001
	(1.302)	(−0.742)	(−2.024)	(−1.620)

Is All Work The Same? 137

Table 4. continued.

No. of children 3–6	0.001***	0.002	0.000	0.000
	(4.005)	(1.127)	(−0.369)	(0.152)
Presence of other females 12–64	0.004***	−0.007**	−0.000	0.001
	(3.174)	(−2.236)	(−1.245)	(0.147)
Male wage worker in household	0.005**	0.004	0.002	−0.000
	(2.481)	(1.394)	(2.920)	(−0.392)
Male agric. non-wage worker in household	0.046***	0.075***	−0.002	−0.001
	(7.875)	(6.829)	(−1.622)	(−0.382)
Male non-agric. non-wage worker in household	−0.001	0.001	−0.001**	−0.001
	(−1.298)	(−0.169)	(−2.439)	(−1.628)
Total male wage earnings in 000s LE	−0.005**	−0.005**	−0.001	−0.000
	(−2.013)	(−2.013)	(−1.439)	(0.074)
Log Likelihood		−3852.834		
Total No. of Observations	154	248	1242	38

t-stats are in parentheses. Significance of the coefficients at the 1% (***), 5% (**) and 10% (*) level is marked.

can be explained by the differences in the composition of employment across states for different levels of educational attainment. As shown in Table 4, the highest probability of employment for the reference individual is in non-wage non-agricultural employment (2.2%). If they work, urban illiterate women are likely to be either self-employed or family workers outside agriculture. As education levels rise, the probability of non-wage employment whether in or outside agriculture declines. The results for rural areas, shown in Table 5, show that the highest probability of employment for the reference individual is in non-wage agricultural work (8.7%), followed by casual wage work (3.2%) and non-wage work outside agriculture (3%). The probability of being in each of these states declines with education. Like in urban areas, women with low levels of education are virtually shut out of regular wage work. The probability of participating in such work increases somewhat with primary and preparatory education but as mentioned earlier explodes at the secondary level when government employment becomes an option. The difference in the pattern of participation by education between regular wage work and all other forms of work explains the non-monotonic effect of educational attainment on overall participation.

Table 5. Marginal Effects – Multinomial Logit Estimates of the Probability of Participation in Various Employment States, Females Ages 15–64, Rural Areas.

Variables	Non-Wage Agric. Work.	Non-Wage, Non-Agric. Work.	Regular Wage Work.	Casual Wage Work.
Probability for Reference individual	0.087	0.030	0.005	0.032
Age	0.009***	0.007***	0.006***	0.000
	(7.158)	(5.208)	(3.725)	(0.898)
Age Squared/100	−0.014***	−0.009***	−0.008***	−0.001*
	(−8.137)	(−5.122)	(−3.314)	(−1.785)
Rural Upper Egypt	−0.065***	−0.005	−0.002***	−0.024***
	(−6.763)	(−0.928)	(−2.739)	(−3.581)
Ability to read and write	−0.021*	0.015	0.006	−0.022 **
	(−1.649)	(1.306)	(1.235)	(−2.356)
Primary	−0.046***	−0.010	0.034***	−0.023 **
	(−2.867)	(−1.025)	(3.989)	(−2.005)
Preparatory	−0.056***	−0.017*	0.011*	−0.030***
	(−3.465)	(−1.787)	(1.669)	(−3.012)
Secondary and Above	−0.077***	−0.020	0.360***	−0.031***
	(−6.099)	(−1.214)	(13.77)	(−3.473)
Head of Household	0.099***	0.017***	−0.001	0.080***
	(6.262)	(3.437)	(0.272)	(5.995)
Unmarried	0.006	0.025***	0.002	0.041***
	(1.416)	(4.120)	(1.145)	(4.313)
No. of children 0–2	−0.001	−0.005	−0.001	−0.005
	(0.169)	(−1.114)	(−1.564)	(−1.586)
No. of children 3–6	0.001	−0.003*	0.000	0.001
	(−0.376)	(−1.745)	(0.527)	(0.390)
Presence of other females 12–64	0.000	−0.011**	−0.001*	0.006
	(0.105)	(−2.289)	(−1.920)	(0.319)
Male wage worker in household	0.017*	0.008	0.000	0.014
	(1.824)	(1.604)	(0.445)	(1.102)
Male agric. non-wage worker in household	0.219***	0.023***	0.000	−0.008
	(10.271)	(2.720)	(0.589)	(0.752)
Male non-agric. non-wage worker in household	0.065***	0.002	−0.003	−0.018***
	(4.306)	(−0.035)	(−1.138)	(−3.869)
Total male wage earnings in 000s LE)	−0.009	−0.003	0.000	−0.002
	(−0.924)	(−1.133)	(−0.337)	(−0.347)
Log Likelihood			−5229.562	
Total No. of Observations	1619	286	243	185

t-stats are in parentheses. Significance of the coefficients at the 1% (***), 5% (**) and 10% (*) level is marked.

We now move to the remaining explanatory variables that capture household conditions affecting the woman's participation decision. As shown in Table 3, being a household head nearly doubles the probability of participation in any kind of economic activity in rural areas. The disaggregated results in Tables 4 show that headship affects the probability of participation in urban areas as well, but only in certain employment states, namely those involving non-wage work. Though they clearly need access to income, female household heads are basically excluded from regular wage employment. In rural areas, the increased participation of female heads does not extend to regular wage work either. These results suggest that regular wage work in Egypt is basically a closed domain for women who don't have the requisite educational qualifications to get it.

Being unmarried has a positive and statistically significant effect on overall participation. It increases participation by nearly 100% in urban areas and by 25% in rural areas (Table 3). As shown in Tables 4 and 5, the increased participation of unmarried women is in the different forms of market work, rather than subsistence work. In urban areas, women are somewhat less likely to participate in non-wage agriculture, which is essentially subsistence work. The largest and most important differences in participation in favor of unmarried women are in both forms of wage work in urban areas, and in non-agricultural non-wage work and casual wage work in rural areas.

Once the effect of marriage has been taken into account, having young children has no additional negative effect on participation, either in the overall participation equation or in the disaggregated equations. The effect of children two and under is essentially statistically insignificant, except on the probability of regular wage work in urban areas, where it is statistically significant but quite small. The effect of children aged three to six on overall participation is actually positive in urban areas, mostly coming from increased participation in subsistence activities in the home. The presence of children aged three to six has a small negative effect on non-agricultural non-wage work in rural areas.

The presence of other adult or adolescent females in the household, who could act as alternative caregivers, does not have the expected positive effect on participation in Table 3. In fact, it reduces overall participation in rural areas and has no statistical significant effect in urban areas. The disaggregated results shown in Tables 4 and 5 indicate that other females in the household have no effect on wage employment but do have a small positive effect on non-wage agricultural employment in urban areas. In rural areas, the negative effect is limited to non-agricultural non-wage work and to regular wage work.

The presence of a male wageworker or a male non-wage agricultural worker in the household increases the overall probability of participation for females in both urban and rural areas, but more so in the latter (Table 3).[11] Conditional on

the presence of a male wageworker, male wage earnings have no effect on participation, however. The results from the disaggregated equation provide a similar but more nuanced picture. In urban areas, the presence of male wageworkers increases participation in both non-wage agricultural work *and* in regular wage work. However, female non-wage work both in agriculture and outside agriculture declines with higher male wage earnings. The presence of a male agricultural non-wage worker, which essentially means a farmer, increases a woman's overall probability of participation, especially in rural areas, with most of the increase, as expected, being concentrated in non-agricultural non-wage work. However, it also affects the probability of participation in other sorts of self-employment in both urban and rural areas. Hence, the female kin of farmers are also more likely to be self-employed in trade and other small-scale home-based activities than the female kin of male wageworkers. Finally the female kin of self-employed males outside agriculture have somewhat lower participation rates, overall, and, surprisingly, have no higher probability of being engaged in non-agricultural self-employment. In fact, in rural areas, they are more likely to engage in subsistence agriculture and less likely to engage in casual wage labor.

The results discussed above show that household structure and the employment status of male kin play a role in women's employment decisions and outcomes. Participation in all kinds of market work declines at marriage, with no additional effect of having children. This means that once their children are older, married women who withdrew from the labor force earlier are not likely to return to work in Egypt. Their participation rates in market work drop after marriage and do not recover except if they become household heads. The results on the effect of having other adult or adolescent females in the household on participation suggest that rather than acting as alternative caregivers, individuals may represent additional people in need of care and attention, such as mothers in law.[12] The positive effect of the presence of male wage workers on participation in regular wage work may suggest that the support and information provided by male wage workers helps their female kin find this clearly desirable form of employment. Self-employment (or non-wage work) outside agriculture, on the other hand, is clearly perceived as an inferior form of employment. The women who are more likely to engage in such employment are those who have limited access to wage income from their husband's employment, household heads, and the female kin of male farmers. Finally, the female kin of males engaged in non-agricultural self-employment are no more likely to be self-employed outside agriculture than other women. This suggests that women in Egypt do not actively participate in their husbands' or fathers' enterprises outside agriculture. If anything these women are more likely to be home engaging in subsistence activities.

B. The Determinants of Hours of Work by Employment Status

Once the decision to participate has been made, the next decision the worker faces is how many hours of work to provide? In this section, we look first at the determinants of hours of work, without distinguishing between forms of employment, and then separately examine the determinants of hours of work for each form of employment. Since individuals are not randomly selected into each employment state, we need to correct the disaggregated hours of work equations for selectivity using the multinomial logit selection equation.[13] The hours equations are identified by the exclusion of non-wage male workers that were included in the participation equations.

Table 6 shows the determinants of hours of work in any form of economic activity and Tables 7 and 8 show the determinants of hours of work in specific forms of employment in urban and rural areas, respectively.[14] In all cases, the dependent variable is log annual hours. We first note that the reference female in rural areas puts in longer hours than the reference urban female. Again this is due to the definition that allows subsistence activities in agriculture to be considered economic activity but not those outside agriculture. Because work in urban areas is more likely to be paid work outside the home, the supply of work hours has a much better defined age profile than in rural areas. Hours of work in any sort of employment peak at age 41 in urban areas and at 32 in rural areas, but in fact the pattern with age is essentially flat. From Tables 7 and 8, we can see that the strong dependence of work hours on age is not reflected in any of the disaggregated employment states. The only states where age is a statistically significant determinant of hours is non-wage agricultural work in urban areas and non-wage non-agricultural work in rural areas. This suggests that the strong dependence on age in the urban hours equation shown in Table 6 is due to changes in the likelihood of participation in the various employment states over the life cycle rather than changes that occur within each state. As we have seen before, regular wage employment, which has the highest number of hours, peaks in urban areas between the ages of 20 and 40, thus raising the supply of hours for these age groups.

There are no significant differences in hours of work among regions in urban areas. In rural areas, female workers in Upper Egypt supply fewer hours that their counterparts in Lower Egypt. As expected, the large metropolitan regions, Greater Cairo and Alexandria, supplied fewer hours in agricultural non-wage work (Table 7). The difference in hours supplied between female workers in Upper and Lower Egypt can be attributed to fewer hours spent in such work. Rural Upper Egyptian women are therefore less likely than their Lower Egyptian counterparts to engage in agricultural non-wage work and, when they do, they

Table 6. Hours of Work – Corrected for Selectivity using Aggregated Participation Equation Dependent Variable ln (annual hours), Females Ages 15–64.

Variables	Urban	Rural
Constant	1.949	7.111***
	(1.301)	(26.245)
Age	0.217***	0.023*
	(4.087)	(1.765)
Age Squared/100	−0.266***	−0.035**
	(−3.979)	(−2.018)
Greater Cairo	−0.020	
	(−0.262)	
Alexandria and Suez Canal Cities	−0.058	
	(−0.680)	
Urban Upper Egypt	−0.116	
	(−1.162)	
Rural Upper Egypt		−0.188***
		(−2.922)
Ability to read and write	−0.174	−0.127
	(−1.111)	(−1.062)
Primary	0.132	−0.602***
	(0.870)	(−4.140)
Preparatory	0.019	−1.176***
	(0.130)	(−7.566)
Secondary and Above	0.740***	0.119
	(2.597)	(1.470)
Head of Household	0.056	−0.002
	(0.622)	(−0.027)
Unmarried	0.301**	−0.04
	(2.490)	(−0.668)
No. of children 0–2	0.003	−0.020
	(0.061)	(−0.702)
No. of children 3–6	0.003	−0.011
	(0.077)	(−0.494)
Presence of other females 12–64	−0.002	0.045
	(−0.042)	(−0.787)
Male wage worker in household	0.109	−0.223***
	(1.623)	(−3.534)
Total male wage earnings (in 000s LE)	−0.007	0.084**
	(−0.442)	(2.471)
Participation selection term	0.582*	−0.248***
	(1.875)	(−2.617)
No. of Observations	1682	2333
R−Squared	0.071	0.073

t-stats are in parentheses. Significance of the coefficients at the 1% (***), 5% (**) and 10% (*) level is marked.

Table 7. Hours of Work in Each Employment State – Corrected for Selectivity Using Disaggregated Selection Equation, Females Ages 15–64, Urban Areas.

Variables	Non-Wage Agric. Work.	Non-Wage, Non-Agric. Work.	Regular Wage Work.	Casual Wage Work.
Constant	4.149 ***	5.827 ***	7.590 ***	-0.822
	(2.777)	(4.316)	(4.914)	(-0.080)
Age	0.097 *	0.047	0.055	-0.243
	(1.691)	(0.830)	(1.010)	(-1.539)
Age Squared/100	-0.132 *	-0.027	-0.072	0.250
	(-1.773)	(-0.391)	(-1.039)	(1.083)
Greater Cairo*	-1.443 **	0.121	-0.007	3.542 **
	(-2.183)	(0.591)	(-0.118)	(3.229)
Alexandria and Suez Canal Cities	-1.115 ***	-0.245	0.036	3.097 *
	(-3.380)	(-0.661)	(0.537)	(1.749)
Urban Upper Egypt	-0.780 *	-0.154	-0.007	2.763 ***
	(-1.745)	(-0.540)	(-0.097)	(2.585)
Ability to read and write	-0.574	-0.290	-0.108	-0.893
	(-0.625)	(-1.017)	(-0.690)	(-0.574)
Primary	-0.021	0.168	-0.547 ***	-2.116
	(-0.034)	(0.463)	(-2.821)	(-0.751)
Preparatory	0.425	-1.143 ***	-0.345 *	-2.210
	(1.077)	(-2.617)	(-1.750)	(-1.354)
Secondary and Above		-0.093	-0.927 ***	-1.632
		(-0.273)	(-2.599)	(-0.704)
Head of Household	0.023	0.270	-0.004	2.001
	(0.047)	(1.069)	(-0.052)	(1.486)
Unmarried	-0.208	-0.208	-0.071	1.337
	(-0.572)	(-0.903)	(-0.627)	(0.648)
No. of children 0–2	0.128	0.108	-0.028	0.105
	(0.742)	(0.740)	(-0.632)	(0.055)
No. of children 3–6	0.196	-0.044	0.022	-0.742
	(1.542)	(-0.401)	(0.680)	(-1.127)
Presence of other females 12–64	0.306	-0.044	0.069	1.220
	(0.689)	(-0.233)	(1.288)	(1.300)
Male wage worker in household	0.238	0.186	-0.071	-0.042
	(0.732)	(0.743)	(-1.009)	(-0.045)
Total male wage earnings (in 000s LE)	-0.537 ***	-0.131	0.012	0.027
	(-2.706)	(-1.111)	(0.975)	(0.161)
Participation selection term	0.615 *	-0.094	-0.347	2.576
	(1.659)	(-0.331)	(-1.528)	(0.767)
No. of Observations	154	248	1242	38
R-Squared	0.147	0.157	0.084	0.602

t-stats are in parentheses. Significance of the coefficients at the 1% (***), 5% (**) and 10% (*) level is marked.

Table 8. Hours of Work in Each Employment State – Corrected for Selectivity Using Disaggregated Selection Equation, Females Ages 15–64, Rural Areas.

Variables	Non-Wage Agric. Work.	Non-Wage, Non-Agric. Work.	Regular Wage Work.	Casual Wage Work.
Constant	7.458***	6.258**	6.127**	5.994***
	(27.89)	(2.413)	(2.101)	(4.083)
Age	0.000	0.122*	0.103	0.034
	(0.009)	(1.822)	(1.237)	(0.684)
Age Squared/100	-0.008	-0.161*	-0.134	-0.067
	(-0.419)	(-1.797)	(-1.227)	(-0.955)
Rural Upper Egypt	-0.367***	0.064	-0.059	-0.283
	(-5.167)	(0.347)	(-0.331)	(-0.858)
Ability to read and write	-0.173	-0.632*	0.158	1.046
	(-1.280)	(-1.775)	(0.352)	(1.462)
Primary	-0.958***	-0.247	-0.198	-0.823
	(-5.695)	(-0.502)	(-0.392)	(-1.274)
Preparatory	-1.654***	0.193	-1.002**	0.110
	(-10.10)	(0.354)	(-1.989)	(0.106)
Secondary and Above	-0.977***	-0.303	-0.425	-1.552
	(-4.292)	(-0.550)	(-0.366)	(-1.021)
Head of Household	0.129	0.059	-0.025	0.272
	(1.388)	(0.235)	(-0.114)	(0.547)
Unmarried	0.029	-0.065	0.033	-0.148
	(0.423)	(-0.234)	(0.191)	(-0.499)
No. of children 0-2	-0.040	0.121	0.022	0.004
	(-1.311)	(0.949)	(0.270)	(0.024)
No. of children 3-6	0.010	-0.152	-0.047	-0.067
	(0.411)	(-1.578)	(-0.815)	(-0.649)
Presence of other females 12–64	-0.085	0.341	0.057	0.094
	(-1.238)	(1.551)	(0.338)	(0.359)
Male wage worker in household	-0.116	-0.522**	-0.125	-0.093
	(-1.530)	(-2.410)	(-0.755)	(-0.329)
Total male wage earnings (in 000s LE)	0.003	0.267**	0.018	0.133
	(0.079)	(2.156)	(0.288)	(1.440)
Participation selection term	-0.085	-0.765	-0.064	0.158
	(-1.102)	(-0.946)	(-0.104)	(0.288)
No. of Observations	1619	286	243	185
R-Squared	0.125	0.111	0.080	0.081

t-stats are in parentheses. Significance of the coefficients at the 1% (***), 5% (**) and 10% (*) level is marked.

spend fewer hours in it. This appears to be also true for casual wage work as well, which, in rural areas, would be mostly in agriculture. While reduced casual wage work is understandable in light of the more conservative social norms in Upper Egypt because it involves work outside the home, reduced agricultural non-wage work is not. It may be attributable instead to the lesser access Upper Egyptian households have to agricultural land and farm animals.[15]

In the aggregated hours equation shown in Table 6, education has no effect on hours until the secondary level, at which point hours increase markedly. In rural areas, hours decline at the primary and preparatory levels, but are about the same for secondary school graduates and above as for illiterates. Again these results are mostly due to compositional shifts rather than changes in hours within the same form of employment. In fact, the increase in hours at the secondary level in urban areas can be fully attributed to the shift toward regular wage employment at that level. Among regular wageworkers in urban areas, having a secondary education or above *reduces* hours of work (Table 7). Illiterate women who work for wages, most of whom are probably household servants, work many more hours than ones with either primary or secondary education, who tend to be in the formal sector. In rural areas the reduction in hours for women with some formal schooling is probably due to a shift away from non-wage agricultural work, which has relatively long hours in rural areas. This is further reinforced by the strong negative effects education has on hours within that employment state.

In the aggregated analysis, unmarried women have longer work hours in urban areas but not in rural areas. Since being unmarried has no statistical significant effect on hours within each employment state, we conclude that the overall effect is also due to compositional shifts in employment types with marriage. We also note that none of the children variables nor the adult female variable has an effect on hours either overall or in any employment state.

The presence of a male wageworker in the household has a strong negative effect on overall hours for rural females, but no statistical significant effect for urban females. The rural effect comes primarily from reduced hours in non-wage employment outside agriculture. Surprisingly, however, the number of hours in such employment rises with male wage income, contradicting the earlier result that self-employment outside agriculture dropped with higher levels of income. This result is particularly puzzling as well because it contradicts what one would expect for the effect of unearned income from the standard labor supply model.[16]

Finally, there is little evidence of non-random selection into the various employment states once the observables have been taken into account. The selectively correction terms are statistically insignificant or very weakly significant.

V. CONCLUSION

Our investigation of the determinants of female labor force participation and hours of work has shown that a great deal of insight can be gained from disaggregating work into several employment states. We have shown that this sort of disaggregation not only matters from a statistical point of view, but also allows for a much richer and more nuanced analysis of the factors that affect women's decision whether to be economically active and what sort of activity to engage in. We hope that we were able to convince the reader that all forms of work are not the same and that the form of work a woman engages in depends strongly on the point she is at in her life-cycle, her education, where she lives, and, most importantly, what role she plays in her household and the status of other members of her household.

We have shown that age and education are very important determinants of the form of participation and the level of participation in each form. For example, we found that participation in regular wage work is essentially limited to women with at least a secondary education who are between the ages of 20 and 40. Most other women appear to be excluded from this seemingly desirable form of participation. Casual wage work is primarily the domain of younger women with low levels of education. Other forms of employment are not strongly determined by age, but are powerfully determined by education. Non-wage work, whether in or outside agriculture, declines with education. This suggests that programs targeting secondary and university graduates with loans to start their own businesses are targeting the wrong group, at least among women.

We have also shown that the effect of age and education on the number of hours of work supplied is primarily due to how education and age affect the sort of employment a woman engages in rather than the number of hours in any given type of employment. In fact secondary education, which appears to increase hours of work does so only because it substantially increases regular wage employment. Among regular wage employees, secondary education *reduces* hours of work.

A woman's role in her household is also a determinant of the kind of economic activity she is likely to engage in. As expected married women are less likely to engage in market work. We find however, that there is no additional effect on participation with the presence of young children in the home. Women reduce their participation at marriage and those that do withdraw from market work do not return to it after their children are older. Marriage appears to have a negative effect on hours supplied as well, but that effect is also due to compositional shifts in the type of participation at marriage rather than to reduced hours in any given type of work. The presence of young children does

not further reduce the number of hours supplied, once the effect of marriage has been taken into account.

The presence of other potential caregivers in the household does not have the expected effect. In fact, the presence of other adult women seems to reduce women's participation rates, suggesting that they add to a woman's domestic burden. This is especially true in rural areas where extended family households are more common.

Female household heads, because of their need for cash income, are much more likely to participate in market work than their counterparts who are not household heads. However, because they, for the most part, do not have the necessary educational qualifications to get regular wage work, they are limited to self-employment and casual wage work, in rural areas.

The employment status of male members of the household is also an important determinant of women's employment behavior. Male wageworkers appear to facilitate women's entry into regular wage labor, probably through contacts and information. The income from male wages has a negative effect on participation, as one would expect from the theory of labor supply, but the effect is only statistically significant for urban women engaged in non-wage work in and out of agriculture. Male wage income also reduces female hours in non-wage agricultural work in urban areas, but unexpectedly increases female hours in non-wage non-agricultural work. On the whole, self-employment outside agriculture appears to be an inferior form of employment that only female household heads and women who have limited access to income from a spouse engage in. It can therefore be used as a means to target poor women in microenterprise and other sorts of production, marketing and training assistance.

As expected, the presence of a male farmer, which is an indication of the presence of a family farm, increases women's participation in non-wage agriculture. However, the presence of a male non-wage worker outside agriculture, which is an indication of the presence of a family business does not increase women's non-wage participation outside agriculture. This is an intriguing result that suggests that women do not participate in the non-agricultural businesses of their male kin.

The patterns described above result from a complex interaction of past and present policies and social norms and therefore do not lend themselves to simple policy prescriptions. However they have some important implications for some of the currently popular microenterprise and microcredit programs aiming to alleviate poverty and reduce youth unemployment. Directing these programs to unemployed educated youth, especially educated females, seems unwarranted given their tendency to shun self-employment. On the other hand female heads of household, who have a strong incentive to work, but who appear to be

excluded from the paid labor market, could greatly benefit from such credit programs.

A number of issues related to gender and work in Egypt have not been tackled in this paper. For example, the paper did not distinguish between public and private sector wage employment. Would education continue to have such a strong effect on obtaining regular wage employment for women if such employment were limited to the private sector? Do private sector employers place much value of these educational credentials? Given the association between labor-intensive, export-oriented manufacturing and an increase in female paid employment in other countries, did Egypt's failure to promote such industries limit women's prospects in the paid labor market? Another issue that was not addressed here is the extent to which women's labor market choices are constrained by their more limited geographical mobility, both in a migration and a commuting sense. Could their ability to participate in the labor market and the form of their participation in it be determined by the structure of labor demand in their local community? If so, what does this imply for policies that influence the location of economic activities? Answers to these questions must await further research.

NOTES

1. See Papps (1992) for a review of the literature on women and work in the Middle East.

2. http://www.ilo.org/public/english/120stat/res/ecacpop.htm The qualification that non-market production and or processing of primary commodities must comprise "an important contribution to household consumption" to be counted as economic activity has proven difficult to apply in practice. The definition of economic activity currently used in Egyptian labor force surveys considers any individual engaged in the production or processing of primary commodities (agriculture, fishing, hunting, and mining) for at least one hour a week to be economically active, regardless of whether the activity is for the purpose of own consumption or market exchange and irrespective of the activity's contribution to household consumption.

3. While it is not possible to distinguish between market and non-market activities for this category of female workers in the survey we are using, it is possible to do so in the Egypt Labor Market Survey 1998. That survey indicates that 93% of female agricultural non-wage works engage exclusively in production for own use. See Assaad (1999, p. 20).

4. Besides asking the question about work directly, the October 1988 LFSS used a series of six screening questions to detect participation in economic activity.

5. The test is as follows: In a multinomial logit model with S+1 states, assume that there are two states that are likely to be pooled, e.g. s1 and s2. The null hypothesis is that the two states have the same regressor coefficients, or:

$$\beta_{s1} = \beta_{s2} = \beta_s \tag{1}$$

To test this hypothesis, we use the test statistic
$$LR = 2(\log L - \log L_R), \qquad (2)$$
where log L is the maximum likelihood of the original model and log L_R is the maximum likelihood if the estimates are constrained to satisfy (1). Crammer and Ridder (1991) show that the restricted maximum likelihood is given by:
$$\log L_R = n_{s1} \log n_{s1} + n_{s2} \log n_{s2} - n_s \log n_s + \log L_p \qquad (3)$$
Where log Lp is the unconstrained maximum of the log-likelihood of a model where the two states are pooled into one, and nj is the number of observations in each group. The test follows chi-square distribution with k degrees of freedom, where k is the number of restrictions implied by (1).

6. The standard errors we report are corrected for the inclusion of a predicted regressor.

7. The lower fertility rate in urban areas is readily apparent in the smaller number of children under six for all categories of women.

8. The predicted probabilities do not show the increase from secondary to university because the model lumps all secondary education and higher into a single category to avoid the problem of very sparse cells.

9. We use the SVY routines of STATA to correct the standard errors for the cluster design of the sample.

10. We do not distinguish between educational levels beyond the secondary because of very scarce cells in the non-wage work category at these levels.

11. Normally the employment decisions of other members of the household should be considered endogenous to the woman's decision. However, we assume that in the socially conservative cultural context of Egypt, it is fair to assume that male household members make their decisions on employment independent of those of female members. See Assaad (1997b) for further discussion of this issue.

12. Connelly, DeGraff and Levison (1996) found a similar negative effect of the presence of adult women aged 25–54 in the case of Brazil.

13. The aggregated hours of work equations are also corrected for selectivity in the working females sample.

14. For purposes of this analysis we assume that the various employment states are mutually exclusive even though a small proportion of women engage in more than one form at one time. We should also caution that the measurement error is probably larger for non-wage workers and casual wage workers than it is for regular wage workers.

15. The lower female participation in non-wage agricultural work in rural upper Egypt could also be due to the fact that conservative social norms there make male and female labor less substitutable. See Commander (1987).

16. Given the relatively small sample of non-wage non-agricultural workers in rural areas, these contradictory results need to be tested further using other data sets.

REFERENCES

Anker, R. (1990). Methodological Considerations in Measuring Women's Labor Force Activity in Developing Countries: The Case of Egypt. In: I. Serageldin (Ed.), *Research in Human Capital and Development,* 6 (pp. 26–58).

Assaad, R., & El-Hamidi, F. (forthcoming). Female Labor Supply in Egypt: Participation and Hours of Work. In: I. Sirageldin (Ed.), *Population Challenges in the Middle East & North Africa: Towards the 21st Century*. New York: Macmillan.

Assaad, R., El-Hamidi, F., & Ahmed, A. U. (2000). *The Determinants of Employment Status in Egypt*. Discussion Paper 88, International Food Policy Research Institute, Washington D.C.

Assaad, R. (1997a). The Employment Crisis in Egypt: Current Trends and Future Prospects. Forthcoming in: K. Pfeifer (Ed.), *Research in Middle East Economics*, Vol. 2. Greenwich, Conn.: JAI Press.

Assaad, R. (1997b). The Effects of Public Sector Hiring and Compensation Policies on the Egyptian Labor Market. *World Bank Economic Review, 11*(1), (January).

Commander, S. (1987). *The State and Agricultural Development in Egypt since 1973*. London and Atlantic Highlands. N.J.: Ithaca Press for the Overseas Development Institute, London.

Connelly, R., DeGraff, D., & Levison, D. (1996). Women's Employment and Child Care in Brazil. *Economic Development and Cultural Change, 44*(3), 619–656.

Cramer, J. S., & Ridder, G. (1991). Pooling States in the Multinomial Logit Model. *Journal of Econometrics, 47*, 267–272.

Greene, W. H. (1993). *Econometric Analysis*. Second Edition. New York: Macmillan.

Lee, L. F. (1983). Generalized Econometric Models with Selectivity. *Econometrica, 51*, 507–512.

Moghadam, V. (1998). *Women, Work and Economic Reform in the Middle East and North Africa*. Boulder: Lynne Rienner Publishers, 1998.

Olmsted, J. (1996). Women 'Manufacture' Economic Spaces in Bethlehem. *World Development, 24*(12) 1829–1840, December 1996.

Papps, Iv. (1992). Women, Work and Well Being in the Middle East: An Outline of the Relevant Literature. *Journal of Development Studies, 28*(4), 595–615, July 1992.

MEN'S WORK/WOMEN'S WORK: EMPLOYMENT, WAGES AND OCCUPATIONAL SEGREGATION IN BETHLEHEM

Jennifer Olmsted

ABSTRACT

In this paper I examine differences in labor patterns in the Bethlehem area by sex. I find that there is considerable occupational segregation, as well as a wage gap between men and women, particularly among less educated women. This wage gap is accentuated by men's and women's differential opportunities vis à vis the Israeli economy. Men working in the Israeli sector, primarily in the construction sector, receive a wage premium, while women, who work primarily as subcontractors to Israeli textile and garment producers, do not and are among the lowest paid workers in the economy.

I. INTRODUCTION

An important topic within the field of labor economics concerns the scope and cause of occupational segregation and wage differences by sex. The debate over levels and causes of occupational segregation and wage differences is an on-going one in the economics literature. Some labor economists argue that

employment differences between men and women are primarily a matter of choice and that wage differences are a matter of skill differences, while others argue that the structure of the economy, as well as sexism and rigid gender role ideology are behind both occupational and wage differences between men and women. With the exception of a few studies, most of the research which attempts to quantify occupational segregation and the wage gap has used data from the U.S. and Europe. In particular, very little has been written about differences between male and female employment patterns in Southwest Asia and North Africa (SWANA). This is particularly true for the Palestinian population, where much of the published research has focused on the political situation or the social conditions, but little has looked at gender and labor issues. In this paper I begin to address this gap in the literature by providing an analysis of employment and wage data for Palestinians from the Bethlehem area, using data I collected in 1991.

One of the most comprehensive studies of occupational segregation, which provides comparisons from throughout the world is provided by Anker (1997, 1998), who also does an excellent job of synthesizing the literature on occupational segregation. He rejects the neoclassical argument that segregation is a matter of choice and specifies particular gender stereotypes which lead to women (and to a lesser degree men) being over/underrepresented in certain professions. Table 1 on page 325 of his 1997 paper provides a list of stereotypical characteristics associated with 'women's work.' These include women's roles as care givers, their skill in house cleaning and management, their manual dexterity, honesty and attractiveness. He also provides a list of positions where women are generally overrepresented, which coincide with one or more of the above attributes. These include the positions of nurse, doctor, teacher, maid, cook, sewer, knitter, typist, cashier, receptionist and shop assistant, among others.

A separate, but related literature has attempted to distinguish between wage differences which are due to skill, educational or experience differences between workers from those based on factors such as sex or race. Gunderson (1989) summarizes the standard ways in which wage differences due to sex discrimination have been estimated empirically.

In this paper, I follow both Gunderson and Anker, providing a detailed analysis of the wage and occupational differences between men and women living in the Bethlehem area of the West Bank. My paper includes six sections. Following the introduction, section two includes an econometric model of labor force participation for men and women in the Bethlehem area. Labor force participation is modeled as a function of various household and individual characteristics. Because determinants of men's and women's labor force participation tend to differ, especially the signs on some coefficients, separate

models are run for men and women. Next, I discuss employment patterns by occupation and sex. Descriptive statistics, as well as a measure of occupational segregation, are used to describe the type and level of occupational segregation among these Palestinian workers. Also included is a brief discussion of how patterns in Bethlehem are similar or different from those found in other parts of the Arab region and the world. In Section IV, I provide an in-depth analysis of wage patterns, comparing men and women across different education levels and occupations. In addition, I carry out a wage analysis for two occupations, teaching and textiles, where most female workers work. Before concluding, I provide a discussion of how the unique structure of the Palestinian labor market, with its links to the Israeli economy, contributes to patterns of employment and payment by sex.

II. PATTERNS OF EMPLOYMENT

Extensive micro-level socio-economic data for the Palestinians in the West Bank and Gaza have not been readily available historically, although changes since the peace process and the establishment of a Palestinian statistical agency have meant that this problem is now being remedied. Since the 1967 occupation, the Israeli government has collected some statistics, but these were not always considered reliable because of the level of mistrust between the military government and the Palestinian people. In addition, the level of detail about household and individual characteristics needed for this type of study was not generally available. Because of the lack of data at the time I was completing my dissertation, in the fall of 1991, I designed and carried out a household survey with the help of two field workers. A random sample of 262 households was surveyed in three villages, two towns and one refugee camp in the Bethlehem area. In each community 3% of town households were surveyed, and 6% of village and refugee camp households were interviewed.[1] One household member was interviewed about his or her family members (children, siblings and/or spouse). Data were collected on individual characteristics, such as age, education, pre and post Gulf war employment status, wages and hours, as well as household characteristics, including size of house, refugee status and religion, etc. While the data were collected in a small area of the West Bank, making generalizations about the entire West Bank and Gaza difficult, they can provide scholars with a preliminary idea about patterns of employment and the degree of occupational segregation among Palestinians.

In my survey 19% of women and 80% of men in the Bethlehem area were involved in income generating employment.[2] The figures of 19% for women and 77% for men are reported by Heiberg and Ovensen (1993, p. 387), for the

entire West Bank region, suggesting that my figures correspond with findings from other studies and that Bethlehem area labor force participation rates for women are similar to those in other parts of the West Bank. Actual occupational patterns though may be somewhat different, given that Bethlehem is a more urban area, closer to Jerusalem, and also given that industrial mixes differ in different parts of the West Bank.

How do Palestinian women's labor force participation rates compare with the rest of SWANA? Labor force participation figures for the region range from 8 to 48% for Algeria and Turkey respectively (World Bank, 1995), with a mean value of 20 and median of 19%, suggesting that Bethlehem is average for the region.[3]

In order to get a better idea of the specific characteristics of labor force participants, a number of probit equations were estimated, with labor force participation (0=not in labor market, 1=in labor market) being modeled as a function of sex, education, religion, number of children, marital status, age and some proxies for wealth or non-wage income. The results of these are presented in Table 1. Because some of these variables are expected to affect men and women in different ways, separate equations were run for men and women, as well as a single equation which combined both.

As can be seen in the first column of Table 1, sex is an important determinant of labor force participation, with men being far more likely to work than women. With the possible exception of age, the coefficients on the other variables in the first column are less helpful, since, as can be seen in the last two columns, most of the variables affect men's and women's labor force decision quite differently and often in the opposite direction. From the last two columns one can see how labor force participation of men and women varies with age, marital status, number of children, and education. The effect of age is fairly predictable for both men and women with a positive coefficient and then a negative square term, suggesting a concave function. Both men and women's labor force participation rates increase and then decrease with age.

The more interesting, but not entirely surprising, results surround some of the other variables, particularly education. Four terms were included to capture the effect of education. These included schooling (in years) and schooling squared, plus two dummy variables, one to capture the effect of having a post high school degree (Higher Degree =1) and the other to account for the fact that particularly among the younger cohort, some are still studying (Still Studying =1). While for men increased schooling is positively associated with a higher probability of working, in the case of women, schooling enters negatively, with schooling squared having a positive impact, thus suggesting a convex relation between women's schooling and work.[4] In other words, those

Table 1. Determinants of Labor Force Participation.

Variable	All $N = 2117$ $F = 24.30$	Women $N = 1072$ $F = 24.91$	Men $N = 1045$ $F = 28.82$
Constant	−0.9* (0.31)	−1.94* (0.46)	−0.55 (0.43)
Sex (Women = 1)	−1.68* (0.07)	−	−
Schooling	0.02 (0.03)	-0.07** (0.04)	0.08* (0.04)
Schooling2	0.002 (0.002)	0.006* (0.003)	−0.003 (0.002)
Higher Degree (= 1)	0.88* (0.15)	1.20* (0.22)	0.50* (0.21)
Still Studying (= 1)	−1.91* (0.17)	−1.24* (0.28)	−2.05* (0.20)
Age	0.10* (0.01)	0.09* (0.02)	0.04* (0.02)
Age2 (0.000)	−0.001* (0.000)	−0.001* (0.000)	−0.001*
No. of cars	0.007 (0.08)	−0.18* (0.05)	0.09 (0.08)
Religion (Christian = 1)	0.21* (0.08)	0.3* (0.12)	0.2** (0.12)
Married (= 1)	−0.26* (0.09)	−0.89* (0.13)	0.66* (0.15)
No. of dep children	−0.007 (0.04)	−	−0.77* (0.03)
No. of children	0.02 (0.02)	0.06* (0.02)	−
No. of children under 6	−0.07 (0.06)	−0.11** (0.07)	−
No. of migrants	−0.06* (0.02)	−0.05** (0.03)	−0.06* (0.03)

Note: Standard Error in parenthesis.
* denotes 10% and ** denotes 15% significance.

with very low levels of education, as well as those with very high levels are the most likely to work. A number of effects are being captured here. Professionals, who tend to be quite educated, make up the largest group of female workers, but there are also large groups of women workers in the agriculture, production and service sector with low education levels.[5]

In addition to the impact of the schooling variables, the higher degree variable captures the even greater positive effect of having a post high school degree on women's labor force participation rates. The coefficient on the higher degree variable is positive for both men and women, but is much larger in the women's equation. One interpretation of this variable is the opportunity cost or reservation wage argument, (Mincer, 1962) which says that women with more education can earn higher wages and therefore give up more by staying out of the labor market. I have argued elsewhere that in the case of Palestinian women, this variable may also be acting as a proxy for increased social acceptance of labor force participation (Olmsted, 1998). Finally, and not surprisingly, the dummy variable for those who were still studying was strongly negative, suggesting that students are unlikely to work while in school.

The effect of marriage differs for men and women. Single women and married men are more likely to be in the labor force. As in most patriarchal societies, women are defined primarily as economic dependents, while men are seen as the bread winners. Once a woman marries she is thus less likely to work.[6] Men on the other hand, since they are defined as the economic providers, are more likely to work if married, primarily because they have more economic responsibilities.

A number of different variables were included to look at the impact of children on labor market behavior. For men the variable with the most explanatory power was number of dependent children, for which the coefficient was positive, suggesting that the more dependents a man has the more likely he is to work. It is generally assumed that women with more children will be less likely to participate in the labor market, but, in this case, the results do not support this conclusion. In fact, total number of children had a positive impact on women working, while having children under the age of 6 had only a small negative (and statistically weak) effect on women. This outcome has a number of interpretations. First, one could argue that families with more children have more economic need, explaining the positive sign on the total number of children variable. Another interpretation is that in larger families older siblings may take over the responsibility of caring for younger children, thus freeing the mother to return to the labor market. Finally, number of children may not be an important negative determinant of labor force participation for women, because many women may leave the labor market upon marriage, with the

expectation that they will have children. In this case, marriage, but not the number of children, will be a more important negative determinant of labor force participation.[7]

To capture the possibility that women in families with greater economic need are more likely to work, a number of variables were included as possible, but imperfect proxies for wealth or non-wage income. Size of house, number of cars owned by a household, and number of migrants were included as proxies of wealth or non-wage income. House size was statistically insignificant in all equations and was thus dropped from the analysis. The coefficient on the number of cars variable in the women's equation was negative, suggesting that women in families with more wealth are less likely to work.

Number of migrants was also included as a proxy to capture certain forms of non-wage income, since migrants may remit money to families. Also the ability to migrate often suggests the possession of some economic assets, needed to absorb the cost of migrating. Here again, there is a negative effect of migrants on women's labor force participation rates, although the results are statistically weak. The effect is actually stronger in the men's equation, suggesting that households with migrants can afford to have lower local labor force participation rates for men.

Another variable included in the analysis, which may capture both socio-economic and cultural differences is religion (Christian=1, Muslim=0). Shakhatreh (1995) and Grossbard-Shechtman and Neuman (1998) find lower labor force participation rates among Muslim women than among Christians. The econometric results for my sample suggest that Christian men *and* women are more likely to be labor market participants than their Muslim counterparts. Past studies have argued that it is the doctrine of Islam which prevents women from working, but such an interpretation of the religion variable must be done with extreme caution. First, the fact that Muslim men also have lower labor force participation rates than Christian men casts doubt on this assertion. In addition, evidence from Papps (1993) suggests that Islam is not universally associated with lower women's labor force participation rates. As Papps also points out, lower labor force participation rates are not necessarily found among families articulating a greater degree of religiosity. It should be recalled that within the region (Israel, Palestine, as well as surrounding Arab countries) persons are generally identified by their religion, whether they practice or not. Within each group identified as 'Christian' or 'Muslim' there is a great deal of variation in practice, as well as in degree of religiosity. Finally, the religion variable may be capturing unmeasurable socio-economic differences between Christians and Muslims. For instance, Christians, are more likely to live in an urban community. Also, because of their status as a minority group, they have

pursued different economic strategies than Muslims. In particular, Christian women may have fewer marriage opportunities because of high emigration rates among Christian men.

It is pretty clear just from looking at the raw percentages that women's labor force participation rates (19%) are still far below men's (80%). The above analysis sheds some light on why. Women who are most likely to work are single women, those with high levels of education, Christian women and those with increased economic need. Married women and those with low education levels (although not the lowest) are much less likely to work. As will be discussed in the next section, one factor driving this result may be that employment opportunities, particularly for women with less education, are somewhat limited.

III. OCCUPATIONAL PATTERNS

A closer examination of the employment data from my survey can answer the questions, where are Bethlehem area Palestinian women and men likely to work, and are occupations segregated by sex? Table 2 provides a breakdown of employment by occupational sector and sex.

While women represent only 23% of the total labor force, they represent 38% (60/158) of professional workers. At the same time, they are seriously underrepresented in the production sector (textiles, construction and other production), where they represent about 12% (49/393) of workers. The textiles industry is about the only production industry which employs women. The dominant industry for men is construction, where no women are employed.

The good news is that women are overrepresented in professional fields, suggesting that women do have access to higher paying, more prestigious positions in the West Bank. This 'good news' though must be viewed with intrepidation for two reasons. Professional employment generally requires more education and educated women are far more likely to work for a number of reasons, thus women are overrepresented in the professional sector primarily because they have a higher probability of being in the labor market. In addition, it should be noted that within the professional classification, women are highly concentrated in a few areas. Eighty percent of all professional women are concentrated in two stereotypically female occupations: teaching and nursing. By contrast only 40% of professional men are teachers or nurses. Professions which have few if any female representatives include medicine (other than nursing), engineering and accounting.

The remaining women, most of whom have less education, are primarily grouped into two areas, agriculture and textiles. Since the importance of

Table 2. Employment Sector by Sex.

Occupation	All	Women	Men
Professional	158 20%	60 32%	98 16%
Administrative	13 2%	2 1%	11 2%
Clerical	12 2%	4 2%	8 1%
Sales	78 10%	14 8%	64 10%
Service	51 6%	16 9%	35 6%
Agriculture	47 6%	20 11%	27 4%
Construction (Production)	165 21%	0 0%	165 27%
Textiles (Production)	58 7%	42 23%	16 3%
Other Production	170 21%	7 4%	163 26%
Unemployed	53 7%	20 11%	33 5%
Total	805 100%	185 100%	620 100%
Labor force part. rate	–	19%	80%

Source: 1991 household survey conducted by author.
Note: % = No. in occupation/total for all, women and men respectively.

agriculture has diminished, particularly after the Israeli occupation, this sector can no longer be considered a viable economic option for most of the younger cohort. In fact, most of the women in agriculture are older, village women who are working on their family land. Younger women, especially from urban and/or refugee populations, have little or no access to land. Women in need of income, but with few skills and no access to land, end up working in either the garment or the service industry, in some of the lowest paying, least desirable jobs.[8] Less skilled men by contrast, have access to the highly lucrative construction industry jobs.

The service and sales sectors together employ between 17% of women and 16% of men, but the types of jobs men and women do differ considerably. Within the service sector, 75% of the women work as cleaners and housekeepers. 17% of men in the service sector also work in cleaning, but men also hold positions as clerks, telephone operators, cooks and guards, occupations which do not appear open to women. In addition 17% of men in the service sector are entrepreneurs who own restaurants.

While there are no women entrepreneurs in the service sector, within the sales category almost all the women are self-employed. Women, it seems, have very little access to positions as employees in small retail shops, positions which in other parts of the world are seen as 'women's work.' Instead, all but one of the women in the sales category are entrepreneurs, often running small family grocery stores. This suggests that women in the sales sector enjoy a certain amount of autonomy, but it should also be noted that they appear to be excluded from retail sales positions. In addition, the types of businesses women run tend to be smaller, and less lucrative than male run businesses. Men for instance own factories and wholesale distribution centers as well as butcheries and bakeries.[9]

One important difference between male and female employment is that there are few occupations with no men in them. Men make up 30% of all nurses, 50% of all teachers and 27% of textiles workers. In contrast, no women were employed as construction workers, clerics (priests or imams), guards, drivers, gardeners, carpenters, stonecutters, blacksmiths, electricians, plumbers, printers or painters. So while it is not impossible for a man to work in a stereotypically female occupation, the opposite is not true. Women are almost completely absent from traditionally male professions.

One exception to this finding is that there are a number of women scientists included in my sample. A disturbing corollary to that is that these women are almost all unemployed! Concerning unemployment more generally, it should be noted also that while women make up about 23% of the labor force, they comprise about 38% of the unemployed and this does not include discouraged workers.[10]

Table 3. Index of Dissimilarity (ID).

COUNTRY or REGION	1 digit ID	2 digit ID	2 digit ID – ag. excluded	number of non-ag. occupations
Bethlehem area	0.27	0.673	0.682	45
Bahrain	0.47	0.635	0.627	86
Egypt	0.53	0.586	0.587	74
Jordan	0.68	0.769	0.776	61
Kuwait	0.50	0.743	0.733	268
Tunisia	0.15	0.663	0.695	55
Average (including Bethlehem)	0.43	0.678	0.683	–
OECD average	0.39	0.600	0.563	–
Ave. for all countries included in Anker	0.37	0.597	0.577	–

Source: Anker, 1998, p. 177, except Bethlehem and Average (including Bethlehem) which were calculated using Anker and data from author's survey

In addition to using descriptive measures to look at occupational segregation, it is also helpful to calculate a single number, such as the index of dissimilarity, developed by Duncan (Anker, 1998), to examine the level of occupational segregation. The index of dissimilarity can range from 0 and 1,[11] with 0 suggesting no occupational segregation and 1 indicating 100% segregation. Using the 1 digit International Labor Organization (ILO) codes to classify occupations, an index of dissimilarity of 0.27 was calculated, suggesting that occupational segregation is not a serious problem among Bethlehem area workers. But as pointed out by Anker, the one digit codes are considered rather unreliable, with two digit codes providing much more accuracy. Using the two digit codes, the index measure jumps to 0.673, and once agriculture is excluded it rises to 0.682.

As can be seen in Table 3, occupational segregation rates in the Bethlehem area appear to be similar to those reported by Anker (1998) for other parts of the Arab world. The index is somewhat lower than for Jordan, which was 0.769,

but higher than the two digit measure for Egypt, which was 0.586. Bethlehem's ranking does not change much with the inclusion or exclusion of agricultural workers.

Although only a small geographical area was covered in this survey, workers employed in a surprising number of occupations were included. As can be seen in the last column, 45 different non-agricultural occupations were included, only 10 fewer than Tunisia. At the same time, given the small geographical area covered by this study and the fact that it was a household survey covering only 262 households, comparisons with national statistics should be done with some care.

Evidence from Tables 2 and 3 suggests that considerable occupational segregation exists in the Bethlehem area and that women are indeed excluded from many of the same types of positions as in other parts of the world. These include the categories manager, construction worker, scientist, engineer and guard. In particular, traditional blue collar men's work appears to still be closed to women.

Similar to international patterns, Palestinian women are bunched into the occupations of nurse, teacher, maid, sewer and typist. Unlike in other parts of the world, the categories of cook, knitter, cashier, receptionist and shop assistant, which are often labeled as 'female occupations' do not contain a large number of females and in fact in some cases are exclusively male occupations. These results are similar to Anker's findings for SWANA as a region and suggest that while there are some occupations which are often almost universally associated with a particular sex, this is not always the case, suggesting that at least some dimensions of occupational segregation are determined by locally defined cultural norms about acceptable gender roles, rather than universally applicable differences between men's and women's abilities or skills.

IV. EARNINGS

The next question to ask is, given that women and men have access to different types of employment, how well are they compensated for their work? An analysis of the determinants of wages can provide an idea of how wages differ by human capital, sex, and other factors in the Bethlehem area. Given the small sample sizes and the number of missing observations in the wage data, all findings concerning wages are tentative and are presented with the caveat that they are based on the rather limited available data.[12]

Table 4 includes mean values for wages, education, age, percent married, hours of work and years of seniority. The first column provides averages for all working men (Palestinian and Israeli sectors), while the second column presents averages for women, who all (except for 2) work in the Palestinian

Table 4. Mean values of Wage and Individual Characteristics.

Variable	Men All	Women All	Men Pal. Sector	Men Isr. Sector
Hourly Wage*+	5.9	4.6	5.3	6.4
Education+	9.7	10.1	10.2	9.2
Age+	33.3	33.8	35.3	31.6
Married*	78%	55%	81%	76%
Hours of work*	170	153	170	170
Seniority+	7.0	7.6	9.4	4.9

Note: Wages in New Israeli Shekels (NIS). In 1991 1 US$ =2.21 NIS approx.
* and + denote statistically significant differences between men and women and men working in Israeli and Palestinian sectors respectively.

sector.[13] In the final two columns averages for men working in the Israeli and Palestinian sectors respectively are given.

Men on average earn higher wages, are more likely to be married and work longer hours than women. Differences between men and women in wages, marital status and hours of work are all statistically significant. Whether comparing to all men or only those in the Palestinian or Israeli sectors, the average wage for women is lower, although women's mean age and education levels are comparable to men's. Statistically significant differences among men by work location include wages, education, age and seniority, with men working in Israel being younger, less educated, and having less seniority, yet receiving higher pay.

Table 5 provides an econometric analysis of the available wage data. Regression analysis was done on logged values of reported wages, adjusted to an hourly rate, as a function of sex, age, age squared, education, seniority and marital status.

Starting with the coefficients in column 1 of Table 5, which is labeled 'All,' and includes all women and men (both those commuting to Israel and those working in the Palestinian sector) for whom wages were reported in the sample, we see that the results on the human capital variables are somewhat standard. Increased education is associated with increased wages. Age is positively and then negatively associated with wages, suggesting that older workers do earn

Table 5. Wage Regression Results.

Variables	1 All $N=395$ Adj. $R^2=0.33$ $F=28.64$	2 All $N=394$ Adj. $R^2=0.46$ $F=31.70$	3 Men $N=331$ Adj. $R^2=0.29$ $F=23.66$	4 Men $N=331$ Adj. $R^2=0.40$ $F=25.31$	5 PalMen $N=152$ Adj. $R^2=0.45$ $F=21.92$	6 Women $N=63$ Adj. $R^2=0.51$ $F=14.04$	7 Women $N=63$ Adj. $R^2=0.61$ $F=17.10$
Constant	5.88* (0.19)	6.13* (0.20)	6.00* (0.20)	6.07* (0.20)	5.40* (0.32)	4.55* (0.37)	5.09* (0.36)
Sex	−0.37* (0.06)	−0.09** (0.06)	−	−	−	−	−
Schooling	0.02* (0.005)	0.02* (0.009)	0.02* (0.006)	0.02* (0.009)	0.02* (0.008)	0.06* (0.012)	0.05* (0.01)
Age	0.04* (0.01)	0.04* (0.01)	0.04* (0.01)	0.04* (0.01)	0.06* (0.02)	0.03* (0.01)	0.03* (0.01)
Age2	−0.0004* (0.000)	−0.0004* (0.000)	−0.0004* (0.000)	−0.0004* (0.000)	−0.0006* (0.000)	−	−
Seniority	0.002 (0.003)	0.005* (0.003)	0.002 (0.003)	0.005** (0.003)	0.006 (0.004)	0.000 (0.009)	0.003 (0.008)
Married	0.04 (0.06)	0.02 (0.05)	0.04 (0.07)	0.03 (0.06)	−0.01 (0.10)	0.14 (0.10)	0.07 (0.09)
Hours	−0.004* (0.00)	−0.004* (0.00)	−0.004* (0.00)	−0.004* (0.00)	−0.004* (0.00)	−0.003* (0.001)	−0.003* (0.001)
Textiles	−	−0.37* (0.08)	−	−	−	−	−0.40* (0.10)
Pal	−	−0.69* (0.18)	−	−0.56* (0.19)	−	−	−
Sch*Pal	−	0.01 (0.01)	−	0.002 (0.01)	−	−	−
Age*Pal	−	0.008* (0.004)	−	0.007** (0.004)	−	−	−

Note: Standard Error in parenthesis.
* denotes 10% and ** denotes 15% significance.

more, but that at the end of a person's career, that trend may be reversed. There do not appear to be additional gains from having extensive experience in a particular occupation, which would have been captured by the seniority variable, measuring how long a person has held a particular job. There does not appear to be a wage premium associated with being married. Hours are negatively related to wages, perhaps suggesting a backward bending labor supply curve, but more likely an artifact of the data.[14] Finally, and most importantly for this analysis, sex (women =1) is an important determinant of wages, with women on average earning less than men, even after correcting for differences in human capital attributes.

The results reported in column 2 of Table 5 include two dummy variables to capture possible differences in earnings for those who work in Israel (Palestinian sector=1, Israeli sector = 0) and in the textiles industry (1 if working in the textiles industry). Because it is possible that the wage structure for those working in the Israeli sector may be quite different from the Palestinian labor market, a dummy variable (Pal), as well as two interactive variables to capture possible differences in returns to experience (Age*Pal) and schooling (Sch*Pal) were included. The large negative coefficient on the Palestinian dummy variable suggests that those working in the Israeli sector do earn a premium.[15] The coefficient on the age variable interacted with the sectoral dummy suggests that there are considerably higher returns to experience in the Palestinian sector. This is not that surprising, since workers in Israel are generally in manual labor positions, particularly in agriculture and construction, where their strength and physical abilities are likely to be valued over experience. The coefficient on the Sch*Pal variable is positive, as expected, but is not statistically significant. Finally, the results on the textiles variable suggest that garment workers receive lower pay than other workers with similar human capital characteristics. In reexamining the sex variable, one can see that most of the differences in wages between men and women disappear when these four variables are added, suggesting that wage differences are closely linked to occupational segregation, primarily because of men's access to employment in Israel[16] and women's crowding into the textiles industry. Finally, in the second column, we see that once the dummy variables for sectors and work in Israel are added, the seniority variable becomes positive and statistically significant.

In the next four columns separate estimates are reported for male and female workers. Three regression equations were run for men, two for all male workers (Men) and one for the subset of workers in the Palestinian sector (PalMen) so that comparisons between men and women working in the Palestinian sector could be made. In columns 3 and 4 results for all working men, with and without the Palestinian sectoral dummies, are reported. These results reinforce

the findings discussed above, that there is a premium for working in the Israeli sector, and that there are greater gains from experience in the Palestinian sector. In column 5 only data for men working in the Palestinian sector were included, in order to be comparable with the data on women's wages, since women almost exclusively work in the Palestinian sector.

Separate equations were also run for women, as reported in the last two columns (6 and 7).[17] One interesting finding is that the coefficient on the schooling variable for women is greater than for men, whether all men or just the men in the Palestinian sector. The negative coefficient on the textiles variable in the final column suggests that even among women, textiles workers are some of the lowest paid. The large positive coefficient on schooling and the large negative coefficient on the textiles variable suggest that the gap in wages due to education may be greater among women than among men. This is not surprising, considering that educated women are likely to be working in the formal sector, as teachers, nurses, etc., while less educated women are limited to garment industry positions. Men, on the other hand, even if they are not highly educated, have access to better paying manufacturing jobs.

Given that women are clustered into particular occupations, such as teaching and textiles, another set of regressions was run to look more closely at the wage structure in occupations where women are likely to be employed. In Table 6 separate OLS results are reported for teachers, textile workers and all production sector workers, including textiles, construction and others, primarily home workers producing souvenirs for the tourist market. Among those for whom wage data were available, women made up about 42% of all teachers, 72% of textile workers, but only 11% of all production workers.

In the first column, which includes all teachers, the coefficients on the sub-sample of wages reveal returns to schooling and seniority, but no evidence of a wage gap between men and women.[18] This suggests that additional education lessens the chance that women will suffer from a wage gap.[19] It should be noted that teachers are generally employed by the United Nations, the government and religious institutions. The lack of a wage gap among teachers suggests that these agencies have done a better job assuring that women and men are equally well compensated.

The same is not true when one looks at column two where the results for the textiles industry are reported. In this sector there appear to be no returns to schooling, but some returns for experience and a significant wage gap between men and women. The gap between lower skill men and women becomes even more evident if one examines the results in the third column, where all women production workers are compared with all men production workers. Here the coefficient on the sex variable doubles.

Table 6. Wage Regressions for Specific Sectors.

Variable	Teaching N = 37 Adj. R² = 0.52 F = 8.875	Textiles N = 28 Adj. R² = 0.39 F = 4.581	All Production N = 258 Adj. R² = 0.36 F = 29.87	All Production N = 258 Adj. R² = 0.44 F = 34.971
Constant	5.60* (0.53)	5.97* (0.36)	6.33* (0.10)	6.13* (0.10)
Sex	0.04 (0.10)	−0.33* (0.15)	−0.76* (0.09)	−0.55* (0.09)
Schooling	0.09* (0.03)	0.005 (0.02)	0.03* (0.01)	0.03* (0.01)
Seniority	0.03* (0.006)	0.02* (0.01)	0.007* (0.003)	0.009* (0.003)
Married	−0.07 (0.11)	0.20 (0.15)	0.14* (0.05)	0.15* (0.05)
Hours of work	−0.006* (0.002)	-0.002 (0.002)	−0.003* (0.00)	−0.003* (0.000)
Pal.	–	–	–	0.31* (0.05)

Note: Standard Error in parenthesis.
* denotes 10% and ** denotes 15% significance.

Is this difference due to men's access to work in the Israeli sector? Adding the dummy variable to capture differences in production workers' earnings based on work in the Israeli and Palestinian sectors decreases but does not eliminate the negative coefficient on the sex variable. Women working in the production sector then suffer from a considerable wage gap, even after accounting for the fact that much of the premium gained by men is due to their access to work inside Israel.

There is significant evidence then of a wage gap between men and women workers in Palestine, at least in the Bethlehem area, and I would argue, no reason to believe that these patterns are unique to this geographical area, since other areas are even more dependent on work in Israel. The wage gap is much larger among less educated women, who not only have less employment options, but receive

very low wages for their efforts. Female textiles workers, who are often employed as subcontractors to Israeli firms, earn some of the lowest wages, which is somewhat ironic considering that for men during the same period there was a considerable premium for working in the Israeli sector. In the next section, a further discussion of the dependency relation between the Palestinian and Israeli economies will be addressed, with a particular focus on the gender implications.

V. EMPLOYMENT AND THE ISRAELI ECONOMY

Palestinian employment was closely linked to the Israeli economy at the time I carried out my survey. Among male workers surveyed, 25% were relying on work inside Israel. In particular, construction, which accounted for almost 27% of all male employment, was linked to the Israeli economy. Seventy-eight percent of the men working in construction at the time of the survey were commuting into Israel and among the rest, a number were working in Israeli settlements. In addition about half of male service sector workers (18 of 35) and about 40% of other male production workers (66 of 163) were earning their wages inside Israel. At the same time, less than 1% of women were commuting into Jerusalem or Israel for work. This suggests that women, at least as individuals, relied less on the Israeli economy for employment.

But such a conclusion would be erroneous for two reasons. First, even if women did not work inside Israel, as daughters, wives and sisters of men working in Israel, they were impacted by the employment prospects of their kinfolk. Secondly, much of women's employment, although physically taking place in the West Bank, was indirectly linked to the Israeli economy. 23% of the women in my sample, for instance, worked in textiles. Much of this work existed because Israeli firms relied on Palestinian women to work as subcontractors. These women worked at home or in small factories, sewing garments which were then shipped back to Israel, for domestic consumption or export. The economic livelihood of these women then was closely linked to economic and political changes in Israel, and numerous women articulated concern over the uncertainty of the income derived from their work, since it varied with business cycles and closures. And yet, as discussed in the previous section of the paper, whereas men working in the Israeli sector earned a wage premium, women did not, and in fact were among the lowest paid workers.

This suggests that one possible explanation of the wage premium earned by men in the Israeli sector, the fact that they face increased risk and uncertainty than other workers, is problematic. The risk premium argument would suggest that uncertainties caused, for instance, by military closures would increase

wages. Men working in Israel are generally day laborers and thus do not know, from one day or week to the next, whether they will find work. In addition, the work tends to be informal and even illegal, and thus the enforcement of rights of workers, such payment of wages, minimum wages, etc. is difficult.[20] So perhaps the high wages can be seen as a premium to account for higher risk and uncertainty do to political and economic swings. The question remains though, why textile workers, most of whom are women, who also work in a highly uncertain, informal sector, do not earn similar premiums? Textile workers' work is also closely linked to the Israeli economy and the flow of sub-contract work is often halted due to military closures. This work is generally piece rate, and highly susceptible to business cycle swings, making it even more unstable. And yet from the data it is clear that women in this informal sector do not receive a similar wage premium to men, and that men in the same industry earn more than women. So while the risk premium explanation may explain part of the wage premium for men who work in Israel, it does not explain why women in textiles, who also face considerable employment uncertainty, do not earn a similar premium. A more likely explanation is that sex discrimination and occupational segregation play a role. Women workers have few employment alternatives and thus relatively less labor market power, making it easier for employers to pay them low wages.

VI. CONCLUSION

In this study I found that Palestinian women in the Bethlehem area have fairly low labor force participation rates. Peasant women with access to land, single women, educated women and women in economic need are the most likely to work. Women who do work are located in a small number of sectors – primarily in teaching, nursing, textiles and agricultural production. Gender role norms are more rigidly applied to women than to men. In other words, the level of segregation is asymmetrical, with men having more access to traditionally female positions than women have to male jobs.

While differences in wages and employment by sex are in some ways similar to patterns in other parts of the world, there are some important differences as well, particularly in terms of employment patterns. On the one hand, as in many other countries, women are concentrated in those occupations stereotyped as being more appropriate for women, including teaching, textiles and nursing. On the other hand women are less likely to be employed in some sales, service and clerical positions which are often defined as 'women's work' in other parts of the world.

In addition to considerable occupational segregation, there is also a wage gap between men and women. The women most affected by this wage gap are women with low levels of education, whose primary employment option is work in the textiles industry, one of the lowest paying occupations. At the time I carried out this study, the wage gap was actually exacerbated by Israeli occupation, since Palestinian men had access to relatively more lucrative work inside Israel, while Palestinian women who worked as sub-contractors for Israeli firms in the textiles industry received very low pay. Within the Palestinian/Israeli economy, it seems that there are various degrees of occupational segregation and the wage gap varies for different groups of men and women. Palestinian workers in Israel, who are men, are limited to particular occupations and are paid less than Israeli workers, (Semyonov & Lewin-Epstein, 1987) but when compared to Palestinian women, as well as Palestinian men working in the Palestinian sector, they do quite well economically. A combination of the unique relationship between the Palestinian and Israeli economies and social norms which restrict women's labor force participation as well as their access to certain types of jobs, leads to less educated women's position at the bottom of the wage scale.

Despite the fact that men with lower levels of education were able to earn fairly high wages by working in Israel at the time I completed this study, I would argue that generally speaking, the most vulnerable workers, both men and women, are less educated workers, since most of their jobs are directly linked to the Israeli economy which in turn suggests a high degree of job uncertainty. When I carried out this study, the Gulf war had just ended and massive economic changes were beginning to occur in the West Bank and Gaza. Since 1991, the Israelis have drastically reduced the number of workers allowed into Israel. World Bank and United Nations reports both note the strain that this shift in employment options has had on the Palestinian economy (World Bank, 1993; UNSCO, 1998). To date though, I have not seen any empirical studies which look at the changing nature of subcontracting, which is more likely to affect women workers, in the same period.

At the same time, the installation of the Palestinian National Authority, and the influx of foreign aid and capital has created new employment opportunities in both the new government sector and the growing private sector. These two impacts have doubtless changed the patterns of occupations for men and women, as well as the wage structure. It is unlikely that occupational segregation and the wage gap have disappeared, although the magnitude of each may have changed. It is also highly possible that these changes have improved prospects for the educated, but increased the economic vulnerability of the less educated.

Such a conclusion though is merely conjecture and clearly, more studies which look at patterns of employment and earnings by sex are needed. My data

base was quite small, and only provided me with the ability to do a cross-sectional analysis of employment patterns for a small subset of the Palestinian population. Time series analysis of occupational segregation and wage differences can provide researchers with a better understanding of whether shifts in economic conditions have improved or worsened women's positions and how women and men with less education are presently faring. This study can only provide a static glimpse at the degree and level of segregation and the wage gap by sex in Palestinian labor markets, but far more work is needed.

ACKNOWLEDGMENTS

Funding for this research was provided by the Institute on Global Conflict and Cooperation of the University of California, San Diego, CA, and the International Christian Committee, Jerusalem. Thanks also go to my wonderful field workers Akram Attallah and Reem Moughrabi as well as the Palestinian families who permitted me to interview them. Finally, thanks to Edward Sayre, Mine Cinar and an anonymous reviewer who provided me with helpful comments on various earlier drafts. An earlier draft of this paper, entitled "Gendered Construction(s) of Occupation(al) Segregation in Palestine," was presented at the Middle East Studies Association meetings in Dec. 1998.

NOTES

1. For more details concerning data collection and survey techniques see Olmsted (1994).
2. There is some dispute in the literature over how to measure and define labor force participation. I have defined all those engaged in income generating activities as labor force participants and will use the two terms interchangeably. Thus I include informal and formal sector work, but do not include non-market (domestic sphere) work. See Hammami (this volume) for more discussion of the controversies surrounding the measurement of labor force participation, and in particular, Palestinian women's labor contributions in all of these spheres.
3. In general, women in the SWANA region have low labor force participation rates. See Hijab (1988) and Khoury and Moghadam (1995) for more discussion of issues relating to women's labor force participation and regional labor force patterns.
4. Although the schooling coefficient is only significant at the 0.15 level, multicollinearity can explain the weak statistical significance. Coefficients with the same magnitudes and signs (Sch −, Sch2 +), but statistically significant at the 0.01 level were estimated after the higher degree dummy was dropped.
5. See Olmsted (1996) for further discussion of differences in employment patterns among refugee and non-refugee Palestinian women, as well as a discussion of why women with low and high levels of education more likely to be in the paid labor force.
6. Generally husband's income is also included as a factor determining labor force participation. This variable was included in some models, but was not found to be statistically significant. This result could in part be due to problems of incomplete income data.

7. In an alternative specification, I included number of adult children and number of dependent children. The number of adult children variable was positively associated with women's participation. I also tried a specification with only dependent children, in case there was strong multicollinearity between the various measures of number of children, but neither number of dependent children nor number of children under age 6 was statistically significant, even when other children variables were excluded.

8. This argument is developed further in Olmsted (1996).

9. Although profit information was generally unavailable, given the size and type of businesses owned and managed by men, it was pretty clear that their businesses are larger and more lucrative than women's businesses. It should be noted though that as with any family business, it is often difficult to gauge what women's contributions and/or claims to income are. The data were entered as reported by the interviewees and may underestimate women's joint ownership in or labor contributions to family businesses.

10. Unemployment rates were calculated using the standard definition which defines unemployed persons as those currently seeking employment who have not worked any hours during a two week period. Both male and female unemployment rates are underestimated, because of high numbers of discouraged and underemployed and informal sector workers in the population. It is likely that women are even more likely to be discouraged than men.

11. $$ID = \frac{1}{2} \sum_i [(\frac{occ_i^f}{lfp^f}) - (\frac{occ_i^m}{lfp^m})]$$

where f and m are female and male respectively, occ is the number of workers by sex in occupation i, lfp is the number of workers by sex in the labor force.

12. It should also be noted that income data for the self-employed were almost impossible to obtain, for a number of reasons. First, Palestinians were staging a tax revolt as a protest against Israeli occupation when I was collecting my data. The self-employed in particular were often targeted by the Israeli authorities, who confiscated property and closed shops of those suspected of hiding income or avoiding taxes. They were thus unwilling to provide any information which might be a useful proxy for income. In addition, for some, income was difficult to estimate because it fluctuated or because a careful separation of profits and revenues was not carried out. For these various reasons, self-employed are excluded from the analysis.

13. There were only five women in my sample who worked in Israel, mostly in cleaning services. Of those only two reported wages.

14. Palestinians are generally paid a daily or monthly salary. Workers were asked to estimate how many hours they worked, but there may have been some problems with the consistency of the hour data, as respondents may have included travel time or may have been unsure of hours worked for other household members. In order to comply with the existing literature, which generally uses hourly rates to estimate wage equations, monthly wages were divided by the hours of work reported.

15. There is considerable evidence that West Bank and Gaza Palestinians face wage and occupational discrimination inside Israel. (Semyonov & Lewin-Epstein, 1987, p. 97) Thus, while they receive a premium when compared to Palestinians who do not work in Israel, they still receive lower pay than Israelis doing comparable work.

16. Only five women in my sample worked in Israel, far fewer than the number of men. Relative to men's, employment opportunities in Israel for Palestinian women are few. In addition, there seems to be a consensus within Palestinian society that women should not work in Israel (it may be considered shameful or dangerous), and therefore very few women do so. This is particularly true since the only possible employment options for women who want to commute to Israel, at least in Bethlehem, are in cleaning or maid services. While in the field though I did hear some reports that women in other regions of the West Bank migrated into Israel to work in agriculture, so women's access to employment in Israel may vary depending on the part of the West Bank and the types of available jobs.

17. No dummy variable to distinguish workers in the Palestinian and Israeli sectors was included, since so few women fell into the latter category. For women, the model fit was also somewhat improved after dropping the age squared variable and therefore results are reported for age, but not age squared. Dropping this variable did not significantly alter the coefficients on the other variables in the equations.

18. When running regressions using the subset of wage data for various sectors, the best fit was obtained by including the seniority variable. Because of the small sample sizes, the high degree of correlation between seniority and age became problematic. Including age, age squared and seniority in these regressions simultaneously led to none of the three variables being statistically significant. Dropping age and age squared improved the results on the seniority variable without affecting the other coefficients being estimated.

19. It should be noted that while educated women appear less likely to suffer from wage discrimination, they may still experience discrimination, because of occupational segregation, which limits them to participation in less lucrative occupations, and pre-market discrimination, such as unequal access to schooling, etc. Pre-market discrimination in particular is not captured by this type of analysis.

20. When collecting my data, I heard numerous stories from workers who had been denied their wages by their Israeli employers. The workers felt that because they had been working illegally they had little recourse in claiming wages if their employers refused to pay them for work already completed.

REFERENCES

Anker, R. (1997). Theories of Occupational Segregation by Sex: An Overview. *International Labor Review*, *136*(3), 315–339.

Anker, R. (1998). *Gender and Jobs: Sex Segregation of Occupations in the World*. Geneva: International Labour Office.

Grossbard-Shechtman, S., & Neuman, S. (1998). The Extra Burden of Moslem Wives: Clues from Israeli Women's Labor Supply. *Economic Development and Cultural Change*, *46*(3), 491–517.

Gunderson, M. (1989). Male-Female Wage Differentials and Policy Responses. *Journal of Economic Literature*, *27*, 46–72.

Heiberg, M., & Ovensen, G. (1993). *Palestinian Society in Gaza, West Bank and Arab Jerusalem: A Survey of Living Conditions*. FAFO – report 151, Oslo, Norway.

Hijab, N. (1988). *Womanpower: The Arab Debate on Women at Work*. Cambridge: Cambridge University Press.

Khoury, N., & Moghadam, V. (1995). *Gender and Development in the Arab World: Women's Economic Participation: Patterns and Policies*. London: United Nations University, Zed Press.

Mincer, J. (1962). Labor Force Participation of Married Women: A Study of Labor Supply. In: H. G. Lewis (Ed.), *Aspects of Labor Economics*. Princeton: Princeton U. Press.

Olmsted, J. (1994). *Family Investment in Human Capital: Education and Migration Among Bethlehem Area Palestinians*, Ph.D. dissertation, University of California, Davis, Ca.

Olmsted, J. (1996). Women 'Manufacture' Economic Spaces in Bethlehem. *World Development*, 24(12), 1829–1840.

Olmsted, J. (1998). *What Would Your Father Think? Social Norms, Gender and Education in Palestine*. Working paper, Washington, D.C.

Papps, I. (1993). Attitudes towards Female Employment in Four Middle Eastern Countries. In: H. & M. Maynard (Eds), *Women in the Middle East: Perceptions, Realities and Struggles for Liberation*, (Women's Studies at York). London: MacMillan.

Semyonov, M., & Lewin-Epstein, N. (1987). *Hewers of Wood and Drawers of Water: Noncitizen Arabs in the Israeli Labor Market*. Ithaca, N.Y.: ILR Press, Cornell University.

Shakhatreh, H. (1995). Determinants of Female Labour-Force Participation in Jordan. In: Khoury & Moghadam.

UNSCO (United Nations Office of the Special Coordinator in the Occupied Territories) (1998). *UNSCO Report on Economic and Social Conditions in the West Bank and Gaza Strip*, Spring report, (online) http:www.arts.mcgill.ca/mepp/unsco/unfront.html

World Bank (1993). *Developing the Occupied Territories: An Investment in Peace*. Washington D.C.: The World Bank.

World Bank (1995). Workers in an Integrated World. *World Development Report*, 1995. Washington D.C.: The World Bank.

GENDER SEGMENTION IN THE WEST BANK AND GAZA STRIP: EXPLAINING THE ABSENCE OF PALESTINIAN WOMEN FROM THE FORMAL LABOR FORCE

Rema Hammami

ABSTRACT

This paper argues that the longstanding absence of Palestinian women from the formal labor force in the West Bank and Gaza Strip can be located in the distorted nature of Palestinian labor markets as they were patterned and conditioned by economic policies aimed at meeting the needs of the Israeli economy. The extremely gender segmented and concentrated nature of Palestinian labor markets is an outcome of the way in which gender relations in Palestinian society interact with the extremely constrained labor opportunities for the population as a whole. As such, the informal sector remains the dominant option for women seeking work income.

INTRODUCTION

The development profile of Palestinian women in the West Bank and Gaza is marked by paradox. A relatively strong women's movement has ensured a respectable level of female representation in various spheres of political life, although social equity (especially in spheres of legislation and public policy) lag behind. Women's educational achievement levels are high and nearly symmetrical with males (both in terms of basic literacy and higher education), while persistently high rates of fertility continue to dominate women's post-education life experience (Ghali, 1997; PCBS, 1998). The starkest contrast is in employment. Women's integration into the formal labor force is extremely low (at roughly 10% of the labor force) and is characterized by women working in a very limited number of labor sectors. In short, the picture that emerges is of Palestinian women's relatively high access to political life, their near equal representation with males at almost every level of education, co-existing with their extreme marginalization from the formal labor force.

This absence of Palestinian women from the formal labor force is usually explained with reference to local norms and traditions which are described as opposing women engaging in work outside the home.[1] In this view, economic activity is seen as in contradiction to women's main socially prescribed role as child-bearers and care-givers. As such, culture is seen as the main obstacle to women's integration into economic life in Palestine. The logical outcome of this view is that integrating women into economic activity can be achieved simply through changing attitudes, particularly changing women's own conservatism.

It is not difficult to identify data that supports the finding of low labor force participation. Standard labor force surveys continually show that Palestinian women's participation in the formal labor force is extremely low, at approximately 10% compared to a regional average of 25% and an average for developing countries of 39% (UNDP, 1996, 38). Attitudinal surveys show the majority of men claiming that it is preferable that women not work outside the home.[2] Finally, high fertility rates provide added support to the notion that women are too busy fulfilling their social role as child-bearers to be engaged in economic activity.

This study attempts to redress two aspects of this dominant view. On the one hand, it will attempt to show that despite women's low representation in the formal labor force, large segments of the female population in the West Bank and Gaza are simply not counted as working, due to the fact that they are engaged in a variety of informal sector activities. On the other, the study aims to question the culturalist arguments dominantly used to explain women's absence from the workplace. Given that so-called norms and traditions do

not mitigate against women's access to other areas of public life (politics and education), it seems unlikely that they could be a main factor in keeping women out of the labor force. The approach taken is to both critique the existent data and provide an alternative conceptual framework for understanding the extent to which, and particular ways that, women are engaged in economic life. In order to do so, this study will raise a number of questions. Does the existent data accurately reflect women's economic contribution in Palestinian society or does it only reflect a small part of women's economic activities? If women are only marginally active in formal labor activity is this due to problems of tradition or absence of opportunity? In what types of labor activities do women tend to be more active and why? And finally, what are the implications of these findings for both the prospects of gender equity and sustainable development in Palestine? The main aim of the study is to see how gender is an organizing category in the Palestinian economy. The study then goes on to analyze the various problems of women within the labor force itself. What are the types of jobs and employment levels which are accessible to women? What types of discrimination and obstacles do women encounter within the various sectors of the economy? Finally, the study will attempt to understand what types of policy measures are appropriate for a more equitable integration of women into the economy and to what extent the issue of high fertility rates and their treatment must play a role.

THE CONTEXT: TRENDS IN THE PALESTINIAN ECONOMY

Although the West Bank and Gaza economies have largely been shaped by the Israeli occupation, they nevertheless share certain commonalities with other economies in the region.[3] Prime among these is the fact that productive sectors are small compared to trade. This imbalance between the productive and trade sectors is one of the most basic causes of the inability of many Arab economies to absorb their labor force; the outcome being a dependency on exporting labor. The problem of absorbing the labor force is worsened by a general decline in the role of agricultural sector, and more fundamentally, by high fertility rates in relation to the growth and availability of jobs (World Bank, 1995).

While Palestine's economy clearly fits this overall regional pattern, Israel has played a formidable and ongoing role in determining the shape and intensity of these features, as well as in precluding attempts to positively change them. Prolonged occupation brought to bear on the Palestinian economy a host of pressures which impeded its development. The steady decline in the role of agriculture since 1967 proceeded within the context of an active

Israeli policy to obstruct the development of the industrial sector. Instead, while traditional Palestinian employment sectors were undermined, the labor force was re-oriented to serve the more labor intensive areas of the Israeli economy. Productive sectors were also re-aligned in ways congruent with Israeli production and consumption needs, while Israeli control of trade channels also ensured their domination of Palestinian domestic and international trade.

By the end of the 1980s, the effects of these policies could be seen in the strong imbalances in various sectors of the Palestinian economy. Palestinian manufacturing accounted for only 7% of GDP and absorbed only 17% of the labor force (UNCTAD, 1993, 13) and Palestine's trade deficit with Israel was enormous with twice as much imported from Israel as was exported to it (UNCTAD, 1993, 14). Simultaneously the role of Palestinian agriculture had declined dramatically providing only 26% of the West Bank's GDP and 19% of Gaza's GDP and absorbing only 16% of the former's labor force and 11% of the latter's in 1988 (UNCTAD, 1993, 9, 10). The primary dependence on the Israeli labor market to absorb the labor force is attested to by the fact that by 1987, more than 42% of the West Bank and Gaza labor force were working in Israel, accounting for over 30% of Palestine's GDP (UNCTAD, 1993, 40, 19). Despite the negative implications for Palestinian economic development, the Israeli market's ability to absorb Palestinian labor offset large-scale unemployment, even as the number of labor force participants expanded rapidly due to high birthrates.[4]

This overall situation changed dramatically in 1992. While the basic structural imbalances have remained, the Palestinian economy has undergone an intermittent but near continuous series of shocks since the Gulf War, brought about by the closure of Israel to Palestinian labor and goods. Simultaneously, continued macroeconomic control of the Palestinian economy by Israel, through control of external trade and financial measures, makes the creation of sustainable job alternatives in the immediate future a near impossibility. The effects of the closure are summed up by the massive drop in GNP that took place between 1992 and 1996 and the massive rise in unemployment rates. Between 1992 and 1996 real per capita GNP, a measure of income generated per person declined 39%, while the unemployment rate has risen to 39% in Gaza and 24% in the Gaza Strip in mid-1996 (UNSCO, 1996, i–ii).[5] Loss of employment opportunities in Israel were exacerbated by the fact that the Palestinian labor force has continued to grow at an annual rate of 6% which means that on a monthly basis approximately 4,600 persons enter the labor force seeking new jobs (UNSCO, 1996, ii, 11).

Women's labor activities cannot be understood separate from this larger context of the structure of the Palestinian economy and the more recent crises

it has undergone. The legacy of a work force geared to meet specific sectors of the Israeli labor market (especially in the construction and industrial sectors) and the co-terminus obstacles put on Palestinian manufacturing have had very specific implications for the integration of women into wage work. The declining role of agriculture has meant the agricultural sector's growing reliance on marginal and underpaid or non-paid labor – again, of great significance for women. Recently, massive male joblessness added to the lack of employment opportunities in the formal sector and has had a dramatic impact on women both within and outside the formal labor force, possibly reducing the ability of new generations of women to enter formal labor force activity for the first time.

FEMALE LABOR FORCE PARTICIPATION

Until the founding of the Palestinian Central Bureau of Statistics (PCBS) in 1994, following the Oslo Peace Agreement, Israel's Central Bureau of Statistics (ICBS) was the sole producer of comprehensive statistical data on the Palestinian population in the territories it occupied. Using the ILO's Labor Force Survey framework the ICBS consistently found low labor force participation rates among Palestinian women throughout the period of the occupation.

According to the data presented in Table 1, the percentage of women in the labor force has historically been quite low and was even declining between 1980 and 1993. However, the Palestine Central Bureau of Statistics labor survey in 1995 found significantly higher numbers of women in the labor force in Gaza and the West Bank than Israeli statistics showed in the previous survey year.

Table 1. Female Labor force Participation Rates by Region (Selected Years 1968–1995).

Year	Gaza	West Bank	East Jerusalem	Total
1968	6.4	8.6	–	–
1972	4.0	11	–	8.2
1976	4.4	13	–	9.4
1980	4.4	12	–	9.3
1984	3.4	11	8.1	8.2
1988	2.4	10	7.9	7.3
1993	1.8	9.5	–	6.2
1995*	7.6	12.8	–	11.2

Source: 1968–1993 figures (Semyonov, 1994) and (PCBS, May 1995).
1995 figures (PCBS April 1996).

In Gaza, the PCBS found almost five times as many women active in the labor force and a one-third increase in the West Bank. The reasons for the dramatic increase are probably due more to definitional and administrative factors than to the sudden entry of women into the labor force. The PCBS was probably more accurately able to collect data at the field work level than their Israeli counterparts were able to in the past – especially in Gaza and during the intifada. As importantly, however may be the fact that the PCBS expanded their employment definitions to include some forms of unpaid family labor – although this would have affected employment rates among women predominantly working in agriculture. Finally, a slight increase may also be due to new employment opportunities available to women in Gaza with the coming of the Palestinian Authority.

THE CURRENT GENDER GAP IN LABOR FORCE PARTICIPATION

Table 2 present statistics on the current labor force status of men and women fifteen years of age and above in Palestine using data collected by the Palestine

Table 2. Population Age 15 Years and Over in WBGS By Labor Force Status and Sex (1995–1997).

LFS Round Year	Labor Force				Not in Labor Force
	Full Employed	Under-Employed*	Unemployed	Total	
1. 1995					
Male	58.8	22.9	18.3	66.9	33.1
Female	71.7	10.4	17.8	11.2	88.8
2. 1996					
Male	64.9	13.2	21.9	69.7	30.3
Female	74.7	3.9	21.4	11.4	88.6
3. 1997					
Male	68.1	10.2	21.7	69.5	30.5
Female	75.4	4.1	20.5	12.3	87.7

Source: (PCBS, 1998, 103)
* The PCBS defines underemployment as less than 35 hours of work per/week.

Central Bureau of Statistics between 1995 and 1997. In the first three years of its existence PCBS has also found women's participation rates to be persistently low (albeit slightly higher than found by the ICBS). Only 11–12% of the female working age population have been counted as in the labor force, while in the same period men's participation rates have remained between 67–70%. Among those in the labor force, unemployment rates among females have remained as high as for their male counterparts throughout this period. At the same time, women's employment profile compares positively with male counter-parts – with full-employment being higher among employed women than men. Given the extremely small number of women in the labor force, 17% to 21% unemployment is greatly disproportionate to the overall number of women versus men in the labor force.

Additionally, along with earlier ICBS findings, there continues to be a strong regional disparity in women's labor force participation rates between the two regions of Palestine; up to 17% of women were in the labor force between 1995 and 1997 in the West Bank while a much lower 8% were participants in Gaza.

GENDERED LABOR MARKETS

Due to the limitations of the labor force status (LFS) framework in capturing the variety of female labor activities, especially in third world contexts, feminist economists have developed a number of different approaches that seek to uncover the range and magnitude of women's labor activities and their structuration within national economies. One alternative is to look at the economy in terms of its labor markets and how they differentially utilize male and female labor (Beneira, 1987; Kabeer, 1994; Rees, 1992; MacEwan-Scott, 1994).

We can divide the Palestinian economy into five labor market spheres according to female labor opportunities: the national agricultural sector, the national non-agricultural sector,[6] the Israeli labor market, the informal economy, and the domestic economy. The first four encompass all the opportunities for wage work or employment for Palestinians living in the West Bank and Gaza. The additional market, the domestic economy, is an area of predominantly female labor activity which is usually not considered economic and is ignored altogether by conventional economists. Since a large part of women's productive lives in Palestine are actually centered around domestic production, it is extremely important to understand this sphere and how it interconnects with other economic and non-economic dimensions of life and family survival.

FEMALE LABOR ACTIVITY IN FIVE LABOR MARKETS

Standard labor force surveys only include the first three labor markets in their calculations of labor force participation rates; labor in the informal sector and domestic sphere are not counted. While wage labor in Israel and agriculture are included in the LFS framework, both Israeli and Palestinian CBS data on women in these spheres have tended to be partial or incomplete.

Table 3 brings together data from various sources on the extent of women's participation in the five labor markets covering various periods in the 1990s.

Due to problems in how available data are reported, the above figures refer to women as percentages of those employed in these various labor markets, as opposed to the percentage of employed female manpower. It remains clear, however, that formal labor participation surveys while being statistically valid, nevertheless misrepresent the magnitude of Palestinian women's economic activities by only providing a part of the overall picture. Even if women's participation in the informal sector was factored in to labor force statistics one

Table 3. Females as Percentage of Total Employed in Five Labor Markets.

National Agricultural		National Non-Agricultural		Wage Labor in Israel		Informal Economy		Domestic Economy	
West Bank	Gaza	West Bank	Gaza	West Bank	Gaza	West Bank	Gaza	West Bank	Gaza
39.4	20	18	12	3.6	0.6	55.6	60.6	83.6	85.7
Source: PCBS, April 1996		PCBS, 1994		PCBS, April 1996*		Ovenson, 1994**		Ovenson, 1994	

* In 1992, Heiberg and Ovenson found women in Gaza made up 2% of the labor force working in Israel while women in West Bank made up 8%. In 1994, Ovenson found that women in Gaza made up 2% of the labor force working in Israel while in the West Bank camps they comprised 7%.

** The figures on participation in the formal and domestic spheres are derived from data from Ovenson's 1994 survey based on calculations by the author of data on page 62. There are a number of constraints in using them. Firstly, the data for the West Bank only covers the refugee camp population. Secondly, the survey treats household income generating activities which are divided into food-processing and other household production – the latter category includes growing vegetables/fruits/herbs, raising poultry and other animals, fishing, producing crafts, and conducting services or trade from a mobile installation on the street (Ovenson, 1994, 62–64). In the table I have treated "other household production" as representing informal economic activities and food processing as representing domestic economy – although clearly the line separating the two is somewhat arbitrary.

would find a sharp rise in overall rates of women as a percentage of the labor force.

However, the table points out that while we may conclude that women are much more economically active than either ICBS or PCBS labor surveys claim, there is also clear gender segmentation across these labor markets. Most crucially, women are highly segregated from wage work in Israel – historically one of the main forms of employment for the labor force as a whole. While the 4% indicated above is probably somewhat lower than the norm, it is unlikely that it represents a massive drop relative to male employment in Israel. Instead, it most likely represents a sharper statement of an asymmetry that existed prior to the overall downturn of labor opportunities in Israel for Palestinian workers as a whole. As such, if wage work in Israel was excluded from calculations, women's participation rates in the labor force would appear much higher, at around approximately 20% of the overall labor force. However, even excluding wage work in Israel we find that there is still strong gender segmentation in the remaining labor markets – especially for Gazan women who constitute only 12% of the non-agricultural employed.

Finally, the data bear out the hypothesis that women tend to be concentrated in the non-formal sectors of the economy – the informal and domestic spheres. While their participation in the other sectors is higher than previously assumed, women overall appear to be concentrated in the latter two non-formal spheres. Significantly, Gazan women appear as relatively more active in the informal sphere than their West Bank counterparts (the former constituting 62.5% of informal economy workers, while the latter constitutes 55.5%). This tends to suggest that there is a relationship between opportunities for employment across these markets – that women "excluded" from formal sectors find or create employment for themselves in the non-formal sectors.

Educational, social and demographic factors all contribute to Palestinian women's employment patterns. While the role of education, and fertility are fairly well established in the literature, the uniqueness of the economic situation in Palestine suggests some additional factors shaping women's employment opportunities. As such, a closer look at the various sectors of the Palestinian and Israeli economies is warranted, to determine women's participation in various sectors of the economy and the ways in which female labor is organized and utilized within various labor markets and their component sectors.

THE ISRAELI LABOR MARKET

At the beginning of the occupation, Israel opened special labor offices to encourage women from the occupied territories to register for work in Israel

(Simhe, 1984, 6). During that period, the government of Israel claimed that one positive outcome of Israeli "administration" of the occupied territories was that through these offices it had provided substantial employment opportunities for Palestinian women. However, in the only three years in which the ICBS provided data on Palestinian workers in Israel disaggregated by sex, women never accounted for more than three percent of the total.[7] It is difficult to ascertain whether these figures are accurate. The absence of these women from the Israeli statistical abstracts is symbolic of the larger silence on the issue within Palestinian society. However, in the early 1970s there is evidence that more than 6,000 women from Gaza alone applied to work in Israel (Samed, 1976, 26).

During this earlier period, when Israel had a labor shortage, Palestinian women were employed as factory workers (predominantly in the food industry), and in the service industry (hospital and hotel cleaners) (Hammami, 1994; Moors, 1995). But by the early 1980s many of these jobs had been turned over to Israelis and Palestinian women tended to be concentrated in agricultural wage labor – considered the most poorly paid and insecure labor sectors for workers in Israel. More recently, according to the PCBS statistics of September–October 1995, women made up 4% of the Palestinian labor force working in Israel. The majority of them (69.3%) were in the 45+ age group, had zero years of education (62%), and were employed predominantly in seasonal agriculture (42%). In 1995 women represented 6% of the agricultural workers from Gaza working in Israel. In comparison, the majority of males working in Israel were and continue to be concentrated in the construction industry (55% of male workers), tend to have 7–12 years of education and are predominantly under 45 years of age.[8]

Ethnographic accounts indicate that women who work in Israel are those without a male breadwinner, usually divorced or widowed or with an ailing spouse – in other words, female heads of households (Rockwell, 1984, 27; al-Malaki & Shalabi, 1993, 163; Moors, 1992, 183; Hammami, 1994).[9] In both Gaza and the West Bank they tend to be from refugee camps and to a lesser extent from West Bank border villages.[10] They also tend to be older females with little education. They are usually women under extremely difficult social and economic situations. The latter status suggests not only a particular economic incentive which motivates women to work in Israel – but perhaps more importantly, a social status which "allows" them to work in Israel. Cultural inhibitions towards women's wage labor seem most apparent in attitudes towards women working in the Israeli labor market. The ethnographic literature reveals a strong social taboo against it, which is mitigated only by socially acknowledged need – i.e. when women have no male breadwinner. However,

even this powerful social justification did not prove strong enough during the intifada, when many women who had worked in Israel found social sanctions too strong and thus attempted to find local alternatives.

Work in Israel appears as the most anomalous labor market in terms of sex. While it was the largest labor market for males throughout the 1970s and 1980s, it was the smallest in terms of females. While the social sanctions against women working there seem to have played an important role, the fact that labor opportunities for women in Israel were of the lowest occupational status and with the lowest pay (agriculture) may also have mitigated against women's greater integration into it. Ultimately, the most prominent role of work in Israel vis à vis female wage labor was its impact on labor markets in the West Bank and Gaza; an issue that will be discussed in the following sections.

Finally, the fact that the Israel labor market has been perceived as "male", has led to post-closure job-replacement strategies that are designed solely in terms of male workers. No consideration has been given to the actual or potential numbers of women who have lost work in this sector.[11]

THE AGRICULTURAL LABOR MARKET

Women comprise a substantial proportion of the agricultural labor force, but one which is largely unpaid and unrecognized. According to PCBS, women were 36.9% of the agricultural workers in the West Bank and Gaza in mid-1996. With greater agricultural production taking place in the West Bank than Gaza, women were 40.2% of agricultural workers in the former and 12.1% in the latter area during the same period. However, due to the seasonal nature of agricultural production, PCBS has found some variation in these numbers according to the year and season in which various surveys were conducted.

While the data in Table 4 reveal a high proportion of female involvement in the agricultural labor market, the overall proportion is lower than findings of various micro-studies which find greater female participation at the village level. In a survey of three West Bank villages in 1989, women in 92% of the families surveyed participated in agricultural production (al-Malaki & Shalabi, 1993, 156). The disparity in the proportions found in micro-studies in comparison to large scale surveys is most likely due to under-reporting, as well as the fact that less women are involved in agriculture as day laborers. Under-reporting is common since female agricultural labor is usually unpaid, and often considered an extension of women's household duties. A much greater proportion of men are wage workers in agriculture, predominantly coming from camps and urban areas working either in Israel or on Israeli settlements.

Table 4. Women as a Percentage of Total Agricultural Workers in Three PCBS Labor Force Survey Periods 1995–1996.

PCBS Survey Round	Survey Period	Total (%)	West Bank (%)	Gaza (%)
Round I	9–10 1995	34.7	38	19.9
Round II	4–5 1996	29.4	31.1	18.9
Round III	7–10 1996	40.2	36.9	12.2

Thus, although men form the majority of the agricultural labor force, agriculture is the second largest market for female labor – accounting for 28.5% of female employment, as opposed to 14.6% of male. When looked at historically, it becomes clear that since the beginning of the occupation, men have been moving out of local agriculture into other sectors (predominantly wage labor in Israel), while women's involvement in this sector has declined much less dramatically. Table 5 shows that while 32% of the male work force were engaged in agriculture in the early 1970s, by the late 1980s this had declined to 18%. In comparison 57% of women in the labor force were involved in agriculture in 1970, declining to 30% by 1989. The difference is due to the lack in growth of alternatives labor markets for women during the same period.

The data in Table 5 also support a pattern described by a number of researchers: as rural males became integrated into the Israeli labor market, rural females remained working on the family farm, often taking on a greater number of agricultural tasks. This occurred without any change in the gender division of resources, capital or decision making. Instead, many agricultural tasks became redefined as extensions of housework. The relationship is summed up by the observation that instead of women going out to work in the fields, the opposite

Table 5. Percent of Male versus female Labor force Engaged in Agriculture 1970–1984.

1970		1975		1980		1985		1989	
male	female	male	female	male	female	male	female	male	female
32.4	57.4	21.4	51.7	18	55.1	18.5	45.9	17.7	45.3

Source: (Semyonov, 1994, 143).

occurred; the fields entered the house and became yet another responsibility of women (al-Malaki & Shalabi, 1993, 157).

Researchers have also noted that technological innovation (such as the introduction of drip irrigation and greenhouses) has increased women's agricultural workload as well, without a corresponding re-division of resources or power (Giacaman & Tamari, 1996, 57). Various studies note the dominance of women in agricultural tasks which are labor intensive, physically demanding and non-mechanized, such as hoeing, weeding, sowing seeds, and harvesting (Giacaman & Tamari, 1996, 57; al-Malaki & Shalabi, 1993, 159; Ramsis, 1997, 11). Moreover, women's activities are concentrated in routine productive tasks that are not related to the market or control over economic resources, rather than market-related jobs such as the buying of agricultural in-puts and the sale of agricultural products. Women's marketing activities are limited to the local peddling of surplus products as women are perceived as not having the knowledge necessary to deal with merchants (al-Malaki & Shalabi, 1993, 162).

Women working in agriculture overwhelmingly work as non-paid family labor, this category accounting for 76% of females employed in West Bank agriculture and a full 82% of females employed in agriculture in Gaza in 1996. As Table 6 shows, by comparison males working in this sector tend to be self-employed or wage employees.

Women's access to employment in this sector is thus overwhelmingly contingent on whether a spouse or parent is engaged in agriculture either as small-holders or as share-croppers. According to one survey, only 8% of Palestinian women claimed to have inherited land (Heiberg & Ovenson, 1993, 295). Thus it is not surprising to find only 17% of women engaged in agriculture in the West Bank and less than 2% of women in Gaza defined themselves

Table 6. Male and Female Employment Status in Agriculture by Region.

Employment Status	West Bank		Gaza Strip		Table Total
	Male	Female	Male	Female	
Employer	1.9	0.2	2.5	1.9	1.5
Self-employed	50.5	17.3	33.2	1.9	37.4
Wage employee	20.7	6.4	36.8	14.2	19.2
Unpaid family worker	27.0	76.1	27.5	82.0	41.9
Total	100.0	100.0	100.0	100.0	100.0

Source: (PCBS Labor Force Survey Data, 1996).

self-employed. While the situation of women working in family agriculture is one of hard work with no direct material compensation, the situation of women working as wage laborers in agriculture may be comparatively worse, especially in relation to male counterparts. The average daily wage for women agricultural laborers is 27 NIS compared to a male wage of 34 NIS (Ramsis, 1997, 9).[12]

Given the family-based nature of farming in Palestine it seems "natural" that women largely work without wages, but simply do so in order to help their families. Given these circumstances, the obvious problem could be perceived as women's lack of "choice" concerning whether they help a spouse or family in earning a livelihood. However, choice is an extremely problematic notion when people perceive certain social relations and responsibilities as "natural" or given. Instead, the issue of recognition and compensation for women's responsibility in agriculture is a critical issue for gender equity. This lack of recognition of the critical importance of women to agricultural production is reflected not only in their lack of wages, but also in their absence from agricultural cooperatives and agricultural training colleges.[13] Women's lack of compensation also has implications for the agricultural sector as a whole; overall wages in this sector are kept low for all agricultural workers and it remains the sector with the lowest wage scale in the economy. An agricultural worker in Israel or the settlements makes close to half of what workers in all other occupations do (PCBS, April 1996, 73). The social costs of women's lack of rights and resources in agriculture are perhaps even higher. Agriculture is the labor sector in which one finds the highest rate of workers with no education; 41% of the labor force with no education are employed in agriculture (PCBS, April 1996, 74).

Rural women have the highest illiteracy rates, although this tends to be primarily among women in the older age categories. More significantly, educational achievement rates of women are lower in rural areas – especially among women in agriculture. Finally, the highest incidence of cousin marriage is found in rural areas, as well as persistent high fertility rates of 6.39 which are only slightly less than those found in refugee camps.

THE NATIONAL NON-AGRICULTURAL/ NON-FARM SPHERE

This sphere includes labor in all business establishments in both the conventional public and private sectors excluding agriculture. It includes four types of economic activity, based in the West Bank and Gaza: industry (including manufacturing), services, trade, and construction. Only formal, registered work-places

are included in this sphere, although non-paid (family) workers are included alongside paid employees.[14]

According to the PCBS Census of Establishments women make up 16% of the employees in the national non-agricultural sphere (PCBS August, 1995). There are regional asymmetries in this sphere with women comprising 18% of employees in the West Bank and only 12% in Gaza. There are also stark patterns of gender segmentation and concentration across and within various sub-sectors. Table 7 represents the sex composition of employees in the four main economic activities in this sphere.

While women are not the majority of employees in any single area, they are predominantly found in services where they account for 39.3% of employees, (55% of all women employed in the national non-agricultural labor market). Industry is the second largest employer of women in this sphere, accounting for 27.5% of employed women. However, women make up a much smaller percentage of total employees in industry at only 11.4%. Finally, women's presence in trade is minimal (6% of total employed) and they are virtually absent from construction, accounting for only 2.4% of workers in that category.

When analyzing the above data regionally, the patterning of female employment across various sectors of the national non-agricultural labor market shows wide differences. Although women account for 11.4% of all employees in industrial and manufacturing activities in both regions, in the West Bank women account for 15% of those employed in manufacturing compared to only 3.8% in Gaza. The asymmetry between the two regions is due to women's dominance in apparel manufacture in the West Bank, where they account for more than half (57.8%) of those employed in that industry compared to only 6% of those in Gaza. The only other manufacturing sector with significant numbers of women is the textile industry where women account for 17.7% of those

Table 7. Employment in Main Economic Activities of National Industrial Sphere by Sex. Distribution of Employed Females.

Economic Activity	Male	Female	Total	Female Distribution
Industry/ manufacture	88.6	11.4	100	27.5
Services	60.7	39.3	100	55.0
Trade (wholesale/retail)	93.9	6.1	100	16.8
Construction	97.6	2.2	100	0.5
				100.0

Source: Calculated figures based on (PCBS, December 1996).

employed in the West Bank. Once again, women in Gaza have a much smaller presence, comprising only 3% of workers in textiles. Overall, their presence in industry and manufacturing is extremely low for both regions, although women fare relatively better in manufacturing than in heavy industry and infrastructure. The sex ratios in manufacturing show significant asymmetry with an average of one woman for every eight males employed. In the heavy industry sectors sex ratios are extremely asymmetrical with for instance, 2,147 men for every one woman engaged in quarrying.

The dynamic regional difference between the numbers of women in clothing and other manufacturing sectors in the West Bank versus Gaza allude to the impact of labor supply on the sex composition of those sectors in Gaza. Although statistical data for the 1980s do not exist, a number of micro-surveys from the period suggest that the clothing industry in Gaza was at one time dominated by female labor. In a survey of women workers in local industry undertaken in Gaza in 1980, it was found that women constituted the majority of workers in local sewing and conversion industries (Rockwell, 1984, 120). In the same study official estimates put the number of women factory workers at 1,112, but claimed there were potentially two to three times as many (Rockwell, 1984, 134). Ten years later in a similar survey conducted in 1990, it was found that ... "most factories in Gaza employed five to six women", the majority (87%) of which specialized in sewing and textiles (Hindiyeh-Mani, 1996, 4–5). However, in the 1990 study only 54 factories were found employing women in Gaza, in comparison to 243 in 1980 (Rockwell, 1984, 134; Hindiyeh-Mani, 1996, 4).[15] What the data suggest is that protracted closure of Israeli labor markets to Gaza men, which began affecting young men in 1989 ultimately led to a process in which males displaced female workers from significant areas of local industry. A similar process seems to be underway in the West Bank, but, due to the greater range of labor alternatives there, is far less complete.

THE SERVICE SECTOR

The service sector is not only the largest employer of female labor in the national non-agricultural sphere, it is also the largest employer of women in the formal economy as a whole. Fifty-five percent of women working in the national non-agricultural labor market are working in services.

Within the service sector two sub-sectors, education and health/social work, alone account for 40% of women in all areas of the national non-farm economy. Education is the only sector in which there is an almost equal sex ratio of female to male employees (one female for every 1.33 males employed). Despite the almost symmetrical sex ratios in health/social work (one female for every

Table 8. Males and Females as Percent of Employed in Service Sector Activities.

Sector	West Bank Female	West Bank Male	Gaza Female	Gaza Male	Ratio of Female to Male
Transport, communication	6.3	93.7	1.5	98.5	1:21
Financial mediation	25.8	74.2	24.9	74.1	1:3
Total real estate, rent	16.4	83.6	9.9	90.1	1:6
Education	45.3	44.7	40.7	59.3	1:1.3
Health/social work	45.4	44.6	28.1	71.9	1:1.5
Membership organizations	13.6	86.4	7.0	93.0	1:7
Recreation, sports, culture	13.7	86.3	7.5	92.5	1:8
Other personal/social service	16.5	83.5	17.8	82.2	1:5
Hotels/restaurants	5.7	94.3	0.2	99.8	1:19
Public administration/ Social security	7.4	82.6	9.5	90.5	1:11

Source: PCBS Census of Establishments, 1994.

one and half males employed) there is a relatively strong regional imbalance in female employment in these sectors. In the West Bank women make up 45.4% of the health and social workers, while in Gaza, they constitute only 28%. This may suggest another example of the impact of labor supply problems in Gaza, with males displacing females, especially from the health sector. While West Bank women working in health constitute 43.9% of employees in hospital activities and 39.4% of employees in medical practices, their Gaza counterparts are only 27.9% of employees in the former and 25.2% in the latter.[16] In terms of social work, women are 41% of social workers in Gaza, and 57.5% of social workers in the West Bank.

Clearly, women are segregated from most other sectors and "crowded" into these two activities. The pattern is even stronger in Gaza, where education

Table 9. Percentage of Male to Female Teaching Staff in Three Educational Levels (Both Regions) 1995/1996.

Educational Level	Male %	Female %	Total %
Pre-school	00.2	99.8	100
All school cycles	53.9	46.1	100
Community College	82.5	17.5	100
University	87.5	12.5	100
Total employees in Education	55.9	44.1	100

Source: PCBS and Ministry of Education Educational Statistics Yearbook, 1997.

constitutes the single main employer of all women in the national non-agricultural labor market. On the positive side, women in these two sectors are predominantly in professional or semi-professional occupations such as teachers, nurses and social workers although in health, a substantial number of them are also tertiary staff such as hospital cleaners and secretaries in private practices. The education sector also shows a greater disparity between female employment at the school level than at the college and university levels.

Although women are almost equally likely to be employed as teachers as men are, the positions they hold are primarily located on the bottom rungs of the educational system. In particular the number of women declines dramatically in higher education. This is despite the fact that the student body in higher education shows very symmetrical sex ratios (females were 52% of community college students, and 43% of university students in the 1995/1996 academic year).

Sex segregation in education does not seem to be the principle that determines the overall pattern of teacher sex ratios. Instead, assumptions about natural roles and abilities of males versus females seem to be determinant. Pre-school education is assumed to be the "natural" role of women, since caring for small children is an extension of their roles as mothers. Perhaps similar assumptions apply to women's role as school teachers, although the sex segregation of schools probably played the most dominant role historically in justifying women's employment in teaching. Neither pre-school nor school teaching are perceived as high skill or status occupations – as reflected in their very low salary scales. This low status may be a product of the high numbers of women employed in education. In contrast, higher education dominated by male teachers is perceived as a high status and skill occupation – also reflected in the relatively higher wage compensation.

Within the service sector as a whole a second group of activities show relatively high numbers of female employment. In descending order of these are; "financial mediation" (20.1% female), "other personal/social service" (16.6% female), and "real estate/ renting/ business activities" (14.3% female). "Financial mediation" includes banks, money changers and insurance companies. "Other personal/social service" predominantly involves personal care activities (such as hairdressing, beauty centers, and laundry services). "Real estate rent and business" includes computer activities, legal and accounting services, research and developmental activities, engineering and architectural firms.[17] In the West Bank two thirds of women working in financial intermediation are working in insurance companies, while in Gaza the majority are working in banks. In the category of personal/social services the vast majority of females are listed as working in hairdressing and beauty care, although in both areas they are the minority of employees in this activity. Women are 28.6% of hair and beauty technicians in the West bank, and 17.8% in Gaza.

Women's employment is low in public administration with an overall sex ratio of one female to ten males. In the West Bank the majority of women working in this sector work in "the regulation of health-care" while the majority in Gaza work in the "regulation of business agencies." Overall, this compares negatively with the situation in other Middle Eastern countries, in which women constitute a substantial portion of support staff in government bureaucracies. Since the above data is based on a census carried out in 1994, while the Palestinian National Authority (PNA) bureaucracy was still in the initial stages of formation, it is likely that the data reflects the situation under the Israeli Civil Administration. More recent data on the public sector from 1997 show that while the employment in the Palestinian National Authority accounts for 12% of employed males, it only accounts for 5% of employed females (UNSCO 1999, 23). Given the much smaller size of the female labor force, this means in pure numbers a huge disparity between male and female employment in the government. This is largely explained by the fact that the police and security forces are the dominant forms of employment in the PNA.

WHOLESALE AND RETAIL TRADE

Internal trade employs more individuals than any other single activity in the national non-agricultural sphere.[18] Simultaneously, out of the four main economic activities (services, industry/manufacture, construction, and trade) it has the second lowest level of female employment. The majority of such establishments are small family-owned and run businesses. More than 95% of them

employ less than five persons.[19] Table 10 represents the employment data on males and females in sales.

Women have a relatively greater presence in retail than wholesale trade with a 1 : 12 sex ratio in the former compared to a 1 : 43 sex ratio in the latter. Moreover, regional differences are minimal with women constituting 7.8% of those engaged in retail trade in the West Bank and 6.6% in Gaza. In terms of wholesale trade, women constitute 3.2% in West Bank and less than 1% in Gaza – representing one of the most male dominated sectors throughout the national non-agricultural sphere along with quarrying, and electricity and water.

The few women working in retail trade are predominantly working in shops that do not specialize in food but sell it along with other goods. This can be assumed to mean corner grocery shops, that are usually attached to the family home. To a much lesser extent, they are working in shops selling clothing items related to women and children. In terms of the wholesale trade the vast majority of women are selling "other household items." According to the data, the numbers of women working as unpaid family labor in retail trade is minimal compared to males.

Trade as a whole is a traditional sector, with a long historical legacy and strongly evolved culture which is male dominated. The networks which support tradesmen such as those with suppliers, money-changers, customers, and other tradesmen, are not simply economic relationships but are also social relationships which have evolved across generations. These networks operate as

Table 10. Male and Female as Percent of Total employed in Selected Trade Sectors.

	West Bank		Gaza		Total Ratio
Activity	female	male	female	male	F:M
Wholesale other household goods	13.4	86.5	1.8	98.2	1:9.8
Wholesale clothing/footwear	3.3	96.7	0.9	99.1	1:22.5
Total wholesale trade	3.2	96.8	0.7	99.3	1:43
Retail in stores with food	10.3	89.7	11.2	89.9	1:8.4
Retail clothing/footwear	11.6	88.4	6.3	93.7	1:5.5
Total retail trade	7.8	92.2	6.6	93.4	1:12

Source: Based on PCBS Census of Establishments data, 1994.

informal regulatory systems to ensure access to credit and re-payment of debt in a system which is highly dependent on taking goods on consignment. Women's lack of capital resources necessary to operate a trade is thus only one obstacle. The difficulty of gaining access to these networks which are so fundamental to traditional forms of mercantilism are probably more important. The idea of women as bad credit risks was until recently encoded in law in Gaza, in which the permission of a male guardian was necessary in order for women to open a bank account, and more significantly, under existing Egyptian law it was illegal for a woman to register businesses in her own name.

CONSTRUCTION

The fourth main economic activity in the national non-agricultural sphere, construction, rates as the worst in terms of female employment. The construction sector (as a category within the national non-agricultural sphere) only includes construction activity taking place in the West Bank and Gaza under the auspices of Palestinian contractors. That women make up only 5.6% of those involved in construction in the West Bank and 1.8% in Gaza is not surprising given the overall absence of women from activities which involve heavy physical labor. Obviously, these few women are actually working as support staff in contracting companies rather than as construction workers.

OCCUPATIONAL STATUS

Gender segregation and concentration is also apparent in the way that women are distributed across occupational statuses; women are absent from most statuses and concentrated within a few. Women are largely absent from the top managerial and highest status positions – where they account for 13% of all employees but only 3% of all employed women. Women are also far more likely to be employed in the categories technicals, clerks and agriculture where they account for approximately a third of all employees in each of those occupations.

Women are primarily concentrated as professionals/clerks/technical assistants or as agricultural workers. The former category is quite high on the occupational ladder, while the latter is quite low. Perhaps more importantly, very few women are employed at the top of the occupational hierarchy (in management) and and at the bottom, except in the case of agriculture. Women then are unlikely to be employed in crafts or as plant and machine operators. The overall data suggest a similar pattern of gender segmentation and concentration as was found in the last section on women in the various sectors of the non-agricultural

Table 11. Employed Persons by Occupational Status and Sex.

Occupation	Male	Female	Total	Male	Female
Legislators, Senior officials, Managers	87.1	12.9	100	3.4	2.9
Professionals	72.9	27.1	100	5.8	12.3
Technicals	66.8	33.2	100	6.9	19.5
Clerks	62.3	37.7	100	2.3	7.9
Service, shop, market	91.4	8.6	100	19.2	10.4
Agriculture and fishery	62.7	37.3	100	8.0	27.4
Craft and related trade	91.5	8.5	100	25.8	13.7
Machine operators/assemblers	98.9	1.1	100	8.7	0.5
Elementary occupations	95.6	4.4	100	19.9	5.4
Total	85.1	14.9	100	100	100

Source: PCBS Labor Force Survey, 1996.

sphere. Importantly, however, women are not simply at the lower rungs but are highly represented in the intermediate category of professionals, technicals and clerks.

Although women are not downgraded to the lowest employment statuses, various studies suggest evidence of a wage gap between men and women. Two recent studies, one by the PCBS, the other by Olmsted (this volume) found differences in men's and women's wages, although in the former study the data suggested that the greatest wage discrimination took place among the most elite professions (senior officials and managers), while the latter study concluded that the wage gap was largest among low skilled workers.

THE INFORMAL ECONOMY

Findings of a 1993 household survey suggest that women constitute 60.6% of all individuals engaged in informal sector work in the Gaza Strip and 55.6% of those in West Bank refugee camps.[20] In other words, the survey found that overall women were more than half of all informal sector workers in Palestine. While, as mentioned earlier, this data needs to be used carefully, the findings suggest that in terms of women's dominance in the informal sector, the trend in Palestine is congruent with the situation in other developing economies.

One of the underlying assumptions of informal sector analysts was the segmented or exclusionary nature of the formal labor markets resulting in self-employment strategies by marginal or under-utilized workers (MacEwan Scott, 1994). Many economists have adopted a simple cut-off point of employment

size to distinguish between formal and informal sectors with the latter defined as enterprises employing less than five workers (MacEwan Scott, 1994). If this categorization was used for Palestine, 87% of all establishments listed in the Census of Establishments (the national non-agricultural sphere) would fall under the category "informal" (PCBS, August 1995, 21). This points to the distorted nature of enterprise development in Palestine due primarily to the severe constraints put on Palestinian business under the Israeli Occupation. As such the definition adopted here is of activities that fall outside the Census of Establishments, activities which are predominantly home or street based, and almost exclusively employ family members.[21] In simple terms, this means primarily unregistered businesses.

Ironically, the few studies that focus on the informal sector in the West Bank and Gaza concentrate exclusively on women – with the result that there are no data on men in this sphere. Examples of informal labor activity that have been documented for Palestinian women include street peddling, home-based manufacturing of food and clothing, home-based hairdressing and piece work for garment subcontractors. Two of the most significant demographic factors shared by women across these four activities are their age and marital status. The 1993 FALCOT survey also found that the majority of women engaged in informal sector activity were in the middle and older age groups (Ovenson, 1994). However, in the micro-studies two age ranges are dominant; the first group are women over forty engaged in peddling and home-based vegetable cleaning for merchants; and the second group, women in their twenties and thirties, are working in the more skilled home-based sectors, as hairdressers and seamstresses.

Educational achievement levels are comparatively low among women in the informal sector, ranging from zero years among peddlers and food cleaners to completion of some secondary school among home-based hairdressers and seamstresses. The low educational levels of informal workers is extremely significant given the fact that high educational achievement is a pre-requisite for female entry into most areas of the national non-agricultural sphere. Significantly, women in more skilled informal sector work (seamstressing and hairdressing) were graduates of training courses provided by charitable societies.

Besides their comparatively low educational achievements, the greatest common denominator among women in the informal sector is being married with children. Only in peddling were there a substantial number of female heads of households, in all other activities women were working to supplement a spouse's income. Many home-based workers claimed that it allowed them to make income concurrently with fulfilling childcare and housework responsibilities. As such, for many women the informal sector offers flexibility – especially

when they have young children. The case of home-based seamstresses, mostly in their twenties, is suggestive of this relationship. Many claimed to have switched from sewing in subcontracting workshops to home-based work following marriage.

For women with higher skills the informal sector may also be an alternative when formal opportunities are closed to them or too exploitive. Many hairdressers claimed that they were unable to find work in salons or had left salons because the work circumstances were extremely poor. The issue of poor wages and exploitation was cited by the majority of seamstresses for why they had left sewing workshops and preferred to do home-based work. Finally, given the age ranges of women in peddling and vegetable cleaning (40-plus) it seems that the informal sector may also play a role of a "second career" option for women in the post-childbearing age. Once children have reached a certain age, the informal sector offers women one of the few opportunities to re-enter the labor force.

Informal sector work for women is marked (regardless of activity) by instability and extremely low wages. Women in all four activities covered in this section complained of the seasonal and erratic nature of their work. Those dependent on merchants and subcontractors (home-based seamstresses and vegetable cleaners) worked when there was an order. Peddlers and hairdressers were at the mercy of markets. The former predominantly selling women and childrens' clothing did well during religious holidays, while the latter were dependent on the wedding season.

In 1994, women peddlers in the Gaza Strip made an average of 20 to 50 NIS per/day depending on their stock. This would average out to between 500 to 1250 NIS monthly ($160 to $300 at the 1994 exchange rate). Similarly, home-based seamstresses averaged 500 to 1200 NIS per/month. No information is available on hairdressers and vegetable cleaners although many in the former group claimed that only in the summer wedding season did they make any significant income at all.

CONCLUSION

A fundamental conclusion of this paper is that more women in Palestine are economically active than standard labor force measures are able to represent. However, the low formal labor force participation rates for Palestinian women attest to the fact that women tend to be segregated into marginalized sectors of the economy (the informal and domestic spheres). This low level of formal labor activity is primarily due to the structural limitations of the economy rather

than to ideological or cultural inhibitions. Palestinian labor markets are highly sex segmented, offering women access to a limited number of sectors. These few sectors are in non-growth areas of the economy, and are unable to absorb new female labor market entrants, leading to a persistently high rate of female unemployment over the last five years. Additionally, the number of sectors of formal labor markets available to women actually seem to be narrowing with women being displaced from areas of manufacturing which were once female concentrated as males are affected by loss of work in Israel.

The dominance of high education among women in the formal labor force is a negative indicator, reflecting the limited job opportunities for women outside the service sector in the national non-farm economy. Women with low educational qualifications can be found working in agriculture, conditional on their families owning land and in a situation in which their work is unpaid. Women seeking paid work who have low educational qualifications and are from non-agricultural backgrounds tend to be pushed into the informal sector. The informal sector is the only Palestinian labor market which seems to be female dominated – attesting to its extreme marginality in terms of income, status and security.

Wage labor in Israel which is so pivotal in absorbing large parts of the male labor force (especially those with lower educational qualifications) provides few opportunities to women. Women working in Israel are concentrated in the least paid and most unstable sector – agriculture. In comparison, males are concentrated in construction and the service sector. While the absence of women from work in Israel may be due to ideological factors (social norms precluding it), the fact that greater numbers of women in the 1970s and early 80s were found working in Israel also occurred at a time when women were found in other sectors of the Israeli economy (services and manufacturing).

Women suffer occupational segration and there is evidence that they suffer from wage discrimination as well. The notion of a "family wage" predominates and thus it is assumed that female wages only supplement those of the male breadwinner and this could be one factor deflating women's wages. In addition, this attitude leads to policies which exclude female employees from health insurance and family benefits. Women's involvement in labor unions is low, estimated at only 8% in the West Bank and Gaza combined.

As important as occupational segregation and wage discrimination is the fact that women in many sectors of the economy work under extremely poor and unfair conditions. Evidence of this is found especially among women in manufacturing and lower level service sectors. In some cases, it seemed that women preferred the instability of the informal sector over employment in workshops due to the level of exploitation in the latter.

Although data on fertility was not addressed in this paper, Palestinian women's fertility rates remain quite high and this could be a contributing factor to low rates of labor force participation among women. The fact that a much greater number of never married women are in the formal labor force (as compared to the low number of never married men) suggests, that employment policies that are not supportive of motherhood are contributing to this outcome.

NOTES

1. A recent example of such a view can be found in Lina Hamardee-Banarjee et al., *At the Crossroads: Challenges and Choices for Palestinian Women in the West Bank and Gaza Strip.* UNDP, New York 1993 (pp. 66–67).

2. The first FAFO household survey found that only 43% of males over 15 years old supported women working outside the home, compared to 78% of women (Heiberg & Ovenson, 1993, 251).

3. The commonality is particularly true vis à vis non-oil producing nations in the region.

4. The Israeli Central Bureau of Statistics assessed Palestinian unemployment figures at a mere 1 to 5% during the first twenty-five years of occupation, an assessment similar to Ovenson's figure of a 7% unemployment rate in the 1992 FAFO survey (Heiberg & Ovenson, 1993, 188). However, Ovenson did find substantial numbers of under-unemployed and under-utilized workers, especially among those with higher education (Heiberg & Ovenson, 1993, 192–194).

5. Estimated real per capita GNP in 1992 for the West Bank and Gaza Strip was U.S.$2,426. By June 1996 it had dropped to U.S.$1,483 (UNSCO, 1996, 2).

6. I have used the term "non-agricultural" since "industrial" is misleading, given that this sector also covers non-industrial business establishments such as the public sector and trade. Industrial refers to the fact that these activities are listed under the "International Standard Industrial Classification of all Economic Activities" (ISIC). See (PCBS, April 1996, 12).

7. The three years and women as percentage of workers in Israel were; 1975 (1.5%), 1977 (2.8%), and 1981 (3.1%). The data is from (Semyonov & Lewin-Epstein, 1987, 10).

8. These percentages are calculated from (PCBS, April 1996, 53, 55) and (PCBS, October 1997, 64).

9. A study done in the early 1990s based on a sample of 20 Gazan women who worked in Israel found that only one was a woman with a working spouse. Seven were divorced, seven widowed, two were unmarried and, out of the three who were married, only one had a working husband – the other two husbands were too old or too sick to work. All of them were refugees and their ages ranged from 28 to 64, with the majority of them in their forties (Hammami, 1994).

10. Studies by al-Malaki and Shalabi (1993) and Giacaman and Tamari (re-published 1997) found substantial numbers of rural women working in agriculture on nearby Israeli settlements. Women were usually working under the aegis of a village contractor who mediated the problematic social circumstances, as well as taking a large cut from their pay.

11. It could be argued, however, that current providers of social security potentially cover these women since both UNRWA and the Ministry of Social Welfare give priority to female headed-households.

12. NIS refers to New Israeli shekels. In 1997 one shekel was equivalent to $0.25 U.S.

13. Ramsis found that there were only two female members in all of the agricultural cooperatives in the West Bank. In addition, females make up less than 15% of students at the only agricultural school – Kedourie Agricultural College (Ramsis, 1997, 3).

14. Due to tax policies of the Israeli occupation authorities, many smaller family-owned businesses were unregistered even though they would be regularly included in this sector. A stated aim of the PCBS Census of Establishments was to help in the registration of all such establishments in Palestine.

15. The small number of Gaza factories identified in the 1990 study may be due to sampling problems. In the 1994 PCBS Census of Establishments 705 factory/workshops engaged in the manufacture of clothing, were counted in Gaza. While the political stability engendered by Oslo may account for a certain growth in clothing manufacture, given the larger economic constraints produced by Oslo it is unlikely that such massive growth did indeed occur.

16. These are the two main areas in which women are employed in the health sector. As sub-sectors they are not listed in the table.

17. The component activity of each of these categories is described in detail in the PCBS Establishment Census. (See PCBS, May 1995, p. 18).

18. See PCBS (May 1995, p. 58).

19. Calculated from PCBS data (May 1995, p. 45).

20. PCBS used Jordanian Dinars since it is the main currency in which service sector employees receive their paychecks in the West Bank. The 1994 exchange rate was approximately 1.4 JD to the dollar.

21. This working definition would include home-based workers for subcontractors, but not subcontracting workshops themselves.

REFERENCES

Beneira, L. (1987). Gender and the Dynamics of Subcontracting in Mexico City. In: C. Browne & J. Pechman (Eds), *Gender in the Workplace*. Washington D.C.: Brookings Institute.

Ghali, M. (1997). *Education: A Gender profile of the Determinants and Outcomes of Schooling in the West Bank and Gaza*, Palestinian Women: A Status Report No. 6. Birzeit: Women's Studies Program.

Giacaman, R., & Tamari, S. (1996). *Zbeidat; The Social Impact of Agricultural Technology on the Life of a Peasant Community in the Jordan Valley*. Birzeit: Birzeit University.

Hammami, R. Between Heaven and Earth: Transformations in Religiosity and Labor among Southern Palestinian Peasant and Refugee Women, 1920–1993. Unpublished Ph.D. Dissertation, Temple University, May 1994.

Heiberg, M., & Ovenson, G. (1993). *Palestinian Society in Gaza, West Bank and Arab Jerusalem: A FAFO Survey of Living Conditions*. Oslo: Fagbevegelsens Senter for Forskning Utredning og Dokumentasjon.

Hindiyyeh-Maneh, S. (June 1996). *Conditions of Female Wage Labour in Palestinian Factories in the West Bank and Gaza Strip*. Jerusalem: Women's Studies Center.

Kabeer, N. (1994). *Reversed Realities; Gender Hierarchies in development Thought.* London: Verso books.
Lewin-Epstein, N., & Seymonov, M. (1987). *Hewers of Wood and Drawers of Water: Non-Citizen Arab Labor in the Israeli Labor Market.* Ithaca, New York: ILR Press. Cornell University.
MacEwan Scott, A. (1994). *Divisons and Solidarities; Gender Class and Employment in Latin America.* London and New York: Routledge.
al-Malaki, M., & Shalabi, K. (1993). *al Tahowlaat al Ijtimaa'iya – al Iqtisaadiya fi Thalaath Qura Falastiniyya; Shuruut Iyaadat al Intaaj al Usur al Rifiyya al Falastiniyya Taht al Ihtilaal.* [*Socio-Economic Transformation in Three Palestinian Villages; The Conditions for Reproduction of the Rural Household Under Occupation*]. Jerusalem: Ma'an Center for Development Work.
Moors, A. (1995). *Women, Property and Islam; Palestinian Experiences 1920–1990.* Cambridge: Cambridge University Press.
Ovenson, G. (1994). *Responding to Change; Trends in Palestinian Household Economy.* Oslo: FAFO Publications.
Palestine Central Bureau of Statistics (PCBS) (August 1995). *The Establishment Census, 1994.* Final Results. Ramallah: PCBS.
Palestine Central Bureau of Statistics (PCBS) (May 1995). *Labour Force Statistics in the West Bank and Gaza Strip.* Current Status Report Series (No. 3). Ramallah: PCBS.
Palestine Central Bureau of Statistics (PCBS) (December 1995). *Survey of Wages and Work Hours – 1994.* Main Findings. Ramallah: PCBS.
Palestine Central Bureau of Statistics (PCBS) (April 1996). Labour Force Survey: Main Findings (September October 1995 Round). *Labour Force Survey Report* (No.1). Ramallah: PCBS.
Palestine Central Bureau of Statistics (PCBS) (October 1996). *The Industrial Survey – 1994: Main Results.* (Report No. 1). Ramallah: PCBS.
Palestine Central Bureau of Statistics (PCBS) (November 1996). *Services Survey – 1994: Main results.* (report No.1). Ramallah: PCBS.
Palestine Central Bureau of Statistics (PCBS) (January 1997). Labour Force Survey: Main Findings (July October 1995 Round). *Labour Force Survey Report* (No. 3). Ramallah: PCBS.
Palestine Central Bureau of Statistics (PCBS) (October 1997). Labour Force Survey: Main Findings (October 1996–January 1997 Round). *Labour Force Survey Report* (No.4). Ramallah: PCBS.
Palestine Central Bureau of Statistics (PCBS) (1997). *The Demographic Survey in the West Bank and Gaza: Final Report.* Ramallah: PCBS.
Palestine Central Bureau of Statistics (PCBS) & Ministry of Education (1997). *PCBS Educational Statistics Yearbook*, No 3, 1996–1997. Ramallah: PCBS.
Palestine Central Bureau of Statistics (PCBS) (1998). *Women and Men in Palestine; Trends and Statistics.* Ramallah: PCBS.
Ramsis, N. (January 1997). Situation Analysis and Plan of Action of Gender in Agriculture in Palestine. Unpublished Report, Palestine Ministry of Agriculture.
Rees, T. (1992). *Women and the Labour Market.* London and New York: Routledge.
Rockwell, S. (1984). Palestinian Women Workers in the Israeli-Occupied Gaza Strip. Bachelor's Thesis. Harvard/Radcliffe Universities, Cambridge, Mass.
Samed, A. (1976). *The Proletarianization of Palestinian Women in Israel.* MERIP Reports (August), No. 50, pp. 3–8.
Semyonov, M. (1994). Trends in Labor Market Participation and Gender-linked Occupational Differentiation. In: T. Mayer (Ed.), *Women and the Israeli Occupation; The Politics of Change.* London and New York: Routledge.

Simhe, E. (1984). *The Status of Arab Women in Judea, Samaria and the Gaza Strip.* Israeli Civil Administration, Jerusalem. Mimeo.
UNCTAD (1993). *UNCTAD'S Assistance to the Palestinian People: Developments in the Economy of the Occupied Palestinian Territory. Report by the UNCTAD Secretariat.* (TD/B/40(1)/8).
UNCTAD (November 1994). *Prospects for Sustained Development of the Palestinian Economy in the West Bank and Gaza Strip; 1990–2010: A Quantitative Framework.* Report by the UNCTAD Secretariat (UNCTAD/ECDC/SEU/6).
UNDP (1996). *Human Development Report 1996.* UNDP, New York.
UNSCO (October 1996). *Economic and Social Conditions in the West Bank and Gaza Strip; Quarterly Report* Autumn 1996. Gaza: Office of the United Nations Special Coordinator in the Occupied Territories.
UNSCO (April 1997). *Economic and Social Conditions in the West Bank and Gaza Strip; Quarterly Report* Winter Spring 1997. Gaza: Office of the United Nations Special Coordinator in the Occupied Territories.
UNSCO (1998). *The West Bank and Gaza Strip Private Economy: Conditions and Prospects.* Gaza: Office of the United Nations Special Coordinator in the Occupied Territories.
UNSCO (1999). *Economic and Social Conditions in the West Bank and Gaza Strip; Quarterly Report.* Gaza: Office of the United Nations Special Coordinator in the Occupied Territories
Women's Affairs Nablus et al. (February 1994). *Self-Employed Women in the Informal Economy of the Occupied Palestinian Territories.* Sponsored by NOVIB.
World Bank (1995). *Will Arab Workers be Left Out in the Twenty-First Century?* Regional Perspectives on World Development Report 1995. Washington D.C.: World Bank.
World Bank (September 1993). *The Economy, Developing the Occupied Territories; An Investment in Peace: Volume 2.* Washington D.C.: World Bank.

WHY WOMEN EARN LESS? GENDER-BASED FACTORS AFFECTING THE EARNINGS OF SELF-EMPLOYED WOMEN IN TURKEY

Simel Esim

ABSTRACT

In this study I examine gender-based earnings differences among the urban self-employed in Turkey. I argue that human capital, as well as prevailing social and institutional structures, contribute to earnings differences. Social and institutional factors considered include women's heavy non-market work burden, and their reduced mobility. I conclude that women's lower earnings are not a result of free and rational choices. Since women are not really expected to choose *to concentrate in low-return, labor-intensive tasks, these choices are more likely to be made within the context of uneven economic development and pre-existing gender inequalities.*

I. INTRODUCTION

The determinants of earnings of the self-employed have not been widely studied and in particular little is known about earnings differences between men and women in the self-employed sector. Researchers and policymakers need better information on the determinants of earnings and differences between women and men, in particular because much of the growth in women's work in the Middle East and North Africa (MENA) is in the area of self-employment. Using a unique data set that includes extensive information about the urban self-employed workers in Turkey, I am able to examine the various determinants of earnings differences between men and women. I argue that in order to explain the gender-based earnings gap modelers need to take into account the interaction between economic factors and prevailing social and institutional structures such as the links between women's market and non-market work. The self-employed who are the focus of this study are urban lower middle-class and working-class women and men involved in a set of productive and service activities. These individuals are most likely unable to find employment in the formal sector and thus must generate income with relatively little or no access to capital, depending mainly on their own labor. I find that the determinants of women's earnings are different from the determinants of men's earnings and that gender, in particular women's heavy non-market work burden, is a factor contributing to women's low earnings. This in turn, I argue, has important policy implications.

The existing approaches to gender-based earnings gap isolate the market outcomes from their social and institutional contexts by focusing only on individual characteristics. I argue that in addition to human capital variables, there are social and institutional factors, which affect the earnings of the self-employed. Some of these are gender-based factors, affecting women's earnings only and affecting women more than men. I emphasize that the earnings of an individual are not necessarily resulting from free and rational choices. Since women are not really expected to choose to concentrate in low-return, labor-intensive tasks, these choices are more likely to be made within the context of uneven economic development and gender inequalities.

II. APPROACHES TO GENDER DIFFERENCES IN EARNINGS

Neoclassical economists generally use the human capital approach to examine the determinants of earnings in the labor market. According to the proponents of this approach, education, training and experience, embodied in a person and

defined as human capital, can explain earnings in the labor market (Mincer, 1962; Malkiel & Malkiel, 1973; Oaxaca, 1973; Mincer & Polachek, 1974; Polachek, 1981). These studies ascribe women's lower earnings to their free choice in deciding to make smaller investments in productivity enhancing human capital. According to the human capital approach women choose lives that yield lower rewards in the workplace. Mincer (1962) shows that the differential in earnings rate would narrow by 45% if the work experience of women were as long as that of men. Mincer and Polachek (1974) emphasize continuity of experience in the labor market as well as years of experience in determining the occupational distribution for both women and men.

On the other hand, labor market discrimination approaches assert that labor market discrimination occurs where different wages are set for workers with the same productivity, but different personal non-economic characteristic such as sex, class, or race. (Arrow, 1972, 1973; Birdsall & Behrman, 1991) According to this theory, there are two main kinds of sex-based labor market discrimination, both of which result in an earnings gap between women and men. These include: occupational segregation, where women are distributed among occupations differently from men even after differences in education are accounted for (Beller 1982, 1984); and earnings discrimination, where within the same occupations, men earn more than women (Cain, 1986; Blau, 1992).

The crowding model of Barbara Bergmann (1974, 1986) is one of the labor market-based approaches to gender differences in earnings. In this model occupational segregation occurs when employers discriminate against women by excluding them from "men's work." The crowding model explains women's secondary labor force status as a result of the exclusion of women from many occupations and their confinement to a relatively small number of occupations.

The "discriminating tastes" argument, developed by Becker (1957, 1968), is one of the longest standing explanations of earnings discrimination, despite doubts about its compatibility with competitive markets. This taste-based model of earnings discrimination begins with the assumption that the utility of some or all the relevant agents is affected by association with members of other identifiable groups. The idea behind sex-based taste discrimination is that employers, coworkers and/or customers have a taste for discrimination and prefer to hire, work with and/or be served by men. Finally the statistical discrimination approach (Phelps, 1972) sees the source of discrimination in firms' attempts to preserve their profit advantages. According to this model, labor market discrimination against women and minorities occurs because of perceived differences in costs.

There are some basic shortcomings of both the human capital and the labor market approaches. The emphasis of the human capital approach on voluntary choice of women tends to underestimate the extent to which persons confronted

by less favorable options because of their sex and therefore their gender roles are likely to be caught up in a circle of unfavorable feedback effects. These feedback effects derive from labor-market discrimination that discourages women from making human capital investments, which in turn weakens their attachment to the labor force. Even relatively small amounts of initial discrimination can generate magnified supply effects that reinforce traditional gender roles in the behavior of employers toward women.

Others argue that the variables which seem to be unproblematic indicators of productivity to neoclassical economists are actually based on deeply embedded gender biases in the social and economic institutions of society (England, 1982; England & Farkas, 1986; Wooley, 1993). For instance, skills are socially constructed within a culture, with activities undertaken by women being perceived as unskilled. Moreover, the time and labor constraints brought about by women's unpaid work in the care economy are not taken into account in the human capital approach (Folbre, 1994; Elson, 1995a).

Similarly, the labor market discrimination approach fails to address the issue of pre-labor market inequalities, which are part of the larger social and institutional constraints faced by women. Factors outside the labor market, such as the household structure, cultural norms, and the overall structure of the economy, are likely to be more important sources of earnings differences between men and women than factors that originate from within the labor market. Finally, the interactions between women's market and non-market work are not incorporated into many studies of the wage gap.

I argue that women's choices are a function of a dynamic and historical process and are likely to evolve within the context of social, cultural and institutional inequality. Informal and formal rules or terms of agreement thus play an important part in shaping women's earnings potential. Women and men are expected to enter into and participate in the labor market on an unequal basis owing to pre-existing gender related structures and parallel non-market structures which require large amounts of time and labor from women. This study thus examines the individual factors addressed by the human capital approach, while also linking earning inequality in the labor market to cultural norms and institutions in the society. Gender-based differences determining earnings are explained as stemming from women's lack of control over resources and from pre-existing inequalities prior to and outside the labor market. Institutional (household) and larger economic environmental (spatial-sectoral) factors define and limit women entrepreneurs' labor market outcomes. While employer discrimination is not an issue for self-employed women, these women do have to deal with restrictions brought about by community and family, and prejudices in the market from colleagues and/or customers.

III. A MODEL OF EARNINGS WITH GENDER-BASED FACTORS

Although the human capital earnings theory has been applied to developing countries in order to analyze the determinants of women's and men's earnings in the formal and informal labor markets (Birdsall & Sabot, 1991; Psacharapoulos & Tzannatos, 1992), I would like to argue that a more nuanced model of earnings, which takes into account gender differences, is necessary. I thus propose the use of a Gender Based Factors of Earnings (GBFE) model, which is an augmentation of the basic human capital model. The earnings function is augmented to explore the determinants of earnings including, human capital, household and spatial-sectoral variables. In the gender-based factors of earnings model, it is hypothesized that:

- in addition to human capital variables, there are social and institutional factors which affect earnings of the self-employed;
- some of these individual, household and spatial-sectoral factors are gender-based factors, meaning that they only affect women's earnings.

IV. APPLICATION OF THE GBFE MODEL

A. Data

Data on micro and small entrepreneurs are not available on a national scale in Turkey. Labor force surveys include information on formal sector businesses only. The most recent, reliable, and representative statistics on entrepreneurs in Turkey are the 1990 census data collected by the State Institute of Statistics (SIS). These data, because they were collected at the household level, provide the widest coverage of both male and female entrepreneurs working in registered and unregistered businesses. Entrepreneurs are classified as self-employed and/or employers[1] in this data set. While these data provide an excellent sampling base for the selection of districts surveyed in this study, they do not include much additional information, such as the size of the business or other business characteristics and therefore they were of limited use, beyond assisting us with designing the sample frame.

The data used for this study come from a survey which was conducted in seven provinces of Turkey (Mugla, Corum, Denizli, Ankara, Istanbul, Gaziantep, Urfa), representing differing levels of regional development and urbanization, as well as differing rates of population growth and occupational opportunities for women and men. The seven provinces were selected from

among the provinces which had the highest percentage of women entrepreneurs according to the census. The selected provinces represent a broad spectrum of the regional variation and economic diversity found in modern Turkey.[2] A stratified random sample was carried out. Half as many self-employed men ($N=235$) as women ($N=470$) were interviewed for the surveys. Some descriptive characteristics are presented in Table 1.

Women in our sample were somewhat less likely to be married. They also have less education then men. But the most striking difference between male and female entrepreneurs in our sample is the number of non-market hours of work they performed. Women work almost 20 hours more in non-market work. Given their heavy non-market work burden, women entrepreneurs also on average spend about 10 hours less in market work, although their total hours of work are higher than men's by an average of almost 10 hours. The differences in men's and women's education, marital status, and hours of market and non-market work will be explored in further detail in the econometric analysis which follows.

Ordinary Least Squares (OLS) regression analysis was used to estimate the various results reported. Two sets of regressions were run. In the first set, the data on men and women were pooled, in order to look at the impact of sex. All other variables were assumed to impact men and women in the same way, in the pooled regression. In the second regression model men and women's earnings were examined in separate equations, in order to determine if the impact of these variables differed for men and women.[3] In both cases logged earnings were modeled as a function of three sets of factors. The individual factors that are identified as having the most effect on the earnings of the self-employed are sex, age, experience, education and marital status. Because exploring the differences between the determinants of women and men entrepreneurs' earnings is the basic purpose of this research, sex is the main axis of comparison among the self-employed. Men's businesses were selected as a control group to explore the differential effects of individual, household and spatial-sectoral factors on the earnings of self-employed women and men. The household variables all of which were expected to impact women, but not men, included time in non-market work and child care arrangements. Some of the spatial sectoral factors are expected to impact only women, while others are expected to impact both men and women. These include three location variables, one indicating whether the individual is located in an urban area, the other indicating whether their business is home based, and the third indicating whether they are in the west or east of Turkey. In addition the model includes two sets of occupational dummy variables. Table 2 contains predictions about the signs of various variables. Among the variables which are expected to affect

Table 1. Descriptive Statistics.

	Women	Men
Average Number of Hours Worked Per Week		
Hours of non-market work	21.7	2.2
Hours of market work	60.5	71.4
Total hours of work	82.2	73.6
Marital Status		
Single	18.9	14.9
Married	70.2	82.6
Other (divorced, separated, widowed)	10.9	2.6
Age Distribution		
Under 20	3.8	2.1
Between 21–30	25.4	26.3
Between 31–40	36.7	33.0
Between 41–50	25.8	25.9
Over 50	8.3	12.7
Level of Education		
No formal education	7.9	2.1
Some primary education	2.3	1.7
Graduated from primary school	50.5	64.3
Graduated from secondary school	25.6	21.7
Higher Education	13.6	10.2

both women and men, education is expected to have a positive effect on earnings. Both men and women are expected to earn more in more urban areas, as are those located in the west, which is considered the more economically developed region within Turkey. Both men and women who are employed in non-traditional occupations, including work as translators, travel agents, and real estate dealers, are expected to have higher earnings, although being in a traditional occupation such as textiles, is expected to negatively impact women's earnings only.

A number of other variables are also expected to only impact women's earnings. Marital status is expected to affect women's earnings, but not men's, with the prediction that married women will earn more than single women. Similarly, time spent in non-market work is expected to negatively affect women's earnings, but have no effect on men. Having child care responsibilities is expected to reduce earnings for women but not for men. Women who are home based are expected to earn less.

Table 2. Expected Results of the Gender-Based Factors of Earnings (Yi) Model.*

Variable	Hypothesis (women & men)	
	Women	Men
Sex: Men = 0, Women = 1	(Used in the pooled data set only)	
Years of formal education	$dY_i/dI_2 > 0$	
Marital status; Single = 0, Married = 1	$dY_i/dI_3 > 0$	no effect
Ratio of time spent on non-market work over market work	$dY_i/dH_1 < 0$	no effect
Child care arrangements; entrepreneur takes care of children while working = 0, others take care of children when working = 1.	$dY_i/dH_2 > 0$	no effect
Level of urbanization; metropolitan cities = 1, small cities = 0.	$dYi/dS1 > 0$	
Location of business; home based micro-business = 0, shop based small business = 1.	$dY_i/dS_2 > 0$	no effect
Regional economic development; west = 1, east = 0.	$dY_i/dS_3 > 0$	
Most traditional occupations such as textiles, handicrafts, food production and B&B places.	$dY_i/dS_{41} < 0$	no effect
Non-traditional occupations (translators, travel office owners and real estate dealers.	$dY_i/dS_{43} > 0$	

* The five variables that are bold in this table are the gender-based factors, which are expected to affect women entrepreneurs only women entrepreneurs or women more than men.

B. Pooled Data Set

According to the results of the pooled data set, presented in Table 3, all the factors of the GBFE model are significant except for sex and child care arrangements. While the insignificance of sex may seem to be a contradictory result,

Table 3. Estimations of the Gender-Based Factors of Earnings Model.

Variable	Pooled Data set	Women	Men
Sex	0.068	–	–
(Individual)	(0.076)	–	–
Education	0.056 **	0.041 **	0.078 **
(Individual)	(0.009)	(0.007)	(0.018)
Marital Status	0.139 **	0.209 **	−0.291
(Individual)	(0.119)	(0.085)	(0.290)
Non-market over market work	−0.210 **	−0.178**	0.107
(Household)	(0.064)	(0.050)	(0.751)
Type of Child Care Arrangement	0.064	0.214**	0.476
(Household)	(0.107)	(0.075)	(0.517)
Urbanization Level	0.093 **	0.186**	−0.040
(Spatial-Sectoral)	(0.067)	(0.059)	(0.105)
Location of Business	0.202 **	0.298**	400.1E-04
(Spatial-Sectoral)	(0.079)	(0.065)	(0.159)
Regional Development	0.203 **	0.159**	0.275**
(Spatial-Sectoral)	(0.067)	(0.060)	(0.104)
Most Traditional Sectors	−0.153 **	−0.184**	−0.033
(Spatial-Sectoral)	(0.105)	(0.089)	(0.173)
Non Traditional Sectors	0.209 **	0.181**	0.248**
(Spatial-Sectoral)	(0.099)	(0.084)	(0.173)
(Constant)	5.902	5.852	6.322
	(0.204)	(0.136)	(0.252)

** Indicates 95% Significance Level, standard errors reported in parentheses.

Adjusted R Square	0.44	0.51	0.38
Standard Error	0.48	0.46	0.48
$N =$	470	470	235

it actually does not contradict the premises of the GBFE model, which suggests that gender is a complex independent variable which must be deconstructed into its various components. Sex is only the biological component of gender. Other components of gender are captured by this model, in the variables marital status, time spent on non-market work over market work, and type of business. These factors are expected to affect the earnings of women entrepreneurs only or women entrepreneurs more than men.

In addition to sex, two other individual factors were included in the GBFE model. One of them, education, has a positive, statistically significant effect on the earnings of the self-employed in the pooled data set. This coefficient may slightly underestimate the impact of education, since the occupational dummies, identifying which sectors the self-employed work in, may be capturing part of this effect.[4] Being married is the other individual factor in the GBFE model. The coefficient on the marriage dummy variable indicates that being married has a significantly positive effect on the earnings of the self-employed in the pooled data set.

The first household factor in the GBFE model is the ratio of time spent on non-market work over market work. The larger the ratio, the more time entrepreneurs spend on non-market work with respect to market work. This ratio also signifies a time constraint on market work or the over all availability of time for the entrepreneurs. On average, for every hour spent on market work, entrepreneurs spend 41 minutes on non-market work. The coefficient of this factor is negative and significant. This result signifies that the more time entrepreneurs spend on non-market work with respect to market work, the lower their earnings will be. The second household level variable in the model is child care. According to the results of the pooled data set, taking care of one's children while working does not impact earnings.

Five spatial-sectoral factors were included in the GBFE model. The first spatial-sectoral factor is the level of urbanization. Metropolitan areas offer better access to bigger markets, more capital and better infrastructure for the self-employed compared with small cities. The coefficient for living in a metropolitan area is positive, as predicted. The second spatial-sectoral variable is the location of a business in or outside the home. Home-based micro entrepreneurs are more limited than entrepreneurs with a permanent/continuous stall or shop. The coefficient of the variable is statistically significant and positive, indicating that the effect of being shop based as opposed to being home based is positive for the pooled data set. The third variable captures differences in regional development. Western regions of the country have historically been economically more developed compared with the east. Around 61% of the respondents lived in the western provinces. I have argued that the self-employed

have better access to bigger markets, more capital and better infrastructure in the west of the country compared to the east. As predicted, this coefficient is positive and statistically significant.

The last two factors in the spatial-sectoral factors category address the occupational distribution of the entrepreneurs. The data were divided into three groups, based on the type of occupation of the respondent. The earnings of those working in the most traditional (handicrafts, textiles, embroidery, weaving) and least traditional (professional services, retail) occupations are compared with the middle category, which includes personal and social services. The coefficients for the two sectoral factors support the predictions of the GBFE model. Working in more traditional sectors such as textiles and handicrafts has a significant negative effect on the earnings of self-employed as compared to those working in somewhat traditional sectors such as personal and social services, while the effect of working in non-traditional sectors such as retail and professional services has a positive impact on earnings.

C. Separate Data Sets for Women and Men

Next the GBFE model is applied to the separate data sets for self-employed women and men. This breakdown of the data set helps demonstrate the factors that affect the earnings of women entrepreneurs differently from men's. The results of the two separate regressions on women and men clearly show that the model is a better fit for women than for men. All the variables of the regression are significant for women entrepreneurs in the expected directions. Only four variables are significant for men entrepreneurs. The factors which affect women and men both are education (individual factor), child care arrangements (household factor), the regional development level (spatial-sectoral factor) and working in non-traditional occupations (spatial-sectoral factor). It should also be noted here that while education has a positive impact on both men and women's earnings, the impact on men's earnings is greater.

The level of urbanization is one factor which was expected to positively affect both women and men entrepreneurs' earnings, due to increased access to markets, infrastructure and information in metropolitan areas. However, it is only the earnings of women entrepreneurs that are positively affected by living and working in a metropolitan area. This again suggests that gender factors are coming into play. One explanation of this result is that greater mobility constraints are placed on women in smaller town settings. The pressures and expectations of everyday life in a more urban environment require women to get out more and move further away from the household for daily tasks and chores.

All the other variables support the predictions of the GBFE model. The gender-based factors which only affect women are marital status (individual factor), time spent on non-market work over market work (household factor), location of business (spatial-sectoral factor), and most traditional sectors (spatial-sectoral factor). One interpretation of the impact of the marital status variable is that, as in the case of the urban variable, married women may have increased public mobility and access to markets and information. The ratio of time spent on non-market work over market work has a negative impact on the earnings of women entrepreneurs. The more time a woman entrepreneur spends on non-market work with respect to market work, the lower her earnings are. This is an expected result considering the time constraints brought about by the extensive hours of work women have to put in housework and child care.

Having a shop-based business has a positive effect on women's earnings as well since this increases access to information and markets. Working in the most traditional sectors, such as textiles and handicrafts, has a negative effect on the earnings of women entrepreneurs compared with working in medium traditional sectors such as personal and social services since these products and services have limited returns and face intense competition from other women entrepreneurs like themselves.

V. CONCLUSIONS AND POLICY IMPLICATIONS

I have argued that events which occur before entering the labor market, and which take place parallel to market work (socialization, non-market work, pre-labor market discrimination) are likely to be important explanations of the observed earnings differences between men and women. Women entrepreneurs face pre-labor market discrimination in the form of inequalities in accessing markets, public mobility, and time constraints, due to the gender division of labor in the household.

These results clearly show that earnings of women and men entrepreneurs are affected by similar, and different factors. The study is, therefore, instrumental in showing that men should not be considered the norm when identifying determinants of earnings for the self-employed. It is not sufficient to focus on men and develop policy conclusions based on their constraints. Moreover, the self-employed are not a homogenous group. In addition to gender, there are other differences based on region, location of business, urbanization levels, and type of occupation which impact earnings of lower middle-class and working-class entrepreneurs.

As predicted, the factors capturing the role of gender only affected the earnings of women entrepreneurs. These included marital status, ratio of time spent on non-market work over market work, child care responsibilities, location of business, and work in the most traditional sectors. A number of factors, such as a woman's marital status, and the location of her business (in terms of both of urban location and whether her business is home based) suggest that women's mobility, or lack thereof is an important contributor to earning power. The more public mobility women have, the better access they have to markets, information, and communication. These empirical results suggest that increased access to markets and information increases women entrepreneurs' earnings opportunities. Access is determined by the institutional structure of cities and the level and type of economic development in the region. Cultural norms, which also define gender-roles, emerge as important indicators of the earnings of women entrepreneurs in this context. Roles ascribed to women and their place in the household, as well as community, have important repercussions on women's market work, and involvement in income generating activities. A major contribution of this study was its attempt to identify gender-based factors that affect the earnings of women entrepreneurs. Urban lower-middle class and working class women entrepreneurs labor market outcomes such as earnings from their market work are shown to be permeated by gender-based factors. The findings from this study have significant policy implications, especially in the areas of poverty reduction and gender equity. Four key strategies will be discussed here. These include: increased provision of child care services so as to reduce women's labor burden; vocational training and education; microfinance services; and finally greater efforts to organize women who work in the informal sector, with the goals of advocating for changes in policies, and increasing solidarity among these women, both at the local, and international levels. Each of these strategies/policies will be discussed in turn.

A. Child Care

Women micro and small entrepreneurs are constrained in terms of their time allocations between market work and non-market work. Their allocations to non-market work, in the form of housework and child care, are much higher than those of men. This leads to lower earnings, and in some cases opting to be home based. An obvious solution is more egalitarian sharing of these non market labor responsibilities between women and men within the household. A policy option is providing affordable, accessible kindergardens and daycare centers in the neighborhoods where women micro and small entrepreneurs are concentrated.

For women entrepreneurs government provided child care centers are one affordable option. However, an extensive network of such public child care centers in the neighborhoods of women entrepreneurs could be very costly. Another suitable child care arrangement is that of neighborhood, family operated informal daycare centers. The Directorate General for Social Services and Child Protection Agency (SSCPA), which is currently responsible for all child care centers in Turkey, can provide training, certification, price regulation and inspections to help initiate affordable, efficient and healthy day-care centers in the lower middle class and working class neighborhoods in urban areas. Such arrangements do not currently exist in Turkey. Community or home day care facilities that are run and staffed by women would also provide business opportunities for women. Credit facilities could be extended to women in order to establish these community or home-based day care centers.

B. Vocational Training

There continues to be a literacy and enrollment gap between women and men in Turkey and this gap is greater in poorer communities. In this study, the gap in education between women and men micro entrepreneurs was much larger than the gap between women and men small entrepreneurs. One result of the gender gap in education and training is the concentration of women entrepreneurs in the most traditional sectors. Providing extended training facilities in the neighborhoods where women entrepreneurs are concentrated would help improve their skills and earnings opportunities. These skills training arrangements could be provided through a number of state organizations and nongovernmental organizations (NGOs) in order to help women entrepreneurs enter into more lucrative non-traditional sectors such as professional services. The People's Education Centers of the Ministry of Education, the Turkish Employment Agency, local municipalities, and the Association to Support Modern Life are among the organizations that already provide some skills training courses for women.

However, training in Turkey remains highly segregated by sex and this in turn is a major contributor to occupational segregation. The existing skills training courses provided to women by the Directorates General for Girls' Vocational Education and Apprenticeship and Non Formal Education continue to direct women into traditional occupations with limited career prospects. These programs offer training in only a limited number of traditional skills, and are plagued by poor instructional methods and a lack of linkages to product and labor markets. Training programs need to be designed to reverse the current segregation in the formal and informal labor markets. New courses in skills

that are demanded in the formal and informal labor markets, such as professional services, enterprise development skills, marketing and product design, could be provided by these agencies. The courses could also provide child care facilities for participating women. Coordination among various government agencies and NGOs involved in skills training courses would also increase their effectiveness.

C. Microfinance Services

While the data are not conclusive, home-based work seems to have become an important form of employment for women in Turkey. The vulnerability of home-based workers, by virtue of their isolation, comes out clearly in the results of this study. Increased and facilitated access to credit helps women take their businesses out of the home, and make capital investments in their businesses to increase their productivity. In the context of the Turkish financial system, it is not possible for financial intermediaries to be in any institutional form other than banks. Providing NGOs with the legal rights to distribute loans would be a policy decision in the right direction. Public and private bank officials, and related governmental and non-governmental agency representatives need to be informed about poverty lending and targeting women entrepreneurs who have capital needs.

There are only two government banks, HalkBank and Vakiflar Bankasi, which provide microcredit for women's businesses in urban Turkey. Only registered home-based businesses qualify for these lines of credit. These programs are also limited in their scope since they were designed to finance investments in equipment and machinery not working capital. The scope of such programs needs to be adjusted to include working capital as well as unregistered businesses. In order to reach women micro and small entrepreneurs living in urban lower middle class and working class neighborhoods, new and extensive credit lines and programs need to be developed. The scale of these programs also needs to be expanded considerably.

The success of these programs could most likely be enhanced by: having extension agents visit groups of clients on a regular basis, rather than requiring clients to come to the institutions' offices; hiring female extension workers to work with women borrowers; having large field staffs who get directly involved with the women and their businesses; lending to women clients in groups, rather than as individuals; accepting alternative forms of collateral such as group guarantees and peer-group (not elite) co-signers on loans in lieu of property or real estate; and starting women off with small loans and very short repayment periods initially.

D. Organizing Women

The organizing efforts by urban women in the informal economy come about mainly as a result of the lack of legal support and marketing services. Women home-based workers and street vendors are quite invisible in the eyes of public policy makers. Any support women micro and small entrepreneurs receive from local governments and NGOs is haphazard and unlikely to be continuous. Solidarity efforts among urban women micro and small entrepreneurs are still in their initial stages. Membership is small and these groups remain isolated from other women's and labor organizations. However, they should not be dismissed as marginal. Groups such as these exist around the world, and when developed fully, can be instrumental in winning the right to a minimum wage or piece rate, and social security and unemployment benefits for informal workers. Strategies developed by these informal economic organizations among urban women micro and small entrepreneurs need to receive more recognition and support. Public education on the issue of women home-based workers is a must. It is important for international donors and international and national women's groups and labor organizations to follow the developments of women's non-financial economic groups in Turkey and elsewhere.

A recent initiative in Turkey includes a gathering of nearly 40 individuals in the city of Istanbul to discuss the nature and status of home-based work in Turkey in October 1999. The workshop participants included international and national researchers, Turkish government officials, women home-based workers, NGOs, and representatives from the United Nations and International Labor Organization (ILO). Organized by a coordinating committee of researchers and activist women based in Turkey, the International Center for Research on Women (ICRW), HomeNet, and the Self Employed Women's Association (SEWA), the three main objectives of the workshop were to (ICRW, 2000):

(1) increase visibility for women home-based workers in Turkey among government agencies, the general public, and research institutions and initiate a discussion for the creation of a national policy around home-based work;
(2) introduce the rationale and the terms of the 1996 ILO Convention on Homework to conference participants and the general public and discuss strategies to implement the ILO Convention on Homework in Turkey;
(3) and initiate a discussion around how to best provide support for women home-based workers' organizing efforts.

One important result of the workshop was the initiation of a Working Group on Women Home-based Workers (WG-WHW), an informal network of

interested individuals who are professionals, researchers and activists. Following the workshop, the working group emerged with the main objective of increasing the visibility of women home-based workers in Turkey particularly among key stakeholders, including trade unions, related state organizations and ministries, and researchers. The strategies of the working group in achieving these objectives include:

- launching research in areas where there are gaps in knowledge;
- identifying and developing relevant statistics;
- engaging with interested members of the media to write or broadcast news on home-based work;
- undertaking policy advocacy activities around home-based work;
- establishing a dialogue with key stakeholders such as trade unions, local governments, and women's organizations to integrate home-based work in their research, and organizing work;
- developing common international strategies with solidarity networks such as HomeNet, WIEGO, etc.[5]

The efforts following the workshop on women home based workers in Turkey in October 1999 and the follow-up work accomplished by the WG-WHW can help provide the much needed institutional capacity building support for the economic organizing efforts of women in the informal economy, especially home-based workers. The multi-pronged strategy of the WG-WHW around organizing, action-research, public education and outreach, national and regional policy advocacy and international networking is proving to be a promising model. Yet such efforts are also still an early stage and need to be supported by international donor agencies, women's organizations and networks.

NOTES

1. The two definitions of ownership used by SIS are: (1) employer: a person who has one or more employees working for him/her for pay in his/her work place; (2) self-employed: a person who works in his/her own business (land, garden, shop, office, workshop, atelier, etc.) alone or with family members who do not get paid and has no paid employees.

2. Provinces included in this survey included: Urfa and Gaziantep from the economically less developed southeast; Corum from the largely agricultural Central Anatolia; Mugla and Denizli which are the tourist and cottage industry areas of the southwest; Istanbul, the trade and business capital of the country, which straddles Asia and Europe; and finally Ankara, the second largest metropolitan city and the capital of the country located in Central Anatolia.

3. A difference of means test showed significant differences in means of women and men on a few variables (location of business, ratio of time spent on non-market work

over market work, child care arrangements). Therefore the model was run on separate data sets. The pooled data set was also adjusted to include equal number of men and women (half of the women selected randomly).

4. However there is no harmful collinearity between the two variables. Results of the collinearity tests show that the highest level of collinearity was among the child care and marital status variables (0.64). Anything less than 0.80 or 0.90 is considered unharmful collinearity. The largest eigen value was 6.76. Any eigen value between 5–10 is considered weak collinearity, while values of 10–30 signify moderate collinearity. The variance inflation factor VIF was 1.0 to 3.0 in my tests on the sample (only VIFs >10 indicate harmful collinearity).

5. The WG-WHW web page at http://homepages.msn.com/VolunteerST/homebasedworkers, contains more information about their strategies.

REFERENCES

Arrow, K. J. (1972). Models of Job Discrimination in the Labor Market. In: A. H. Pascal (Ed.), *Racial Discrimination in Economic Life*. D.C. Health and Co., Lexington, Mass.

Arrow, K. J. (1973). The Theory of Discrimination. In: O. Ashenfelter & A. Rees (Eds), *Discrimination in Labor Markets* (pp. 3–33). Princeton, NJ: Princeton University Press.

Becker, G. S. (1957). *The Economics of Discrimination*. Chicago: University of Chicago Press.

Becker, G. S. (1968). Discrimination, Economics. *International Encyclopedia of the Social Sciences*, 4, 208–210.

Beller, A. H. (1982). Occupational Segregation by Sex: Determinants and Change. *Journal of Human Resources*, XVII(3) 358–370, Summer.

Beller, A. H. (1984). Trends in Occupational Segregation by Sex and Race, 1960–1981. In: *Sex Segregation in The Workplace*, National Academy Press.

Bergmann, B. R. (1974). Occupational Segregation, Wages and Profits when Employers Discriminate by Race or Sex. *Eastern Economic Journal*, 1(2/3), 103–110.

Bergmann, B. R. (1986). *The Economic Emergence of Women*. New York: Basic Books.

Birdsall, N., & Behrman, J. R. (1991). Why Do Males Earn More Than Females in Urban Brazil: Earnings Discrimination or Job Discrimination? In: N. Birdsall & R. Sabot (Eds), *Unfair Advantage: Labor Market Discrimination in Developing Countries*. Washington, D.C.: The World Bank.

Birdsall, N., & Sabot, R. (Eds) (1991). *Unfair Advantage: Labor Market Discrimination in Developing Countries*. Washington, D.C.: The World Bank.

Blau, F. D. (1992). Race & Gender Pay Differentials. National Bureau of Economic Research, Working Paper No. 4224, Cambridge, M.A.

Blau, F. D. (1995). The Gender Earnings Gap: Some International Evidence. In: *Differences and Changes in Wage Structures*. Chicago: University of Chicago Press.

Cain, G. C. (1986). Labor Market Discrimination. In: O. Ashenfelter & R. Layard (Eds), *Handbook of Labor Economics*. North Holland, Amsterdam.

Elson, D. (1995a). Gender Awareness in Modeling Structural Adjustment. *World Development*, 23(11), 1851–1868.

Elson, D. (Ed.) (1995b). *Male Bias in the Development Process*. Manchester: Manchester University Press.

England, P. (1982). The Failure of Human Capital Theory to Explain Occupational Sex Segregation. *Journal of Human Resources*, XVII(3), 358–370.

England, P., & Farkas, G. (1986). *Households, Employment, and Gender: A Social, Economic and Demographic View*. Hawthorne: de Gruyter Publishing.

Folbre, N. (1994). *Who Pays for the Kids?: Gender and the Structures of Constraint*. London: Routledge.

International Center for Research on Women (January, 2000). *Home-based Work in Turkey: Issues and Strategies for Organizing*. Washington D.C.: ICRW.

Malkiel, B., & Malkiel, J. (1973). Male-Female Pay Differentials in Professional Employment. *American Economic Review, 63*(4), 693–705.

Mincer, J. (1962). Labor Force Participation of Married Women: A Study of Labor Supply. H. G. Lewis (Ed.), *Aspects of Labor Economics*. A Report of the National Bureau of Economic Research, Princeton: Princeton University Press.

Mincer, J., & Polachek, S. (1974). Family Investments in Human Capital: Earnings of Women. *Journal of Political Economy, 82*(2), S76–S108.

Oaxaca, R. (1973). Male-Female Wage Differentials in Urban Labor Market. *International Economic Review, 14*(3), 693–709.

Phelps, E. S. (1972). The Statistical Theory of Racism and Sexism. *American Economic Review, 62*(4), 659–661.

Polachek, S. W. (February, 1981). Occupational Self-Selection: A Human Capital Approach to Sex Differences in Occupational Structure. *Review of Economics and Statistics*, 60–69.

Pollack, R. H. (1985). A Transaction Cost Approach to Families and Households. *Journal of Economic Literature, XXIII*(2), 594–608.

Psacharopoulos, G., & Tzannatos, Z. (1992). *Women's Employment and Pay in Latin America: Overview and Methodology*. Washington, D.C.: World Bank.

Wooley, F. The Feminist Challenge to Neoclassical Economics. *Cambridge Journal of Economics, 17*(1), 485–500.

FACTORS AFFECTING FEMALE MANAGERS' CAREERS IN TURKEY

Isik Urla Zeytinoglu, Omur Timurcanday Ozmen,
Alev Ergenç Katrinli, Hayat Kabasakal and
Yasemin Arbak

ABSTRACT

Based on an empirical data set including 432 managers, of whom 41 are women, this paper examines factors affecting female managers' careers in Turkey. Focusing on behavioral, human capital and demographic factors, results show that there are no differences in leadership styles and personalities between female and male managers. There are, however, differences in the level of education and family's socio-economic status by sex. We argue that higher socio-economic status of female managers' families affects their careers positively. By contrast, the lower level of female education as compared to males in addition to culturally pervasive and legally institutionalized discriminatory societal attitudes negatively affect female managers' career progress.

INTRODUCTION

Throughout history, Turkish women have worked in paid and unpaid jobs, contributing to the country's growth and development. Turkish women's employment traditionally consisted of work on family-owned farms and in their homes as homemakers (housewives). In the 1940s, women were employed in medical, legal and educational professions (Zeytinoglu, 1998). By the 1970s women were being employed in managerial positions although in the late 1990s, women's representation in managerial positions was only 10% (SIS, 1997). Such low female representation in managerial positions is not unique to Turkey. Women around the world are under-represented in such positions, particularly in higher level executive positions (Adler & Izraeli, 1994; Kabasakal, 1998; Powell & Butterfield, 1994; Zeytinoglu, 1994). Despite their increased education and training the proportion of female graduates in managerial positions remains low and as such researchers are now attempting to understand the reasons behind women's slow progression in managerial ranks.

The purpose of this paper is to examine women's work in the paid labor force in Turkey and their treatment under labor laws. We focus on women in managerial positions to present the case of unequal treatment of women attempting to reach powerful decision-making positions in management. We examine how the level of education, family's socio-economic status and sexist norms that are culturally pervasive and legally institutionalized can create barriers for women in the labor force. We first present the literature on women's employment in managerial positions and factors discussed in the literature as affecting women's employment in general and for managerial women in particular. After this overview, we discuss our own findings based on data from our survey of 432 managers, of whom 41 are women.

WOMEN'S EMPLOYMENT IN MANAGEMENT

The State Institute of Statistics (SIS) 1997 data show that women in Turkey primarily work on family farms (see Table 1). The second largest number of women are in the clerical sector, with 35% of all clerical workers being women. Women in Turkey have a relatively large share of employment in professional occupations. However, women within professional occupations are not evenly distributed, as female professionals work primarily as nurses, teachers, university lecturers, medical doctors, lawyers, and, in the engineering fields, as chemical and industrial engineers and architects (Acar, 1991; Zeytinoglu, 1998). These are the professions presumed to be appropriate for women, since it is perceived that women have innate characteristics necessary for such positions

(Zeytinoglu 1994). As Table 1 shows, the managerial,[1] service, sales and production sectors all have low female participation rates, ranging from 9 to 13%.

Unfortunately, there are no nationally representative data in Turkey that show how women's concentration in different managerial ranks varies. However, several studies show that women's representation in management positions drops sharply as they move up the organizational hierarchy[2] (See for instance, Arbak et al., 1998; Kabasakal, 1991a, b, 1998; Kabasakal et al., 1994; Katrinli & Özmen, 1991, 1992; Senesen, 1992; Zeytinoglu, 1998). In examining the manufacturing sector, Ozbasar and Aksan (1976) showed that women constituted 25% of the employees in firms located around the Istanbul area. However, only 14% of middle-level management and 4% in upper-level management were women. Earlier studies have found similar results. Tabak's 1989 survey of 500 of the largest manufacturing companies revealed that women's representation in upper-level management positions in the manufacturing sector has not increased in the last two decades. Women comprised 15% of managers and their representation dropped to 3% among upper-level managers. An earlier study by Dilber (1981) also found that only 4% of upper-level managers were women.

Certain segments of the service sector, such as banking, employ large numbers of female workers. A study conducted in the banking and insurance sectors in the 1990s (Kabasakal et al. 1994) found that while women made up 43% of all employees, they represented only 26% of middle-level management and a

Table 1. Labor Force Distribution by Occupation and Gender, 1995.

Occupation	Male*	Female*	% Female
Farmer	5,342	4,852	48
Clerical	659	357	35
Professional	819	396	33
Service	1,357	195	13
Managerial	438	49	10
Production	4,502	449	9
Sales	1,689	166	9
Other	86	22	10

* Numbers in thousands.

Source: Household Labor Force Survey Results as reported in Table 161, reported in State Institute of Statistics (1997), Statistical Yearbook of Turkey, 1996 : 266. Ankara: State Institute of Statistics.

mere 3% of upper-level management. Figures indicate that in the last two decades, the fast-growing banking and insurance sector has provided more employment opportunities to women in managerial positions. However, upper-level management positions are still out of reach for many women in this sector. As studies in North America (Denton & Zeytinoglu, 1993; Gentile, 1994; Northcraft & Gutek, 1993) argue, there should be leadership diversity in organizations, and women and other minorities should have the opportunity to lead.

FACTORS AFFECTING WOMEN'S CAREERS

The literature discusses a number of external institutional and individual factors affecting women's career progression. In the following literature review, we first discuss the external institutional factors of laws and attitudes and follow with the individual factors of human capital attainment and behavioral factors.

A. Laws Affecting Women's Careers

We argue that employment-related laws are a major factor affecting women's employment and career progression. Employers can draw on legislation to support female career progress, but they can also interpret the legislation to hinder women's career progression. Workers in Turkey are covered by four sets of laws.[3] The Constitution (Law No. 2709, dated 1982) states the basic principles for Turkish society. In addition, the Civil Servants Law (Law No. 657, dated 1965), Labor Law (Law No. 1475, dated 1971) and State Owned Enterprises Employment Law (Law No. 3771, dated 1992) cover workers. The laws define and regulate three main categories of employment: civil servants, contractual personnel in state owned companies and all other workers. The wording of laws and policies are, in general, gender-neutral, yet this is insufficient to ensure equality in employment for women.

1. Relevant Provisions of the Constitution
According to Article 10 of the 1982 Constitution, all individuals are equal before the law, irrespective of language, race, color, sex, political opinion, belief, religion and sect, or any such consideration. The article also states that no privilege shall be granted to any individual, family, group or class. State organs and administrative authorities shall act in compliance with the principle of equality before the law in all their proceedings. However, even as the constitution espouses these principles of equality, it also implicitly designates Turkish women as a vulnerable group that needs to be protected. For example, Article

41 specifies the state's responsibility for protection of the family, especially the protection of the mother and children, and for family planning education.

Under the Constitution, everyone has the right and duty to work (Art. 49). No one shall be required to perform work unsuitable for her/his age, sex or capacity. Minors, women and persons with disabilities shall enjoy special protection with regard to working conditions (Art. 50). Every citizen has the right to enter public service. No criteria other than merit shall be taken into consideration for recruitment into public service (Art. 70).

Despite such provisions, established administrative practices have often contradicted constitutional ideals. In recent years, such practices have begun to change as a result of women's groups' protests and constitutional challenges brought by individual women. However, those who object to women's inferior treatment by employers and the courts are primarily university-educated women and men who belong to the economically privileged group in Turkish society. Generally, when female workers are excluded from vacant positions or promotions, they do not sue the prospective or present employer. Lack of political-social consciousness, lower levels of education, economic dependence on men in their families and the traditional roles of women in society are all important factors contributing to women's reluctance to sue employers who discriminate against them (Zeytinoglu, 1994). On the other hand, the influence of international organizations and the European Union's insistence that Turkey improve its human rights record have spurred the government to initiate changes, albeit mostly cosmetic, to eliminate discrimination against women in the workplace.

2. Labor Law (Employment Law)
The three employment laws are gender-neutral in their wording in most articles but also contain some sections that are discriminatory or patronizing. Their discriminatory impact is most evident for women who hold professional positions in both public and private sectors.

Civil Servants Law. This law regulates qualifications of civil servants, procedures governing their appointments, duties and powers, rights and responsibilities, salaries and other matters related to their occupations. Under this law, women have been treated fairly in most aspects. Aside from the pregnancy/ maternity provisions, the Civil Servants Law applies equally to both sexes. All civil service jobs are, in theory, open to women. In public service organizations, women have been accepted into entry-level professional and managerial positions and many have reached middle-level management positions. However, their presence in higher-level managerial positions is still negligible. For

example, until 1991, with the appointment of the first female governor, there were no women serving as governors in provinces or deputy governors in towns. Although the legislation does not specifically discriminate against women, the lack of anti-discriminatory clauses allows administrators to exclude women from the post-bachelor training programs required for appointment to these posts.

State Owned Enterprises Employment Law. Starting in1984, with Statutory Decree no. 233, state owned enterprises were given the legal right to employ contractual personnel. The decree became Law No. 3771 in 1992. This law does not include female-specific provisions. Since this law is relatively recent, its impact on female employment has not been established.

Labor Law. The minimum employment standards are covered by Law No. 1475 of 1971. This law defines a worker as "an individual employed under a labor contract and earning a wage" (Art. 1). The law applies to both private and public sector workers (except civil servants and contractual personnel in state owned companies) and covers both manual and non-manual labor. Agricultural workers (as paid laborers) are outside the scope of the Labor Law. Workers in the informal sector, such as domestics and street vendors, are neither covered by this nor any other employment-related law. The female-specific provisions of the Labor Law are as follows:

Pregnancy/Maternity Provisions. Both the Labor Law and the 1987 Regulation on Conditions of Work for Pregnant or Nursing Women, Nursing Rooms and Day Nurseries provide certain protections for female workers. There is no specific parental leave provision since child-rearing is presumed to be solely women's responsibility.

Pregnant women are entitled to take paid leave of absence from work for medical check-ups during the first three months of pregnancy and once a month thereafter (Regulation, Art. 4). They are entitled to six weeks of paid leave before and after giving birth. If the worker does not return to her job within the six-week period following the maternity leave, the employer has the right to dismiss the worker without waiting for the notice period (Labor Law, Art. 17/1b).

The Labor Law requires that employers establish or support nursing rooms and daycare centers for their female employees. These places should be close to the employment premises, and workplaces may share daycare and nursery facilities (Regulation, Art. 7). The fact that nurseries and daycare centers must be established in accordance with the number of female workers reveals that child-rearing is presumed to be solely women's responsibility. Although, on the surface, this law is progressive, the provision mandating the establishment of

daycare centers at the workplace or nearby is rarely applied. Many employers in the private sector manage to avoid providing such facilities by keeping the number of employed women slightly below the legally required numbers. The few employers who do comply are mostly in the semi-public sector, such as in municipalities or state owned enterprises. Most women in paid employment seem to rely on family members or relatives for daycare.[4] Among lower economic status workers, it is common for daughters as young as ten or eleven years old to be in charge of the housework and care of younger siblings after school. Only female workers of higher socio-economic status can afford to hire nannies for childcare.

Prohibitions or restrictions on the employment of women in specific types of work under the Labor Law. Women in Turkey have low participation rates in the manufacturing, mining, utilities and construction sectors. This is closely related to the legislative restrictions on the employment of women in underground and underwater work, night work and dangerous or heavy work (Art. 68). Although this provision is discriminatory, the practice has not been challenged in Turkish courts. The absence of a challenge is also a consequence of the belief, held by many female workers, that such work is men's work. Many women opt out of these jobs by simply not applying.

Women are also prohibited from night work in industry with some exceptions as stated in the 1987 Regulation (Art. 69). Night work is defined as employment between 8 p.m. and 6 a.m. Women of all ages are generally prohibited from working in industrial jobs during those hours. The only exceptions require that the workers in question be at least 18 years of age and that approval from the Ministry of Labor is obtained. This night work restriction limits women's employment in sectors such as mineral exploration and extraction, manufacturing and processing, construction, energy and gas generation operations, shipbuilding and repairing, transportation and printing operations. These jobs are generally well-paying and stable, but most operate evening or night shifts. Employers are thus reluctant to hire female workers.

Although originally intended to protect female workers, this law effectively excludes women from jobs that tend to pay high wages. Moreover, these legal provisions perpetuate the notion that women are the weaker sex and need protection. To protect them, the law restricts or prohibits women's employment in certain types of jobs rather than attempting to improve safety conditions for all workers regardless of their sex.

In addressing these restrictions, it is important to note that these are not applied universally across sectors. Although female workers are legally excluded from night work in industrial jobs, they are routinely employed during night

hours in the hospitality sector as well as in service sector venues such as health care institutions.

Wage and Severance Pay. There has been no legislation to establish the principle of 'comparable worth,' but the notion of 'equal pay for equal work' has been a statutory provision in Turkey since the 1950s (Law no. 5518). However, it has not been applied in practice. Female workers have been paid less than their male counterparts on the basis of presumed differences in tasks, seniority, merit or skills (Zeytinoglu 1994). With the onus of proof of discriminatory pay on female workers and in light of societal acceptance of lower female pay, there have not been many challenges to the practice. In fact, female workers have been ghettoized in a few female-dominated job classes that are generally known to be lower paying.

Another provision of the labor law, the entitlement to severance pay upon termination of a labor contract, includes a female-specific provision: if the female worker decides to leave her employment within one year following marriage, she is entitled to severance pay (Art. 14 as amended in 1983). Even though this provision gives the impression that the legislation favors women, it perpetuates women's secondary role in the paid workforce and society. Granting severance pay upon marriage, the policy encourages married women to leave paid employment to become unpaid 'homemakers' and 'caretakers' for their families. The tacit goal seems to be maintaining women as homemakers who provide support and comfort to working males, thereby manipulating the work force to favor men. Thus, the overall impact of the provision has been the perpetuation of the sex-based division of labor.

It is also important to note that under a government Decree on Social Security Law (2000), women are entitled to retire at age 58 and men at age 60. Thus, gender plays a role in defining the official working years.

B. Norms and Attitudes as Barriers in the Workplace

An extensive literature highlights the existence of attitudinal barriers and discrimination against women's labor force participation at managerial levels in Turkey and elsewhere (Acker, 1991; Kabasakal, 1998; Ozbay, 1995; Katrinli & Ozmen, 1991, 1992; Schwartz, 1992; Weber & Zeytinoglu, 1999; Zeytinoglu & Weber, 1999). In a reflection of pervasive social tolerance for sex discrimination in employment, women in Turkey are often channeled into positions that are an extension of their domestic care-giving tasks and not recruited into decision-making positions or technical jobs, even if they have experience and the required level of education (Ecevit, 1995). Most employers and managers,

who also happen to be males, have negative attitudes toward women and prefer to hire men (Kabasakal, 1991b; Katrinli & Ozmen, 1992). Women are hired for jobs that do not attract males and are often characterized by poor working conditions and low pay (Zeytinoglu, 1994).

Shaped, or at least influenced, by societal norms, female managers' attitudes toward their work also influence their employment success. Kabasakal's study (1998) shows that senior level female managers work hard and are high achievers but are reluctant to be 'at the forefront.' These women act in line with female cultural expectations, working hard but maintaining 'low visibility' and avoiding publicity. They present a 'controlled feminine appearance' as expected by society. A female manager may say she is 'not a feminist' to avoid making enemies with mainstream male managers. Kabasakal (1998) states that "only those who think 'like men' are trusted as senior executives, and therefore, women managers who reach the top eschew feminism (p. 230)." Similarly, in North America, a stereotypical association between maleness and managerial ability is commonplace (Heilman et al., 1989; Marshall, 1995).

Furthermore, there are widespread biases against women in decision-making positions. Reaching findings similar to those in North America (Norris & Wylie, 1995), a study investigating attitudes of senior students in the business administration department of a Turkish university indicated that both female and male business students perceived females to be lacking in managerial traits (Turk-Smith, 1990). Students believed that the characteristics of an ideal manager were equivalent to the characteristics of an ideal male manager and an ideal male. An ideal female image was neither compatible with the ideal female manager nor the ideal manager. These types of attitudes, carried into the workplace, create discrimination in employment and an identity crisis on the part of women who choose managerial careers.

Another cultural and attitudinal factor is the societal expectation of women to be 'good' mothers and wives first, before pursuing career goals. As has also been found in other countries (Zeytinoglu et al., 1999), women in the labor force experience overload and exhaustion due to their husbands' minimal participation in family work. Akar and Boralioglu, (1989) found that women worked an average of about 14 hours per day: 8.8 hours at the workplace, 0.8 hours commuting and shopping, and 3.6 hours doing housework. This literally suggests that, aside from sleeping hours, no time remains for leisure and rest. Thus, role overload and role conflict serve as barriers to the contribution of women to the labor force. For women in senior- and middle-level managerial positions, however, the situation of time management is slightly better. They tend to employ paid-help (maids and nannies), delegating housework and child rearing responsibilities to these low-paid workers (Kabasakal 1998; Zeytinoglu 1998).

C. Investment in Human Capital

In addition to the factors discussed above, investment in human capital plays an important role in an individual's employment (Weber & Zeytinoglu, 1999; Zeytinoglu, 1994). Human capital models assume that individuals will be employed according to their investment in education and training. Those who have invested in human capital will be able to find jobs regardless of their sex. From the human capital point of view, many women and men in Turkey have difficulty finding employment because they lack the basic requirements for most jobs, including a low level of literacy and marketable skills. Although women generally have lower education than men, their labor force participation rates increase with their level of education. University educated women have the highest labor force participation rate (73%), although this is still lower than the labor force participation rate for males (86%) (Zeytinoglu, 1998).

D. Behavioral Factors

Behavioral factors of leadership styles and personalities can also play a role in female managers' careers. With more women assuming leadership positions, there is a growing interest in whether women exercise participatory leadership styles (Eagly, 1990; Fagenson, 1993; Romaine, 1999). While some maintain that there is no difference between women and men in their leadership styles (Dobbins & Platz, 1986; Powell, 1990), others argue that female and male managers do practice different leadership styles (Fierman, 1990; Heilman et al., 1989).

Everyone seems to agree that leaders provide an example for other employees and share the following fundamental attributes: courage, confidence in self and others, self-control, fortitude, patience, perseverance, intelligence, problem solving skills, good judgment, credibility, energy, concern for people, persuasiveness, and responsiveness (Kets de Vries, 1994; Tracey, 1990). Studies show that these attributes are presumed to be present in male managers (Hearn & Parkin, 1988; Schein, 1973). Being inclusive, nurturing and caring, concerned with consciousness-raising, promoting community and cooperation, encouraging democracy and participation, and striving for transformational outcomes are considered to be key characteristics of female leaders (Eagly and Johnson, 1990; Rosener, 1990). Arat (1994), studying leadership and decision-making processes used in a foundation for a Turkish women's shelter, found that in this all-female managerial environment, there was an absence of hierarchy, and principles of participatory democracy and consensus decision making were used. However, at certain times, long sessions devoted to equal participation undermined the

goals of the organization and hindered quick responses to problems, and at other times, feminist principles faltered when natural leaders emerged.

Rosener (1990) argued that female corporate leaders in her sample exercised 'interactive' management styles as opposed to the traditional 'command and control' leadership style. While the traditional style is predominant among males (Lips, 1991), female and male leaders can exercise a variety of leadership styles. As Rosener (1990) suggested, managers lead effectively using their individual strengths only when organizations value diversity in leadership styles. Romaine (1999) showed that gender was not an independent factor in female managers' decision-making style. Instead, the organizational culture affected the male and female managers' decision-making styles. In traditional organizational cultures, female and male managers acted in line with societal expectations, i.e. females were more participatory and males more autocratic. Romaine argued that when gender salience diminishes in organizations, female and male managers act in accordance with their own personal styles.

As the above literature indicates, there are a number of factors affecting female managers' careers, including the legal structure, norms and attitudes, education, and leadership style. In the following sections, we examine how the behavioral factors of leadership style and personality, individual factors of investment in human capital and other demographic characteristics impact women's careers. We make comparisons between men and women and discuss our findings in light of the societal norms and attitudes and the legal framework in Turkey.

METHODOLOGY

A. Sample Selection and Data Collection

As a sampling frame, we used a list prepared by Istanbul's Chamber of Commerce of the 500 largest manufacturing companies in Turkey in addition to lists prepared by regional manufacturing associations. From these lists, which included 1,070 organizations, we randomly selected 500 organizations and mailed them a self-administered questionnaire. We included a cover letter addressed to the chief executive officer of each organization, requesting that upper-level, middle-level and lower-level managers complete the questionnaire. We guaranteed confidentiality and received responses from 460 managers in 100 organizations. Of these managers, 432 responded to the gender questions and were included in this analysis. Sixty-one percent were in companies with 200 or more employees and 6% were in smaller organizations (30% did not provide this information).

B. Measurement Instrument

A self-administered questionnaire was used for collecting the data. In addition to collecting basic information about educational status, sex and various demographic factors, we asked questions to gauge the managerial leadership style and personality type of the managers. Following Rao (1986), respondents were asked to provide a self-assessment of their managerial leadership styles. A scale which measured the benevolent, critical and self-dispensing tendencies of the respondents (with three statements for each style, adding up to a total of nine statements) was included.[5] The reliability coefficients (Cronbach's alpha)[6] derived from the current sample were: for benevolent leadership style, 0.68; for critical leadership style, 0.70; and for self-dispensing leadership style, 0.65. Respondents were asked to indicate the extent of their agreement with each statement on a 5-point Likert scale, with 1 indicating strong disagreement and 5 indicating strong agreement. As a result, three different scores were obtained from this instrument to measure the benevolent, critical and self-dispensing leadership styles of the managers.

The instrument used for measuring the personality type of respondents was taken from Ivancevich and Matteson (1980). This 12-item instrument measures the extent to which a person exhibits Type A (competitive, aggressive and achievement-oriented) or Type B (relaxed, patient and non-hostile) behavior. Type AB is a mixture of Type A and B personalities. For each item, two alternatives were presented. The respondents were asked, using a 5-point scale, to indicate which alternative best described them. On this scale, 5 indicates that statement A most accurately describes the attitudes of the respondent (typical Type A behavior). At the other extreme, 1 indicates that statement B most accurately describes the attitudes of the respondent (typical Type B behavior). Scores can range from a minimum of 12 to a maximum of 60. Score ranges of 12–23, 24–36, and 37–60 were defined as Type B, Type AB and Type A behavior, respectively. The reliability coefficient (Cronbach's alpha) derived from the current sample was 0.63.

Respondents were asked to indicate their age and to check the appropriate categories for educational level,[7] father and mother's occupations[8] and their managerial level.[9] We decided to use the father and mother's occupations as an indicator of socio-economic status since those occupations suggest the education and income level of the family.

C. Analysis of the Data

The data have several limitations. First, because of a lack of data for Turkey, it was impossible to define a sampling frame for all managers and organizations.

Thus, we cannot generalize our results to all Turkish managers. Second, the number of women in upper-level management in our sample was small. This is the result of the small number of women holding such positions. Third, our study used self-response questionnaires. Thus, there is a self-selection bias. In addition, responses may not show the actual leadership styles and personalities, but how individuals want to present themselves. The small number of females in managerial positions did not allow for a more powerful statistical technique for the analysis. Thus, the data were analyzed using descriptive statistics and t-tests.

Fewer than 10% of the 432 responding managers were female. Of the forty-one female managers, most (30) were in middle-level positions, with only three (7%) in upper, and eight in lower-level management. Overall, 17% of the respondents were upper-level managers, while 73% were middle-level and 10% were lower-level. This suggests that men are more likely to be represented in top management. The results in Table 2 support this conclusion. Male managers were generally higher ranked, with the difference being statistically significant.

Forty-four percent of the managers were between the ages of 36 and 45, followed by 27% between 46 and 55. There were a few managers younger than 36 years of age (19%) or older than 55 (6%), and 4% of the respondents did not give their age. The average age for male managers was 48, while the average age for female managers was 37 a difference which is statistically significant.

Those surveyed were highly educated. The response rate to the question was 97%, and, of those, 92% had undergraduate or higher degrees. Only 5% had a high school degree or less. Eighty-nine percent of female managers had undergraduate degrees or above, 95% of male managers had similar degrees. While mean education levels between men and women appear similar, statistical results presented in Table 2 suggest that the level of education for female managers was significantly lower than that for male managers.

Comparisons of parents' occupations showed that there were no differences between female and male managers' mothers' occupations. The great majority of the mothers were housewives (90% for men and 88% for women). However, the father's occupation differed significantly for female and male managers. While the majority of female managers had fathers who were bureaucrats and managers, there were relatively few male managers with fathers in these occupations. At the same time, while none of the female managers had fathers who were farmers (considered the least prestigious occupation), 15% of the male managers' fathers worked as farmers. Female and male managers were equally likely to have fathers who were entrepreneurs. More male managers had fathers in the teaching profession.

An examination of critical and self-dispensing leadership styles and personality types revealed no significant differences between female and male managers,

Table 2. Comparing Female & Male Manager's Characteristics (N = 432).

	Female Managers Mean (Std. Dev.)	Male Managers Mean (Std. Dev.)	t-test significance level (ρ)
Managerial Positions[1]	2.05 (0.54)	1.86 (0.57)	0.036
Age	37 (0.80)	48 (0.80)	0.001
Educational Level[2]	2.27 (0.66)	2.24 (0.53)	0.012
Benevolent Leadership Style[3]	8.3 (2.21)	7.49 (2.40)	0.025
Critical Leadership Style[3]	9.29 (2.86)	8.78 (2.40)	0.307
Self-Dispensing Leadership Style[3]	7.21 (2.70)	7.01 (2.22)	0.433
Personality[4]	3.74 (0.55)	3.57 (0.53)	0.065

[1] 1= Upper Level Management 2 = Middle Level Management 3 = Lower Level Management.
[2] 1= High school or lower 2= University (Undergraduate Degree) 3 = Graduate Degree (Master's or Ph.D. degree).
[3] Higher scores indicate that the mentioned leadership style is more dominant.
[4] 1 and 2 = Type B, 3 = Type AB, 4 and 5 = Type A personality.

except that female managers scored higher in benevolent leadership styles. The majority of female and male managers perceived themselves as exhibiting critical leadership styles. The second most frequent leadership style was the self-dispensing leadership style, followed by the benevolent leadership style.

In terms of personality types, as shown in Table 2, the majority of both female (67%) and male managers (57%) seem to exhibit behaviors close to Type A (competitive, aggressive and achievement-oriented). The rest of the managers exhibited Type AB personalities, with none showing a Type B personality. Although it appears that female managers are more close to Type A behavior than male managers, this difference is significant only at the 0.065 level.

These results showed that, for our data, there were almost no differences between female and male Turkish managers in terms of their management styles and personality types. Thus, women and men were found to be similar in terms of attributes that are associated with managerial performance.

DISCUSSION OF RESULTS

Our data showed that, for our sample, managerial positions, particularly at the upper-level, are male-dominated. In examining managers' behavioral characteristics, we did not find significant differences between female and male managers in terms of their leadership styles and personality types. Thus, our sample suggests that differences in personality and leadership styles do not provide a plausible explanation for women's under-representation in managerial positions. On the other hand, our data indicate differences in human capital and demographic characteristics, including age, education and socio-economic status. Female managers were younger. In terms of human capital investments, a substantial majority of female managers had graduate and undergraduate degrees. This notwithstanding, they were less educated overall than men. Using fathers' occupations as a proxy for socio-economic status, our data showed that female managers were more often from higher socio-economic groups. Thus, the findings based on our sample suggest that in examining factors affecting female managers' careers, in particular their low representation in senior levels of management, we have to look beyond the behavioral factors. We argue that human capital and other individual factors, as well as societal attitudes of and about female managers, may be linked to the low representation of women in managerial levels.

In terms of human capital and individual factors, two other case studies conducted in Turkish organizations (Kabasakal & Usdiken, 1995; Velibese, 1994) also showed female managers to be younger and with less formal schooling than their male counterparts. The fact that female managers are younger and less educated may be interpreted as the cause of their concentration in lower managerial levels. However, we suggest that these factors are correlated with the fact that women are employed in less powerful and lower-level managerial positions. As we discussed elsewhere (Arbak et al., 1998), it is well known that since the early 1970s, there has been a sufficient supply of female business school graduates in Turkey, yet few women are able to enter or progress through the managerial ranks (Kabasakal, 1993; Zeytinoglu, 1994).

Perceptions of and about management as 'male' might be influencing women's progress in managerial ranks. Other studies comparing Turkish female and male managers also found that female managers were often placed in staff departments with low decision-making power (Velibese, 1994) or recruited into clerk/administrative positions, while their male counterparts were more often placed into management trainee positions (Kabasakal & Usdiken, 1995). Female managers in Turkish organizations believed that higher effort and performance were required for women to be promoted and that women had lower

compensation packages than their male peers with similar titles and positions (Sarvan & Numanoglu, 1995). Other studies have shown the sex-stereotyping of managerial jobs, reporting that women obtained middle- and upper-level management positions only when jobs were not institutionalized as 'male' in the organizations or departments (Kabasakal et al., 1994, 1993).

In terms of their socio-economic status, we found that female managers in our sample came from higher socio-economic status families, where the father was in an occupation such as a public servant,[10] entrepreneur or manager. Such a background plays an important role for women in overcoming their perceived lower status in the society due to their sex (Kabasakal, 1993, 1998; Zeytinoglu, 1994, 1998). Given that females have a lower status in managerial ranks in most countries (Adler & Izraeli, 1994; Fagenson, 1993; Lips, 1991), women need additional status bases to be accepted into prestigious managerial ranks. In Turkey, our data suggest that a higher socio-economic family background can provide women with the status they need for entering into and progressing through the ranks of management.

CONCLUSIONS AND IMPLICATIONS OF THE STUDY

This paper examined factors affecting female managers' careers in Turkey. Based on the literature reviewed, we discussed the external, environmental and individual factors affecting women's managerial careers and career progression. We argued that labor legislation, although gender-neutral in most aspects, still reinforces the institutionalization of sexist norms and values, thereby contributing to women's inferior position in the paid work force. Laws and societal attitudes, norms and values, the investment in human capital and leadership style and personalities may all affect managers' career progress. For those variables with available data in our sample, we found that there were no sex-based differences in leadership styles and personalities.

Our survey results indicate that low representation of women in managerial positions can not be explained by differences in their personality characteristics or leadership styles. This finding is particularly important since there is an ongoing debate in North America that perhaps women manage differently than men, and as a result cannot reach senior positions where appointment decisions are made by men currently dominating those positions. As an alternative to this perception, we suggest that sex-role stereotypes and a discriminatory organizational culture might serve as barriers to women's advancement into managerial positions. In addition, we found that, for our sample, there were sex-based differences in the level of education, age and family's social-status. Our data

suggest that investment in human capital is important for managers to progress in their organizations. If women lack such investment, they are left behind in career advancement. Although in our sample we found female managers to be younger than their male counterparts, this might be due to the fact that some older women have left these large size organizations to pursue their goals elsewhere, perhaps in smaller organizations that need them or in their own small businesses. This is certainly the trend for many middle-level female managers in North America who 'hit the glass ceiling.' Alternatively, some older female managers might have chosen to retire at age 40 (under the previous Social Security Law) rather than continuing to struggle to advance in their profession.

Our data also reveal a gap between managers who are from higher status families with good education and those who lack this type of support and these qualifications. Those from higher socio-economic status families may be able to break into managerial careers because their high socio-economic status has given them more self-confidence. High socio-economic status may also have been a source of social connections, thereby improving their chances of being considered for and employed in managerial positions.

Our results have implications for those interested in gender issues in organizations and the labor market. Our paper presents findings similar to those of other studies conducted in the industrialized and industrializing countries. Throughout the world women continue to face discrimination, despite having obtained appropriate skills and qualifications (Zeytinoglu & Weber, 1999). In addition, women of higher economic status and education tend to have better opportunities to reach positions of power and influence, such as the ranks of higher-level management.

The major limitation of our study was the small number of women managers we were able to reach. This is in part due to the fact that women are underrepresented in managerial positions, particularly at the top. Still, our cross-sectional, in-depth study provided some suggestions for factors affecting female managers careers in Turkey. We recommend that in order to verify and expand on our findings, larger, nationwide data sets be gathered and so that eventually a more rigorous longitudinal analysis will be possible, allowing for broader generalizations.

NOTES

1. This occupational group includes entrepreneurs as well as executive and managerial staff.

2. Similarly, in the U.S. during the early 1990s, the percentage of women in top management was still less than 5, despite the fact that 42% of managers were women (Powell & Butterfield, 1994).

3. The State Owned Enterprises Employment Law is not covered here since it does not have gender-specific provisions. There are also laws on unions and collective bargaining, which are not covered here since they are gender-neutral.

4. In 1988, there were 614 daycare centers in Turkey with a capacity to hold 16,000 children. This capacity could serve only 1.5% of working women at that time (Akar & Boralioglu, 1989).

5. See, for example, our recent publication, Arbak et. al., 1998.

6. For more on this and others such as the Likert scale see, Bickman and Rog, 1998, among others.

7. For education: 1 = high school or lower, 2 = university graduate, 3 = postgraduate degree, and specify master's or Ph.D.

8. Father's occupation is listed as: public servant, manager, teacher, entrepreneur, farmer, and other-specify. For mother's occupation housewife is added to this list.

9. For managerial level, 1 = lower-level (i.e. supervisor), 2 = middle-level (i.e. department manager or assistant department manager), and 3 = upper-level (i.e. chief executive officer, president or vice-president).

10. For a public servant, because of educational requirements at all levels of public sector jobs, working for the state or in a state-owned enterprise was traditionally perceived by the public as 'respectable because only selected people are accepted.' It is important to note that this value system began to change during the mid-1980s, with the spread of free market-oriented views.

REFERENCES

Acar, F. (1991). Women in academic science careers in Turkey. In: V. Stolte-Heiskanen (Ed.), *Women in Science, Token Women or Gender Equality* (pp. 147–171). International Social Science Council and Unesco Publication, Oxford, GB: Berg Publishers.

Acker, J. (1991). Hierarchies, jobs, bodies: A Theory of gendered organizations. In: J. Lorber & S. Farrell (Eds), *The Social Construction of Gender* (pp. 162–179). Newbury Park: Sage Publishers.

Adler, N. J., & Izraeli, D. N. (Eds) (1994). *Competitive frontiers: Women managers in a global economy*. Cambridge, MA: Basil Blackwell.

Akar, R., & Boralioglu, G. (1989). Kadinin fendi. [Women's determination.] *Ekonomik Panaroma*, 2(20), 8–13.

Arat, Y. (1994). Purple roof women's shelter foundation: Democratic aspirations in institution building. *Bogazici Journal: Review of Social, Economic and Administrative Studies*, 8(1–2), 121–135.

Arbak, Y., Kabasakal, H., Katrinli, A. E., Ozmen, O. T., & Zeytinoglu, I. U. (1998). Women managers in Turkey: The impact of leadership styles and personalities. *Journal of Management Systems*, 10(1), 53–60.

Bem, B .L. (1974). The measurement of psychological androgyny. *Journal of Consulting and Clinical Psychology*, 42, 155–162.

Bickman, L., & Rog, D. J. (Eds) (1998). *Handbook of Applied Social Research Methods*. Thousand Oaks: Sage.

Denton, M., & Zeytinoglu, I. U. (1993). Perceived participation in decision making in a university setting: The impact of gender. *Industrial and Labor Relations Review*, 46(2), 320–331.

Dilber, M. (1981). *Turk ozel kesim endustrisinde yonetsel davranis*. (Managerial Behavior in the Turkish private industries). Istanbul: Arastirma, Egitim, Ekin Yayinlari.

Dobbins, G. H., & Platz, S. J. (1986). Sex differences in leadership: How real are they? *Academy of Management Review, 11*(1), 118–127.

Eagly, A. M., & Johnson, B. T. (1990). Gender and leadership style: A meta analysis. *Psychological Bulletin, 108*(2), 233–256.

Ecevit, Y. F. (1995). The status and changing forms of women's labour in the urban economy. In: S. Tekeli (Ed.), *Women in Modern Turkish Society* (pp. 81–88). London and New Jersey: Zed Books Ltd.

Fagenson, E. A. (Ed.) (1993). *Women in management: Trends, issues, and challenges in managerial diversity*. Newbury Park, CA: Sage Publishing.

Fierman, J. (1990). Do women manage differently? *Fortune*, Dec. 17, 115–118.

Gentile, M. (Ed.) (1994). *Differences that work: Organizational excellence through diversity*. Boston, MA: Harvard University Review Press.

Gurbuz, E. (1988). *A measurement of sex-trait stereotypes*. Unpublished master thesis, Bogazici University.

Hearn, J., & Parkin, W. P. (1988). Women, men and leadership: A critical review of assumptions, practices, and change in the industrialized nations. In: N. J. Adler & D. N. Izraeli (Eds), *Women in Management Worldwide* (pp. 235–242). Armonk, NY: Sharpe.

Heilman, M. E., Block, C. J., Martell, R. F., & Simon, M. C. (1989). Has anything changed? Current organizations of men, women and managers. *Journal of Applied Psychology, 74*, 935–942.

Ivancevich, J. M., & Matteson, M. T. (1980). *Stress and work: A managerial perspective*. Illinois: Scott, Foresman & Co.

Kabasakal, H. (1991a). Kadinlar, orgutler ve guc dagilimi. [Women, Organizations and Power Distribution] *Toplum ve Bilim, 53*, 55–62.

Kabasakal, H. (1991b). Yöneticilik, kadinlar ve toplumsal tutumlar (Management, women and societal attitudes). *Journal of Economics and Administrative Studies, 5*(1), 25–35.

Kabasakal, H. (1993). Turkiye'de ust duzey kadin yoneticilerin profili (Profile of top women managers in Turkey). Paper presented at the Conference on Turkish Management, May 20–22, Silivri, Istanbul, Turkey.

Kabasakal, H. (1998). A profile of top women managers in Turkey. In: Z. Arat (Ed.), *The Turkish Woman: Deconstructing Images and Ideologies* (pp. 225–239). New York: St. Martin's Press.

Kabasakal, H., Boyacigiller, N., & Erden, N. (1994). Organizational characteristics as correlates of women in middle and top management. *Bogazici Journal: Review of Social, Economic and Administrative Studies, 8*(1–2), 45–62.

Kabasakal, H. E., Sunar, D. G., & Fisek, G. D. (1993). Sex-role perceptions and attitudes toward women as managers in Turkey. Paper presented at the Conference on Turkish Management, May 20–22, Silivri, Istanbul, Turkey.

Kabasakal, H. E., & Usdiken, B. (1995). Gender, socioeconomic background, and dual career paths in a Turkish organization. Paper presented at the 12th EGOS Colloqium, July 6–8, Istanbul, Turkey.

Katrinli, A. E., & Ozmen, O. T. (1991). Women in management. Paper presented at the Women in Management Learning: An Holistic Approach, Fall, Lancaster, England.

Katrinli, A. E., & Ozmen, O. T. (1992). Attitudes toward women as managers: A case of Turkey. 7nci Ulusal Psikoloji Kongresi, Fall, Hacettepe University, Ankara.

Kets de Vries, M. F. R. (1994). The leadership mystique. *The Academy of Management Executive, 8*(3), 73–89.

Lips, H. M. (1991). *Women, men and power*. Mountain View, CA: Mayfield Publishing.
Marshall, J. (1995). *Women managers moving on: Exploring career and life choices*. London: Routledge.
Norris, J. M., & Wylie, A. (1995). Gender stereotyping of the managerial role among students in Canada and the United States. *Group and Organization Management, 20*(2), 167–182.
Northcraft, G. B., & Gutek, B. A. (1993). Point-counterpoint: Discrimination against women in management – going, going, gone or going but never gone? In: E .A. Fagenson (Ed.), *Women in Management Trends, Issues, and Challenges in Managerial Diversity*, Women and Work Series, Vol. 4 (pp. 219–245). Newbury Park, CA: Sage Publications.
Ozbasar, S., & Aksan, Z. (1976). Isletmelerimizde beseri kaynaklarin ozellikleri ve yonetimi (Characteristics and management of human resources in organizations). *Yonetim, 2*, 97–116.
Ozbay, F. (1995). Changes in women's activities both inside and outside the home. In: S. Tekeli (Ed.), *Women in Modern Turkish Society* (pp. 89–111). London and New Jersey: Zed Books Ltd.
Powell, G. (1990). One more time: Do female and male managers differ? *The Executive, 4*, 68–75.
Powell, G., & Butterfield, A. (1994). Investigating the 'glass ceiling' phenomenon: An empirical study of actual promotions to top management. *Academy of Management Journal, 19*, 786–820.
Rao, T. W. (1986). Supervisory and Leadership Belief Questionnaire. *The 1986 Annual Developing Human Resources*.
Romaine, J. (1999). The effect of organizational culture and gender salience on managers' decision-making style. Ph.D. dissertation, McMaster University, Hamilton, On, Canada. Unpublished.
Rosener, J. B. (1990). Ways women lead. *Harvard Business Review, 68* (Nov./Dec.), 119–123.
Sarvan, F., & Numanoglu, G. (1995). Contrasting the perception of gender discrimination in the workplace. Paper presented at the 12th EGOS Colloqium, July 6–8, Istanbul, Turkey.
Schein, V. E. (1973). The relationship between sex role stereotypes and requisite management characteristics. *Journal of Applied Psychology, 57*, 95–100.
Schwartz, F. (1992). *Breaking with tradition*. New York: Warner Books.
Senesen, G. G. (1992). An econometric analysis of female participation in university administration: The case of Turkey. Paper presented at the International Conference on Business and Economic Development in Middle Eastern and Mediterranean Countries, May 25–27, Malta.
SIS (State Institute of Statistics). (1997). *Statistical Yearbook of Turkey, 1996*. Ankara: State Institute of Statistics, February.
Tabak, F. (1989). *Women top managers in different types and sizes of industry in Turkey*. Unpublished master thesis, Bogazici University.
Tracey, W. (1990). *Leadership skills: Standout performance for human resources managers*. New York: American Management Association.
Turk-Smith, S. (1990). Obstacles on the way to management: A study of Business students' images of the ideal manager. *The Journal of Contemporary Management, 3*, 174–184.
Velibese, E. (1994). The reasons preventing women from achieving high level positions in the hierarchy of business organizations: The starting-out effect. Unpublished Master Thesis, Bogazici University.
Weber, C., & Zeytinoglu, I. U. (1999). The effect of computer skills and training on the career outcomes of male and female industrial relations professionals: 1970–1990. In: R. Chaykowski & L. Powell (Eds), *Women and Work*. forthcoming. Kingston, ON: John Deutch Institute of Economic Policy and Queen's University Press.
Zeytinoglu, I. U. (1994). Employment of women and labour laws in Turkey. *Comparative Labor Law Journal, 15*(2), 177–205.

Zeytinoglu, I. U. (1998). Constructed images as employment restrictions: Determinants of female labor in Turkey. In: Z. Arat (Ed.), *The Turkish Woman: Deconstructing Images and Ideologies* (pp. 183–197). New York: St. Martin's Press.

Zeytinoglu, I. U., & Weber, C. (1999). The effect of disadvantages in early career on later career outcomes: A gender-based analysis of one occupation. In: *Ageing in a Gendered World: Issues to Identify for Women*. forthcoming, Santa Domingo & New York: INSTRAW/UN Publications.

Zeytinoglu, I. U., Denton, M., Hajdukowski-Ahmed, M., O'Connor, M., & Chambers, L. (1999). Women's work, women's voices: From invisibility to visibility. In: M. Denton, M. Hajdukowski-Ahmed, M. O'Connor & I.U. Zeytino(tm)lu (Eds), *Women's Voices in Health Promotion*. forthcoming. Canadian Scholars' Press.

GENDER-BASED OCCUPATIONAL SEGREGATION IN THE TURKISH BANKING SECTOR

Gülay Günlük-Senesen and Semsa Özar

ABSTRACT

This paper analyzes the patterns of employment in Turkey's banking sector during the post-1980 era from the perspective of occupational sex segregation. Occupational status of women and men in the banking sector is studied using sample survey data collected from 16 private banks. Indices for occupational segregation are computed for each bank as well as for the sector. Although the sampled banks are not homogenous in terms of the patterns of segregation, there is evidence of weak segregation. The findings indicate that many banking sector employees, especially females, are overqualified for their positions. The disproportionate representation of occupational categories by education and sex highlights the need for caution in evaluating the recent feminization of the banking sector as a definitely positive trend.

I. INTRODUCTION

In this paper we analyze the changing structure of employment in the Turkish banking sector in the post-1980 era from the perspective of sex-based occupational segregation. The structural adjustment policies that were implemented in

the 1980s to integrate the Turkish economy into international markets brought about significant developments in the banking and, more generally, the finance sector. These developments improved backward and forward employment linkages as well as leading to banking becoming a key sector in employment generation in the 1990s (Günlük-Senesen, 1998a).

According to official statistics women made up 19% of Turkey's urban labor force as well as 19% of the service sector workforce in April 1999 (State Institute of Statistics, 1999). An examination of the sub-sectors within the service industry reveals two major areas where women's employment is concentrated. These are finance, insurance, real estate and business services, where women comprise 29%, and community, social and personal services, where women comprise 28% of total employment.

The focus of this study is the banking sector. According to the data provided by the Turkish Banks' Association (TBB)[1] women comprised 32% of all banking sector employees in 1970, and this figure increased to about 35% in the 1980s. By 1997, women comprised 40% of employees. In some developing countries, public banks have led the increase in women's employment (Gothaskar, 1995, p. 10), however, in Turkey, the recent increase in female employees in the banking sector has taken place in private banks. In 1997, 33% of the employees in public banks were women, whereas the corresponding figure in private banks was 46%.[2]

Furthermore, private banks are more innovative than public banks in that they are quicker to adopt new technologies and implement new methods of work organization. Because this study deals with private banks, it will examine the correlation between these innovations and employment structure.

It may seem paradoxical that in order to examine sex-based segregation, this study focuses on banking, a sector where there is a high concentration of female employees. In other words, when we look at the overall economy, it may be said that discriminatory practices against women are to be found in sectors where men dominate. In comparison to other sectors, banking is a sector where the proportion of women is high, employees are relatively well-educated and women and men perform similar jobs. It is precisely for these reasons that, to quote Senel (1998, p. 55), "... the banking sector offers subtle mechanisms of discrimination as well as more blatant forms of it. Therefore, the data to be obtained in banks can shed light upon not only today's gender-based issues, but also those that might be encountered in the future".[3]

Gender inequality prevails in the labor markets of all countries, regardless of their level of development. The patterns and extent of female/male labor force participation and the wage gap differ from one country to another, just as one might find differentiation between "women's jobs" and "men's jobs."

Nevertheless, the common denominator of occupational patterns across the board is the fact that women occupy a different position from men in the labor market.[4]

Many studies of segregation have focused on the gap in earnings by sex. These studies have pointed to differences in productivity and discrimination as explanations for the wage gap. As the explanatory power of human capital variables has increased (along with the number of variables which can explain differences in human capital), wage differentials resulting from productivity differences between men and women become less relevant, and thus discrimination becomes more crucial (Duraisamy & Duraisamy, 1996; Humphries, 1995; Psacharapoulos & Tzannatos, 1992).

In the labor market, one not only encounters wage discrimination against women, but also occupational segregation. Studies have found that rather than offering different wages to men and women having identical productive endowments and performing similar work, women are given inferior jobs and are therefore paid less (Alizadeh & Harper, 1995; Malkiel & Malkiel, 1973; and Watts & Rich, 1993).

This study will not approach sex-based segregation from the viewpoint of wage differentials between men and women in similar occupations, but from the viewpoint of vertical occupational differences based on sex. One of the reasons for this is the lack of adequate data on wages in Turkey and the difficulty of obtaining such information from employers. The second reason, and perhaps a more important one, is that many studies that are carried out in developing countries indicate that sex-based segregation results from vertical occupational discrimination rather than wage discrimination (Cohen & House, 1993; Eraydin & Erendil, 1996; and Tam, 1996).

The second section explains the methodology and the construction of the database. Section III examines the restructuring of the banking sector in the post-1980 period and its impact on employment. Section IV deals with sex-based occupational segregation and presents the findings in terms of an occupational segregation index. Section V attempts to establish a relationship between education levels and sex-based occupational segregation. Section VI is devoted to concluding remarks.

II. DATA AND METHODOLOGY

A. The Methodology

This research stems from feminist criticism of mainstream economic analysis. The feminist approach does not provide a single method for analyzing social

phenomena. Despite the fact that there are sharp differences among feminists in their approach to methodology, they share some common elements. The most important point that they have in common is the centrality of gender as an analytical category (Burnell, 1993a).

The feminist approach has challenged the nature of data use in mainstream economics. Too often, economists are only interested in developing testable models and forecasting methods and neglect to question the nature of their data. The data used by most economists are obtained through field surveys and categorized by other researchers. Economists assume that these data are value-free and objective. However, value judgements are already embedded when these surveys are conceptualized and implemented, and these values generally reflect a male perspective. Therefore, empirical questions can be answered only to the extent to which the data allow (Berik, 1997).

Feminist economists take as their point of departure the fact that "scientific" findings can be as powerful as the validity of the data that they are based on. They thus encourage methods such as participant observation, face-to-face interviews, in-depth interviewing, life stories and field surveys that are employed in other social sciences (Strassman, 1997). The goal is to apply the appropriate method for the research question. Therefore, it may be necessary to transcend the boundaries of the existing methodologies (Berik, 1997). In keeping with feminist approaches, in this study we employed both quantitative and qualitative methods.

B. The Database

The Turkish Banks' Association publishes annual data on banking personnel by sex and educational level. However, this database does not include the data on sex-based occupational categorization and segregation that are essential for this study. Instead, the research team collected these data.[5] Both qualitative and quantitative methods were used in data collection. In the first stage, before proceeding to systematic data collection on occupational segregation, interviews were conducted with experts on the recent developments in the banking sector, future expectations, problems, the employment structure and female employment prospects.[6] These interviews provided not only first-hand information on the sector, but also preliminary information on the categorization of occupations, which is necessary for systematic data collection.

In order to reveal the sex-based employment structure in the banking sector, a total of 30 banks were contacted. Of these banks, 7 were large banks (over 2,000 employees), 10 medium-sized (500–1,999 employees) and 13 small (1–499 employees).[7] Questionnaires filled out by the personnel departments

included information on education level, age and year of experience of employees by sex on the basis of occupational categories. These data do not provide information on an individual basis. Unfortunately, there is no data source that provides data on human capital characteristics and occupational categories of individual employees for the banking sector in Turkey. Furthermore, most of the banks that we contacted refused to give information about their individual employees.

As will be seen in Section IV, only 16 banks provided information that complies with the requirements of the indices of occupational segregation. The total employment in private banks was 81,289 as of December 1997 (TBB, 1998). Our sample covers 39,440 employees, representing 49% of the employees in private banks.

In addition, upper-level executives of human resources departments from the banks sampled were interviewed. They were asked to comment on the characteristics of their company, personnel and recruitment policies, with a particular focus on sex-based segregation.

Since the main purpose of this research was to investigate the extent of sex-based occupational segregation in the banking sector, we utilized the occupational segregation index that is used in the relevant literature. Our research cannot address all aspects of sex-based occupational segregation or all of its causes. For example, only by interviewing women who experience occupational segregation, as well as those who practice discrimination, can we hope to understand its different forms as well as how and why it is practiced. This research does not delve into these areas.[8]

III. RESTRUCTURING IN THE BANKING SECTOR AND THE CHANGE IN THE STRUCTURE OF EMPLOYMENT

The Turkish banking system has undergone a restructuring as a result of the financial liberalization policies of July 1980, which were implemented following the 24 January 1980 program. While banking and related financial activities were highly regulated during the import substitution era, the post-1980 period witnessed the lifting of many regulations so that the resulting competitive environment could improve efficiency. The encouragement of entry of foreign financial institutions and the liberalization of foreign exchange transactions were two radical changes in policy. A stock exchange was also established in the liberal era.

In short, the banking sector in Turkey evolved from a mainly deposit-management position into a financial activities sector with an enhanced variety of transactions like credit and investment banking and personal banking (Ada,

1993; Aydogan, 1993; Denizer, 1995). Both firms and banks improved their contacts with foreign financial institutions, leading to the increased significance of the banking sector in the economy as a whole. Government borrowing at high interest rates from the financial system to finance huge budget deficits is another important factor that has nourished the financial system. Moreover, the banking sector has become a key sector in direct and indirect employment generation (Günlük-Senesen, 1998a).

These developments have been accompanied by rapid computerization, requiring fewer but more qualified workers. Employment increased by 89% from 1970 to 1980, and only by 24% from 1980 to 1990. A decline in overall employment was observed starting in 1990, with a striking contraction in 1994 due to the financial crisis. The increase in employment during 1980–1997 was 18% (14% for private banks), implying smaller annual increases in the post-1980 era, despite the expansion of the sector in terms of output and monetary indicators. In addition, many bank branches in the South-East region have closed due to the unsafe environment. Specialists seem to share the opinion that future development of banking is not likely to lead to increased employment. This is due to technological developments such as the increased use of computers to provide on-line banking services and operate ATMs.

The interviews we conducted revealed the common opinion that the basic desired feature of future employees is not knowledge of banking, but an overall intellectual ability. The primary reason for this is that both banks and the Turkish Banks' Association provide training programs on a continual basis. Individuals from a variety of disciplines, including engineering, law, and business administration, are frequently employed, as well as individuals with only a high school diploma. Among the latter category, those who have attended commercial vocational schools are preferred. As the emphasis on personal banking continues to expand, employees will need to be individuals who are self-confident and knowledgeable, in short, those with general rather than specific skills.

While technological developments in the banking sector tend to decrease employment, increased personal banking tends to generate more employment. The interviews revealed that all of the banks that were contacted hired new employees last year, and most of the applicants were women.[9] According to the statements made by people in the sector, there will probably be more women working in banking in the future. The personnel managers who make this prediction maintain that the service sector is more suitable for women, more women apply in the case of vacancies, and women are more enthusiastic and successful. Most of the managers who predict no change or a decrease in the number of female workers indicated that they are trying to maintain a balance between men and women in their organizations.

As can be seen from Fig. 1, the percentage of women employed in private banks increased between 1986 and 1997.[10] This increase accelerated after 1994. The trend suggests that the banking sector is experiencing a "feminization" of its workforce.

Several reasons for the recent increase in the percentage of female employees in the banking sector were suggested during the interviews. These suggestions, made by personnel managers and banking sector experts,[11] reflect their own perceptions and prejudices about female employees:

(1) The possibilities for vertical advancement in banking are limited. The fact that women are burdened with household responsibilities dampens their professional ambitions, and therefore, banking becomes a suitable choice for women.
(2) Women reflect the bank's image.
(3) The organizational structure in the banking sector is more authoritarian than democratic.
(4) The work environment is rather monotonous. Women have more tolerance for jobs that require patience and perseverance and are more able to work without moving around, usually at a desk, in such closed quarters.
(5) Women have talent for organizational work. Therefore, there are many women working in departments of training and human resources.
(6) Activities related to training and human resources do not require technical training.

Similar conclusions regarding increased "feminization" of the workplace are reached upon examining female employment in banks in other countries. For example, at Grindlays Bank in Bombay, female employment rose from 5 to 50% between 1970 and 1992. According to a union official, the change is due to the fact that, "Management realized that women are more submissive, overworked, and have less time for union work" (Gothoskar, 1995, p. 165).

IV. HIERARCHICAL SEGREGATION

Sex-based occupational segregation can occur in the form of men and women concentrating in different jobs (horizontal segregation), as well as hierarchical segregation (vertical segregation). This study examines the latter. Table 1 gives the percentage of women by job category using data collected from 16 private banks. Our occupational categories are as follows:

(1) top management, consisting of general managers, their assistants, and department managers,
(2) mid management, consisting of branch managers, their assistants, department heads and their supervisors,

Fig. 1. Percentage of Female Employees, 1986–1997.

Source: Annuals of Turkish Banks' Association

(3) skilled personnel, consisting of trained cashiers, tellers, computer operators and other such staff,
(4) unskilled personnel, consisting of service workers, janitors, security guards and couriers.

Table 1 shows that although women represent a significant proportion of the total workforce in the banking sector, they are not equally represented at all levels. It is possible to assert that during their career advancement, women face a "glass ceiling." Although their employment exceeds 50% at the level of skilled personnel, their share sharply declines as one moves up in the hierarchy; and it is especially the case that they are underrepresented in the top management level. The reason why there are so few women in the category of unskilled employees is that most employees in this group are security guards, who are predominantly male.

The female composition presented in Table 1 gives a rough picture regarding the position of women. The picture can be further developed by the quantification of sex-based occupational segregation, with respect to the position of males, through the Occupational Segregation Index (OSI), described in more detail in the appendix. OSI values were computed for each of the 16 private banks and ranged between 17 and 45.7. The average for the sector as a whole was 25.6. Given that OSI values are 46 in textiles and apparel and 42 in tourism, we can conclude that occupational segregation is relatively low in the banking sector.[12] However, this conclusion holds only if men and women with similar qualifications are in the same category. In order to provide a more complete picture, the next section examines the same phenomenon of occupational segregation but brings personnel education levels into the analysis.

Table 1. The Percentage of Female Employees by Occupation.

Occupational categories	Percentage of Female Employees (%)
Top management	18.8
Mid management	38.7
Skilled personnel	50.3
Unskilled personnel	3.4
All banking jobs	41.2

Source: Findings of the Survey Research, June–August, 1997.

V. OCCUPATIONAL SEGREGATION AND EDUCATION

In this section, we turn again to data on private banks. As can be seen from Fig. 2, the percentage of employees with primary and middle or high school education decreased in private banks between 1986 and 1997, while the percentage of personnel with higher education increased dramatically. It is especially noteworthy that the proportion of university graduates rose from 20% in 1986 to over 30% in 1994 with an even sharper increase after 1994, reaching 44% by 1997. The striking difference in patterns of education levels over time was also confirmed statistically using linear trend analysis.

This rapid transformation in education levels, however, differs by sex. Figures 3 and 4 examine how educational trends differ for women and men, respectively. As can be seen in Fig. 3, within a 12-year period between 1986 and 1997, educational composition of female employees changed quite rapidly.

From Fig. 4 we see that although the educational level of male personnel also rose within the same period, the increase was not as radical as it was for women. Among male employees, individuals with middle or high school education were still the predominant group. In 1986, the percentage of all individuals with higher education was about 20%, but by 1997 it had risen to 55% for women and only 39% for men. Statistical analyses confirm that there was a structural change in female composition with respect to education and that this was stronger than the overall change.

Figure 5 shows the change in educational levels by giving the percentage of females in each educational category over time. During the period between 1986 and 1997, the proportion of female university graduates increased from nearly 30% to above 50%.

At this stage, the point that needs to be addressed is whether or not women's relatively higher education is reflected in their occupational status. Our survey findings address this question. Our sample survey data are consistent with the education structure discussed with respect to the population of private banks while providing additional information on the occupational distribution with respect to sex and education. When interpreting these data though, it should be kept in mind that the information presented herein is provided by the personnel management departments of the banks surveyed. Therefore, we do not have information on the individual characteristics of the employees, such as age, marital status and years of experience.

Although very few in numbers, those primary and middle or high school graduates in skilled and upper position levels are likely to be on-the-job-trained, experienced and approaching retirement. Similarly, the position of university

Gender-Based Occupational Segregation in the Turkish Banking Sector 257

Fig. 2. Education Trends, 1986–1997.

Fig. 3. Education Trends of Female Employees, 1986–1997.

Fig. 4. Education Trends of Male Employees, 1986–1997.

Source: Annuals of Turkish Banks' Association

graduates in the unskilled category might be transitory rather than permanent. One striking observation from Table 2 is that the total number of female university graduates (including postgraduates) is higher than that of males (9,163 vs. 8,805). Focusing on university graduates in skilled and upper levels, we note that this relative dominance prevails for the skilled level but not for the upper management positions.

Table 3 presents the data of Table 2 in terms of percentages. Among university graduates positioned in top management only 16.7% are women. This stands

Table 2. Distribution of Employment by Gender, Education and Occupational Status, 1997 (W: Women; M: Men).

Educational level	Occupational Status									
	Unskilled Personnel		Skilled Personnel		Mid Management		Top Management		Total	
	W	M	W	M	W	M	W	M	W	M
Primary school	40	1,411	3	65	1	1	-	-	44	1,477
Middle school	14	1,841	76	930	5	38	1	1	96	2,810
High school	115	2,000	6,121	6,665	647	1,249	61	187	6,944	10,101
University +	16	32	7,322	5,714	1,700	2,437	125	622	9,163	8,805
Total	185	5,284	13,522	13,374	2,353	3,725	187	810	16,247	23,193
Total employment	5,469		26,896		6,078		997		39,440	

Source: Findings of the survey research, June-August, 1997.

Table 3. Percentage of Female Employees by Education and Occupational Status, 1997 (%).

Educational level	Occupational Status				
	Unskilled Personnel	Skilled Personnel	Mid Management	Top Management	Total
Primary school	2.8	4.4	50.0	-	2.9
Middle school	1.0	7.6	11.6	50.0	3.3
High school	5.4	47.9	34.1	24.6	40.7
University +	33.0	56.2	41.0	16.7	51.0
Total	3.4	50.3	38.7	18.8	41.2

Source: Table 2.

Gender-Based Occupational Segregation in the Turkish Banking Sector 261

Fig. 5. Percentage of Female Employees by Education Level.

Source: Annuals of Turkish Banks' Association

in sharp contrast with the finding that over 50% of university gradudates in the banking sector are women. The overqualification of women is thus much more strikingly reflected in the numbers presented in Table 3. In the skilled and mid management levels, the female proportions increase as education level increases, but the pattern is reversed with top management positions. Again focusing on university graduates, whereas about 18.8% of positions in the banking industry are in top management, only about 16.7% of these positions are held by women.

Studies of the relationship between education and employment suggest that there are increasing demand for education because of its high returns in terms of wages and low private costs. Unfortunately, labor markets faced with an excess of applicants cannot always absorb all of the educated. Employers tend to select by level of education, and this creates further demand for educational opportunities. Employers reinforce this trend by continuously upgrading formal educational entry requirements for jobs previously occupied by less educated employees. Thus, minimal educational requirements rise, and resistance is formed against a possible downward adjustment (Todaro, 1997).

Our interviews with banking experts and personnel managers confirmed that Turkey's banking sector is experiencing the above-mentioned phenomenon. Especially in occupations that are categorized as "skilled" (i.e. trained cashiers, tellers, computer operators, etc.), almost half of the personnel are university graduates even though a high school education is considered sufficient. In particular, large- and medium-scale private banks have their own training programs for their personnel and are not necessarily keen on recruiting university graduates of finance or economics. As one of the personnel managers put it, "We give our own training, so it does not make much difference for us whether the newcomer has an economics or physics degree. In our bank, since four or five years, university graduation is an entry requirement. There are so many applicants with university diplomas that we have no difficulties in recruitment". It appears that the banking sector uses the university diploma as a screening criterion in recruitment due to the excess supply of applicants.

A majority of all employees in our sample data (68.2%) fall into the category of skilled personnel. Although half of all those who are in the category of skilled workers are women (50.3%), the percentage of women with higher education in this category is 56.2%. It is mostly women who are educationally overqualified in the banking sector.

This trend is observed not only in Turkey, but also in other developing countries. In recent years the increase in the percentage of female employees of the Hong Kong Bank is attributed to women being more diligent and better qualified than men. While overqualified women apply for jobs in the banking

sector, men with comparable qualifications are able to get jobs with ambitious career lines and which are more promising in terms of job satisfaction and pay (Gothaskar, 1995). Another study conducted on the Turkish banking sector also supports these findings. "An opinion is that while women in banking are willing to work in their jobs regardless of the conditions, men consider working in banking only if they are hired as managers". (Özdamar et al., 1996, p. 463.)

VI. CONCLUDING REMARKS

The recent changes in the employment structure of private banks in Turkey exhibit two general trends that can be outlined as follows: there is a feminization of employment in the banking sector; and there is an improvement in the education level of banking employees. The findings of this research indicate that these two trends are related. Women with higher education are increasingly employed in occupations requiring lower levels of education and with very limited promotion opportunities.

Many studies have emphasized educational attainment as an important variable in explaining female participation in the labor force. Women with a university education are far more likely to take part in occupational life. Even if only for this reason, raising women's education is an important issue which should be addressed with a sense of urgency. However, the employment of women in relatively inferior jobs compared to their educational background is an issue of equal importance and needs to be explored in depth.

Our paper adds to the literature identifying the various forms which sex-based segregation can take. The banking sector in Turkey includes a large population of female employees and OSI figures indicate relatively low sex-based occupational segregation as compared to other sectors. This notwithstanding, the disproportionate representation of occupational categories by education and sex highlights the need for caution in evaluating the recent feminization of the banking sector as a definitely positive trend.

ACKNOWLEDGMENT

The authors wish to thank Mine Çinar and the anonymous referee for all their advice and helpful comments. We would also like to thank Ayse Eyüboglu and Engin Pulhan from TRiO Research Ltd. for survey data and Aylin Soydan for compilation of data for the population of private banks.

NOTES

1. The only organization that regularly publishes data on employment in the banking sector in Turkey is the Turkish Banks' Association.
2. After recent attempts of privatization, public banks still retain their leading position in terms of employment by employing almost half of the employees (48%) in the banking sector (TBB 1998).
3. This study investigates sex-based discrimination in three banks with different organizational characteristics, using only qualitative methods such as in-depth interviews and focus groups.
4. For cross-country statistics concerning female labor force participation, occupational segregation, and wage differentials between men and women for the same job, see Jacobsen (1994); for similar figures related to Turkey, see Çağatay and Berik (1991), Kasnakoğlu and Dayıoğlu (1996), Özar (1994), World Bank (1993).
5. The database used in this study is part of a comprehensive research project entitled *New Perspectives for Female Employment and Forecasts for Female Labor Demand* conducted by the authors and TRIO Research Ltd. during 1996–1997 and financed by the Directorate of Status and Problems of Women and the World Bank.
6. Six individuals were interviewed from banks and trade unions, including the General Secretary of the Turkish Banks' Association.
7. Scales were determined on the basis of employment data provided by the Turkish Banks' Association.
8. Regarding this, see Şenel (1998).
9. Eighty percent of the personnel managers said that there were more female applicants, 3% declared that there were more male applicants and the rest said that there was an approximately equal number of men and women applying for vacancies in their banks.
10. The Turkish Banks' Association only began publishing employment data broken down by education and sex in 1986.
11. Fifty-seven percent of the respondents were women.
12. The OSI value is relatively low despite the fact that women are strikingly underrepresented in the unskilled category, a characteristically male one. Occupational segregation almost disappears, with an OSI value as low as 9.5, when computed from Table 1 for the three skilled categories, excluding the unskilled one. The OSI values for textiles and apparel and tourism were calculated by the authors.

REFERENCES

Ada, Z. (1993). Türk bankacilik sisteminin yapisi (1980–1990), 3. Izmir Iktisat Kongresi, 4–7 Haziran 1992, Bildiriler (The structure of the Turkish banking system(1980-1990), Izmir Economics Congress, 4–7 June 1992, Proceedings.

Alizadeh, P., & Harper, B. (1995). Occupational sex segregation in Iran 1976–1986. *Journal of International Development*, 7(4), 637–651.

Aydogan, K. (1993). The competitive structure of the Turkish banking industry. In: Y. Asikoglu & H. Ersel (Eds), *Financial Liberalization in Turkey* (pp. 167–180). Ankara: TCMB,.

Berik, G. (1997). The need for crossing the method boundaries in economics research. *Feminist Economics*, 3(2), 121–125.

Burnell, B. S. (1993a). Alternative methodological perspectives. In: *Technological Change and Women's Work Experience. Alternative Methodological Perspectives* (pp. 11–30). Connecticut: Bergin and Garvey.
Burnell, B. S. (1993b). New evidence on the relationship between technology and occupational sex segregation. In: *Technological Change and Women's Work Experience – Alternative Methodological Perspectives* (pp. 137–166). Westport: Bergin and Garvey.
Cohen, B., & House, W. J. (1993). Women's urban labor market status in developing countries: how well do they fare in Khartoum, Sudan? *The Journal of Development Studies*, 29(3), 461–483.
Cagatay, N. & G. Berik. (1991). Transition to export-led growth in Turkey: is there a feminization of employment? *Capital and Class*, 43, 153–177.
Denizer, C. (1995). Liberalization and competition in the Turkish banking market. In: R. Erzan (Ed.), *Policies for Competition and Competitiveness: The Case of Industry in Turkey* (pp. 52-90). UNIDO.
Deutsch, J., Flückiger, Y., & Silber, J. (1994). Measuring occupational segregation – summary statistics and the impact of classification errors and aggregation. *Journal of Econometrics*, 61, 133–146.
Duraisamy, M., & Duraisamy, P. (1996). Sex discrimination in Indian labor markets. *Feminist Economics*, 2(2), 41–61.
Eraydin, A., & Erendil, A. (1996). *Dis pazarlara açilan konfeksiyon sanayinde yeni üretim süreçleri ve kadin isgücünün bu sürece katilim biçimleri* (New production processes in export-oriented garment industry and different ways of participation of female labor to this process). KSSGM, unpublished manuscript, Ankara.
Gothoskar, S. (1995). Computerization and women's employment in India's banking sector. In: S. Mitter & S. Rowbotham (Eds), *Women Encounter Technology. Changing Patterns of Employment in the Third World* (pp. 150–176). London: Routledge.
Günlük-Senesen, G. (1998a). An input-output analysis of employment structure in Turkey: 1973–1990, Economic Research Forum Working Paper, WP 9809, Cairo.
Günlük-Senesen, G. (1998b). Cinsiyete dayali ayrimciligin düzeyi nasil ölçülebilir? (How should the extent of gender-based discrimination be measured?). *Iktisat Dergisi*, 337, 26–36.
Humphries, J. (1995). Introduction. In: J. Humphries (Ed.), *Gender and Economics*. Aldershot: Edward Elgar.
Jacobsen, J. P. (1994). *The economics of gender*. Cambridge: Blackwell.
Kasnakoglu, Z. & Dayioglu, M. (1996). Education and earnings by gender in Turkey, Erc Working Papers in Economics, No. 96/10, METU Economic Research Center, Ankara.
Malkiel, B. G. & Malkiel, J. A. (1973). Male-female wage differentials in professional employment. *American Economic Review*, 63(4), 693–705.
Orazem, P. F., Mattila, J. P., & Yu, R. C. (1990). An index number approach to the measurement of wage differentials by sex. *The Journal of Human Resources*, XXV(1), 125–136.
Özar, Ş. (1994). Some observations on the position of women in the labor market in the development process of Turkey. *Bogaziçi Journal*, 8(1–2), 21–43.
Özdamar, S., Senel, D., Incir, G., Ilgaz, N., Fidan, E., & Ince, Y. (1996). Çalisma yasaminda cinsiyete dayali ayrimcilik.Bankacilik sektöründe örnek olay incelemesi (Gender based segregation at work. A case study in the banking sector). KSSGM, unpublished manuscript, Ankara.
Psacharopoulos, G., & Tzannatos, Z. (1992). Women's employment and pay in Latin America: Overview and methodology. World Bank Regional and Sectoral Studies. Washington D.C.: The World Bank.
State Institute of Statistics (SIS) (1999). Household Labor Force Survey, April, Ankara: SIS.

Strassman, D. (1997). Editorial: expanding the methodological boundaries of economics. *Feminist Economics*, 3(2), vii.
Senel, D. (1998). Çalisma yasaminda cinsiyete dayali ayirimcilik: bankacilik isyerlerinden örnekler (Gender-based discrimination at work: a case study in the banking sector). *İKTİSAT Dergisi*, 377, 54–61.
Tam, T. (1996). Reducing the gender gap in an Asian economy: how important is women's increasing work experience? *World Development*, 24(5), 831–844.
Turkish Banks' Association (TBB) (1998). *Türkiye Bankalar Birligi Yilligi* (Annual of Turkish Banks' Association), Istanbul.
Todaro, M. P. (1997). *Economic development*, Sixth Edition. London: Longman.
Watts, M. (1992). How should occupational sex segregation be measured? *Work, Employment and Society*, 6(3), 475–487.
Watts, M. & Rich, J. (1993). Occupational sex segregation in Britain, 1979–1989: The persistence of sexual stereotyping. *Cambridge Journal of Economics*, 17, 159–177.
World Bank (1993). Turkey. Women in development. A World Bank Country Study, Washington D.C.

APPENDIX

Measuring Occupational Segregation

A common measure in applied studies is the Occupational Segregation Index (OSI) or Duncan-Duncan Index defined as follows:

$$\text{OSI} = 0.5 \sum_i |f_i - m_i| * 100 \qquad (i=1, \ldots, n)$$

where

- i : occupation category
- n : total number of occupations
- f_i : ratio of females in the occupation category i in the firm (or sector) to total females in the firm (or sector)
- m_i : ratio of males in the occupation category i in the firm (or sector) to total males in the firm (or sector)

The *ideal* case of no segregation implies that for every occupation $f_i = m_i$ and thus OSI=0. The minimum value that OSI takes is therefore zero. On the other hand, non-zero values for OSI indicate the presence of gender inequalities in occupations. A typical case is the 'glass ceiling' case: females are underrepresented in higher ranks but over-represented in lower ranks. As OSI differs from zero, it indicates the percentage of *total* (female+male) employees who (theoretically) have to reshuffle in order to attain the *ideal* situation of no segregation, keeping total number of employees unchanged (Burnell, 1993b; Deutsch, Flückiger & Silber (1994); Günlük-Senesen (1998b); Orazem, Mattila & Yu

(1990); Watts, (1992)). This reshuffle might be horizontal (between males and females in the same occupation category), vertical (between occupation categories) or both. Since OSI is a symmetrical measure in terms of sex, it does not directly refer to females or males. The OSI value must be interpreted with reference to the information conveyed by the occupation data. In the case of extreme segregation in terms of sex, OSI=100. That is, if all females are in one occupation and all males are in another one, OSI equals its maximum value.

POST-FORDIST WORK, POLITICAL ISLAM AND WOMEN IN URBAN TURKEY

Aysenur Okten

ABSTRACT

"Post-Fordist" organization of production brings about new paradigms and restructuring in the labor markets. This paper studies informal labor markets and the role of women in post-Fordist production in Turkey. The aim of the paper is to discuss the hypothesis that the female role in an Islamic society, as modeled in accordance with political Islam, is quite compatible with the differentiated labor market structure in the post-Fordist production organization.

INTRODUCTION

Women's status in relation to work in Turkey reflects the interaction of cultural, social and economic dynamics. It is situated within the context of Turkey's cultural framework, including religious and non-religious references, social heritage, in terms of roles and behavior patterns, and economic policies, including the associated production and employment schemes. Thus, the implications of recent trends in the employment strategies of global capital, as far as women in Turkey are concerned, must be examined with attention to these

various dynamics. Against this backdrop, growing social inequalities, increasing demands of disadvantaged groups and the rise of political Islam all play a role in shaping the relationship between women and work.

Emergent attitudes towards women's role in work and community life reflect conflicting standpoints. From the feminist point of view, the economic value of the work that is generally and traditionally done by women for the reproduction and welfare of the family must be acknowledged. From the viewpoint of political Islam, woman's role as a housewife and mother should be supported, promoted, imposed and even dictated on the basis of religious considerations. The points of conflict between feminist and political Islamic trends epitomize the controversial dynamics involved in the process of restructuring production.

This paper is structured on the assumption that economic globalization is based on the "post-Fordist" re-organization of production and that this process brings about new paradigms in every fundamental aspect of social life. The first part of the paper is a review of the restructuring process. The second part discusses the implications of post-Fordist production in terms of the informal economy, informal labor market and the role of women with particular reference to Turkey. The third part discusses the discourse of political Islam with respect to women's social and economic role. The aim of the paper is to discuss the hypothesis that the female role in an Islamic society, as modeled in accordance with political Islam, is quite compatible with the differentiated labor market structure in the post-Fordist production organization. Indeed, the role perception espoused by political Islam provides the ideological basis for the supply of cheap female labor.

GLOBAL RESTRUCTURING OF WORK

For over two decades restructuring (of capital) has been affecting the organization of production in terms of the division of labor, the management of enterprises and reconsiderations of space. The invention of microprocessors and the oil crisis in 1973 provided an impetus for the search for a new global order. Increasing competition in the world market pushed manufacturers towards new ways of reducing costs which included a shift of investments away from most industrialized areas where land and labor were high-cost inputs towards less developed areas where these factors of production were less costly and ecological threats were less of a concern (Moulaert & Salinas, 1983).

Fordist production, which was the dominant form of Western capitalism until the late 1970s, relied on economies of scale, the use of single-purpose machinery (technology) and employment of regular labor. The workforce was mainly unskilled or semi-skilled. On-the-job-training was a main source of skill

acquirement. Thus, this Fordist type organization created giant plants where huge numbers of workers, generally with low skills, produced masses of a single type of product for undifferentiated world markets. This type of production organization was replicated in the plants of international firms in less developed countries like Turkey, often supported by the state's employment and tariff policies.

Fordist production organization became too slow to respond to the crises and new market dynamics of the 1970s. Globalization forced firms that had previously enjoyed oligopolistic advantages in their local markets to seek other of ways of staying competitive. The survival of a firm came to depend on the diversity of its products and its ability to meet rapid changes in demand. Restructuring became necessary to attain flexibility and competitiveness.

New production technologies and quality control made it possible to break down the manufacturing process into many simple steps, each of which could be executed at a different location with maximum advantages. Radical improvements in transportation and communication technologies resulted in the reduction of associated costs which, in turn, made resources and markets all over the world accessible. Thus technological developments in the processing, management, transportation, and information technologies made drastic geographical shifts feasible (Moulaert & Salinas, 1983).

The earliest alternatives to Fordist schemes of production were carried out in the Japanese car manufacturing industry, beginning in the 1950s. In the crisis years of the 1970s, the Japanese "miracle" drew attention once again and provided the basics of the post-Fordist production organization. The most radical restructuring elements of the Japanese organization were "flexible specialization" and "lean production" (Womack et al., 1990), to be realized through vertical disintegration of production, or decrease in plant scale and new management techniques. In flexible specialization, each phase of production is delegated to a firm/plant which specializes in that phase of the production process. These supplier plants are smaller in size and use highly computerized production technologies which increase their flexibility and enable them to make rapid adjustments in design and shipment amounts in response to demand.

Lean production is a complementary scheme of flexibility whereby parts are produced in small lots by the assembler's suppliers. These suppliers produce within a subcontracting network based on a hierarchy of firms ranging from large or medium-size producers with hundreds of workers to small family enterprises with less than 20 employees. In some industries the bottom of this hierarchy includes a considerable proportion of homeworking people. As an outcome of this reorganization of production, subcontracting has become the major scheme of production organization, regularly employed labor per plant

has decreased, and the percentage of skilled labor among regular employees has increased.

These features of the post-Fordist organization are inevitably associated with dualities in both commodity and labor markets, reinforcing the already existing informal market. The existence of a differentiated labor market was recognized in the early 1970s, when the ILO report for Kenya was published (ILO, 1977). This report suggested the possibility of solving the urban employment problem by evaluating the productive capacities of the informal sector and treating it as an indispensable part of development policy. Later studies (Tokman, 1979) pointed to the formal sector's need of the informal sector as a buffer system in crisis periods. Further development was the neo-dualistic conception of the capitalistic economy, where informal and formal sectors were conceived as complementary parts of the same production structure and as a way of creating a cheap labor supply within the capitalistic economy (Portes & Benton, 1984). This was contrary to the conventional dualistic model in which the informal (traditional) and formal (modern) sectors were mutually exclusive spheres of production.

Post-Fordism incorporated this symbiotic relationship between formal and informal employment mechanisms into managerial strategies as a means of maximizing flexibility in production organization and minimizing labor costs. The post-Fordist terms "flexible specialization" and "lean production" describe different features of subcontracting processes. These processes are better controlled in terms of technical qualities and timing of production, as compared to the subcontracting processes of the Fordist production.

"Flexibility" is the keyword of survival in post-Fordist capitalism: a firm needs several forms of flexibility pertaining to the production process and employment scheme for competitiveness in world markets. Technological flexibility requires the use of general-purpose technology which can be adjusted to variations in production as well as skilled workers who also can adjust rapidly. Post-Fordist production is achieved by employing a relatively small number of skilled and continuously trained labor regularly, as the core workforce, and a larger number of less skilled or unskilled casual labor as the peripheral workforce. Functional and numerical flexibilities are achieved through a dualistic employment scheme which enables a firm to adjust the specifications and the volume of its total workforce to fluctuations in the market (Nielsen, 1991: 47).

The dualistic labor market is a sex-differentiated employment mechanism. According to Walby (1992), women have greater chances of finding work in the informal market for several reasons. First, woman's traditional role as the caretaker of the family, coupled with her subordinate status in the family, imposes constraints in terms of her working hours and job choice. She thus

"... provide(s) the ideal captive labor for the subcontractors of large companies" (Mitter, 1987: 119). A lack of social facilities such as nurseries and homes for the elderly, increases the amount of women's domestic work. This leaves little time for regular, full-time formal jobs and forces women, especially those with small children or other dependents, to look for part-time or home-based jobs. Moreover, the lack of urban facilities limits women's mobility in the city. Commuting (daily travel between work and home) is either too costly and/or too time consuming. Many married women thus prefer homeworking in spite of the fact that this type of job pays extremely little. Finally, in less developed societies, women's chances of receiving vocational training may be restricted by traditions and, in some cases, by laws. When this is the case, many women lack the necessary skills for "modern" jobs in production and only have access to traditionally "female" jobs (Walby, 1992: 134). Portes (1989) states that several researchers find "vulnerability" to be the key characteristic of informal labor, "... extending to all social situations that are marked by some kind of social stigma" (p. 26). He concludes that this vulnerability depends upon certain characteristics that allow companies (or intermediaries) to enforce their demands.

TURKISH WOMEN AND THE DIFFERENTIATED LABOR MARKET

Post-Fordist production organization, along with growth in the labor force, results in a differentiated labor market structure and a large informal sector. The formal participation rates of women in Turkey, as of October 1992, were 16.1% in urban areas and 50.2% in rural areas. These rates were much lower than men's rates, which were 67.6 and 75.7% respectively. SIS (1994b) statistics indicate that the unemployment rate for women in the urban formal market (20.5%) is much higher than that for men (9.8%). Many of the jobs which women hold are in small-scale industries: 13.33% of the female workforce is employed in industrial production and 14.74% in services. As can be seen in Table 1, 53% of women in industrial production work in firms with 1–4 employees, whereas only 24% of men work in the same size category of enterprises. In addition, as the data in Table 2 suggest, women are employed mostly (82.23%) in family enterprises and informal jobs.[1]

There is a greater demand for female labor in certain industries than in others. The textile and clothing industry is one of the sectors where women are preferred and employed in formal as well as informal labor markets. The findings in two cities in Turkey, Bursa and Istanbul, surveyed by Cinar and Okten between 1987 and 1991, indicate that potential informal laborers in the textiles and

Table 1. Labor Force, Industry and Firm's Size.

Size of enterprise (Average number of employees)	Women	%	Cumulative	Men	%	Cumulative
GENERAL TOTALS	6,066,396			13,461,113		
1	471,547	7.77		1,866,685	13.87	
2	1,391,362	22.94	30.71	2,302,940	17.11	30.98
3	1,039,472	17.13	47.82	1,672,610	12.43	43.41
4	975,290	16.08	63.92	1,342,296	9.97	53.38
5–9	1,155,065	19.04	82.96	2,003,986	14.89	68.27
10+	1,034,160	17.05	100.01	4,272,596	31.74	100.01
Totals in agriculture	4,363,778			4,420,955		
1	230,352	5.28		560,076	12.67	
2	1,154,368	26.45	31.73	1,112,613	25.17	37.84
3	921,521	21.11	52.84	810,804	18.34	56.18
4	876,187	20.08	72.92	801,583	18.13	74.31
5–9	1,010,714	23.16	96.08	937,517	21.21	95.52
10+	170,636	3.91	99.99	198,362	4.49	100.01
Totals in industry	808,698			2,631,731		
1	177,590	21.96		81,943	3.11	
2	143,913	17.80	39.76	193,499	7.35	10.46
3	53,494	6.61	46.36	204,976	7.79	18.25
4	56,712	7.01	53.37	159,150	6.05	24.30
5–9	65,443	8.09	61.46	379,863	14.43	38.73
10+	311,546	38.52	99.99	1,612,300	61.26	99.99
Totals in services	894,420			6,408,427		
2	93,081	10.41	17.52	996,828	15.55	34.66
3	64,457	7.21	24.73	656,830	10.25	44.91
4	42,391	4.74	29.47	381,563	5.95	50.86
5–9	78,908	8.82	38.29	686,606	10.71	61.57
10+	551,978	61.71	100.0	2,461,934	38.42	99.99

Source: SIS, Household Labour Force Survey, Table 47.

clothing industry are women who *cannot* work in regular wage jobs. They either have no access to the formal labor market due to social restrictions associated with predominant perceptions of the female role or because they do not have the appropriate qualifications with respect to education and skills (Cinar, 1991; 1994).

Table 2. Status in Work (October 1992).

Status in work	Women	%	Men	%
Employee	1 055 336	17,39	5 102 462	44.06
Casual worker	245 273	4,04	1 155 203	9.97
Employer	22 277	0,36	1 036 784	8.95
Self-employed	793 132	13,07	4 283 950	36.99
Unpaid family worker	3 950 878	65,12	1 882 714	16.26
Totals	6 066 896	100.0	11 578 399	100.0

Source: SIS, Household Labour Force Survey, p. 64, Table 40.

The textile industry constitutes a major part of the Turkish economy. Twenty-three percent of all establishments in the Turkish manufacturing industry are engaged in the production of textiles and clothing. Further, employment in this branch of production constitutes 22% of total employment in manufacturing (SIS, 1994a). This industry provides 40% of urban employment. In 1980, 96% of all textile firms were small-scale enterprises with less than 10 employees. Although market conditions have not been favorable for small-scale producers thus far, these producers constitute the great majority of enterprises in the industry. Most of these firms have four or fewer employees, making them, according to the SIS definition, "informal business units".[2]

The dualistic employment mechanism in the Turkish textiles and clothing industry is based on two patterns of organization which support the symbiotic relationship of the formal and informal sectors: the traditional work organization within the enterprise and the intersectoral dependency relation. The symbiosis of formal and informal production organizations is made up of five types of economic units, including factories and workshops, wholesalers, retailers, agents, and homeworking women. The factories and workshops produce for international and/or domestic markets and usually carry out their activities in non-residential locations. Smaller producers operating in the domestic market base their survival strategies on price competition and consequently, on cost reduction strategies, such as the employment of casual or informal labor. The wholesalers and retailers organize production through subcontracting to workshops or by employing homeworking labor. Agents, who may be firms or individuals, organize the production of the homeworking women on behalf of small enterprises which may be workshops, wholesalers or retailers. In addition, some retail shops operate as agents of larger firms in organizing the homeworking women. Individuals who act as agents conduct business in their own

Table 3. Level of Education, Labour Force Participation, Unemployment, Underemployment in Urban Areas (Oct. 1992).

LEVEL OF EDUCATION	Labour Force Participation rate %		Unemployment rate %		Underemployment rate %	
	Women	Men	Women	Men	Women	Men
Illiterate	7.2	52.2	7.5	10.1	6.5	20.5
Literate without diploma	10.7	49.5	21.4	16.3	7.9	9.7
Primary school	11.4	73.0	23.1	9.1	7.2	8.9
Junior highschool (JH)	13.0	53.6	21.1	8.7	7.3	5.6
Equivalent of JH	10.2	51.0	14.8	9.3	—	5.5
Highschool (H)	37.9	74.6	29.3	13.4	3.6	4.2
Equivalent of H	49.0	78.6	19.9	14.0	4.2	5.4
College	83.3	89.1	11.1	5.3	1.8	3.2

Source: SIS, Household Labour Force Survey.

neighborhoods as "home-based managers." The homeworking woman is at the bottom of this production organization.

The production organization in an industrial sector may include more than one composition of these production units depending on the phase of production and conditions of the market. While relatively large firms supplying export goods to foreign markets draw on informal labor resources casually, small firms operating in domestic and immediate markets rely almost entirely on informal labor, including homeworking women.

Women participate in the formal workforce at higher rates as they attain higher education levels, but at all levels have less access to formal labor opportunities than men. The workforce participation rates of illiterate employees and of those with college degrees differ by 36.9 points for men and 76.1 points for women. The average participation rate among women with junior high school or lesser education is 10.5% and for women with high school or higher education is 56.7% (Table 3).

In addition, women's access to education is also limited. Officially, the Turkish state provides equal education opportunities for men and women, yet, as can be seen in Table 4, the proportion of female graduates is lower than that of male graduates at all levels of education. This discrepancy may be due to various socio-cultural factors. As can be seen in Table 5, the lower primary

Table 4. Type and Level of Education.

Type and level of education	Women	%	Men	%
Primary school	568 775	46.43	656 345	53.68
Junior highschool	205 460	39.13	319 579	60.87
Vocational school (junior)	26 046	42.10	35 817	57.9
Highschool	85 299	43.36	111 420	56.64
Vocational school	47 396	32.28	99 433	67.72

Source: SIS (1994b), Table 15, p. 29.

Table 5. Enrollment ratios, Turkey.

Educational year	Primary school		Junior highschool and equivalent		Highschool and equivalent		Higher education	
	Female	Male	Female	Male	Female	Male	Female	Male
1988–1989	87.3	91.7	46.2	71.0	25.6	43.5	7.1	12.6
1989–1990	87.9	91.5	46.2	70.1	27.3	43.7	7.9	15.2
1990–1991	86.4	91.6	41.4	71.4	28.6	45.1	8.5	16.1
1991–1992	85.9	91.4	48.3	71.4	31.6	47.7	9.1	16.9
1992–1993	82.9	87.9	50.8	72.8	32.2	53.6	10.2	18.4
1993–1994	81.3	84.8	51.3	71.3	35.7	54.2	13.2	21.5
1994–1995	88.6	92.6	54.5	76.0	39.5	59.0	13.8	21.3
1995–1996	88.2	92.3	53.9	75.3	41.8	60.5	14.6	22.0

Source: Turkish Government State Ministry for Women's Affairs and Social Services, Directorate General on the Status and the Problems of Women (DGSPW), http://www.die.gov.tr/toyak/, 1998.

school enrollment rates for females suggests that some families do not even enroll their daughters in primary education, thus denying them any chance to obtain some formal education.

Microlevel studies have found similar results. In 1991, Alpar and Yener conducted a survey in "gecekondu," (squatter areas), home to an estimated 70% of the metropolitan population in Istanbul, Ankara, and Izmir. They found that 86.6% of women interviewed had no secondary education. At the same time, 83.1% of the household heads expressed the wish for their daughters to have access to college education. This desire though does not necessarily indicate that fathers also wish for their daughters to participate in the labor force. In

the same survey, 60.6% of household heads answered the question "Should a husband give his wife the permission to work in a paid job?" negatively, 7.3% were undecided, and only 35.2% gave a positive answer. These surveys provide evidence for the socio-cultural factors which may be preventing women from gaining access to education and the labor market.

In addition to social norms and education, labor force participation of woman also depends on her marital status. Young, unmarried women meet with less resistance from their fathers or older brothers when they wish to work outside the home because it is quite customary that a girl prepares her own trousseau. This is particularly true in urban areas. While in rural areas, a girl does all the sewing, knitting, weaving and other necessary work to produce her trousseau, in the city, she earns money to buy these items instead. After marriage, it is often up to the husband to decide whether a woman will continue to work. Some women continue working until they become mothers. Women who did not work prior to marriage are unlikely to start, particularly in the formal sector, after marriage. The end of a marriage, particularly in the case of divorce, may also lead to a woman entering the labor market. As can be seen in Table 6, divorced women have the highest rates of labor force participation.

Married women, particularly those with children, consider casual jobs and homeworking to be "family-friendly" economic opportunities that are compatible with their social roles. Accordingly, 90% of homeworking women interviewed in a survey carried out by Cinar and Okten in 1989 were married with two or three small children (Okten, 1993). For those women who cannot work outside of the home due to their traditional obligations as mothers and wives and/or because they lack sufficient skills, homeworking seems to be the only way to contribute to the family budget. For those women who wish to have a paid job, yet a personal income is unwelcome by the male members (father, older brother, husband) of the family, homeworking provides a compromise between the female role perception in their social environment and their economic independence. In many cases, casual jobs and even homeworking are done in secrecy. This is partly to secure a personal income without intrusion on the part of the husband (or father) and partly because the husband (or father) cannot tolerate having his wife (or daughter) hold any paid job, including homeworking. For her to do so would contradict his perception of his own role as the sole breadwinner. Such social parameters of female labor supply reduce the bargaining power of these women because they don't consider themselves working. Rather, they view themselves as making some money in their free time for something (like knitting) which they would have been doing in any case.

Table 6. Marital Status, Labour Force Participation, Unemployment, Underemployment (October 1992).

MARITAL STATUS	LF Participation Rate %		Unemployment rate %		LF Participation rate of the underemployed	
	Women	Men	Women	Men	Women	Men
URBAN						
Unmarried	23.5	49.3	28.7	21.4	5.2	7.9
Married	13.2	81.4	14.7	5.7	5.5	7.7
Divorced	50.0	63.0	15.4	31.1	7.7	–
Widowed	6.4	21.6	8.2	12.8	1.7	23.4
RURAL						
Unmarried	52.6	62.9	5.1	13.5	4.8	13.6
Married	52.0	86.0	1.1	3.2	1.7	8.7
Divorced	41.5	59.8	–	–	–	16.6
Widowed	25.0	38.2	2.5	–	3.0	2.6

Source: SIS, Household Labour Force Survey, p. 59, Tables 35–36.

POLITICAL ISLAM AND WOMEN'S EMPLOYMENT IN TURKEY

The large number of Turkish women in the informal sector is not incompatible with the rise of political Islam. Indeed, this rise occurred at the same time as the spread of globalization in Turkey. The Turkish modernization policy of the 1950s marked the beginning of an intensifying rural exodus. By the 1990s, the larger cities in Turkey were surrounded by unauthorized squatter settlements. Alpar and Yener (1991) report relatively high rates of unemployment, (such as 14.2% in Ankara, 5.9% in Istanbul, 11.6% in Izmir), low household income, informal sector employment and moonlighting in these settlements. Unauthorized construction, unauthorized dwelling in houses which are not qualified for inhabitance and unregistered places of work are typical for such peripheral areas.

Inhabitants of these settlements have poor access to other parts of the city. Numerous surveys revealed that many women in the peripheries of Istanbul did not leave their neighborhoods for many years. Given the lack of public services in such areas, it is easy to conceive how and why the urban poor in large Turkish cities developed an anti-modernist peripheral culture of urban survival.

The socio-cultural and economic problems of the poor in urban peripheries intensified as a result of liberalization and globalization efforts during the 1980s.

These processes included the destruction of the previous framework of a nationalistic, protective import-substitution policy which was constructed upon modernistic principles such as secularism, nationalism and a "national development" ethic which praised individual sacrifices for the benefit of society and consensus rather than controversy. By the end of the 1980s, Turkey had become the scene of growing economic uncertainty, social insecurity, cultural chaos and ethical corruption.

It is no coincidence that political Islam has risen simultaneously with the globalization process and the associated form of production organization, i.e. post-Fordism. In the case of Turkey, political Islam found fertile ground among the *gecekondu* dwellers and other low-income groups. Among these groups, "Western-style" formal organizations of modern Turkey have remained ineffective in meeting people's needs. By contrast, Islamic organizations offer migrants on the urban peripheries guidelines for an alternative social life as well as new business networks. For this reason, political Islam has been most successful in the *gecekondu* areas. It is based on strong propaganda and acculturation at the grassroots level carried out through informal social organizations. These organizations have been providing several types of social support, including monetary assistance to families in need, religious and social guidance, free or low-cost religious summer schools for low-income youth, free or low-cost preparatory courses for university entrance exams, and scholarships and free counseling to help students find lodging and jobs and finance their education. These informal mechanisms of social welfare, as well as political activities, are incorporated within religious frameworks and fill the gaps not being filled by formal "Western-style" organizations in Turkey.

The discourse of political Islam synthesizes Islamic ethics with an idealized socialist utopia, on the one hand, and with the social, scientific and technological instruments of Western capitalism, on the other. It provides culturally legitimate grounds for a critique of capitalism and proclaims to offer an alternative system with which there will be a more conscientious society. Thus, the success of religious sects in replacing modern, formal social institutions in urban areas may lie with their propensity for "legitimizing change," while also providing needed services. These groups seem to respond to the need for an ideological framework of self-defense against the danger of losing cultural identity, although, in reality, they veil the actual loss with a post-modern illusory identity.

The economic "model" of the (Islamic) Welfare Party is called the *Adil Ekonomik Düzen* (Just Economic Order). This is defined as a perfect, heavenly order which will protect humankind from abuse, exploitation, oppression, and all evils of capitalism, the system of slavery in which millions of people

are condemned to poverty, hunger, unemployment and underdevelopment. Equal opportunities, an end to rent, interest, unjust taxation, and exchange rate devaluation are all promised. *Adil Ekonomik Düzen* (*AED*) argues that it incorporates the merits of capitalism and communism while excluding their harmful characteristics.

According to the *AED*, the state must own all mines, forests, land, meadows and water resources that are to be allocated to people according to certain criteria. The state is responsible for macro plans, associated investment projects and declarations of project support. It intervenes in the economy as a wholesaler of basic economic goods via foundations which stock, buy and sell such goods at fluctuating prices. Moreover, the *AED* regulates production by granting credits to investment projects that fulfill the requirements of the "guilds" and the "Ethics Group." The process of project evaluation is based on the judgement of "guilds" and "the certificate of good conduct" which is issued by the "Ethics Group."

Consumption is also subject to regulation in the *AED*. Human nature is assumed to be inclined to consume in excess of production. Since this consumption-oriented nature is incompatible with the realities of this world, people must be warned and told that they are allowed to consume provided that they produce equal to their consumption and do not squander. Social security is of primary importance. Thus, everyone is to be insured and free to retire at any point of time he chooses. However, no premiums are to be paid, either for insurance or for pension. Salaries are to be determined by "support groups" such as guilds and unions, taking into consideration age, education, duration of service and skills. Everyone must be a member of such a support group (Adil Ekonomik Düzen, 1991). After the rescission of the Welfare Party on January 16, 1998, it was replaced by *Fazilet Partisi* (the Virtue Party) which continues to articulate and carry out the same types of policies that the Welfare Party did.

Thus, the discourse of political Islam promises economically disadvantaged groups an Islamic social welfare society with a more balanced distribution of income. In this promised society, these groups would no longer be on the periphery of the system, but right at its core. At the same time "Islamic capital" demands and struggles for an economic order through which it can have more advantageous conditions to compete in domestic and world markets. Inevitably, the chances of successful competition lie with minimizing labor costs through post-Fordist mechanisms like flexible specialization and lean production. Labor costs are minimized within this mechanism through informal employment of peripheral labor extending from casual employment at larger plants to family labor at small workshops and homeworking women at the end of the subcontracting chain.

At this point, the perception of women's role espoused by political Islam in Turkey deserves special attention. In this respect, political Islam reveals itself in a variety of attitudes ranging from calls for extreme seclusion of women to a redefinition of woman's role with her primary duty being reproduction of the family and serving as the "companion" of men in suitable domains of social and economic life. From one political Islamic perspective, the social lives of men and women are totally separate. Woman's world is closed to any foreign intrusion; it is introverted and limited to activities within family, among relatives and female friends. She is defined only as a mother and a housewife, limited in her choice of activities and friends and totally subordinate to the men in her family who are the absolute masters of her world. For this group, a woman has no place in a man's world because she is incapable of making independent and rational decisions. On the other hand, she is a potential danger for men because she may tempt them to commit sinful (sexual) acts due to her physical attributes. Therefore, a woman is denied any kind of participation in men's social life.[3]

Another political Islamic approach also constructs two separate social worlds but with less orthodoxy. Woman's participation in all aspects of social life such as education, the professional world, economic life and politics is accepted (Erbakan, 1975: 35). Yet, there are two conditions to this participation: women will preferably remain within the sphere of women (i.e. female doctors should accept only female patients, female teachers should teach in girls' schools, female political activists should work solely among women, etc.); and women's participation in social life must be as "the supporter of men". These conditions have been articulated by Islamist politicians (Erbakan, 1975)[4] and in Islamist publications (Acar, 1993). Although there may be attempts among Islamist women to define a new social role by combining Islamic discourse with modernist elements, these attempts seem to be very limited and part of an ontological discussion (Ilyasoglu, 1996).

Political Islam has embraced perspectives on women's role that reinforce rather than depart from the traditional status quo. The tendency to limit woman's role to motherhood and wifehood already prevails in local customs. According to miners surveyed in the small town of Soma, a man's primary role is to work in the mines and earn money; a woman's role, on the other hand, consists of homekeeping (Sayin, 1993, p. 101). In another survey in Bornova, on the periphery of the metropolitan area of Izmir, 94% of respondents were housewives. Fifty-eight percent of these housewives expressed no desire to work outside the home, and 24% could not work because their husbands would not permit it (Sayin, 1993, p. 101).

Even in cases where the economic condition, social environment and level of female education and job opportunities are in favor of working women, the

woman's own role perception may channel her out of the formal labor market. In Izmir, 91.51% of respondents in a survey of female high school teachers (i.e. women with university or college degrees) expressed their contentment with working. Yet, 14% said that they would not work if their salaries were not needed in the household and that they would prefer to spend more time with their children. Only 8.49% of these teachers in Izmir received and/or accepted their husband's help in domestic work. Most of them would not let their husbands help in homekeeping because they feared their neighbors' disapproval (Sayin, 1993).

In all these surveys, the primary duty of men is defined as earning enough income for the whole family whereas that of women is homekeeping and supporting men, if necessary. Education seems to have only a limited effect on the traditional priorities within a woman's role perception. Women who attempt to work for cash income not only threaten society's conception of woman's role, as the housewife and the mother, but also the conception of the man's role, as the bread-earner of the family. A woman's professional training does not affect the traditional role expectations associated with sex, but rather, entitles her only to an additional role outside the home. In this respect, the answers of the high school teachers in Izmir are typical. Their wish to stop working in order to devote more time to their children may also be understood as an outcome of the lack of urban facilities such as nurseries and kindergartens. However, the fact that they consciously exclude their husbands from domestic work displays how firmly the traditional role structures are embedded.[5]

CONCLUSION

The era of globalization and post-Fordist production has intensified the differentiated labor market structure for women. While plant closures due to the flight of capital to new points of production threaten local working-class cultures in industrial societies, a different process of socialization takes place in the urban community life on the peripheries in Turkey. Informal forms of employment are carried out through traditional communication and organization networks within neighborhoods, kin groups and religious sects. As the number of sweatshops increases in cities, the associated residential areas provide the material basis for the reproduction of informal work relations. In most cases, community life in squatter settlements also provides the basic conditions for the supply of informal female labor. In these neighborhoods, networks based on kinship, ethnic origin or religious sects dominate social life. They replace formal work organizations and introduce an "anti-modernist" social life based on patriarchal ideas, whereby the role of woman is perceived as being a supporter of men, caring mother and housewife.

The process of informality contributes to the formation of a decentralized model of economic organization. Therefore, it not only represents a restructuring of capital, but also social transformations. "... (T)he very unfolding of global capital restructuring creates profoundly destabilizing conditions of everyday life in the localities most immediately affected," (Smith, 1991: 206). Community life is closely associated with work life, because the workplace provides the framework for enduring social relationships in residential communities. The working-class culture is created by social interactions during, before and after work. Thus, post-Fordist organization of production affects the reproduction of community life and woman's role in it.

The working conditions in informal enterprises require the reproduction of traditional social organizations for survival, because the most effective cost reduction factor for small enterprises is the exploitation of labor through family, kinship, neighborhood ties and traditional female roles. The family business character and the chance of having personal contacts allow for solving employment problems in a traditional fashion. Overtime and unpaid help are readily available within this kind of organization.

Small-scale enterprises in some industries like textiles and within squatter areas provide social and spatial organizations wherein the cost of living can be kept low, and cheap labor of women, in alternative forms of employment, can be secured through patriarchal role perceptions and gender bias. Such networks constitute a structural part of the post-Fordist production scheme with its reliance on partitioning the production process and differentiated modes of employment.

The general tendency to define woman's role as existing primarily within the private sphere places her into the peripheral workforce for several reasons: She may only work at jobs which are considered appropriate for women and only compete for jobs which are compatible with her primary duties as a wife and mother. These conditions rule out business travel, late night work, overtime and even regular eight-hour jobs. Under the influence of patriarchal role perceptions that are traditionally present in society and reinforced by political Islam, women are expected to supply their labor in a limited area of the formal labor market or, increasingly, in the informal market.

NOTES

1. The informal sector is defined here by a criteria set which includes size of business (small number of employees), irregular working hours, unqualified labor and extensive abuse of family labor (Portes & Benton, 1984; McEwen Scott, 1986; Kannapan, 1985). Following ILO, the UN defines the informal sector in a more limited fashion, in terms of enterprises: "The informal sector is an important source of work for women ...".

In 1993, in great part due to concern with improved understanding of women's economic activity, the International Conference of Labour Statisticians agreed on a definition of the informal sector. It defines informal own-account enterprises as enterprises in the household sector owned and operated by own-account workers, which may employ contributing family workers and employees on an occasional basis but do not employ employees on a continuous basis" (UN, 1995). Thus, this figure, 82.23%, is the sum of the rates of those women who work as casual and unpaid family labor or who are self-employed.

2. "The informal economy is thus not an individual condition but a process of income-generation characterised by one central feature: *it is unregulated by the institutions of society, in a legal and social environment in which similar activities are regulated*" (Portes, 1989: 12). The classification may be inaccurate, given that it fails to consider other dimensions of informality such as irregular working hours, use and abuse of family labor, etc. As far as the Turkish clothing industry is concerned, a definite distinction between formal and informal enterprises is not feasible because almost all officially registered enterprises in the private sector, regardless of size, currently utilize or previously utilized informal employment opportunities. On the other hand, most of the small enterprises (1–9 employees) are officially registered, with the exception of persons operating as agencies in residential areas. Therefore, it may be more pertinent to distinguish between informal and formal employment mechanisms and markets rather than informal or formal enterprises.

3. Eyuboglu (1998) reports that, according to the sect of Naksibendis, women are inferior to men; a woman is not to be shaken hands with or spoken to. She should not leave the house unless it is absolutely necessary and may not have any duty outside her home.

4. N. Erbakan, the leader of the Welfare Party, declared in his 1975 address that a Muslim woman may work as a nurse or gynaecologist. It is even preferred that such jobs are taken by women because, in Islam, women should be given duties which are compatible with their nature. However, it is of special importance that women, as future mothers, are educated in good housekeeping and child rearing.

5. Obviously, such role structures can be observed in various societies with patriarchal traditions and customs. Zeytinoglu (1994) points to the tendency of women to work in part-time and non-standard jobs on the basis of the results of a survey in Ontario, Canada: "Religious, educational, and legal institutions socialise women to be primarily responsible for household chores and child care. Some women, born into and raised with these patriarchal values, also believe that household chores and child care are their primary responsibilities, and that paid work outside home is their secondary responsibility, even if they were to work in full-time jobs outside the home. Since people cannot cope with two full-time jobs at the same time, some women make the choice of either leaving the paid employment permanently or staying in it on a part-time basis."

REFERENCES

Acar, F. (1993). Islamci Ideolojide Kadin: Türkiye'de Üç Islamci Kadin Dergisi (Woman in the Islamist ideology: Three Islamist women magazines). In: R. Tapper (Ed.). *Çagdas Türkiye'de Islam* (Islam in Contemporary Turkey) (pp. 205–236). Istanbul: Sarmal Yayinevi.

Alpar, I., & Yener, S. (1991). *Gecekondu Arastirmasi*, (The Gecekondu survey) Ankara: DPT.
Ansal, H. (1995). Çalisma hayatinda cinsiyetçilik ve 1980'lerde Türk sanayiinde ücretli kadin emeginin degisen konumu, (Gender bias in working life and the changing status of the employed labor in the Turkish industry). *Toplum ve Bilim*, *66*(Spring), 17–27.
Banerjee, N. (1989). Trends in Women's Employment, 1971–81. Some Macro-Level Observations. *Economic and Political Weekly*, April 29, 10–22.
Benton, L. A. (1989). Homework and Industrial Development: Gender Roles and Restructuring in the Spanish Shoe Industry. *World Development*, *17*(2), 225–266.
Bromley, R. (Ed.) (1979). *The Urban Informal Sector. Critical Perspectives on Employment and Housing Policies.* Oxford: Pergamon Press.
Brydon, L., & Chant, S. (1989). *Women in the Third World. Gender Issues in Rural and Urban Areas.* New Brunswick, New Jersey: Rutgers Univ. Press.
Christopherson, S. (1987–88). Workforce flexibility: implications for women workers, ISSR Working Papers in the Social Sciences, V.1, No. 2, University of California.
Cinar, E. M., Evcimen, G., & Kaytaz, M. (1988). The Present Day Status of Small-scale Industries (Sanatkar) in Bursa, Turkey. *International Journal of Middle East Studies*, 20, 287–301.
Cinar, E. M. (1991). Labor Opportunities for Adult Females and Home-Working Women in Istanbul, Turkey. The G.E. von Gruenebaum Center for Near Eastern Studies, Working paper No.2, Los Angeles: University of California.
Cinar, E. M.(1994). Unskilled Urban Migrant Women and Disguised Employment: Home-working Women in Istanbul, Turkey. *World Development*, *22*(3), 369–380.
Deshpande, S., & Deshpande, L. K. (1992). New Economic Policy and Female Employment. *Economic and Political Weekly*, Oct.10, 1992, 2248–2252.
Erbakan, N. (1975). *Milli Görüs* (The national perspective). Istanbul: Dergah Yayinlari.
Eyuboglu, I. Z. (1998). *Islam Dininden Ayrilan Cereyanlar – Naksibendilik* (Movements Separating from Islam – The Naksibendism). Istanbul: Yenigün Haber Ajansi.
Gurmen, S. (1987). The Impact of Peripheral Capitalism on Women's Activities in Production and Reproduction – The Case of Turkey (Inaugural-dissertation). Berlin: Die Freie Universitaet.
ILO (1977). *Employment, Incomes and Equality. A Strategy for Increasing Productive Employment in Kenya* (The Kenya report). Geneva: ILO (first impression 1972).
Ilyasoglu, A. (1996). Islamci Kadin Hareketinin Bugunu Uzerine (About the present day status of Islamist women movement). *Birikim*, *91*, November.
Janson, J., (1992) The talents of women, the skills of men: flexible specialization and women, pp 141–155. In S. Wood (Ed.), *The Transformation of Work* (1992).
Joekes, S. P (1987). *Women in the World Economy*. Oxford: Oxford University Press.
Kadin Ve Sosyal Hizmetler Mustesarligi (1993). *Kadini Girisimcilige Özendirme ve Destekleme Paneli – Bildiri ve Tartismalar* (Giving support and incentives to woman entrepreneurship Panel – presentations and discussions). Ankara: Devlet Bakanligi Kadin ve Sosyal Hizmetler Müstesarligi, Kadinin Statüsü ve Sorunlari Genel Müdürlügü.
Kannappan, S. (1985). Urban Employment and the Labor Market in Developing Nations. *Economic Development and Cultural Change*, *33*(4), 699–730.
Keles, R. (1988). *Urban Poverty in the Third World: Theoretical Approaches and Policy Options (With Special Reference to the Middle East).* Tokyo: Institute of Developing Economies.
Mac Ewen Scott, A. (1986). Women and Industrialization: Examining the 'Female Marginalization' Thesis. *The Journal of Development Studies*, *22*(4), 649–680.
Mattera, P. (1985). *Off the books. The Rise of the Underground Economy.* New York: St. Martin's Press.

Mitter, S. (1987). *Excerption from Common Fate-Common Bond, Women in the Global Economy.* Fluto Press.

Moser, C. (1979). Informal Sector or Petty Commodity Production: Dualism or Dependence. In: R. Bromley (Ed.) (1979), *The Urban Informal Sector. Critical Perspectives on Employment and Housing Policies.* Oxford: Pergamon Press.

Moulaert, F. & W.Salinas, P. (Eds) (1983). *Regional Analysis and the New International Division of Labor.* Boston: Kluwer Nijhoff Publishing.

Nielsen, L. D., (1991). Flexibility, Gender and Local Labour Markets – Some Examples from Denmark. *International Journal of Urban and Regional Research, 15*(1), March, 42–54.

OECD, (1991). *Shaping Structural Change. The role of women.* Paris: OECD.

Okten, A. (1993). *Social Determinants of Female Labor Force and Participation in the Informal Sector, Angewandte Stadtforschung in der Tuerkei.* Augsburg: Universitaet Augsburg, Lehrstuhl fuer Sozia – und Wirtschaftsgeographie.

Pahl, R. E. (1985b). Household work strategies in economic recession. In: N. Redcift & E. Mingione (Eds), *Beyond Employment: Household, Gender and Subsistence.* Oxford: Basil Blackwell.

Portes, A. (1985). The Informal Sector and the World Economy: Notes on the Structure of Subsidized Labor. In: M. Timberlake (1985). (pp. 53–62).

Portes, A., & Benton, L. (1984). Industrial Development and Labor Absorption: A Reinterpretation. *Population and Development Review, 10*(4). 589–611.

Portes, A., Castells, M., & Benton, L. A. (Eds) (1989). *The Informal Economy.* Baltimore and London: The John Hopkins University Press.

Portes, A., & Schauffler, R. (1993). Competing Perspectives on the Latin American Informal Sector. *Population and Development Review, 19*(1), 33–60.

Pratt, G., & Hanson, S. (1991). On the Links Between Home and Work: Family-Household Strategies in a Buoyant Labour Market. *International Journal of Urban and Regional Research, 15*(1), March, 55–75.

Redclift, N., & Mingione, E. (1985). *Beyond employment, household, gender and subsistence.* Oxford: Basil Blackwell.

Sayin, Ö. (1993). Türkiye'de ve Dünyada Çalisan Kadinin Aile Ici Etkilesimdeki Yeri (The status of working women in the intra-family relations in Turkey and the world).: Kadinin Calisma Yasami /Frauen im Berufsleben, (Women in professional life). Izmir: Alman Kültür Merkezi.

Shaw, A. (1990). Linkages of Large Scale, Small Scale and Informal Industries. A Study of Thana-Belapur. *Economic and Political Weekly*, Feb. 17–24, 17–22.

Singer, H. W. (1970). Dualism Revisited: A New Approach to the Problems of the Dual Society in Developing Countries. *Journal of Development Studies, 7*(1), 60–75.

SIS (1990). *Census of Population Social and Economic Characteristics of Population.* Ankara: State Institute of Statistics.

SIS (1994a). *Household Labour Force Survey Results.* Ankara: State Institute of Statistics.

SIS (1994b). *Statistical Yearbook of Turkey.* Ankara: State Institute of Statistics.

Smith, J. (1987). Transforming households: working-class women and economic crisis. *Social Problems, 24*, 416–436.

Smith, M. P. (1991). *City, State and Market. The Political Economy of Urban Society.* Oxford: Basil Blackwell.

SPO (1994). Kadin Alt Komisyonu Raporu (Woman sub-committee report). prepared by the State Planning Organization (SPO) Special Committee for Women, Children, and the Youth. Ankara: SPO.

Tokman, V. E. (1979). Competition between the Informal and Formal Sectors in Retailing: The case of Santiago. In Bromley (1979), 1187–1198.
United Nations (1990). *Methods of Measuring Women's Participation and Production in the Informal Sector.* New York: UN Dept.of International Economic and Social Affairs.
United Nations (1995). *The World's Women 1995. Trends and Statistics.* New York: UN Dept. for Economic and Social Information and Policy Analysis.
Walby, S. (1992). Flexibility and the changing sexual division of labour. In: S. Wood (Ed.), *The Transformation of Work* (pp. 127–140).
Welfare Party (1991). *Adil Ekonomik Düzen* (Just economic order). Ankara.
Womack, J. P., Jones, D. T., & Roos, D. (1990). *Dunyayi Degistiren Makine.* Istanbul: OSD.
Wood, S. (Ed.) (1992). *The Transformation of Work.* London and New York: Routledge.
World Bank (1994). Enhancing Women's Participation in Economic Development. A World Bank Policy Paper, Washington, DC: The World Bank.
Zeytinoglu, I. U. (1994). Part-time and other non-standard forms of employment: Why are they considered appropriate for women? In: J. Niland, C. Verevis & R. Lansbury (Eds), *The Future of Industrial Relations: Global Change and Challenge* (pp. 435–448). Beverly-Hills: Sage Publications.

WORKING WOMEN AND POWER WITHIN TWO-INCOME TURKISH HOUSEHOLDS

E. Mine Cinar and Nejat Anbarci

ABSTRACT

We examine the issue of gender power by developing four proxies using data from a field survey conducted in Izmir, Turkey. Four proxies for power include income, absolute and proportional spending, and personal leisure time and all are defined relative to the spouse. We find that women have relative power with respect to monetary measures with a high correlation between intra-family status and socio-economic stratum. In addition we find evidence that working women bear a heavy home work burden. However, we also find that there is a strong socio-economic component to this result, where the lower the socio-economic stratum, the smaller are the number of leisure hours.

INTRODUCTION

Women working in formal or informal labor markets contribute to household income. Since income is traditionally thought to be highly correlated with welfare and power, control over earned income, as well as the division of surplus household income between spouses, is important. Surplus income is defined as

income left over after the basic needs of the household have been met. Social scientists have traditionally examined power to understand work conditions as well as the sphere of influence of gender within the household. Power over the division of household resources can be defined in various ways. We use the term "power" in this study to define the ability to make decisions which affect one's welfare and to denote "non-submissiveness."[1] We quantify power by looking at earning power, spending patterns, and availability of leisure time. We also examine husbands' and wives' perceptions of power in making important household decisions, including those concerning children.

Examining power relations and welfare within a family poses problems for any outsider. The problem is even more complex in the Middle East and North Africa (MENA), where there are differences among countries in political and institutional settings, degrees of urbanization and socio-economic backgrounds as well as differences in micro-level family dynamics. General statistics, including high fertility rates, low education and formal labor market participation rates among women in the Middle East and North Africa (MENA) suggest that women in the region lack power. (UNDP, 1998) To date though there are not many economic studies which examine power within the household or the ways in which it can be measured for working women in MENA. Economic data to examine this issue at the micro level are scarce. As such we conducted a field study in Izmir, Turkey to address these issues. The results are utilized in this study.

LITERATURE ON INTRA-HOUSEHOLD DECISION MAKING

Intra-household allocation studies examining resource allocation are relatively new in economics. Gary Becker's (1965, 1981, 1985) path-breaking studies examined how the altruistic head of the household combined market goods, home production and time to maximize a single set of preferences of the household. The underlying assumption for the household is that all resources, such as capital and labor, are pooled together. However, if individuals in the households have separate preferences, problems of utility aggregation arise. Thus, in the 1980s, alternative bargaining models were developed for cooperative or non-cooperative bargaining.

Cooperative models, which postulate that an individual's gains from households are greater than the benefits from being alone, rely on the economies of scale of household production which generate a surplus. For intra-household bargaining, Manser and Brown (1980) and McElroy and Horney (1981) use a Nash (1950) cooperative bargaining framework, where individuals maximize

the utility from marriage subject to a joint income constraint. The enforcement of the marriage contract occurs through the threat of divorce. Lundberg and Pollak (1993) suggest an alternative model, where instead of divorce, the threat point is marital non-cooperation, or separate spheres. In non-cooperative models, the members of the household do not necessarily contract with each other. They not only have separate preferences but they also act independently. Carter and Katz (1997) consider a two-person household where spouses have control over their own income and spend to maximize their own utility, given the net transfers of income between spouses. Hoddinott et al. (1997) test competing models of intra-household allocation. They examine regional empirical studies to see if the household incomes are pooled and if households are characterized by altruism and discuss the shortcomings of the empirical work. They ask for better econometric modeling, including the study of household formation, a process that is usually taken for granted.

As for hours of work, married women working full time spend about two times as much time on housework as married working men (Gronau, 1977; Hersch & Stratton, 1997a, b; Juster & Stafford, 1991). Hersch and Stratton (1997b, p. 11) find that employed married women spend 33 hours per week on housework, 10 hours less than their not-employed counterparts, and that both married and unmarried men spend about 18 hours per week on housework.

Becker's (1981) well-known model of household resource allocation relies on the premise of altruism and benevolent dictatorship by the male, where preferences are aggregated within the household into a single maximization function. Yet Hochshild (1990) finds that gender norms and conflicts are as important as altruism in household resource allocation. Another criticism of these models is that most rely on the assumption that the various sources of household income are pooled together to meet the household's basic needs, although Dwyer and Bruce (1988) find that full income pooling may not be the norm for households in developing countries. Also challenging Becker's model, Blumberg (1988) and others argue that women are more altruistic in their spending. In her study in India, Blumberg found that women contributed a median of 90+% to households while earning a median of 55% of what males earned. Blumberg's study emphasizes relative male/female control over economic resources as a main (but not the only) predictor of gender stratification and finds that men and women spend their income differently (where women spent more on children and family's basic needs) in third world countries. She defines relative economic power in terms of control over economic resources, especially with regards to the degree of control over the allocation of surplus income (rather income spent on basic needs). Similarly, Thomas (1997) found that as income in the hands of Brazilian women increased, more was spent on health and nutrition related expenditures.

In the U.S., Phipps and Burton (1992) suggest that a woman's power within the household is related to her contribution to the household financial resources. Empirical evidence suggests that the spouses' personal expenditures are more or less egalitarian (i.e. equal) in many households. Anbarci and Cinar (1999) formulate a cooperative game-theoretic model to show that, under certain circumstances, an egalitarian intra-household division of surplus income can be consistent with the fact that women typically earn lower wages than men.

Macro statistics for MENA show large gender gaps in literacy, education, unemployment rates, income and labor force participation rates, both within the region itself and between MENA and other areas of the world (UNDP, 1994–1998). Females in the region experience some of the lowest literacy rates in the world. This in turn impacts the social fabric of the society and its overall growth. In a way, gender gaps within the region and with the rest of the world are one of the largest sources of inefficiency in MENA. Lack of human capital, male migration, and women's reproductive role and time devoted to household work, which are exacerbated by high fertility rates, all diminish women's capacity to earn money by participating in the marketplace.

While macro data and studies suggest women lack access to power, micro-level economic studies on the relation between women, work and household power relations for MENA are scarce. As such, economists need to study the correlation between earning power and decision-making in the household more closely in the region. This is especially needed if one wishes to formulate dynamics of gender and bargaining within the household in the MENA countries and compare results with other areas.

Some studies suggest that gender-based asset inequality in the region becomes a barrier to growth and poverty reduction in MENA (Cinar, 1994, 1997). Massive household rural-urban migration, as well as male labor exports abroad, have also affected women and intrahousehold dynamics in the region (Singerman & Hoodfar, 1996). Country case studies in MENA show that women face barriers in accessing basic assets and resources needed to participate in growth. Recognition of these facts has also led to efforts to correct the gender gaps in the region, which seems to be having a positive effect. Heyneman and Esim (1994) point out that MENA is the region (followed by Sub-Saharan Africa) that has achieved the largest change in its gender and education indicators in the last three decades.

While studies of household bargaining are few, there have been many studies of women in Turkish labor markets in the last decade, in the areas of economics, industrial relations, anthropology and sociology. Female labor force participation rates and the marginalization of women in the labor force have been studied since the 1970s (Kazgan, 1979; Ozbay, 1979; Erkut, 1982; Okten, 1997), A

number of chapters in this volume also contribute to our knowledge of women's employment and pay patterns in Turkey.

In social sciences other than economics, the usual way to study intra-household power is to index or assign categorical variables to varying degrees of influence. Studying power within Turkish households, Timur (1972, p. 103) related the structure of the family (nuclear versus extended) to power and found that both men and women reported that men ruled the households regardless of structure. Kagitcibasi (1984, p.133) examined the link between the type of paid employment women were engaged in and their status within the household (which she categorized as low, middle or high). She found that large proportions of Turkish professional women had middle or high status within the household. Kuyas (1982) analyzed the concept of power ("male control") within patriarchal relations in a framework comprised of two Turkish socio-economic classes (middle versus lower). She stated that "even for most middle class women, working does not mean having money or social resources that are really their own, and it is only in cases where the women's earnings are not to be considered as an important component of the family budget... that they are much more free to dispose of their wages and have much more influence over matters of family organization and maintenance" (p. 202). She also found that working prior to marriage made a significant contribution to control over income and resources after marriage. She stated, "our findings consistently showed that among other socialization factors, women's employment before marriage is much more important in relation to their power status than labor force participation after marriage... In the lower class, the earnings of most women who worked before their marriage were completely appropriated by their families... This relation was observed in the middle class, but in the opposite sense. Almost all of the women who worked prior to marriage controlled their own wages and spent them mostly on themselves. Again, 60% among them thought that women should have liberty of personal decision to dispose of their own labor power. This is a crucial finding which shows that not even early participation in the labor force and social production is enough for a 'liberal' socialization of women, as long as their labor is appropriated as a family resource rather than an individual one" (p. 198, 199).

The intricate balance between individual preferences, income control, labor and spending responsibilities needs to be examined closely. Households do have their own internal dynamics, conflict and cooperation. Some characteristics of household dynamics may be unique to the socio-economic strata to which the household belongs. For working women of different socio-economic strata, the question of "who controls what" is important for the field of development economics. The results of our survey thus are used

to examine the question of how Turkish working women share in the household's resources.

SAMPLING BASE AND DATA

The survey used in this study was conducted in the city of Izmir in Turkey. Izmir is the third largest Turkish city, with a population of 1.2 million residents. The city also has a large group of immigrants, mainly Kurds from southeastern Turkey and Bosnians who have migrated due to the military and civil conflict and lack of jobs back home.[2] As the focus of the study is to examine differences in households by socio-economic group, equal samples were drawn from three different socio-economic strata. These groups can be loosely categorized as upper (strata A and B), middle (strata C and D) and lower (strata E and F) socio-economic classes. The definition used for defining the social strata, as well as the percentage of the population by stratum, are given on Table 1.

One hundred fifty surveys were conducted in Izmir during the summer of 1996. Out of the fifty families interviewed in each socio-economic group, 25 surveys were done with women and 25 with men to examine gender perception differences. To study household decision-making, the sample included only married men and women who were both employed income-earners. Married people living separately were excluded.

To examine what constitutes power in Turkish households, oral in-depth interviews were conducted with academic scholars in addition to several prototype (focus group) households. Based on the concepts formulated in the interviews, detailed questionnaires were prepared. Surveyors collected the data by recording responses to the seventy-question surveys in face-to-face interviews. Table 2 provides some descriptive statistics for our sample.

The average number of children per household in the sample was 1.5, the average number of years married was 13.5 and the average age of the women was 35.2. Women earned 35% of household income on average, with a range of 6 to 80%. Ten percent of women earned more than their husbands and 15% earned the same amount.

MEASURES OF POWER

Power and dominance in the household are relative concepts and can be measured in both monetary and non-monetary terms. Different proxies to measure power thus can be developed and used. Monetary measures of power

Table 1. The Population for the Sampling Base: Definition of Social Strata.

SOCIAL STRATA	EMPLOYMENT	EDUCATION	DISTRIBUTION OF POPULATION (LARGEST 3 CITIES) (%)
A	Top Managerial, Established Professional	University, Post Graduate or self made entrepreneurial	5
B	Middle Managerial, Young Professional	Same as above	15
C1	White collar Workers	Secondary School or technical community school	30
C2	Blue Collar, Skilled Workers	Literate or primary school Or secondary schools	30
D	Unskilled Workers	Illiterate or primary school Middle school	20
E	Informal Economy	Same as above	20

Note: Data Courtesy of Piar-Ege Incorporated and Piar-Gallup (Turkey).

are easier to scale and measure. Three such proxies, which are relative measures (compared to the husband), are developed and used here.[3] One proxy is the absolute amount of the wife's earnings compared to that of her husband. Another proxy is the amount of personal spending reported. Comparing the relative amounts of personal spending by the husband and the wife can shed light on dominance within the household. A third monetary proxy is proportional and compares the wife's share of spending on herself to her share of income. A woman who, out of surplus income, spends a smaller proportion on herself than her income share, would not be considered dominant according to this proxy.

Three non-monetary measures of power were also considered for Turkish households, based on consultations with urban sociologists and on preliminary focus surveys. Having serious input into decisions concerning children and migration, the power to spend money without hiding it from one's spouse, and

Table 2. Some Descriptive Statistics of the Total Sample.

Variable	Mean	Std. Dev.	Skew.	Kurt.	Min.	Max.
NCHILD	1.50	1.1380	0.480	3.497	0.0	6.0
YRSMAR	13.5	9.8898	0.591	2.795	0.7	47.0
FAGE	35.2	9.3518	0.570	3.289	19.0	68.0
FEDU	3.30	1.4092	0.138	1.632	1.0	6.0
MAGE	39.4	9.6508	0.431	3.200	22.0	75.0
MEDU	3.40	1.2833	0.021	1.665	1.0	6.0
YRATIOW	0.35	0.1613	0.106	2.708	0.06	0.8
FYMORE	0.10	0.3010	2.658	8.057	0.0	1.0
FYSAME	0.15	0.3615	1.918	4.671	0.0	1.0

NCHILD: Number of Children
YRSMAR: Years Married
FAGE: Age, female
MAGE: Age, male
FEDU: Education, female
MEDU: Education, male
YRATIOW: Ratio of women's income to household income
FYMORE: Percent of women who earn more than as their husbands
FYSAME: Percent of women who earn the same as their husbands

Note: Education was coded as follows: 1-illiterate, 2-primary school, 3-middle school, 4-high school or community technical school, 5-university graduate, 6-graduate degree.

relative leisure time were deemed important household power variables. The concept of leisure as an alternative to work is very important in the economic labor supply models. Hoddinott et al. (1997, p. 134) discuss labor supply literature to test for the allocation of labor/leisure in both altruistic and game-theoretic models and cite studies which found that women's refusal to perform family labor contributed to the failure of some planned development projects. In the survey data under study here, close to 90% of the urban working women had input into decisions concerning children and migration and reported that they did not hide their expenditures from their spouses. The most variation in observations concerned the personal leisure time variable. Therefore, this proxy was used as the non-monetary measure of power. Since the data were collected from three different socio-economic strata and half the respondents were male, the impact of stratum and sex were examined to see if they affected the four different proxies.

Table 3. Number and Percentage of Women Earning More Than or the Same as Their Husbands.

	Women Dominant	Egalitarian
PROFESSIONAL, UPPER INCOME		
As declared by women	5	6
As declared by men	3	4
SUBTOTAL	8 (16%)	10 (20%)
BLUE COLLAR		
As declared by women	1	3
As declared by men	1	5
SUBTOTAL	2 (4%)	8 (16%)
INFORMAL SECTOR, LOW INCOME		
As declared by women	3	3
As declared by men	2	2
SUBTOTAL	5 (10%)	5 (10%)
TOTAL	15	23

MARGINAL EFFECTS OF SOCIO-ECONOMIC STRATA AND GENDER-OF-RESPONDENT ON WOMEN EARNING THE SAME OR MORE THAN THEIR HUSBANDS.

	Log likelihood function	−88.69109		
	Chi-square statistic	2.96954		
	Significance level	0.22655		

Variable	Coefficient	S. E	z stat.	P[\|Z\|≥z]
Constant	−0.21329*	0.10601	−2.012	0.04422
SOCIO	−0.07820*	0.04799	−1.629	0.10323
WDECLAR	0.05145	0.07902	0.651	0.51502

Notes: Socio-economic variable is 1 for upper, 2 for middle and 3 for lower stratum.
WDECLAR is 1 for data from women respondents.
* denotes significant at 10% error or less.

THREE MEASURES OF POWER IN MONETARY TERMS

One crude and initial way to measure power between spouses is to assume that power within the household is perfectly correlated with the incomes of husband and wife. The underlying economic assumption is that the individual's preferences are cardinal in nature, where total income and total utility are synonymous.

In that case, the higher the income, the higher the individual's welfare, provided that the woman controls spending out of her income. The numbers in Table 3 provide statistics on the number of women who earn the same or more than their husbands, reported by each socio-economic group.

Sixteen percent of women in the upper, 4% of women in the middle, and 10% of women in lower socio-economic stratum earned more money than their husbands. An additional 20% of urban professional women, 16% of middle and 10% of lower socio-economic stratum women earned the same as their husbands. Women categorized as blue collar were the least likely to earn more than their husbands.

Chi-square tests were used to check for significant differences between these groups. Since the dominance measure consists of count data, Poisson regression models can be employed to test the 'row effects', i.e. the differences, if any, in income-earning proportions between social classes and sexes. Both the count regression (Poisson) model and the marginal effects of the variables (calculated at the means) are presented at the bottom of Table 3. The chi-square test shows that there is no significant overall difference between those who earned the same or more than their husbands. The marginal effects for nonlinear regression models give the estimated slope of the regression coefficients. While the respondent marginal effect (WDECLAR variable) is statistically insignificant, the marginal stratum effect (SOCIO variable) is statistically significant at a 10% error level and negative.

These results suggest that the assumption that women control their own income is not necessarily valid and that absolute income is not necessarily a good measure of allocation of resources within the household. In households where income is pooled and basic needs are taken care of initially, the division of surplus funds (for expenditure on self) between spouses gives a better indication of women's control over resource allocation in the household.

A second proxy for power in the household can be the size of personal expenditures women spend on themselves. Personal expenditures on self (such as clothes, grooming, reading materials and personal use of the car as declared by the respondents) were tallied and the absolute amounts of spending were compared between spouses. The correlation coefficient between income and personal expenditures was 0.35 for women and 0.62 for men. That is, earnings of women were not as highly correlated with their personal expenditures as were those of men. However, the personal expenditures of women were highly correlated with their husbands' personal expenditures, with a correlation coefficient of 0.87.

Twenty-two percent of upper and middle and 24% of lower socio-economic class women spent more (in absolute amounts) on themselves than their spouses

did. When the proportions of women in each stratum were added, women were found to be dominant (spent more) or they spent the same about 54 to 62% of the time (Table 4). With this proxy variable for power, we find women to be more dominant than their spouses in each stratum than what their income shares predicted earlier.

The Poisson regression to test the marginal effects (at the means) of stratum and respondent are reported on Table 4. The chi-square test shows that there is no overall significant difference between those who spent the same or more than their husbands. The marginal effect of stratum is also insignificant. However, the marginal respondent effect is statistically significant (at 8% error level) and negative. The model shows that when men declared their spouse's expenditures, they tended to exaggerate the spending by a factor of about 0.21.

The data did not exhibit any evidence of what Kuyas (1982) found earlier regarding the importance of the wife's income and her spending on herself. She found that the less crucial the women's income to the household income, the more power she had over the resources. In our sample, the higher the ratio of the wife's income was to household income, the more she spent on herself. The largest coefficient of correlation between personal spending of wives was with the amount of spending of husbands (correlation of 0.87). There was also a positive but weaker correlation with income level and socio-economic stratum. The correlation between the ratio of wife's income to household income and her spending on herself was very weak but positive. We did not have the data on pre-marital work history to test Kuyas' (1982) other hypothesis on pre-marital income, social class and spending.

A third proxy for power is the proportional share of personal expenditures of husbands and wives. If we pool total household income and total personal expenditures of both parties, we can then compare the percentage of income shares to the percentage of personal expenditure shares. For example, a woman who earns 40% of the household income and has 40% of total personal expenditures (out of surplus income) would be considered proportional personal-expenditure neutral. If she spends more than 40%, she would be considered proportional personal- expenditure dominant. Table 5 gives the proportional personal expenditure dominance between husbands and wives in our sample.

When power in the household is defined in this fashion, we find that a majority of women in all income strata are more proportional-dominant than men (Table 5). If we add dominant (spends more) and neutral (spends same) proportions, we find that 68% of upper, 78% of middle and 64% of low stratum women have greater or equal power than men using this proxy variable. However, as noted earlier, these figures have to be interpreted with caution. The proportional personal expenditures dominance clearly observed in these

Table 4. Comparative Personal Expenditures: Number and Percentage of Women Spending More or the Same as Their Husbands.

	Women Dominant	Same
PROFESSIONAL, UPPER INCOME		
As declared by women	4	13
As declared by men	7	6
SUBTOTAL	11 (22%)	19 (38%)
BLUE COLLAR		
As declared by women	7	10
As declared by men	4	10
SUBTOTAL	11 (22%)	20 (40%)
INFORMAL SECTOR, LOW INCOME		
As declared by women	10	8
As declared by men	2	7
SUBTOTAL	12 (24%)	15 (30%)
TOTAL	34	54

MARGINAL EFFECTS OF SOCIO-ECONOMIC STRATUM AND SEX OF RESPONDENT ON WOMEN SPENDING THE SAME OR MORE THAN THEIR HUSBANDS.

Log likelihood function −133.3909
Chi-square statistic 3.0787
Significance level 0.21451

| Variable | Coefficient | S. E | z stat. | $P[|Z|\geq z]$ |
|---|---|---|---|---|
| Constant | −0.36458* | 0.16538 | −2.204 | 0.02749 |
| SOCIO | −0.02948 | 0.07523 | −0.392 | 0.69512 |
| WDECLAR | −0.21195* | 0.12289 | −1.725 | 0.08458 |

Notes: Socio-economic variable is 1 for upper, 2 for middle and 3 for lower stratum.
WDECLAR is 1 for data from women respondents.
* denotes significant at 10% error or less.

women could be compensation for extra household work and childcare. Poisson regression results reported in Table 5 show that there is no statistically significant proportion difference between strata and respondents.

PERSONAL LEISURE TIME AS POWER

A non-monetary measure of power can be the absolute hours of personal time spouses devote to themselves. Personal leisure hours are those hours carved out

Table 5. Proportional Personal Expenditure Shares and Income Shares: Number of Women Who Spend More Than or Same as Their Income Shares.

	Women Dominant	Same
PROFESSIONAL, UPPER INCOME		
As declared by women	13	4
As declared by men	16	1
SUBTOTAL	29 (58%)	5 (10%)
BLUE COLLAR		
As declared by women	20	1
As declared by men	17	1
SUBTOTAL	37 (74%)	2 (4%)
INFORMAL SECTOR, LOW INCOME		
As declared by women	16	2
As declared by men	10	4
SUBTOTAL	26 (52%)	6 (12%)
TOTAL	92	13

MARGINAL EFFECTS OF SOCIO-ECONOMIC STRATUM AND SEX OF RESPONDENT ON WOMEN SPENDING THE SAME OR MORE THAN THEIR INCOME SHARES.

Log likelihood function −142.8819
Chi-square statistic 0.5241
Significance level 0.7694

| Variable | Coefficient | S. E | z stat. | P[|Z|≥z] |
| --- | --- | --- | --- | --- |
| Constant | −0.25752 | 0.18561 | −1.387 | 0.16535 |
| SOCIO | −0.01995 | 0.08345 | −0.239 | 0.81105 |
| WDECLAR | 0.09323 | 0.13629 | 0.684 | 0.49391 |

Notes: Socio-economic variable is 1 for upper, 2 for middle and 3 for lower stratum.
WDECLAR is 1 for data from women respondents.
* denotes significant at 10% error or less.

after work, housework, childcare, etc. In our sample, average leisure hours reported increased with the socio-economic stratum. These average personal leisure hours per day were as follows: 2.68 for women and 2.72 for men in the upper, 1.88 for women and 1.92 for men in middle, and 1.1 for women and 1.65 for men in the lower stratum. Large numbers of women and men reported zero leisure hours for *both* partners. Eleven couples in the upper, 14 couples in the middle and 20 couples in the lower stratum reported having no time for

personal leisure. These couples made up 22% of the upper, 28% of the middle and 40% of the lower socio-economic stratum households and 30% of the overall sample. Since the purpose of the study is to measure relative dominance in the household, when spouses both reported zero personal leisure time, they were excluded from the count data on Table 6.

Count data show that 30% of upper, 34% of middle and 4% of lower socio-economic stratum women spend more personal time on leisure (in hours) than their husbands (Table 6). It is apparent that low-income women do not have the time for personal leisure that the middle and upper socio-economic strata have. In fact, it is noteworthy that while some low income men stated that their wives had more leisure than them, none of the female respondents in the low-income group declared that they had more personal time than their husbands.

Results from the Poisson regression (Table 6) for those women who reported having the same or more leisure time than their husbands suggest significant differences in the overall regression. Not only are the chi-square statistics significant, but there are significant leisure hour differences by socio-economic stratum. The lower the socio-economic stratum, the less likely a woman is to have at least as many leisure hours as her husband.

All measures of dominance are summarized on Table 7. Several important facts emerge from the table. First of all, if we use the proportional personal spending dominance measures, we find that more than 50% of the women are dominant over their husbands in all income groups.

However, this figure is biased upward since it does not reflect the wife's time cost and compensation for childcare and household activities. All other dominance measures are lower than the proportional spending measure. Still, in both upper and middle stratum households, the percentage of women who are dominant is greater than the percentage of women who earn more income. That is, the power of women in the household is greater than their share of income. The exception is in the lowest stratum, with respect to personal leisure time measure. While 10% of low-income women earn more than their husbands, only 4% are dominant when it comes to personal leisure time.

PREDICTING POWER VARIABLES

The four relative power variables discussed in the section above provided three monetary proxies and one non-monetary proxy for working women's welfare in the household. The first proxy used was whether women earned the same or more than their husbands and 25.33% (38/150) of the sample fit that category. The second proxy, whether women spent at least as much or more than their husbands, made up 58.67% (88/150). The third proxy, whether women spent

Table 6. Personal Leisure Time Expenditures.

	Women Dominant	Same
PROFESSIONAL, UPPER INCOME		
As declared by women	6	9
As declared by men	9	4
SUBTOTAL	15 (30%)	13 (26%)
BLUE COLLAR		
As declared by women	9	4
As declared by men	8	6
SUBTOTAL	17 (34%)	10 (20%)
INFORMAL SECTOR, LOW INCOME		
As declared by women	0	4
As declared by men	2	8
SUBTOTAL	2 (4%)	12 (24%)
TOTAL	34	35

MARGINAL EFFECTS OF SOCIO-ECONOMIC STRATUM AND SEX OF RESPONDENT ON WOMEN SPENDING THE SAME OR MORE LEISURE TIME THAN THEIR HUSBANDS.

	Log likelihood function		−122.5805	
	Chi-square statistic		4.6569	
	Significance level		0.0974 *	
Variable	Coefficient	S. E	z stat.	P[\|Z\|≥z]
Constant	−0.05327	0.14029	−0.380	0.70417
SOCIO	−0.13743 *	0.06404	−2.113	0.03462
WDECLAR	−0.06453	0.10704	−0.603	0.54569

Notes: Socio-economic variable is 1 for upper, 2 for middle and 3 for lower stratum.
WDECLAR is 1 for data from women respondents.
* denotes significant at 10% error or less.

the same or a larger proportion of household surplus income on themselves than their income share in the household, was 70% (105/150). The fourth proxy, whether women had the same or more personal leisure hours than their husbands, was 46% (69/150). Again this excludes the forty-four couples (29.33%) who reported zero leisure time for both spouses.

These proxies for power have their symmetric 'non-power' measures. If one takes the remaining proportion of women, one would then find that, respectively, 74.67% earn less then men, 41.33% spend less than their husbands, 30% spend

Table 7. Summary of Different Proxies of Dominance For Each Socio-Economic Group.

	Women Dominant Households (%)
PROFESSIONAL, UPPER INCOME	
Women earning greater income*	8 (16)
Comparative personal expenditures**	11 (22)
Proportional personal spending	29 (58)
Personal leisure time*	15 (30)
BLUE COLLAR	
Women earning greater income*	2 (4)
Comparative personal expenditures**	11 (22)
Proportional personal spending	37 (74)
Personal leisure time*	17 (34)
INFORMAL SECTOR, LOW INCOME	
Women earning greater income*	5 (10)
Comparative personal expenditures**	12 (24)
Proportional personal spending	26 (52)
Personal leisure time*	2 (4)

Notes: * denotes statistical significance between stratum,
** denotes statistical significance between responses of husband and wife.
Each group has fifty observations.

less out of surplus income than their corresponding income shares, 24.67% have less personal leisure time than their spouse.

We next ran a series of logit regressions, to see how accurately we could predict the women who were powerful using these four measures. The logit model results are given on Table 8. The independent variables used in the regressions were as follows: the binary variables indicating the socio-economic stratum to which the household belonged, the sex of the respondent, the presence of a comfortable level of household income, and homeownership. Other variables included were the number of children in the household, the number of years of marriage, and the education levels and ages of the husband and wife. Two additional non-monetary proxies for power were also added to the models. One was whether the female respondent declared that her spouse was aware of her expenditures on herself or whether they were 'hidden.' As such the 'spouse knows' variable had a value of 1 if the husband knew, and was zero otherwise. Eighty-seven percent of the working women in the sample did

Table 8. Marginal Effects of Variables; Results of Logit Prediction Models.

Dependent variable: Different measures of dominance

VARIABLES	MODEL 1	MODEL 2	MODEL 3	MODEL 4
Intercept	−1.1781 **	−1.0683	0.3700	−0.9015
Socio-econ strata	−0.0210 *	0.0646	−0.0343 *	−0.0057 *
Declared by women	0.0160	0.2163 **	0.1084	−0.1114
Sufficient basic income	0.0375	−0.0092	0.0156	0.0118
Number of children	−0.0746 *	−0.0913 *	−0.0448	−0.0400
Home owner	−0.0674	0.0006	0.0078	0.0413
Years of marriage	0.0002	−0.0074	0.0160	0.0037
Education level-male	−0.0438	−0.0040	0.0067	−0.0083
Education level-fem	0.0919 *	0.0581	−0.0036	−0.0689
Age-male	0.0231 *	0.0282 *	−0.0231 *	0.0061
Age-female	−0.0087	−0.0120	0.0063	0.0033
Spouse knows	0.4817 **	0.3441	0.1760 *	0.2734 *
Control over children	−0.0845	0.0175	0.2004 *	0.2219

PREDICTION RATES

DOMINANCE	13/38 (34%)	69/88 (78%)	98/105 (93%)	39/69 (57%)
SUBMISSION	107/112 (96%)	30/62 (49%)	9/45 (20%)	57/81 (70%)
LOG LIKELIHOOD	−67.69	−89.82	−86.11	−93.94
CHI-SQUARE STAT.	34.39 **	23.77 **	12.69	19.09 **

Notes: * significant at 10 % error level or less, ** significant at 1% error level or less.
Model 1: Dependent variable is the proportion of women who earn the same or more than their husbands.
Model 2: Dependent variable is the proportion of women who spend the same or more than their husbands.
Model 3: Dependent variable is the proportion of women who spend the same or larger proportions than their income shares.
Model 4: Dependent variable is the proportion of women who have the same or more leisure time than their husbands.

not keep their expenditures secret. The other was the control over children, that is, who made the decisions regarding children. If the woman made all the decisions or if she did it jointly with her spouse, the dummy variable had a value of one. If the husband or the in-laws made decisions concerning children, the variable had a value of zero. For 89% of those interviewed this variable was one, with most of the zeros appearing in the low socio-economic stratum.

The prediction rates for each of the proxies are also given in the table. The regression models were able to predict dominance for 34% of women in the

first equation, 78% in the second, 93% in the third and 57% in the last. As for those categorized as submissive, 96% of this group were predicted correctly for the first proxy, 49% for the second, 20% for the third and 70% for the fourth proxy. Models 1, 2 and 4 were significant with error levels of 1% or less.

The socio-economic stratum variable was statistically significant in the first, second and fourth models. The lower the socio-economic stratum, the lower was the proportion of women earning at least as much as their husbands, spending at least as much as their husbands, and having at least as much personal leisure time as their husbands. Whether men or women provided the data made no difference, except in the second model, where men appear to have inflated the personal spending of their wives. Number of children was also statistically significant in the first and the second models, where the proportion of women's earnings and spending decreased as the number of children increased. Education level of the female was only significant in the first model, where it made a positive difference in women's earnings. Level of education did not influence the three other power proxies. The age of the male was a significant positive factor in the first and second models and negative in the third model. The older the husband, the greater was the proportion of women making and spending at least as much as their husbands and the lower the proportion of women spending at least as much as their income shares. Having a comfortable level of income, owning a home (versus renting), years of marriage, education level of the husband and age of the women were not statistically significant in any of the models.

Whether the spouse knew of the expenditures or whether they were hidden was a significant variable in the first, third and fourth models. In cases where the husband was aware of the wife's income and expenditures, a greater proportion of the women were earning at least as much, spending at least as much, and taking at least as much leisure time as their husbands. The variable measuring control over the decisions concerning children was significant in the third model, where those who had control also had larger expenditure shares, implying a compensation for unpaid managerial duties.

CONCLUSION

Economic studies on the power relations of working MENA women have been scarce. More field studies are needed on the household allocation of resources in the area. Based on a field survey conducted in Izmir, Turkey, this study developed four proxies of power for working women in Turkish households who were divided into three different socio-economic strata. All power relations were defined relative to the spouse and dominance was measured with

respect to income, absolute and proportional spending and personal leisure time. In the sample, about 25% of the women earned as much or more than their husbands, although this varied by socio-economic class and the education level of the woman. About 59% of the working women spent more on themselves than their husbands did. Similarly, 70% of women spent at least as much proportionally (compared to their income share) as their spouses. In both these proportions, the age of the male was an important positive factor and in the latter case, socio-economic status also mattered.

The wife's personal leisure time relative to that of her husband was used as a non-monetary proxy of power. Among those families who reported some positive leisure time for at least one spouse, leisure was a scarce good for women and varied by socio-economic stratum. Almost all the women engaged in informal work, who were also likely to be from the low socio-economic stratum, reported zero or near zero leisure hours, implying that lack of human capital and a heavy paid and non-paid work burden were correlated.

Our findings reinforce those of Kagitcibasi (1984), who found a high correlation between intra-family status and socio-economic strata for Turkish working women. We also do not negate Phipps and Burton's (1992) U.S. study, which suggests a woman's power is related to her contribution to the household income. Our results also reinforce the Hersch and Stratton (1997b) study of U.S. which finds that working women's hours of housework are quite high. However, we also find that there is a strong socio-economic component to this method of proxying welfare. The lower the socio-economic stratum, the fewer the leisure hours a Turkish working woman has.

Asymmetric privileges in the household and intra-household inequalities are evident in our sample, as shown by the differences in leisure by sex and socio-economic stratum. Public policy and household transfers must be made with attention to the fact that working women in the lower income stratum face quite different challenges from educated working women in upper stratum. The growth of women's informal work is strongly related to the economic hardships and poverty of low income households. Public policies that ignore informal work and refuse to grant these women the right to participate in private or public social security and health care programs actually reinforce intra-household and cross-strata inequality.

ACKNOWLEDGMENTS

We would like to express our gratitude to Piar-Ege Incorporated of Izmir, Turkey for helping to make the survey feasible. We would also like to thank Dr. A. Okten and T. Orhan for helping define power behavior in Turkish households, C. Orhan

for help with survey and sampling design and Loyola University Chicago for providing a small research grant.

NOTES

1. Bardhan (1992) states "... the idea of power is central to an understanding of socio-economic processes, but I also share the frustration of many analysts in closely examining this vague, slippery, and multifaceted concept...Unlike in economics, there is a large body of literature on power in sociological and political theory. (p. 64)... In game theoretic terms an inclusive way of defining power may be to say that A has power over B if A has the capacity to alter the game (preference, strategy sets, or information sets) in such a way that B's equilibrium outcome changes" (p. 75). In Anbarci and Cinar (1997), we formulate a game-theoretic model where men have the first-mover advantages and women respond to offers. In this study, we use power and dominance synonymously and measure power relative to spouse.

2. The survey was carried out by Piar-Ege Incorporated, which has done extensive field surveys in and around the city of Izmir.

3. Absolute and proportional spending proxies are not adjusted in any way to compensate for women's unpaid household work. The need for such an adjustment was considered, but haphazard assignment of the 'cost per hours of unpaid work,' especially across three socio-economic strata, would have introduced numerous biases into the data. Adjusting for number of children, social strata, the opportunity cost of time and learning effects with age would have been ideal had consistent application been possible. However, because consistency could not be maintained, spending data have not been adjusted in any way.

REFERENCES

Anbarci, N., & Cinar, E. M. (1997). *Intra-Household Division of Surplus Income: Theory and Evidence*, Working Paper 97–98. Miami: Florida International University.

Anbarci, N., & Cinar, E. M. (1999). Intra Marital Sharing *Rules with Evidence From Turkey, Topics in Middle Eastern and North African Economies*, 1, September 1999, electronic journal, www.luc.edu/depts/economics/meea/

Bardhan, P. (1992). Some Reflections on the Use of the Concept of Power. In: K. Basu & P. Nayak (Eds), *Economics, Development Policy and Economic Theory* (pp. 64–77). Delhi: Oxford University Press.

Becker, G. (1965). A Theory on the Allocation of Time. *Economic Journal*, 75, 493–517.

Becker, G. (1981). *A Treatise on the Family*. Cambridge: Harvard University Press.

Becker, G. (1985). Human Capital Effort and Sexual Division of Labor: Part 1. *Journal of Labor Economics*, 3, S33–S58.

Blumberg, R. L. (1988). Income Under Female Versus Male Control: Hypothesis from a Theory of Gender Stratification and Data from the Third World. *Journal of Family Issues*, 9, 51–84.

Carter, M. R., & Katz, E. G. (1992). *Separate Spheres and the Conjugal Contract:Understanding the Gender-Biased Development*, mimeo, Madison: University of Wisconsin.

Carter, M. R., & Katz, E. G. (1997). Separate Spheres and the Conjugal Contract:Understanding the Gender-Biased Development. In: Haddad, Hoddinott & Alderman (Eds), *Intrahousehold Resource Allocation in Developing Countries* (pp. 95–111). International Food Policy Institute, Baltimore, Maryland: Johns Hopkins University Press.

Cinar, E. M. (1997). Privatization of Education, Educational Spending and the Case of the "Missing Girls" in Grade Schools. *Critique*, Fall, 53–64.

Cinar, E. M. (1994). Unskilled Urban Immigrant Women and Disguised Employment: Home Working Women in Contemporary Turkey. *World Development*, 22(3), 369–380.

Dwyer. D., & Bruce, J. (Eds) (1988). *A Home Divided: Women and Income in the Third World.* Stanford: Stanford University Press.

Erkut, S. (1982). Dualism in Values Toward Education of Turkish Women. In: C. Kagitcibasi (Ed.), *Sex Roles, Family and Community in Turkey* (pp. 121–132). Bloomington: Indiana University.

Esim, S. (1996). Gender Based factors Affecting the Earnings of Women Entrepreneurs in Turkey. Ph.D. Dissertation, Washington D.C., The American University.

Gronau, R. (1977). Leisure, Home Production, and Work: The Theory of the Allocation of Time Revisited. *Journal of Political Economy*, 85, 1099–1123.

Hersch, J., & Stratton, L. (1997a). Housework, Fixed Effects, and Wages of Married Workers. *Journal of Human Resources*, 32, 285–307.

Hersch, J., & Stratton, L. (1997b). *Household Specialization and the Male Marriage Wage Premium*, mimeo.

Heyneman, S., & Esim, S. (1994). Female Educational Enrollment in the Middle East and North Africa: A Question of Poverty or Culture? *Horizons*, Summer, 63–65.

Hoddinott, J., Haddad, L., & Alderman, H. (1997). Testing Competing Models of Intrahousehold Allocation. In: Haddad, Hoddinott & Alderman (Eds), *Intrahousehold Resource Allocation in Developing Countries* (pp. 129–141). International Food Policy Institute, Baltimore, Maryland, Johns Hopkins University Press.

Juster, F. T., & Stafford, F. P. (1991). The Allocation of Time: Empirical Findings, Behavioral Models, and Problems of Measurement. *Journal of Economic Literature*, 29, 471–522.

Kagitcibasi, C. (1984). *Aile-ici Etkilesim ve Iliskiler* (Intra-family Dynamics and Relations), *Turkiye'de Ailenin Degisimi: Toplumbilimsel Incelemeler* (The Changes in the Turkish Family: Studies in Social Sciences) (pp. 131–144). Ankara: Turkish Social Science Association.

Kazgan, G. (1979). Turk Ekonomisinde Kadinlarin Isgucune Katilmasi, Mesleki Dagilimi, Egitim Duzeyi ve Sosyo-Ekonomik Statusu, (Women's Labor Force Participation, Job Distribution, Education Level and Socio-Economic Status in the Turkish Economy) Turk Toplumunda Kadin (Women in the Turkish Society), N. Abadan-Unat (Ed.) (pp. 155–189). Ankara: Turkish Social Science Association.

Kuyas, N. (1982). The Effects of Female Labor on Power Relations in the Urban Turkish Family. In: C. Kagitcibasi (Ed.), *Sex Roles, Family and Community in Turkey* (pp. 181–205). Bloomington: Indiana University Press.

Lazear, E., & Michael, R. T. (1988). *The Allocation of Income Within the Household*. Chicago: University of Chicago Press.

Lundberg, S., & Pollak, R. A. (1993). Separate Spheres Bargaining and the Marriage Market. *Journal of Political Economy*, 101, 998–1010.

Manser, M., & Brown, M. (1980). Marriage and Household Decision Making: A Bargaining Analysis. *International Economic Review*, 21, 31–44.

McElroy, M. B., & Horney, M. J. (1981). Nash Bargained Household Decisions. *International Economic Review*, 22, 333–349.

Nash, J. (1950). The Bargaining Problem. *Econometrica*, *18*, 155–162.
Okten, A., (1997). Post-Fordist Work and Women in Urban Turkey. Working Paper. Istanbul: Yildiz University.
Ozbay, F. (1979). *Turkiye'de Kirsal/Kentsel Kesimde Egitimin Kadinlar Uzerinde Etkisi* (The Effect of Education on Urban/Rural Turkish Women) *Turk Toplumunda Kadin* (Women in the Turkish Society) N. Abadan-Unat (Ed.) (pp. 191–219). Ankara: Turkish Social Science Association.
Phipps, S., & Burton, P. (1992). What is Mine is Yours? The Influence of Male and Female Incomes on Patterns of Household Expenditure. Discussion Paper No. 92-12, Department of Economics, Dalhousie University.
Sen, A. K. (1990). *Gender and Cooperative Conflicts, Persistent Inequalities: Women and World Development*, I. Tinker (Ed.) (pp. 123–149). Oxford: Oxford University Press.
Singerman, D., & Hoodfar, H. (1996). *Development, Change and Gender in Cairo*. Indiana: Indiana University Press, Bloomington and Indianapolis.
Thomas, D. (1997). Incomes, Expenditures and Health Outcomes: Evidence on Intrahousehold Resource Allocation. In: Haddad, Hoddinott & Alderman (Eds), *Intrahousehold Resource Allocation in Developing Countries* (pp. 142–164). International Food Policy Institute, Baltimore, Maryland: Johns Hopkins University Press.
Timur, S. (1972), *Turkiye'de Aile Yapisi* (Family Structure in Turkey). Ankara: Hacettepe University Press.
UNDP (1994). *Human Development Report*, New York: Oxford University Press.
UNDP (1995). *Human Development Report*, New York: Oxford University Press.
UNDP (1996). *Human Development Report*, New York: Oxford University Press.
UNDP (1997). *Human Development Report*, New York: Oxford University Press.
UNDP (1998). *Human Development Report*, New York: Oxford University Press.

FERTILITY, EDUCATION, AND HOUSEHOLD RESOURCES IN IRAN, 1987–1992

Djavad Salehi-Isfahani

ABSTRACT

The two most important changes in the lives of Iranian women in the last ten years are rapid decline in fertility and rise in their educational attainment. The prevailing view on the recent fertility decline attributes fertility decline primarily to an energetic family planning program. In this paper I examine the relationship between fertility and education using cross section data. Analysis of two household surveys taken in 1987, and in 1992, shows a close association between education and fertility. I conclude by noting that, in the absence of increased opportunities for women to work outside the home, the observed relationship between fertility and education is likely to derive from the lower cost of child education for more educated couples, which leads households to substitute quality for quantity of children.

I. INTRODUCTION

In the last ten years Iranian fertility has declined by more than one-half. Remarkably, this unprecedented shift in the childbearing behavior of Iranian women has taken place against the backdrop of increased emphasis on the traditional role of women as homemakers and mothers following the 1979 Islamic revolution. Restrictions on how women may appear in the public space, especially at the workplace, and changes in family and marriage laws have favored the traditional role and discouraged women from participating effectively in the social and economic life of the country (Hoodfar, 1994). Despite these setbacks, women have substantially improved their education. In the last twenty years female literacy has more than doubled and the gender gap in educational attainment has narrowed considerably (Salehi-Isfahani, 2001). Female literacy as a percentage of male literacy increased from 57% in 1976 to 90% in 1996. Women now comprise about half of all university students.[1] The increase in education of women has taken place at the same time that their labor force participation has stagnated at levels below 10% (compared to over 90% for men) and is lower than it was twenty years earlier. In Tunisia and Turkey where fertility and education are about the same as Iran, labor force participation rates are more than twice as high.

Such discord between women's increased education and lower fertility on the one hand and their economic status as defined by labor force participation on the other, suggests that the link between education and fertility may not run through increased labor market opportunities for women. The classic Becker (1960, 1991) model allows for female education to affect fertility in two ways: through an increase in the opportunity cost of mother's time and through a drop in the cost of child quality. Education is usually correlated with both prices. More educated women have access to higher paying jobs and are also more productive in raising the human capital of their children, which reduces the cost of child quality. In Iran, the case for a link between education and fertility based on increased market opportunities for women appears weak, even granting the fact that the phenomenon under consideration is only a decade old and fertility could have dropped among more educated women in anticipation of increased market opportunities that are yet to come.[2] The alternative line of causation from education to fertility based on the value of women's time at home may be a better explanation of fertility decline. It is certainly consistent with the remarkable increase in child education, especially of girls, in recent years (Salehi-Isfahani, 2001). Lam and Duryea (1999) discuss a similar phenomenon in Brazil where declining fertility has not led to increased participation in outside work by women. They argue that in Brazil, increased education and

lower fertility are consistent with constant and low labor force participation because education increased the productivity of women at home in the production of human capital (child quality) more than it increased their market productivity. As a result, women's time released by the decline in fertility was absorbed by the demand for higher child quality rather than by market work. It is tempting to apply this model to the case of Iran, but the restrictive social environment in Iran, especially after the revolution, suggests that, unlike in Brazil, the decision for women not to seek outside employment may not be entirely their own. Karshenas (2001), among others, explains the low participation of women in the Middle East by examining social norms and the unwillingness of husbands to let their wives work outside the home.

No matter what its cause, the recent decline in fertility will change the Iranian family and women's lives for good. However, what that change will entail depends in part on how the decline in fertility came about and the role that was played by education. If, at one extreme, the decline in fertility were simply the result of government-initiated family planning programs and not related to increased education, then women's choice of market work versus work at home could be viewed as exogenous. Fertility decline could lead to more market work, increased home production, or increased leisure, depending on the respective returns to each. On the other hand, if the decline in fertility were related to increased education, then the availability of market opportunities and return to home production of child quality are factors that presumably have influenced the fertility decision in the past and therefore can in the future. What happens to the productivity of women's time, at home or in the market, will impact future fertility decisions. Furthermore, if the desire of the average Iranian woman to have fewer children and acquire more education is with a view to attaining a more equal role in the family and society, then the decline in fertility could be regarded as a sign of future contentions over the role of women in Islamic Iran.

In this paper I focus only on the relation between education and fertility. My aim is to determine if the correlation between female education and fertility that we observe in the aggregate and through time also holds at the micro level using cross sectional data. I utilize household survey data to measure the impact of education on the number of children ever born (CEB) to married women. Controlling for other characteristics of women, such as household income, education of husband, and place of residence, I show that more educated mothers do have fewer births. The question of whether the low participation of women in market work is the result of substitution between quantity and quality of children or restrictive social norms remains a question for future research.

I study the relation between fertility and education within the framework of demand for children. This framework has proved very successful in explaining fertility behavior in developed and developing countries (Hotz et al., 1997, Schultz, 1997). Empirical studies in various contexts have found a negative relationship between female education and fertility. These studies are usually of two types: those in which both education and fertility (along with labor force participation) are treated as endogenous; and those in which fertility is considered endogenous to education but not vice versa. Studies of the first type are theoretically more appealing, but are often weak on identification. The decisions to educate oneself, pursue a career, and have fewer children are often closely intertwined; disentangling them empirically is a serious challenge that can only be met with the help of credible instruments for the endogenous variables. The validity of the results of studies of the second type depends on the extent to which education can be considered as predetermined. To pose the question of the impact of education on fertility meaningfully one must assume that the level of women's education is determined independently of their fertility. This is in general not the case as both education and fertility may be influenced by a third factor. Because education is not randomly assigned to individuals, sample correlations do not imply causation. Individuals who seek more education and earn more income may wish to limit their fertility for the same reasons that led them to seek more education (Thomas, 1996). It is therefore best to keep in mind that in cross section studies such as this one, when talking about the 'effect' of education on fertility, the implication of causation is often a mere convenient slip of the tongue.

There are very few studies of demand for children in Iran. Raftery et al. (1995) use micro data from the Iran World Fertility Survey (WFS) of 1976 to conclude that the fertility decline before the revolution was more the result of falling demand for children than changing preferences as a result of government campaigns for smaller families ("ideation"). Two aspects of that study limit its relevance to the post-revolution fertility changes. First, it uses data collected in 1976, well before the fertility decline in question. Second, because the WFS lack data on income and expenditure, the estimated education effect in their regressions includes the income effect and thus may overstate the effect of education. This bias can be particularly large for the effect of husband's education, which is more closely correlated with household income. I use more recent data from the 1987 and 1992 integrated household surveys that include information on household resources.

In this study I focus on marital fertility. Because education also affects the age at first marriage, the results obtained here may underestimate the overall effect of education on fertility. The evidence shows a strong association between

the number of children ever born (CEB) to a woman and her education, after controlling for other key determinants of fertility such as income, rural and urban residence, and the education of her husband. Because the correlation is between women of different cohorts who are at different stages of their childbearing, we cannot draw direct inferences about changes in education and fertility over time. The results indicate that, for both rural and urban women, female education explains the variation in CEB better than the education of the husband. Income is found to be positively associated with fertility and to matter more in the poorer rural sector than in urban areas.

Sections II and III review, respectively, the evidence on recent fertility changes in Iran and their proximate determinants. Section IV discusses changes in factors that affect the demand for children. Section V reports on the estimation of the effect of education on fertility from micro data, and Section VI concludes.

II. REVIEW OF EVIDENCE ON FERTILITY CHANGE

The broad picture of changes in fertility can be gleaned from the inter-censal rates of population growth and the share of children 0–4 years in the total population. The rate of population growth fell from 3.1% for the 1956–66 period to 2.7% for 1966–76, but unexpectedly increased to 3.8% during the 1976–86 period. Correspondingly, the share of 0–4 year olds in the population fell from 17.6% in 1966 to 16.1% in 1976, but increased to 18.2% in 1986. The first accurate sign of a turnaround was provided by the 1991 national population survey. The growth rate for 1986–91 dropped to 3.2% and the share of 0–4 year olds fell to an all time low of 14.6% in 1991. The latter indicated a rapid decline in fertility. The 1996 national census of population confirms this trend: the 0–4 population comprised only 10.3% of the total, having dropped by 5.4% compared to 1991. Annual surveys conducted by the Ministry of Health during 1992–95 show a steady drop in the growth rate from 2.7% to 1.75% per year (Malekafzali, 1995). Not all of these fluctuations took place as a result of changes in fertility. In-migration of refugees in the early 1980s, mainly from Afghanistan, accounts for a significant part of the recorded population increase during 1976–86. Under-reporting of deaths in the 1986 census may have been yet another reason for the faster recorded increase in population, especially in the 0–4 age group. During the 1980s, widespread rationing of consumer goods generated considerable incentives for families to delay the reporting of deaths.

Estimates of fertility based on census and survey data disagree on the extent of the fluctuations in fertility. Bulatao and Richardson (1994) present various estimates of the Total Fertility Rate (TFR) obtained from census and survey data (see Table 1) which show a decreasing trend until 1976, followed by an

Table 1. Estimates of TFR from Various Sources.

Year	TFR	Source
1956	7.3	Census
1966	7.7	Census
1976	6.3–6.8	Census, WFS
1985	5.6	Health survey
1986	7.0–7.7	Census
1991	6.3	National survey
1992	4.7	KAP survey
1993	3.3	Health survey

Sources: Bulatao and Richardson (1994), Malekafzali (1995).

increase until 1986 and then a decline to a low of 3.3 in 1993. Although there is a wide range in estimates for TFRs in the mid-1980s, from 5.6 in 1985 to 7.7 in 1986, these data are consistent with the idea of a rise and fall in fertility. Hill (1993), who carefully examined the 1986 and 1991 population data, also supports the view of an increase in the birth rate in the early 1980s followed by a sharp drop, of as much as 40%, from around 1986 to the early 1990s. Perhaps the most convincing evidence so far of the rise and fall of fertility is from a study by Abbasi-Shavazi (1999) who finds that the TFR increased slightly during the first half of the 1980s before starting its sharp decline. According to his estimates the TFR fell from 6.2 in 1986 to 2.5 in 1996.

Data from the surveys used in this study, taken in 1987 and 1992, can also be used to measure the speed of the decline in fertility in the 1980s (see Section V of the paper for a description of the surveys). I should caution, however, that although both surveys are nationally representative, because of their small size (each has approximately 7000 women of childbearing age), the estimates of the levels of TFR may not be reliable, but the trend they reveal is quite believable (Table 2). For what they are worth, the levels are closer to those obtained by the Ministry of Health for the mid-1980s.

Table 2. Total Fertility Rates from Sample Surveys, 1987 and 1992.

	1986	1991
Urban	4.69	2.78
Rural	7.84	4.74
Total	5.88	3.49

Source: Statistical Center of Iran, 1987 and 1992 panel data sets.

Table 2 also shows that fertility decline was not confined to the urban population. Rural fertility fell from a high value of 7.84 to 4.74 in just five years. Figs 1a and 1b depict age-specific fertility rates computed from the same surveys. They show that the rapid decline in fertility applies to a wide range of ages and to both rural and urban women.

III. PROXIMATE DETERMINANTS OF FERTILITY

It is useful to divide the factors that affect fertility into two categories. One category includes factors that affect demand for children, such as the net price of children and household income. The other includes the so-called proximate determinants of fertility such as family planning, age at first marriage, and infant and child mortality. Changes in these factors can affect the number of births without necessarily changing demand for children. I will begin with a survey of the latter.

The timing of the fertility decline appears closely connected with changes in the Islamic government from pro- to anti-natal policies, and the launching of a family planning program in 1989. After the revolution there was a conscious effort to reduce the importance of the family planning program introduced under the Shah's rule in 1967 (Hoodfar, 1994; Mehryar, 1995a). Although fatvas (written decrees) issued by Ayatollah Khomeini and other leading clergy shortly after the revolution permitted the use of contraceptives (Aghajanian, 1995), pronouncements by other leading clergy created a general anti family-planning atmosphere that contributed to a decline in the provision of contraceptives during the early 1980s, especially by the private sector. In 1988, reversing its pro-natal stand, the government took the first steps to reduce fertility. Gradually the family planning activities of the Ministry of Health were revived and by the mid-1990s the program was in full swing across the country. Information on contraceptive use is not available for the early 1980s, so it is difficult to say if the scaling down of the government family planning program was responsible for the rise in fertility. The reduction in fertility in the 1990s is clearly marked by increased use of contraceptives. In 1992 the percentage of women reporting the use of contraceptives was 64.6% compared to 35.9% in 1976 (Aghajanian, 1995, p. 11).

There are reasons why the timing of the family planning program should not be taken as proof of the program's decisive impact on fertility.[3] First, the effectiveness of the family planning program itself depends on women's willingness to participate in it, which in turn depends on factors that influence demand for children. Second, there is strong evidence presented by Abbasi-Shavazi (1999) that fertility started its decline as early as 1985, well before the change in policy was announced. Third, as Mehryar (1995a) has shown, official statistics show

Fig. 1a. Age Specific Fertility Rates for Urban Women, 1986 and 1991.
Source: 1987 and 1992 SECHI panel data sets.

Fig. 1b. Age Specific Fertility Rates for Rural Women, 1986 and 1991.
Source: 1987 and 1992 SECHI panel data sets.

that the Ministry of Health continued to distribute contraceptives at a constant volume (but declining rate in per capita terms) during the entire period that the government had its anti-natal posture. Finally, other studies have questioned the ability of governments to affect fertility directly. Raftery et al. (1995) argued that policy is ineffective in Iran and Schultz (1994) finds little evidence to support a strong effect of family planning services on fertility in a sample of countries and over time. Nevertheless, the role of the family planning program in Iran should not be underestimated. In particular, its influence on fertility through lowering the cost of contraception and signaling other policy changes that would affect demand for children is hard to deny.[4]

Historically, increases in the age at first marriage have either preceded or accompanied fertility declines. In Europe and India, decline in age at first marriage preceded decline in fertility (Wrigley & Schofield, 1981; Das Gupta, 1995). In Iran, as can be seen in Table 3, age at first marriage appears to explain the upswing in fertility in the early 1980s (Aghajanian, 1991, p. 707). The proportion married in the 15–19 age group, which had been on a steep decline during 1966–76, increased from 34.1% in 1976 to 36.8% in 1986. No doubt the decline in the legal age for marriage for females from 18 to 9 years immediately after the revolution played a role in fertility increase. Since then the legal age for marriage has been raised back to 15 for girls and 18 for boys even though government policy still encourages early marriage (Hoodfar, 1994). Accordingly, by 1996 the proportion of young women married fell to 18.6%. A smaller drop is noted for women in the 20–24 age group. The mean age at marriage appears to have been increasing throughout the second half of this century, failing to increase only during the period 1976–86. Survey data also support the hypothesis of a continuously rising age at first marriage for women. Figure 2 shows the mean age at marriage for men and women estimated from the 1992 survey data. While the female age shows an increasing trend for the

Table 3. Age of First Marriage from Census Data.

Year	Mean age at first marriage	Proportions married 15–19	20–24
1956	18.6	41.0	84.3
1966	18.7	46.8	86.7
1976	19.7	34.1	78.6
1986	19.9	36.8	74.6
1991	20.9	25.6	67.2
1996	22.4	18.6	60.7

Source: Bulatao and Richardson (1994), and Statistical Center of Iran.

Fig. 2. Female and Male Age at Marriage by Year of Marriage.
Source: SECHI, 1992.

entire 50-year period, that of men follows a procyclical trend. The mean age at marriage for men declined during the long stretch of economic growth that began in the late 1960s and ended at the revolution in 1979. Significantly, it begins to rise again after the revolution, quite independently of the increase in fertility that followed the revolution and the family planning program that came a decade later.

IV. FACTORS AFFECTING DEMAND FOR CHILDREN

A. Direct Costs of Children

Changes in the net direct cost of children is yet another clue to understanding fertility changes in post-revolution Iran. During the 1980s, to cope with wartime inflation, the government introduced an extensive rationing system under which most basic consumer goods (food, fuel, and medicine) received heavy subsidies. Because each family received coupons equal to its family size, i.e. adults and children counted the same, the net cost of children declined. After the war's end in 1988, the rationing system was phased out. At about the same time the government switched its position on population growth, announcing its intention

to discourage fertility by reducing the amount of subsidies given to large families. A new law went into effect in 1993 (but had been widely discussed since 1991), which barred the government from giving subsidies of any form to the fourth child of a family. For example, the fourth child must pay the full cost of his or her education and national health insurance and the mother does not benefit from maternity leave. These changes in the direct costs of children mirror changes in fertility after the revolution.

B. Education and Labor Force Participation

In the neoclassical model of fertility a woman's education plays the central role in the determination of her fertility. Education is considered to be correlated with wages and hence the opportunity cost of having a child. The sociological literature also attaches great importance to female education as a determinant of fertility, often invoking the concept of modernization. As noted earlier, in Iran the link between education and the opportunity cost of children, as measured in market wages, has considerably weakened as a result of the adverse trend in participation of women in market work. Women's labor force participation and education appear to have followed different paths in the post-revolution period. Female literacy continues its ascent after the revolution, increasing from 7.3% in 1956 to 35.5% in 1976 and to 74% in 1996. Thus the gap between male and female literacy has narrowed, such that the ratio of literate females to males rose from 57% in 1976 to 70% in 1986 and 90% in 1996.

In terms of enrollment and schooling attainment, the gains in female education in the last two decades are also impressive. The secondary enrollment rates for women increased from 39% in 1989 to 65% in 1996, compared to 59% to 75% for men. Evidence on attainment presented in Salehi-Isfahani (2001) shows a narrowing of the gap in education between men and women at all levels of education. At the university level women have increased their share of enrollments from one-third in 1976 to 50% in 1998.

Female labor force participation rates have moved in a direction opposite to that predicted by changes in education and fertility. The rates for rural areas show an overall decrease, but they move up and down because of sensitivity to the definition of own account workers. The rates for urban areas, which are more reliable in this respect because they primarily include wage and salaried workers, show a continuous decrease, from 9.9% in 1966 to 9.0% in 1976, 8.4% in 1986, and 7.0% in 1991. The downward trend appears to have reversed in 1996 when the rate was back up to 9.1%. Overall, there is little evidence of a positive impact from either increased education or lower fertility on the labor force participation of women during the last three decades.

The relation between fertility and female education in the samples used in this study is presented in Fig. 3. The negative relation observed for rural and urban women in these graphs does not change much in the regression analysis after controlling for other independent variables, such as age, husband's education and income.

V. ANALYSIS OF HOUSEHOLD DATA

In this section I use reduced form regressions to explore the association between education, household resources, and cumulative fertility, and the number of children ever born (CEB). My intention is not to estimate the structure of household decision making that leads to the fertility outcomes observed in the data. Rather, I seek to understand the overall (reduced form) effect of education and

Mother's educational attainment

(0=illiterate; 1=less than 5 years; 2=primary; 3=less than 8 years; 4=middle school; 5=less than 12 years; 6=high school; 7=post secondary)

Fig. 3. Mean Children Ever Born and Mother's Education.

income, both assumed to be exogenous, on fertility. For example, the reduced form coefficient of female education measures its overall influence on the number of births. But education affects fertility in different ways, by increasing the opportunity cost of time, raising the age at marriage, and by facilitating migration to an urban location, among others. By looking at how the mean CEB changes with education we are considering all these effects at once. Clearly, a structural model that could break down the impact of education into these separate effects is superior to a reduced form model, but, unfortunately, with the available data I cannot identify a simultaneous system. Partial attempts to identify the system are unsatisfactory. The reduced form results are at least "pure" and easy to interpret, even though they do not say much about the underlying behavior and are not very helpful in guiding policy (Thomas, 1996, p. 13). For this reason, variables such as age at first marriage that "explain" a significant proportion of the variation in CEB are excluded from the regression.

The estimated equation is of the type:

$$CEB = a + bAge + cWed + dHed + e \log Y$$

The effect of education of the wife (Wed) and the husband (Hed) on fertility is expected to be non-linear (Schultz, 1997), therefore the education of the husband and the wife are captured by including a series of dummy variables for various levels of schooling. The effect of household income, Y, is also assumed to be non-linear. Both surveys report data on income and expenditures. Mean expenditures from both surveys exceed reported mean incomes by a considerable amount.[5] Despite this large discrepancy, the regression results are not much different when using either variable. However, because expenditures better reflect permanent income on which fertility decisions are based, I report those estimates.

Two estimation issues are worth noting. First, rural-urban residence appears to matter for fertility even after controlling for other variables. After testing for this in a pooled regression, I decided to estimate the equations separately for the two sectors, rather than including a rural-urban dummy. Second, the results reported are for OLS estimates, which may not be optimal, given that the CEB is a non-negative integer and as such regression estimation technique using Poisson and the Negative Binomial may be more appropriate. I estimated the CEB equation using all three methods and found that there was no difference in the qualitative results. In particular, the relative magnitudes of the male and female education and the sign of the income coefficient were the same using all estimation procedures. To save space and for ease of interpretation I report only the OLS results. Because of the linearity of the OLS equation, marginal effects of independent variables are constant and therefore easy to communicate.

A. The Data

The data for this study are derived from the Social and Economic Characteristics of Households in Iran (SECHI) panel surveys, collected by the Statistical Center of Iran during 1987–89 and 1992–95. Both surveys are nationally representative, cluster based samples. In each about 5000 households were followed between 1987–89 and 1992–95, respectively. Because of the cluster design of the surveys, observations in the same cluster cannot be assumed to be independent. To correct for the effect of intra-cluster correlation, I report the Huber-White robust standard errors provided for in STATA.

The data sets are unique in Iran in that they contain information on both economic and demographic variables. After discarding those households with either incomplete or inconsistent information, the samples were reduced to about 4000 and 4900 married women, respectively. For this study only the base survey for each panel was utilized.

Table 4 lists the main characteristics of the households for each survey. About 60% of the sample are urban and the rest are rural households. Mean CEB (not controlling for age) is about 5 in both years; for those with completed fertility (45 and older) it is 7.71 in 1987 and 7.17 in 1992. Mean CEB is nearly two births lower among urban women. The mean age at first marriage is remarkably the same for rural and urban women, showing, not surprisingly, only a slight increase from 1987 to 1992. It appears then that the large difference in the mean CEB between the rural and urban women is not caused by a difference in the age at first marriage. This observation is consistent with the point made in Section III regarding the lack of importance of age at marriage in determining fertility, and also indicates significant control in marital fertility among urban women. Over two-thirds of all women in the sample were married by age 15, 95% before age 25 and 99% before age 30.

Comparing the 1987 and 1992 samples we note a remarkable decline in the rate of female illiteracy in five years, from 47% to 32% for urban women, and 84% to 68% of rural women. This is consistent with the census data reported earlier in the paper. Mean educational attainment of women, measured by years of schooling, also increased in this period, from 3.7 years for urban and 0.6 years for rural women in 1987 to 4.6 and 1.3 years, respectively, in 1992.

B. Rural-Urban Differentials

Before discussing the estimation results, I review the evidence for differences in fertility changes in rural and urban areas. As noted in Table 2, the rural TFR in 1986 still averaged about 7.8, whereas in urban areas it was already down

Fertility, Education, and Household Resources in Iran, 1987–1992 325

Table 4. Descriptive Statistics.

	1987 Urban	1987 Rural	1987 Total	1992 Urban	1992 Rural	1992 Total
Mean CEB	4.34	6.17	5.06	4.4	5.98	4.98
Mean CEB, age > 44	6.86	8.68	7.71	6.08	7.98	7.17
Mean age	34.89	37.51	35.92	37.69	39.85	38.48
Mean age at marriage	17.68	17.21	17.5	17.82	17.46	17.69
Proportion married age >= 15	67.28	69.03	67.97	70.97	69.37	70.37
Mother's education (percent)						
Illiterate	47.09	84.04	61.86	31.62	68.27	44.93
Less than 5 years	10.08	8.23	9.36	11.81	7.50	10.24
Primary	13.93	4.12	10.08	14.61	6.16	11.54
Middle school	10.53	1.52	6.99	11.71	2.07	8.21
High school1	0.9	0.44	6.79	11.84	1.51	8.09
Post-secondary	2.13	0	1.29	3.41	0.11	2.21
Religious education	0.08	0	0.05	0.03	0	0.02
Not reported	2.83	1.27	2.21	9.29	11.42	10.06
Father's education (percent)						
Illiterate	30.86	61.75	43	19.3	49.39	30.29
Less than 5 years	11.19	11.15	11.17	12.5	13.92	13.02
Primary	20.66	11.53	17.07	24.94	16.34	21.80
Guidance	11.81	3.87	8.68	14	5.20	10.79
High School	13.11	2.09	8.78	14.77	3.45	10.63
Post-secondary	5.74	0.44	3.66	7.94	0.73	5.31
Religious education	0.49	0.57	0.52	0.77	0.48	0.66
Not reported	6.15	8.61	7.12	5.78	10.47	7.50
Mean household income (rials per year)	884,295	528,940	744,569	3,835,542	2,091,737	3,206,983
Mean household expenditure (rials per year)	1,869,420	1,405,332	1,689,636	4,364,226	2,583,273	3,716,078
Number of observations	2,440	1,579	4,019	3,134	1,788	4,922

to 4.7, a differential of 3.1 births. This differential had declined to 2.0 births by 1992. Age-specific fertility rates, computed from the two sets of survey data and depicted in Figs 1a–1b, show a larger decline in rural areas. Interestingly, the fertility gap has changed quite a bit over time. Estimates based on census data show that the differential was much lower in 1966, 1.2 births, but increased to 3.3 in 1986. Evidence from the 1991 national population survey showed a narrowing of the gap, down to 2.6 births (Mehryar, 1995b). The most recent KAP survey by the Ministry of Health puts the rural TFR at 4.2 and urban at 2.7, which indicates a further decline in the rural-urban gap (Malekafzali, 1995).

The influence of rural background seems to persist even after moving to town. This is evident in Table 5, which includes mean CEB by residence as well as by place of birth. The average number of births for urban women exceeds rural women by 2.23 births. However, the mean number of births for urban women of rural origin appears to be midway between the "true" urban and rural women. As shown in Table 5, the former group has about the same mean age as those born in cities, but is much less educated. This difference could thus be attributed to education but not to age. The rural-urban gap difference remains as we control for other household characteristics, but not the CEB gap by origin of birth. In the equation for urban CEB controlling for education of the couple and income shows that the CEB of women of rural origin exceeds that of urban women by 0.2 births only (results not reported here). This implies that the gap by origin of birth which is noticeable in the sample means is the result of differences in observed characteristics, whereas the rural urban gap is caused in part by unobserved heterogeneity.

Table 5. Mean CEB, Years of Schooling, and Age by Residence and Place of Birth, 1987.

Residence		Birthplace	
		Urban	Rural
Urban	Children ever born	3.99	5.05
	Years of schooling	4.96	1.46
	Age	34.68	35.30
Rural	Children ever born	5.08	6.22
	Years of schooling	2.63	0.57
	Age	33.07	37.71

C. Regression Results

Table 6 presents the results for the OLS regressions separately by rural and urban residence and by survey year. All equations appear to be reasonably good fits. Because the sample consists of married women of all ages, age has a significant and non-linear effect on cumulative fertility. To allow for the non-linear effect, I include age as a spline with nodes in the 20, 30, 40 and 50 years. The advantage of the spline is that it reveals differences in the average cumulative births of women for different age groups. Because these averages are affected by changes in cohort fertility, the coefficients of the age categories do not represent the propensity of the average woman to give birth as she goes through her childbearing years.

I begin the discussion of the results by noting that the overall estimates indicate a significant difference in behavior of rural and urban women. As the OLS results show, the age spline coefficients are highly significant, and indicate a different pattern of accumulation of births for the two groups of women. The conditional mean rate of accumulation of births below age 20 dropped for both rural and urban groups, but much faster for rural women. Between 1987–92 the mean marginal effect of age for the youngest age group declined from 0.24 to 0.09 in rural areas, twice as much as for urban areas, indicating a larger decrease in fertility of younger women in rural areas during the 1987–92 period. Education effects are, as expected, mostly negative and higher for the education of the wife than the husband. The effect of education on fertility increases with the level of education, which is not surprising but is in contrast with some studies in which education at higher levels is positively associated with fertility (Ben-Porath, 1973). The education variables are statistically significant in both equations, but the impact of rural mother's education on CEB is considerably less. Whereas in urban areas the completion of primary education is associated with 1.06 (1987 sample) and 1.52 (1992 sample) fewer births, for rural women the effect is smaller −0.76 and 0.82 fewer births, respectively. This difference between the rural and urban impact of education remains true for middle school, but disappears at the high school level. The effect of the husband's education on fertility is much smaller, as little as half. For the 1992 sample we observe that urban women with post-secondary education (mainly college) have three fewer births compared to illiterates; for husbands it is 1.22 fewer births.

Several observations from Table 6 throw light on the mechanisms through which female education affects fertility. As noted earlier, mother's education can lower fertility by raising the opportunity cost of her time and by reducing the price of child quality. The higher observed effect of female education in

Table 6. OLS Regressions: dependent variable CEB.

	Urban 1987 Coeff.	Urban 1987 Standard error	Urban 1992 Coeff.	Urban 1992 Standard error	Rural 1987 Coeff.	Rural 1987 Standard error	Rural 1992 Coeff.	Rural 1992 Standard error
10 < age < 20	0.23	0.031	0.18	0.040	0.24	0.052	0.09	0.058
20 < age < 30	0.21	0.016	0.19	0.013	0.30	0.023	0.25	0.025
30 < age < 40	0.15	0.018	0.10	0.014	0.28	0.028	0.25	0.031
40 < age < 50	0.08	0.026	0.09	0.019	0.05	0.028	0.06	0.031
Mother's education								
Less than 5 years	−0.55	0.160	−0.99	0.158	−0.50	0.165	−0.42	0.189
Primary	−1.06	0.131	−1.52	0.157	−0.76	0.172	−0.82	0.196
Middle School	−1.07	0.182	−2.00	0.164	−0.51	0.364	−1.30	0.308
High school	−2.10	0.163	−2.55	0.179	−2.00	0.374	−2.31	0.391
Post-secondary	−2.83	0.248	−3.02	0.206	–	–	–	–
Father's education								
Less than 5 years	−0.30	0.177	−0.40	0.205	−0.21	0.196	−0.14	0.213
Primary	−0.68	0.140	−0.51	0.163	−0.64	0.227	−0.32	0.184
Middle School	−0.87	0.164	−0.95	0.191	−0.64	0.194	−0.74	0.281
High school	−1.12	0.166	−1.00	0.192	−0.64	0.298	−0.41	0.288
Post-secondary	−1.14	0.225	−1.22	0.197	−0.62	0.505	−0.49	0.338
Log household expenditures	0.20	0.064	0.39	0.093	0.40	0.106	0.77	0.135
R-squared	0.53		0.56		0.55		0.51	
No. of observations	2232		2327		1422		1269	

urban compared to rural areas is consistent with the opportunity cost hypothesis because the link between education and work is stronger in urban areas. Urban women have more access to jobs that require education. Viewed from the perspective of the hypothesis that emphasizes the impact of mother's education on child quality, the larger coefficient of mother's education in the urban CEB equation seems to indicate that education lowers the price of child quality in urban areas more than in rural areas. This is hard to reconcile with the intuition that inferior supply of schooling in rural areas should make mother's education more important. The magnitudes of the coefficient of the education of husband do not appear to differ in urban and rural areas. The negative sign of these coefficients indicates that men, too, may be balancing their time in raising children, teaching them, and working outside. The increasing effect of education on fertility with the level of education is consistent both with the opportunity cost hypothesis and increased value of her time for child education. It is likely that mother's market wage as well as ability to teach her children would depend on the level of her own education. Finally, the comparison of education coefficients between 1987 and 1992 samples appears to tell the story of changes in the relation between education and opportunity cost of time in the interim years. With one exception, all coefficients for female education in 1992 are higher than 1987. A plausible human capital interpretation of this difference is that the economic revival after the end of the war with Iraq in 1988 and the improved legal and policy environment of the country that followed (Hoodfar, 1994) raised the returns to education for women, thereby increasing the correlation between education and the opportunity cost of childbearing. The increase in coefficients could also be attributed to higher returns to child education after the war, and a greater premium on quality relative to quantity, thus inducing mothers with more education to reduce their fertility by more than before. Among rural women the larger coefficient for female education may be in part due to the greater availability of birth control in rural areas in 1992, the effect of which is plausibly stronger on the more educated (Aghajanian, 1995).

Turning to the effect of income, economic theory does not provide a clear prediction for the sign of the coefficient of household resources (measured here by the log of household expenditures). The ambiguity arises mainly from the fact that income affects positively both the quantity and quality of children (assuming both are normal goods). However, a sufficient increase in quality may result in a net decrease in demand for the number of children. Furthermore, household resources are generally positively correlated with education variables, which are presumed to negatively affect fertility. To deal with the latter problem, unearned income is sometimes used as an instrument for household resources. The quality and coverage of unearned income data in the SECHI surveys are

not good enough to warrant their use in this way. When put in place of total expenditure, unearned income produced insignificant coefficients.

The income effect is always positive. This is consistent with the demand framework, which postulates that, keeping the price effect from parental education constant, household resources should be positively related to fertility. In studies in which the income effect is negative, as in Thomas (1996), it is usually attributed to the residual effect of education on income. Interestingly, the effect of household resources is about twice as high in the 1992 sample compared to 1987, and twice as high for rural compared to urban women. The latter may be due to the fact that for urban households education variables are more closely correlated with income and therefore cause the income coefficient to be smaller. There is no obvious way to explain the former, except that expenditures may have been measured more accurately in the later survey and may therefore be more reliable. Mean expenditure in 1992 is much closer to mean income compared to 1987 (Table 5).

D. *Estimates for Completed Fertility*

The estimates in Table 6 do not show the full effect of education on fertility because they are based on censored observations. Only one in eight women in the sample has actually completed her fertility. Although the regressions in Table 6 adjust for age to correct for the censoring, they fall short of showing the full impact of education on fertility. The impact of education on CEB conditional on age may differ from its effect on lifetime CEB because education may affect the timing of births. The usual remedy for censoring is to use Tobit estimation. However, because of the large number of censored relative to uncensored observations, the Tobit estimates were not robust. To gauge the impact of censoring, I restricted the sample to older women who had completed their fertility (age 45 and older). The results are presented in Table 7.

Although the coefficients are estimated less precisely because of the smaller sample size, the basic picture remains unchanged. For the rural sub-sample there were insufficient observations in each cell to precisely estimate the effect of education at all levels. Age is no longer significant, as expected, indicating no significant cohort differences in fertility among older women, except for rural women in 1992, who exhibit a positive cohort effect. Among urban women education continues to be the most important influence, with a generally greater impact than male education. In the 1992 rural sample there is evidence of the strong influence of mother's education, but this is not true for the 1987 sample. As before, the effect of income is positive, significant, and larger for the 1992 sample.

Table 7. OLS Regressions: dependent variable CEB (age 45 and older).

	Urban 1987 Coeff.	Urban 1987 Standard error	Urban 1992 Coeff.	Urban 1992 Standard error	Rural 1987 Coeff.	Rural 1987 Standard error	Rural 1992 Coeff.	Rural 1992 Standard error
Age	0.02	0.023	0.03	0.018	0.01	0.020	0.05	0.025
Mother's education								
Less than 5 years	−0.51	0.545	−1.14	0.350	0.30	0.663	−4.14	0.247
Primary	−2.43	0.446	−1.40	0.431	0.68	0.225	−3.15	0.626
Middle School	−2.92	0.629	−2.30	0.540	–	–	–	–
High school	−3.62	0.494	−2.93	0.691	–	–	–	–
Post–secondary	−4.17	0.862	−2.62	0.677	–	–	–	–
Father's education								
Less than 5 years	−0.46	0.467	−0.41	0.401	0.67	1.028	−0.10	0.706
Primary	0.00	0.441	−0.57	0.371	−1.57	1.360	−1.51	0.503
Middle School	−0.47	0.595	−2.41	0.401	−2.04	0.321	−2.35	0.732
High school	−1.53	0.449	−2.28	0.575	–	–	–	–
Post–secondary	−0.43	0.602	−2.30	0.685	–	–	–	–
Log household expenditures	0.43	0.163	0.61	0.231	0.61	0.149	0.87	0.245
R–squared	0.17		0.21		0.05		0.06	
No. of observations	450		535		395		435	

E. Fixed Effects and the Effect of Community-Level Variables on Fertility

In addition to individual characteristics, fertility outcomes are affected by many variables that are exogenous to the household and are unobserved in the data. Examples are availability of family planning services, labor market conditions, and community preferences (e.g. religious beliefs). Often community characteristics can be erroneously attributed to variables at the individual or household level. To correct for unobserved community characteristics I take advantage of the cluster sampling nature of the data and estimate fixed effect regressions. This method of estimation averages out the impact of community variables that are common to all households who reside in the same cluster. There are 97 urban and 62 rural clusters in 1987, and 108 urban and 62 rural clusters in 1992. Each cluster has on average about 25 households.

The fixed-effects results are reported in Table 8. Comparing these results to the OLS results in Table 6, we note that correcting for community level variables does not affect the coefficients for age variables, reduces the effect of education, and increases the income effects. Evidently, age is not correlated with unobserved community characteristics, while other variables may well be. The smaller education coefficients may be due to the fact that female education is correlated with such community variables as neighborhood preferences and health infrastructure which affect infant mortality or cost of contraception. For example, to the extent that female education is a substitute for supply of contraceptives, that is, more educated women are less affected by lack of family planning centers, the fixed effects coefficients of female education would be smaller because in some sense they take the supply of family planning services into account. Interestingly, coefficient changes are greater for urban than rural households, especially in the income variable. This is consistent with the expectation that rural households in the same cluster, usually an entire village, are less heterogeneous than households in the same urban cluster.

VI. CONCLUDING REMARKS

Female education is considered to be a central force in economic development because it affects fertility, child education, and the size of the labor force. In this paper I have shown that in Iran education and fertility are closely related, over time and across households, in rural and urban areas. The importance of the question posed in this paper for Iran goes beyond understanding fertility behavior. The prevailing habit of thought in Iran is to attribute social outcomes such as the decline in fertility and increase in female education to government policy with little role for individual or household behavior. Thus decline in

Fertility, Education, and Household Resources in Iran, 1987–1992

Table 8. Fixed effects regressions.

	Urban 1987 Coeff.	Urban 1987 Standard error	Urban 1992 Coeff.	Urban 1992 Standard error	Rural 1987 Coeff.	Rural 1987 Standard error	Rural 1992 Coeff.	Rural 1992 Standard error
10 < age < 20	0.24	0.030	0.18	0.056	0.25	0.064	0.19	0.080
20 < age < 30	0.23	0.016	0.19	0.014	0.33	0.021	0.30	0.025
30 < age < 40	0.16	0.019	0.12	0.015	0.27	0.029	0.24	0.030
40 < age < 50	0.09	0.027	0.12	0.017	0.07	0.029	0.08	0.027
Mother's education								
Less than 5 years	−0.46	0.176	−0.93	0.158	−0.54	0.196	−0.20	0.213
Primary	−0.80	0.131	−1.23	0.153	−0.63	0.226	−0.40	0.221
Middle School	−0.76	0.179	−1.49	0.151	0.41	0.277	−0.62	0.335
High school	−1.68	0.169	−1.96	0.167	−1.65	0.501	−1.22	0.571
Post-secondary	−2.21	0.249	−2.38	0.206	–	–	–	–
Father's education								
Less than 5 years	−0.17	0.168	−0.21	0.183	0.00	0.220	−0.14	0.193
Primary	−0.48	0.136	−0.36	0.141	−0.40	0.236	−0.11	0.180
Middle School	−0.61	0.167	−0.59	0.184	−0.36	0.275	−0.25	0.291
High school	−0.81	0.174	−0.54	0.171	−0.66	0.244	−0.25	0.296
Post-secondary	−0.80	0.225	−0.77	0.183	−0.33	0.580	−0.25	0.504
Log household expenditures	0.37	0.072	0.68	0.089	0.43	0.090	0.89	0.165
R-squared	0.58		0.64		0.61		0.60	
No. of observations	2232		2327		1422		1269	
No. of clusters	97		108		62		62	

fertility is attributed to the family planning program and increase in education to the literacy campaign.[6] The results of this paper suggest that the family planning program of the 1990s owes its success in reducing fertility in part to the increase in women's education, which not only reduced demand for children but also increased the effectiveness of the program.

Two patterns observed in the data speak to the importance of household characteristics, in particular education of women, in determining demand for children. First, the rising effect of education on fertility with the level of education suggests that opportunity cost may be a factor independent of government population policies. Second, the greater impact of female education on fertility in urban relative to rural areas is difficult to understand without reference to demand factors. The explanation for this finding based on the demand framework is that education is more closely associated with the opportunity cost of time, either at home or in the labor market, in urban relative to rural areas.

The family planning program in Iran demonstrates the deep dilemma Iranian society faces between tradition and modernity. Attempts by the Islamic state to promote the traditional role of women as mother and homemaker have been at odds with its attempt to promote a modern pattern of childbearing and lower fertility. What may have made the two goals compatible is increased education of women. In the post-revolution period, women have sought and achieved unprecedented levels of education, influencing their decisions in favor of smaller families. The question that this paper leaves unanswered is the mechanism through which education affects fertility. Mother's education can be a proxy for higher opportunity cost of her time, or it could signal the productivity of female education in the home production of child human capital. In view of the lack of improvement in women's access to market work, the negative effect of education on fertility is likely to result in part from the latter mechanism. The evidence from cross section data presented here does not distinguish between the two channels through which education may affect fertility, so further research is needed to distinguish between the two hypotheses. To the extent that the opportunity cost of time matters, the future of fertility decline depends on increased access by women to market work.

The results of the paper touch on the larger issue of the future role of women in the Iranian society. The generation of Iranian women who grew up after the revolution has more than twice the schooling of the previous generation and will have less than half as many children. As a result, these women will likely lead very different lives than their mothers. An important question is whether the labor market and the legal and political environment of Iran are likely to accommodate or frustrate their ambitions. In the long run, in a society of equally educated men and women a certain equality of legal and economic status would

seem inevitable. Much in the near term future of the country rests on how this question is answered.

ACKNOWLEDGMENTS

I am grateful for financial support from the Social Science Research Council and the Ford Foundation. I have benefited from comments by an anonymous referee, Ragui Assaad, Sohrab Behdad, Mine Cinar, and Jennifer Olmsted, as well as able research assistance of Mohammad Arzaghi, Huei-Ling Chen, and Ajay Tandon. I owe special thanks to the Statistical Center of Iran for making the data available to me and to the Institute for Research in Planning and Development in Tehran for research support.

NOTES

1. For the first time in 1999 women candidates for entrance to university outnumbered men by 15%!

2. Increased education of women may itself be caused by the restrictions imposed after the revolution on the participation of women in social and economic life. Increased female education and diminished market opportunities for women are consistent within the household economics framework if parents follow a compensating strategy rather than one that reinforces social inequality based on gender (Behrman, 1997).

3. The Ministry of Health seems to take the entire credit for the fertility decline. See, for example, the daily *Ettelaat International*, no. 237, April 27, 1995, p. 2.

4. Indeed, the policy to reduce subsidies to families with more than three children went into effect four years after the start of the family planning program.

5. To convert rials to U.S. dollars, use approximate exchange rates of 600 and 1000 rials per dollar for 1987 and 1992, respectively.

6. For an application of the Poisson method to Middle Eastern fertility data see Al-Qudsi (1998).

7. See, for example, Malekafzali (1995) and the daily *Ettelaat International*, no. 237, April 27 1995, p. 2.

REFERENCES

Abbasi-Shavazi, M. J. (1999). *The use and evaluation of the 'own children method' for estimation of fertility with census data from Iran*, mimeo. Demography Group, Tehran University, Tehran, Iran (in Persian).

Aghajanian, A. (1991). Population change in Iran: a stalled demographic transition? *Population and Development Review*, 17(4), 703–715.

Aghajanian, A. (1995). A new direction in population policy and family planning in the Islamic Republic of Iran. *Asia-Pacific Population Journal, 10*(1).

Al-Qudsi, S. (1998). The Demand for Children in Arab Countries: Evidence from Panel and Count Data Models. *Journal of Population Economics, 11*(3), 435–452.

Becker, G. S. (1960). *An economic analysis of fertility,"* in Demographic and Economic Change in Developed Countries. Princeton: Princeton University Press.

Becker, G. S. (1991). A Treatise on the Family. Cambridge: Harvard University Press.

Behrman, J. R. (1997). Intrahousehold distribution and the family. In: M. R. Rosenzweig & O. Stark (Eds), *Handbook of Population and Family Economics*, Vol. 1A (pp. 125–187). Amsterdam: Elsevier.

Ben-Porath, Y. (1973). Economic Analysis of Fertility in Israel: Point and Counterpoint. *Journal of Political Economy, 81*(2), Part II, March–April, S202–33.

Bulatao, R. A., & Richardson, G. (1994). Fertility and family planning in Iran, Middle East and North Africa, Discussion Paper no. 13. The World Bank, November 1994.

Das Gupta, M. (1995). Fertility Decline in Punjab, India: Parallels with Historical Europe. *Population Studies, 49*(3), November, 481–500.

Ettelaat International, no. 237, April 27, 1995. Tehran, Iran.

Hill, K. (1993). Towards a unified system of demographic estimates for the Islamic Republic of Iran. UNICEF, Tehran.

Hoodfar, H. (1994). Devices and desires: population policy and gender roles in the Islamic Republic. *Middle East Report, No. 190, 24*(5), September–October.

Hotz, V. J., Klerman, A., & Willis, R. J. (1997). The Economics of Fertility in Developed Countries. In: M. R. Rosenzweig & O. Stark (Eds), *Handbook of Population and Family Economics*, Vol. 1A (pp. 275–347). Amsterdam: Elsevier.

Karshenas, M. (2001). Economic liberalization, competitiveness and women's employment in the Middle East and North Africa. In: D. Salehi-Isfahani (Ed.), *Labor and Human Capital in the Middle East: Studies of Labor Markets and Household Behavior*. Reading, UK: Ithaca Press.

Lam, D., & Duryea, S. (1999). Effects of schooling on fertility, labor supply, and investment in children, with evidence from Brazil. *Journal of Human Resources, 34*(1), 160–191.

Malekafzali, H. (1995). An evaluation of the Family Planning Program in 1374 (1993/94). Paper presented at the Tehran Population Seminar June 1995.

Mehryar, A. H. (1995a). Repression and Revival of Family Planning in Post-Revolutionary Iran, 1979–1994. Institute for Research in Planning and Development, Tehran, Research Group in Population and Social Policy, working paper no. 2.

Mehryar, A. H. (1995b). The rise and fall of fertility rates of Iranian population after the Islamic Revolution of 1979. Institute for Research in Planning and Development, Tehran, Research Group in Population and Social Policy, working paper no. 3.

Raftery, A. E., Lewis, S. M., & Aghajanian, A. (1995). Demand or Ideation? Evidence from the Iranian Marital Fertility Decline. *Demography, 32*(2), May, 159–182.

Salehi-Isfahani, D. (2001). The Gender Gap in Education in Iran: Evidence for the Role of Household Characteristics. In: D. Salehi-Isfahani (Ed.), *Labor and Human Capital in the Middle East: Studies of Household and Market Behavior*. Reading, UK: Ithaca Press.

Schultz, T. P. (1994). Human capital, family planning, and their effects on population growth. *AER Papers and Proceedings*, May, 255–260.

Schultz, T. P. (1997). Demand for Children in Low Income Countries. In: M. R. Rosenzweig & O. Stark (Eds), *Handbook of Population and Family Economics*, Vol. 1A (pp. 249–430). Amsterdam: Elsevier.

Thomas, D. (1996). Fertility, education and resources in South Africa. RAND working paper DRU-1508-RC.
World Bank, World Development Indicators, 1999. Washington DC.
Wrigley, E. A., & Schofield, R. (1981). *The Population History of England, 1541–1871*. Harvard University Press, 1981.

IRAN'S NEW ISLAMIC HOME ECONOMICS: AN EXPLORATORY ATTEMPT TO CONCEPTUALIZE WOMEN'S WORK IN THE ISLAMIC REPUBLIC

Fatemeh Etemad Moghadam

ABSTRACT

This is an exploratory attempt at conceptualizing the legal and ideological treatment of women's work in the Islamic Republic of Iran. With an awareness of basic methodological differences, I have borrowed and modified concepts and categories developed in economic theory. The neoclassical economic model recognizes two categories of productive female labour, and thus two types of allocation of female labour time: allocation of time for household production, and allocation of time for labor market. I will argue that the Islamic legal perception of female labor, as applied to the case of contemporary Iran, bears similarity to this theoretical model. Post-revolutionary legal system in Iran however, recognizes three categories of productive female labor: marital duties, household labor; and participation in the labor market. The government has also introduced provisions for compensation of household labor, and considers the first two categories the primary duties of a Muslim woman which leads to the justification for

discriminatory policies concerning women's labor market participation and education.

INTRODUCTION

Studies of women's work in the Islamic Republic of Iran generally focus on current patterns in labor market participation and education, and contrast these with patterns during the pre-Revolutionary period (Baqerian, 1990; Moghadam, 1988). Another set of studies has examined changes in the family law and the legal status of women in marriage (Mir Hosseini, 1993). No attempt has been made, however, to conceptualize the Islamic treatment of women's work in Iran. This paper makes an exploratory attempt at placing female labor in such a conceptual framework.

I will borrow, and modify, concepts and categories developed in economic theory, in particular the neoclassical model of "the new home economics" (Becker, 1991). I have used this approach with an understanding and awareness that the neoclassical and the Islamic treatment of women's work are not based on comparable methodologies and are not parallel concepts. Nevertheless in the absence of any theoretical context for the Islamic case, comparisons, modifications, and use of the existing categories in economics allow for the development of a framework. Furthermore, the ideological component of the neoclassical model has already been subject to critical assessments by others, in particular feminist economists. These critical assessments may be borrowed, modified and applied to the case of the Islamic Republic's approach.

I will demonstrate that in spite of basic methodological differences, similarities can be found between the evolution of socio-economic and ideological treatment of female labor in Iran, with that of economic theory; and that the post-revolutionary legal and ideological treatment of female labor is evolving in a direction that bears resemblance to the neo-classical concept of allocation of women's labor time between household and labor market. Thus, I have borrowed, modified, and applied these categories to the Islamic case. This is done with a clear understanding and awareness that the post-revolutionary concept of division of female labor is derived from the Islamic legal system. It is based on new interpretations of the rights and duties of a Muslim woman in marriage, and in society at large. Therefore, the similarities that will be discussed are not based on methodology, but in terms of outcome and perception.

It is worth noting that the conceptual perception of productivity of female labor at home and in the labor market has undergone an evolutionary change in economic theory. These changes were products of industrialization and

economic development, and the accompanying transformations in ideological perceptions and social norms pertaining to the value of women's work and their position in society. Thus household work has evolved from being perceived as unproductive, to productive but unpaid labor, and the desirability of women's labor market participation from advocacy of radicals to that of mainstream economists. Finally, feminist economists have been criticizing the mainstream, and the early Marxist models (England, 1993; Beneria, 1992). In this paper, I will present a brief review of this literature. I will then examine the case of Iran. As mentioned earlier, this paper argues that the similarities in the categories of female labor with the neo-classical theory are not methodological, but based on outcome and perceptions. Therefore, I will examine the historical, ideological and policy changes, patterns, and trends in order to identify conceptual categories. Admittedly, this approach is exploratory. Because of the interdependency of the variables, and absence of rigorous data, it is not always possible to make a clear distinction between theory, ideology, policy, and historical context. These variables, however, are interconnected, and inability to make clear distinctions does not invalidate the generalizations. Furthermore, we are dealing with dynamic and changing conditions. Basic methodological distinctions such as choice versus duty may be subject to modifications resulting from social, structural, economic, and political changes.

Another point to note is use of the term ideology. The post-revolutionary government in Iran has an explicit Islamic ideology concerning women. Thus government policy, treatment of women's work, and changes in the legal status of women are interpreted in this ideological context. Prior to the 1979 revolution, women's personal and legal status were largely defined within the context of the Islamic law, and the reforms were also interpreted in this context, but the state was not committed to an explicit policy of Islamization. The socio-economic position of women and perceptions concerning their role in society have changed over time. Thus the term ideology in this paper is used broadly to include social perceptions and government policies.

WOMEN'S WORK AND ECONOMIC THEORY

In 1776 Adam Smith described economics as a discipline that studied the creation and distribution of the "necessaries and conveniences of life." Clearly creation of goods and services for household consumption fits the category of "necessaries and conveniences". Nevertheless, Adam Smith drew a strict boundary between the market economy, in which individuals in pursuit of self-interest are involved in productive activities, and family life, in which individuals should observe "the moral sentiments." Thus household labor was

not considered productive activity (Nelson, 1993). This approach was followed by the subsequent mainstream economists who were preoccupied with the formal market dominated by male labor.

Some radical critics of mainstream economists, however, recognized the subjugation of women as a social rather than a biological phenomenon. These critics also realized that lack of participation in wage earning activities made women dependent on husbands, and thus placed them in a subordinate position to men. Nevertheless, these critiques failed to recognize the productivity of household labor, and similar to their mainstream counterparts, treated it as non-productive. For example Marx stated that family labor could not be analyzed in the scientific terminology of "value." He considered childbearing and child rearing unproductive of surplus value and irrelevant to its realization (Folbre, 1993). According to Veblen household labor is wasted effort used in serving the master of the house (Veblen, 1899). Nevertheless the historic origin of recognition of productivity of female labor in the labor market, and the idea that labor market participation is a positive contributor to emancipation of women should be traced back to these and other critics of mainstream economics.

In what has come to be known as "the new home economics," and is used as a basic neo-classical gender model, Gary Becker (1985, 1991) distinguishes between two types of productive female labor: the allocation of time to household activities and the allocation of time to labor market. Thus Becker explicitly recognizes the productivity of female labor at home. He argues that because of child bearing and child rearing women have a comparative advantage over men in performing household labor. Thus specialization and division of labor in the family has contributed to a tradition in which men have historically participated in labor market and women have produced for family consumption. Household labor, however, is not channeled through the market system, and is unpaid.

In this model the male head of household is assumed to be altruistic, thus all members share the family resources. Becker's feminist critics, however, argue that the assumption of altruism conceals the possibility of selfishness; and that his choice-based behavioral model overlooks issues such as dependence, interdependence, tradition, and power (Blank, 1993).

Current debates among feminist economists focus on the two aspects of female labor and argue that in both women have been unfairly treated. One body of feminist thought emphasizes the devaluation of and low material rewards accorded to activities and traits that traditionally have been deemed appropriate for women. Sexism here is in failing to see how much child rearing, and household work contribute to "the wealth of nations." A second body of thought emphasizes the exclusion of women from traditionally male activities

and institutions. This includes laws, cultural beliefs, and other discriminatory practices that exclude women from politics, religious leadership, military positions, and traditionally male crafts and professions within paid employment. These exclusions have important implications on women since activities traditionally regarded as male are those associated with the largest rewards of honor, power, and money (England, 1993; Beneria, 1992).

BACKGROUND

Current family law in Iran evolved from medieval Islamic law or *shari'a*. Legally a woman's entitlement in marriage includes her dower, *mahryyeh*, and upkeep, *nafaqeh*. From a legal point of view, a Muslim marriage contract, *aqd*, is essentially a sale contract, and the object of sale is female sexuality and reproductive labor. Thus *mahryyeh* is a compensation for the sale and *nafaqeh* for the upkeep of female sexuality in marriage (Moghadam, 1994). The marriage contract makes no explicit reference to household labor, and it is possible to argue that women are not contractually bound to perform household labor. There are also Quranic provisions, sayings of the prophet, and examples of the lives of revered Muslim women, that can be interpreted to mean that women are not required to perform household labor, and that they are free to perform labor outside the home. For example, there are Quranic provisions indicating that a woman is not required to breastfeed her child, and if she does so, can expect wages from the man (*Qur'an-e* Majid, Verses 2:233). This can be interpreted to mean that women can expect payments for child raising. There is also the advice that men who can afford to should hire domestic help for their wives. This may be interpreted to mean that women are not required to perform housework in marriage.[1] With the possible exception of the legal profession,[2] there are no explicit Quranic rules prohibiting women from participation in the labor market. Indeed the Quran is clear about the entitlement of working women to fair wages.[3] Furthermore, the lives of Mohammed's first and highly revered wife Khadijeh, who was a merchant, and that of Mohammed's granddaughter Zeinab, who showed extraordinary courage and publicly challenged Caliph Yazid, can be used as examples indicating that Islam allows for involvement of women in public life and in the market.

During the medieval period interpreters of Islamic law did not negate the above mentioned provisions concerning women's public and labor market participation, and jurors expressed respect for women such as Khadijeh. Upper class women continued to own property and participated in the market, usually as rentiers or silent partners. The law, however, did not focus on labor-related aspects. The law requiring veiling, and the socio-economic and political conditions of medieval

Iran created a situation in which the majority of women in urban areas were secluded in their private quarters, did not participate in public life, and had no explicit compensation for their household labor.

Many of these legal, socio-economic, and ideological characteristics have persisted in modern Iran. An important development of the modern era, however, is a growing tendency to perceive women as agents whose potential or actual labor can positively contribute to society. For example, at the turn of the century, advocates of women's education stated that educated women can be better mothers (Afary, 1996). The implicit assumption in this argument is that female labor productivity in child bearing and raising is positive and can be increased through education. Similarly, advocates of the removal of veil argued that seclusion kept women away from public life and was a factor contributing to the backwardness of Iran. Thus women were perceived as having the potential ability to contribute positively to public life.

This perception of women as productive labor is most pronounced in the 1960s and 1970s when government aimed at bringing about rapid growth and industrialization. Thus official government documents explicitly referred to women as "a relatively untapped supply of labor" that should be utilized in the labor market for economic development. Furthermore, the underlying strategy for emancipation of women appeared to be the removal/modification of the traditional barriers to women's participation in education and in the labor market (Moghadam, 1994). The government also undertook policies to reform family law. These policies aimed at modifying the gender gap in the personal rights of the spouses in such matters as polygamy, divorce, and child custody. According to these reforms, a man seeking to marry a second wife could not do so without the approval of the first; a man could no longer unilaterally divorce his wife, the issue of divorce had to be settled in civil courts, and divorce could be initiated by a woman as well as a man; a woman could seek the custody of her children after divorce or the death of the husband, and the issue was to be resolved in civil courts (Mirani, 1983; Moghadam, 1994). The reforms, however, did not address the allocation of female time to household labor. The implicit assumption was analogous to that of a Marxian position: only participation in the labor market constitutes productive labor, and labor market participation is a pre-requisite for emancipation of women.

POST REVOLUTIONARY IDEOLOGY AND ALLOCATION OF TIME TO HOUSEHOLD ACTIVITIES

The Post-revolutionary ideology, and thus the legal system, sanctions traditional Islamic law and the legal commoditization of female sexuality. Thus the Family

Protection Law of the 1970s, which had modified the law in favor of women, was suspended. In contrast to medieval law, however, post-revolutionary reforms in family law focus on productivity of female labor at home. The advocates of these reforms argue that the traditional marriage contract compensates female sexual services and reproductive labor only, and does not account for other types of labor at home. They state that Islam emphasizes the complementarity of the sexes, and in contrast to Western liberalism it aims at maximizing family, rather than individual welfare. Therefore, household activities take precedent over participation in the labor market and constitute the primary responsibility of a Muslim woman. In this context, marriage is viewed as quasi-employment, and women's economic rights at the termination of marriage become a central issue. Current reforms stem from a legal distinction between two categories of female labor at home.

The first category is referred to as marital duties, *vazaif-e zanashwiy*, activities directly derived from female sexuality, and an inalienable part of a marriage contract. A married woman is contractually bound to submit to her spouse, *tamkeen*, and to bear his children. In return, the husband is legally obliged to provide full financial support, *nafaqeh* for the wife. *Nafaqeh* is not a minimum support, but the maintenance of a living standard compatible with the woman's status and the man's income. It is payable irrespective of the wife's personal wealth or income. Another financial obligation is the dower, *mahryyeh*, legally due when the marriage is consummated but in practice demanded by women at divorce.

A law passed in 1996 requires cost of living adjustments for the payment of dawer at divorce. The proponents of this law argued that the stipulation of a monetary value in a marriage contract should be interpreted as the specification of the real purchasing power at the time of marriage. Therefore, necessary adjustments for inflation should be made at divorce (*Zan-e Rooz*, December, 1993).

The second category of household labor is child-raising and production for family consumption. Historically women have performed these tasks, but a marriage contract does not legally require women to do so. This legal aspect is used for most financial reforms in the divorce law. In 1984, the Islamic regime introduced a new standardized marriage contract. Among other specified optional conditions, this contract includes a provision for an equal division, at divorce, of the wealth accumulated by the man during the life of the marriage. Legally a woman's personal wealth and income are not shared in a Muslim marriage. This provision applies only if the man is unilaterally divorcing his wife, and the acceptance of the provision by the husband is voluntary. Thus there is no change in the law.[4] The fact that the provision is printed in the

contract, and that the idea is widely advertised, however, appear to have placed pressures on the grooms. Data pertaining to the number of husbands who sign the condition is not available. It seems, however, that many agree to sign.[5] For justification, the *ulama* argue that women perform household labor that is not covered by *nafaqeh* and *mahryyeh*, and should be compensated otherwise. The 1991 reform of divorce law includes another clause based on the same idea. If a marriage contract does not include the provision of wealth sharing, a man who unilaterally divorces his wife has to pay the wage equivalent, *ojrat olmesl*, of the household labor performed during the marriage.[6] This idea is used in yet another way: if a divorced woman does not have a paying job, and if her husband has unemployment insurance, by law she becomes eligible for one-third of her husband's insurance, for the duration of the marriage (*Zan-e Rooz*, no. 1215, 1368).

In summary the post-revolutionary law reinforces the legal commoditization and sale of female sexuality to the spouse. Thus men's unilateral right to divorce, and child custody are reinforced. At the same time, however, new provisions are introduced to guard the sale value of female sexuality. The law also recognizes productivity of female labor at home, and introduces methods of compensation for it.

SOCIO-ECONOMIC AND POLITICAL CONTRIBUTORS TO THE NEW LEGAL INTERPRETATIONS

The above mentioned interpretations and reforms were in part attempts by the government to ameliorate the deterioration of women's rights in marriage after the revolution. The introduction of the new marriage contracts in 1984 was a response to the bitter complaints of women, many of whom had actively participated in the revolution, about the suspension of the Family Protection Law. The ruling clergy argued that the Family Protection Law was un-Islamic, because it applied indiscriminately to all couples. They argued that a woman may include favorable conditions in her marriage contract as long as the man voluntarily accepts them, and if the conditions are not contrary to the essence of an Islamic marriage. Thus the post-revolutionary contracts include a long list of conditions, each of which should be negotiated and signed separately by the man. Furthermore, the 1991, and the 1996 reforms in divorce law were a response to the rising divorce, and the rising number of women and children with no financial support. After the revolution, men could unilaterally divorce their wives in notary publics, instead of civil courts, where they were not required to justify the divorce. Furthermore, rampant inflation had made the

pre-Revolutionary dawers, usually expressed in nominal monetary terms, nearly worthless. Thus divorce became easy and low cost for men. According to the discussions held in the parliament, *majles*, about the passage of the 1991 law, during the first ten years of the Islamic regime, only 15% of divorces were decided by the civil courts, 85% were issued by the notary publics; and in comparison to the pre-Revolutionary period, divorce increased by 200% in the city of Tehran. There were many men who did not pay for the upkeep of their wives; a woman could be divorced in absentia; and there were cases in which the notary publics had taken the law in their own hands and did not honor conditions included by women in their marriage contracts (*Zan-e Rooz*, December, 1990, April, 1993, and November, 1993).[7] It was argued that an Islamic country could not remain indifferent to the suffering of women and children, and that the provision of a minimum welfare for the growing number of poor women and children was too costly for the government.[8]

Published data pertaining to the actual impact of the recent reforms is not available. Various reports in the widely circulated women's magazine, Zan-e Rooz, as well as statements by women lawyers indicate that there are many legal loopholes that create obstacles for the realization of these changes. For example the condition of division of wealth at divorce is applicable only if a man is unilaterally divorcing his wife. Such a man is likely to plan for the divorce and its timing. In the absence of a developed system of income and wealth taxation, it is possible for the man to change the composition of his wealth and to conceal it at divorce. Legally the dower is something that the husband owes to his wife. It is a form of debt. However, if he proves inability to pay, bankruptcy, he can get away with it. There are also problems concerning measurement of *ojrat olmesl*, as its value is determined arbitrarily on a case by case basis by the relevant judge.[9] Furthermore, the woman has to prove that she did not agree to perform these labor services free of charge; and a woman cannot ask for *ojrat olmesl*, if she initiates the divorce (*Zanan*, 1993). In summary, there seems to be a significant gap between the entitlement and the actual resource shares of women at divorce. In the absence of data, however, it is not possible to measure the extent of the effectiveness of the legal recognition of productivity of household labor and the need for its compensation.

Nevertheless, the legal entitlement of women to material resources for household labor is a significant symbolic development. The issue has generated new discussions and controversies that have the potential to generate future reforms. It is also worth noting that there is an ongoing debate concerning additional entitlements to household labor.

In an interview with *Zan-e Rooz* Sayyed Mohammad Khameneii, professor of theology and brother of Iran's spiritual leader Ayatollah Khameneii, argued

that the concept of *nafaqeh* has broad implications and means provision of an adequate living standard for women. This could include insurance for divorce, as well as old-age pension for women. Thus a man may open up a pension fund for his wife at the beginning of a marriage, and the woman should be entitled to the proceeds at divorce or old-age (*Zan-e Rooz*, January, 1993) Advocates of women's rights argue that *ojrat olmesl* is based on the category of household labor which is not contracted in marriage and should be payable upon demand and irrespective of divorce (*Zan-e Rooz*, December, 1993). It is further argued that in cases in which a working woman quits her job to allocate time to housework, the wage-equivalent should be calculated on the basis of the forgone wages. These and similar issues are being debated in seminars, newspapers, and the parliament. The issue of a woman's economic and other rights in an Islamic marriage has become highly politicized, and new reforms are likely to result from the discussions.

ALLOCATION OF TIME TO LABOR MARKET

Taken at its face value, the Constitution of the Islamic Republic does not appear gender biased. It states that no one may be forced into a specific type of job and no one is allowed to exploit others. Irrespective of sex, race, and language, people are entitled to equal access to jobs.[10] This implies that women are free to choose employment in the market, and should not be discriminated against.

The post-revolutionary changes in the family law, however, reinforce the legal commoditization and sale of female sexuality in marriage, and the new provisions are aimed at guarding the sale value of sexuality. As female sexuality and the woman are not separable, the reinforcement of ownership of sexuality implies that a married woman is partially owned by the husband. Thus the husband is entitled to a degree of control, such as the right to prevent the woman from working outside the home. The law also recognizes productivity of female labor at home, and introduces preliminary methods of compensation for it. This compensation can also be used as a justification for the law requiring the husband's permission for a woman to work outside the home. It is argued that a married woman is entitled to nafaqeh and *ojrat olmesl*. Therefore, her employment outside the home should be approved by the husband (*Zan-e Rooz*, November, 1993 and April, 1993)

Thus the underlying assumption in the Islamic approach is that married women cannot freely choose between allocation of time to household and market activities. The approach is duty, not choice-based. It can be argued, however, as feminist economists have, that the assumption of free choice in the neo-classical model is evasive; and that factors such as power, tradition, culture,

dependence, and interdependence limit this freedom. It can also be argued that ultimately economic development, education, and growing productivity of female labor will undermine the secondary aspect of labor market participation. Thus the distinction between the neoclassical choice-based, and the Islamic duty-based approaches are not clear cut. Nevertheless, the explicit assumption of duty to household labor reinforces the traditional division of labor and the patriarchal structure of the family.

Islamic ideology emphasizes the complementary aspects of the biological differences between men and women, and considers family, not individual, as the basic social unit. It is argued that the objective of an Islamic state is to bring about maximum social harmony (Nasr, 1987; Amoly, 1990). Motherhood and wifehood are seen as the primary occupations for women. This can be interpreted to mean that in the job market priority should be given to men as heads and income providers of households. The emphasis on biological and nurturing aspects of women can also be used to reinforce occupational segregation and discrimination in education. It can be argued that women are by nature suitable for certain professions such as teaching, and health and social services, and that they are unsuited for such professions as engineering, sciences, as well as top bureaucratic and religious positions. This interpretation implies that women may be barred from entry to the "unsuitable professions". It can further imply that women should be barred from entry into areas of higher education that train them for the "unsuitable professions." Finally, emphasis on biology, and adherence to religious morality and mediaeval family law can have other implications concerning the control of women's bodies that may have limiting impacts on women's labor market participation.

Again, it can be argued, as neoclassical and other economists have, that because of the expectation of allocation of time to household activities, women may invest less than men in human capital, and may thus be unable to participate in certain professions. Furthermore, women may be discriminated against in the job market and their entry into the perceived "masculine" professions may be difficult. Thus gender-based occupational segregation is a common characteristic of many job markets. Furthermore, changing socio-economic conditions bring about changes in attainment of human capital, and in gender-based discrimination and occupational segregation. Thus the Islamic approach should not be treated as fundamentally different, and may be subject to changes and modifications over time. Nevertheless, reliance on comparative advantage implies that discrimination is a negative factor. Whereas, a straightforward biological argument treats discrimination as positive and desirable. Therefore, the Islamic model can be subject to harsher feminist criticisms than the neoclassical one.

SOCIO-ECONOMIC AND POLITICAL FACTORS AFFECTING LABOR MARKET PARTICIPANTS

The above mentioned legal and theoretical framework is the outcome of socio-political, economic, and historical conditions. These conditions, however, are dynamic and changing. The emphasis on the desirability of allocation of time to production for household consumption, thus the perception of the extent of a woman's freedom to allocate time for market have been subject to change. As will be discussed, two distinct ideological phases can be distinguished. During the first phase that ended with the death of Ayatollah Khomeini in 1989, the state generally aimed at either forcing women out of the job market, or at clustering them within "proper" female occupations such as teaching and health related services. The second phase, however, is one of relative openness, and one in which many of the ideological and legal obstacles against women's participation are being modified.

During the first phase, the state justified discrimination against women in terms of Iran being an Islamic society. In recent years, however, the state is explicitly recognizing that women are being discriminated against in the job market, and that discrimination is undesirable. For example, President Khatami has repeatedly stated that Iran has to take the best advantage of its female labor force for development. He has stated that discrimination against women is unfair and inefficient, it hinders the country from further development. The explicit recognition of inefficiency of discrimination is a new development and a departure from the earlier approach.

This changing ideological position is reflected in government employment policy. At the outset of the revolution, one of the main stated objectives was to end what was perceived by the clergy as un-Islamic and "morally decadent" public appearance and position of women under the Pahlavi regime, and a desire to return to "true Islamic values" that would "elevate" the social and moral position of women. Many women working under the Pahlavi regime were viewed as morally decadent. The government undertook a campaign to expel these women from work, and to purify, *paksazy*, government offices and factories. In addition to intimidation, early retirement incentives were also used to persuade women to leave the job market. According to a law passed in 1979, workers could ask for early retirement after 15 – instead of 25 – years of service. Although the law included male as well as female workers, a larger number of women than men were persuaded to retire (Baqerian, 1990).

Government policy and ideology were also important factors in the textiles and apparel industries that have traditionally been an important source of employment for women. In these industries, there was a significant increase in

the number of cooperatives. In these cooperatives male workers joined as own-account workers, thus the reorganization of factories resulted in job loss for women. During the early post-revolutionary period, many large textile factories came under public control. In addition to the early retirement incentives, another law entitled the husbands of women who resigned from factory jobs to a lifetime salary increase of Rls. 10,000 – roughly $100 at the time of the passage of the law. The law persuaded many poor working women to resign (Baqerian, 1990)

In contrast to the earlier period, however, in recent years, the work environment has become more friendly to women.[11] While in the earlier period daycare centers in some government institutions were closed down,[12] many work places have set up daycare systems for their employees in recent years. A law passed in 1990 allows women to retire after 20, instead of a minimum of 25 years in government service. While this law shows a pattern similar to the earlier policies of keeping women at home, it was a response to the demands of women workers in the public sector, and was a recognition of the double burden of women. Furthermore, the law explicitly states that no woman should be coerced to retirement, and that the law is applicable only if a woman voluntarily asks for early retirement (*Zan-e Rooz*, January, 1990). From the discussions advanced by working women in *Zan-e Rooz*, it is evident that women fought to have this law passed by the majles (*Zan-e Rooz*, September, 1990).

In spite of significant modifications in ideology and the treatment of working women, the system continues to consider household labor the primary occupation of a Muslim woman, and, only certain jobs, such as teaching and medical profession, as suitable for women. Women in growing numbers though are challenging the requirement of a husband's permission for a woman to work outside the home. In an interview with *Zan-e Rooz* (November, 1993), Ostad Amid-e Zanjani, an elected representative of the majles, argued that women have the right to work, but they also have the right not to work. Since they receive *nafaqeh*, their work outside the home should be with the husbands' permission. This point was reiterated by Ayatollah Yazdi (*Zan-e Rooz*, April 1993). The issue, however, is dynamic, surrounded by controversy, and not all religious leaders agree. For example, according to Ayatollah Bojnurdi, a man cannot prevent his wife from pursuing work outside the home and the law requiring the husband's permission is an incorrect interpretation of the Islamic jurice prudence (*Zan-e Rooz*, December, 1993). It should further be noted that these and other legal and ideological issues are being challenged and debate by women groups, and by women parliamentary representatives.

In addition to the government's direct policy and ideology concerning women's work, participation has been affected by legal and ideological treatment of such factors as education, fertility, and age of marriage. These are

important, as studies in other parts of the world indicate that decline in fertility and increase in the age of marriage contribute to increased labor participation. Furthermore, increase in higher education is an important factor contributing to employment and higher wages.

After the Islamic revolution, there were important changes in family law. Under the previous regime, the legal age for girls to become eligible for marriage was initially 16, and was raised to 18 – although 16 years old women could marry provided that a special permit was obtained. Following the early Islamic practices, the present regime reduced the legal age to 9 years, provided that the girl had reached puberty, and a special court and the girl's guardian approved the marriage (*Zan-e Rooz*, September and October, 1989).

As indicated in Table 1, the total recorded number of married girls in the age category of ten to fourteen rose from 0 in 1976 to over 2% in 1986, 1991 and 1996. If we compare the age category of 15 to 19 years, the percentage shares are almost identical for 1976 and 1986, however, the shares are declining for 1991 and 1996. The data suggest a declining trend in the percentage share of married women in the age category of twenty to twenty four. Thus the data indicate a decrease in the age of first marriage for 1986. This decline in the age of first marriage for 1986 is a factor that contributed to a decline in female labor participation. Although the practice of child marriage is still significant, the data shows a general tendency toward an increase in the age of first marriage for 1991 and 1996.[13]

Fertility is another factor affecting female employment. According to data from the Markaz-e Amar-e Iran (1989, 1992), population growth figures are

Table 1. Female Population by Age Categories and by Marital Status.

Age	1976* Total 1000 persons	1976* Married at least once** (%)	1986 Total 1000 persons	1986 Married at least once (%)	1991 Total 1000 persons	1991 Married at least once (%)	1996 Total 1000 persons	1996 Married at least once (%)
10–14	3034	0.00	2704	2.43	3619	2.21	1739	2.19
15–19	1782	34.25	2456	34.29	2831	25.46	1401	20.00
20–24	1451	79.31	2056	74.50	2414	68.37	1044	59.61

* Includes married, widowed, and divorced.
** There is a total recorded number of 112 or 0.00369% of the total in the age category.
Source: Markaz-e Amar-e Iran, 1977, Table 7, p. 19; 1987: Table 31, p. 247; 1993: 48–4; & 1997: Table 33, p. 308.

about 2.7% average annual for 1966–1976. For 1976–1986, the average annual growth is estimated to be 3.9%. This rate declined to less than 2% for 1986–1996 (1.5% for 1991–1996). Some scholars have challenged the accuracy of the 1976–1986 population growth, and have estimated it to range between 3.3 to 3.6% (Hakimian, 1998). Nevertheless, there is consensus that Iran experienced an explosive population growth during the initial years of the establishment of the Islamic Republic.

These changes reflect a change in government policy. After the revolution, abortion became illegal and other measures of population control were decreed to be immoral, against the principals of an Islamic society, and an attempt by the Western countries to reduce the number of Muslims in the world. The revolution vowed to protect the oppressed, *mostazafeen*, promises of free urban housing for the *mostazafs* were made, and it was declared that families with a larger number of children would have precedence. In mosques and through the media, the clergy urged people to get married and to have children.

An explosive population growth, however, alarmed the ruling clergy. In 1989, just before his death, Ayatollah Khomeini made a religious declaration or *fatwa* stating that the use of contraceptives and sterilization of men and women were acceptable. Since then the government has pursued an aggressive policy of population planning, accompanied with free distribution of contraceptives in health clinics, as well as active use of mosques, the media, educational institutions, and other sources to persuade people to have fewer children.

Officially, abortion remains illegal. In practice, however, legal loopholes, and clerical interpretations have made abortion highly accessible, and available free of charge in government hospitals and clinics. According to the law, abortion can be performed if pregnancy is harmful to a woman's health. Furthermore, according to clerical interpretations, if an abortion takes place during the first 120 days, before the "ensoulment" of the fetus, it is not a crime. If challenged, the person who performed the abortion has to pay a penalty, *dieh*, to the fetus's lawful heirs: the parents. After that period, however, it is a crime, and a higher blood money should be paid to the fetus' heirs. This interpretation is a guarantee for the physicians that the potential penalty does not involve imprisonment. According to doctors and nurses abortion is frequent, and no one had heard of a single case of a doctor being reprimanded (Hoodfar, 1994).

Government policy concerning subsidies has also undergone change. Only the first three children in each family are eligible for food and other subsidies (*Iran Times*) Furthermore, the entire policy of food and other subsidies is being re-examined with the recent tilt toward privatization.

During the first decade after the revolution, higher education was characterized by a gender-based discriminatory policy that aimed at segregating men and

women, and reflected an ideological perception of the proper occupations for women. In general women were considered suitable for the profession of teaching, and health. Female students were supposed to be taught by women, and female patients were supposed to be cared for by other women. Furthermore, fields such as engineering were considered to be against the nature of women. In spite of a significant growth in secondary education from 1976 to 1986, the level of tertiary female education remained constant. Because of the ideology of segregation, coeducational vocational schools were closed. Thus women no longer had access to vocational education. Although special female schools have been established, they were limited to the fields of hygiene, first aid, sewing, cooking, and knitting. For 1984–1985, 91 fields of study (54%) out of the 169 areas offered by some 120 institutions of higher education were not available to women, mostly in the technical and scientific fields. In other areas maximum quotas ranging from 20 to 50% were applied to women students. Marginal modifications, were introduced in 1989, increasing the areas open to women by about 10% (Shahidian, 1991). Further changes in 1994 allowed women to participate in all fields of higher education.[14]

CONCLUSIONS

A case has been made here that the post-revolutionary legal system in Iran recognizes three categories of productive female labor: marital duties (*vazaif-e zanashwiy*), which includes activities directly derived from female sexuality, including reproductive labor; household labor; and participation in the labor market. With the exception of the treatment of spousal sexual relations as service in the first category, the first two categories combined correspond closely to the neo-classical concept of allocation of time to household activities, and the Islamic Republic treats this labor as productive and has introduced various provisions for compensation of household labor. Just as Gary Becker's explicit recognition of the productivity of household labor was an important development in economics, the Islamic Republic's explicit recognition of productivity of household labor and the need for its compensation is a departure from the historical treatment of labor in Iran.

In contrast to choice-based neo-classical models, however, the Islamic approach is duty-based. This distinction has important ideological and policy implications. The neo-classical model assumes that women freely choose to allocate time between household and labor market. Feminist economists have criticized this assumption and have argued that the model does not take into consideration such factors as tradition, culture, dependence, interdependence

and power. Nevertheless, this assumption has the underlying implication that women have the right to choose. The neoclassical model argues that the household division of labor is derived from comparative advantage, and that women's biological characteristics contribute to their comparative advantage in allocating time to household labor. Furthermore, according to this model, gender-based discrimination in the job market leads to inefficiency, and is thus considered undesirable. By contrast, the post-revolutionary legal and ideological framework, based on Islamic model, is duty, not choice, based. It assumes that child raising and household activities are the primary responsibilities of women. Participation in the job market is secondary. It uses a straight forward biological argument, makes no pretence to comparative advantage and efficiency, and does not consider gender-based discrimination and occupational segregation undesirable. Thus the model can be subject to harsher feminist criticisms than those applied to the neoclassical case.

It is worth noting, however, that in practice the situation is dynamic and subject to change. Over time, socio-economic and political conditions have tended to modify rigid ideological, legal, and religious interpretations. Thus in practice, the distinctions between choice versus duty seem to be less pronounced, and the rigidities of a purely biologically driven treatment of female labor modified. Thus during the first decade of the Islamic republic, attempts were made by the Islamists to cluster women within strictly female jobs such as teaching and nursing, and to drive them out of other occupations. For the second decade, however, the trends are positive.

The findings of this paper suggest that in terms of treatment of female labor, three periods, each corresponding to a distinct policy, can be found in recent history of Iran. During the two decades of 1960s and 1970s, the government pursued a policy of utilization of female labor and emancipation of women by encouraging labor participation. The underlying theoretical assumption was a recognition of productivity female labor outside the home. For the 1980s, with minor exceptions, the government aimed at reversing these policies. In this period, however, there are indications of an explicit recognition of productivity of household labor. In the 1990s, however, the government is pursuing a policy of providing additional entitlement to women for household labor, and reducing obstacles to women's work outside the home and in higher education.

ACKNOWLEDGMENTS

The author would like to thank Mine Cinar and the referees for their helpful comments.

NOTES

1. Clearly, this is a class-based recommendation, as it is not possible for poor people to afford domestic help. Nevertheless, it indicates that women are not *required* to perform household labor.
2. In court, two female witnesses are considered equal to one male. This can be interpreted to mean that women are not qualified for the legal profession.
3. This point was elaborated in an interview of *Zan-e Rooz* with Ayatollah Sayyed Mohammad Moosavi Bojnurdi (December 1993). *Zan-e Rooz*, is a popular women's magazine that since the revolution has changed its focus from standard popular topics to a serious examination of social and legal issues concerning women.
4. Note that such a condition could have always been included in a marriage contract.
5. This information is based on personal interviews of three notary public managers, and three women lawyers in Tehran, as well as examination of a post-revolutionary marriage contract.
6. Law concerning reform of regulations concerning divorce approved by the parliament in 1992 (Iranian calendar, 1371/8/28) (*Zanan* Vol. 2. No. 9, Jan-Feb. 1993).
7. *Zane Rooz*, 25 Azar 1369 (December, 1990), no 1246: 15; & Interview with Ostad Amid-e Zanjani, elected representative of the parliament [*Zan-e Rooz*, 4 Day 1372 (November 1993), no 1440: 14–15]. Also, another interview with Ayatollah Yazdi [*Zan-e Rooz*, Ordibeheshet 18, 1372 (April 1993), no 1407: 4–6].
8. In addition to the above mentioned reforms, the 1991 law returned divorce cases to the courts.
9. Personal interview with three women lawyers in Tehran.
10. Furthermore, the post-revolutionary labor laws pertaining to women did not change significantly. Comparisons of the pre-and post-revolutionary labor laws pertaining to work at night, maternity leave, breast feeding rights, daycare facilities and the like indicate marginal changes in positive as well as negative directions, and the laws are generally protective. (Mehrangiz Kar, 1992.).
11. Personal observations and comparisons between my visits to Iran in 1989, 1992, and 1994.
12. For example the Agricultural Development Bank had an excellent daycare system, and right after the revolution the daycare was closed.
13. This information can also be detected from various articles in the daily newspaper *Ettella't*, as well as, *Zan-e Rooz*, in which young people and their parents complain about problems of housing, inflation, and heavy initial costs of weddings as obstacles to marriage.
14. Although not discussed in this paper, additional statistics on labor and women in Iran are presented in the Appendix, for interested readers.

REFERENCES

Afary, J. (1996). *The Iranian Constitutional Revolution, 1906–1911*. Columbia University press, New York.
Baqerian, M. (1990). Bar-ressy-e vigegyhay-e eshteqal-e zanan dar Iran: 1355–1365 (An examination of the specific characteristics of female employment in Iran: 1976–1986). Tehran, Plan and Budget Organization, Unpublished Monogram.

Becker, G. S. (1991). *A Treatise on the Family.* Cambridge, M. A., Harvard University Press, 1991.
Becker, G. S. (1985). Human Capital, Effort, and the sexual Division of Labor. *Journal of Labor Economics, 3,* January, 533–558.
Beneria, L. (1992). Accounting for Women's Work: The progress of Two Decades. *World Development, 20*(1), 1992, 1547–1560.
Blank, R. M. (1993). What Should Mainstream Economists Learn from Feminist Theory. In: M. A. Ferber & J. A. Nelson (Eds), *Beyond Economic Man: Feminist Theory and Economics* (pp. 133–143). The University of Chicago Press, Chicago.
England, P. (1993). The Separative Self: Androcentric Bias in Neoclassical Assumptions. In: M. A. Ferber & J. A. Nelson (Eds), *Beyond Economic Man: Feminist Theory and Economics* (pp. 37–53). The University of Chicago Press, Chicago.
Folbre, N. (1993). Socialism, Feminist and Scientific. In: M. A. Ferber & J. A. Nelson (Eds), *Beyond Economic Man: Feminist Theory and Economics* (pp. 94–110). Chicago: The University of Chicago Press.
Hakimian, H. (1998). Population Dynamics in Post-revolutionary Iran: a Re-examination of Evidence. Paper presented to The Middle East Economic Association, Chicago, 3–5 January.
Hoodfar, H. (1994). Devices and Desires: Population Policy and Gender Roles in the Islamic Republic. *MERIP* No. 190, *24*(5), September-October, pp. 11–17.
ILO, Yearbook of Labour Statistics. ILO, Geneva, 1967, 1971, 1982, & 1992.
Iran Times. (a newspaper) no. 1027, July 19, 1991.
Amoly, A. J. (1990). *Zan dar Ayineyeh Jalal va Jamal (Women in the Mirror of Power and Beauty).* Nashr-e Farhangy-e Reja, Tehran, 1990.
Kar, M. (1992). Yek Gozaresh Darbareh Hoquqi kari Zanan (a report on female labor laws) unpublished.
Markaz-e Amar-e Iran (1977) (Iran Statistical Center), Sarshomarye Omoomye Nofus va Maskan, Kolle Keshvar, Sale 1355. (Population census, 1976), Markaz-e Amar-e Iran, Tehran.
Markaz-e Amar-e Iran ((1989). Sarshomarye Omoomye Nofus va Maskan, Kolle Keshvar Sale 1365: Natayege Tafsili. (Population census, 1986, detailed results),), Markaz-e Amar-e Iran, Tehran.
Markaz-e Amar-e Iran (1989). *Iran dar Ayiney-e Amar (Iran in the Mirror of Statistics).* Markaz-e Amar-e Iran, Tehran.
Markaz-e Amar-e Iran (1991). Markaz-e A. I. Keshvar: 1369 (1990), Markaz-e Amar-e Iran Tehran1.
Markaz-e Amar-e Iran (1992). Salnameh Amary-e sal-e 1370 (Annual Statistics of Iran: 1991), Markaz-e Amar-, Tehran.
Markaz-e Amar-e Iran (1992A). Gozydeh-e Mataleb-e Amary (Selected Statistical Topics), Markaz-e Amar-e Iran, Tehran.
Markaz-e Amar-e Iran (1992B). Preliminary results of 1991 Population Survey. Tehran, Unpublished.
Markaz-e Amar-e Iran (1993). *Statistical Yearbook,* 1370, (1992), Markaz-e Amar-e Iran, Tehran.
Markaz-e Amar-e Iran (1997). Sarshomary-e Omoomy-e Nofus va Maskan 1375: Nataiyeg-e Tafssili. (Population Census, 1996: Detailed Results), Markaz-e Amar-e Iran, Tehran.
Mirani, K. (1983). Social and Economic Change in the Role of Women, 1956–1978. In: G. Nashat, *Women and Revolution in Iran* (pp. 69–86). Westview Press, Boulder, Colorado, 1983.
Min-Hosseini, Z. (1993). *Marriage on Trial: A Study of Islamic Family Law: Iran and Morocco Compared.* St. Martin's Press, London, 1993.
Moghadam, F. (1994). Commoditization of Sexuality and Female Labor Participation in Islam: implications for Iran, 1960–1990. In: M. Afkhami & E. Friedl (Eds), *The Eye of the Storm: Women in Post-revolutionary Iran* (pp. 80–97). I. B. Tauris, London.
Moghadam, V. (1988). Women, Work, and Ideology in the Islamic Republic of Iran. *International Journal of Middle East Studies, 20,* 221–243.

Moghadam, V. (1995). Women's Employment Issues in the Islamic Republic of Iran: Problems and Prospects in the 1990s. *Iranian Studies*, 28(3–4), 175–202.
Nasr, S. H. (1987). *Traditional Islam in the Modern World*. Routledge & Kegan Paul Associated Book Publishers Ltd., London.
Nelson, J. A. (1993). The Study of Choice or the Study of Provisioning? Gender and the Definition of Economics. In: M. A. Ferber & J. A. Nelson (Eds), *Beyond Economic Man: Feminist Theory and Economics*. The University of Chicago Press, Chicago.
Qur'an-e Majid (*The Holy Quran*) translated from Arabic to Persian by Abdol-Majid Ayati. Soroush Publishers, Tehran, 1988.
Shahidian, H. (1991). The Education of Women in The Islamic Republic of Iran. *Journal of Women's History*, 2(3), (Winter) 1991, 6–38.
Veblen, T. (1899). *The Theory of The Leisure Class: An Economic Study in the Evolution of Institutions*. The Macmillan Company, London.
Zan-e Rooz, No. 1215, 1368, 2–30.
Zan-e Rooz (October, 1989), no. 1236, pp. 54–55.
Zan-e Rooz (September, 1989), no. 1286.
Zan-e Rooz (January 1990), no. 1304, pp. 6–10.
Zan-e Rooz (September, 1990), no 1235 pp. 14–15.
Zan-e Rooz (December 1990), no. 1246 15.
Zan-e Rooz (January 1993), no. 1443; 10–13.
Zan-e Rooz (April 1993), no. 1407: 4–6 (interview with Ayatollah Yazdi).
Zan-e Rooz (November 1993), no. 1440: 14–15, (interview with Ostad Amid-e Zanjani).
Zan-e Rooz (December, 1993), no. 1444: 10–13 (interview with Ayatollah Sayyed Mohammad Moosavi Bojnurdi).
Zanan (January/February, 1993) Law concerning reform of regulations concerning divorce, 2(9).

APPENDIX

Table A1. Employment and Education of Population of 10 Years and Older.

	1956	1966	1976	1986	1991	1996
Total Population						
(1000 persons)	12785	17000	23002	32874	38655	45401
Male	6542	8794	11796	16841	19997	23022
Female	6242	8206	11206	16033	18658	22379
% in total male						
Active	83.9	77.4	70.8	68.3	65.5	60.8
Employed	81.5	70.2	64.3	59.5	59.3	55.6
Student	7.6	15.1	23.5	23.0	26.9	29.0
% in total female						
Active	9.2	12.6	12.9	8.2	8.7	9.1
Employed	9.2	11.5	10.8	6.1	6.6	8.7
Home-maker*	79.5	73.3	68.8	68.7	63.7	58.4
Student	3.0	7.4	14.8	16.6	22.0	26.6
% in total urban male						
Active	78.5	69.2	63.9	66.8	64.5	58.5
Employed	74.6	65.1	60.7	57.7	58.6	53.6
Student	16.1	23.7	29.6	24.5	27.3	30.9
% in total urban female						
Active	9.3	9.9	9.0	8.3	8.9	8.1
Employed	9.2	9.6	8.5	5.1	6.9	7.1
Home-maker*	77.0	68.1	64.2	66.5	61.5	56.3
Student	8.4	16.4	23.7	20.5	25.2	30.9
% in total rural male						
Active	86.6	82.9	77.9	70.3	66.9	64.5
Employed	85.0	73.6	68.1	61.8	60.1	58.9
Student	3.4	9.4	17.2	21.2	26.6	25.9
% in total rural female						
Active	9.2	14.3	16.6	7.9	8.6	10.7
Employed	9.1	12.7	13.0	6.3	6.1	9.6
Home-maker*	80.8	76.7	73.0	71.8	66.6	61.9
Student	0.4	1.7	6.5	11.8	17.6	19.7

Source: Markaz-e Amar-e Iran, 1991, 1992B: 2–3, & 1997: 109–111.
* This category is not exclusive to housewives and includes family members whose primary occupation is home-making.

Table A2. Active Population (%).

	1956	1966	1976	1986	1996
Males	90	87	80	90	87
Females	10	13	20	10	13
Total	100	100	100	100	100

Source: ILO, 1967: 20, 1971: 28, 1982: 23, & 1992: 31; & Markaz-e Amar-e Iran, 1997: 109–111.

Table A3. Distribution of Employed Women by Economic Sectors (Ten years and older, 1000 persons).

	1976 Total	1976 (%)	1986 Total	1986 (%)	1996 Total	1996 (%)
Total	1212	100.0	975.3	100.0	1765.4	100.0
Agriculture	227.9	18.8	259.0	26.6	294.2	16.7
Industry	639.1	52.7	210.8	21.6	583.2	33.0
Public, Social and private Services	286.6	23.6	414.2	42.5	809.7	45.9
All other Categories*	58.4	4.8	91.3	9.4	78.4	4.4

* In each of the economic sectors included in this category Women's participation is less than 2% of the total. However, the category "activity not classified" accounts for 4.6% and 2.9% of the total for 1986 & 1996, respectively.

Source: Baqerian, M., 1990: 87; & Markaz-e Amar-e Iran, 1997: 112–113.